The Arts in the 1970s

Were the 1970s really 'the devil's decade'? Images of strikes, galloping inflation, rising unemployment and bitter social divisions evoke a period of unparalleled economic decline, political confrontation and social fragmentation. But how significant were the pessimism and self-doubt of the 1970s, and what was the legacy of the decade's cultural conflicts?

In an interdisciplinary collection of specially commissioned essays, *The Arts in the 1970s* covers drama, television, film, poetry, the novel, popular music, dance, cinema and the visual arts, challenging received perceptions of the decade as one of cultural decline. The contributors suggest that the cultural production of the 1970s developed from, and reacted against, the innovations of the 1960s, leading to new kinds of cultural constituency defining themselves not in traditional terms of class but rather in terms of gender, race, region and sexuality.

The Arts in the 1970s breaks new ground in providing the first detailed analysis of the cultural production of the decade as a whole, providing an invaluable resource for students and teachers across the spectrum of social science and arts disciplines, in particular for those involved in literary, cultural, media and communications studies.

The editor, **Bart Moore-Gilbert**, is Lecturer in English at Goldsmiths' College and co-editor of *Cultural Revolution? The Challenge of the Arts in the 1960s*.

The contributors are **Stuart Laing, Antony Easthope, Willy Maley, Elaine Aston, Robert Sheppard, Bart Moore-Gilbert, Garry Whannel, Judith Mackrell, Andrew Higson, Dave Harker, Stuart Sillars, Martin Priestman.**

The Arts in the 1970s

Cultural closure?

Edited by Bart Moore-Gilbert

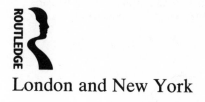

London and New York

First published 1994
by Routledge
11 New Fetter Lane, London EC4P 4EE

Simultaneously published in the USA and Canada
by Routledge
29 West 35th Street, New York, NY 10001

Set in 10/12 pt Times by Florencetype Ltd, Kewstoke, Avon

Printed and bound in Great Britain by TJ Press (Padstow) Ltd,
Cornwall
Printed on acid free paper

British Library Cataloguing in Publication Data

The Arts in the 1970s: Cultural closure?
 I. Moore-Gilbert, B. J.
 700.941

Library of Congress Cataloging in Publication Data

The Arts in the 1970s: Cultural closure?/edited by Bart Moore-Gilbert.
 p. cm.
 Includes bibliographical references and index.
 1. Arts, British. 2. Arts, Modern – 20th century – Great Britain.
 3. Arts and society – Great Britain – History – 20th century.
 I. Moore-Gilbert, B. J.
 NX543.A1A78 1994
 700′.941′09047 – dc20 93–3712
 ISBN 0–415–09905–6 (hbk)
 ISBN 0–415–09906–4 (pbk)

Contents

Notes on contributors

Elaine Aston lectures in drama at Loughborough University. She is the author of *Sarah Bernhardt: A French Actress on the English Stage* (1989), the co-author of *Theatre as Sign-System* (1991), the co-editor of *Herstory: Plays by Women for Women* (2 vols, 1991) and has written articles for *New Theatre Quarterly*.

Antony Easthope is Professor of English and Cultural Studies at Manchester Metropolitan University. His books include *Poetry as Discourse* (1983), *Literary Studies into Cultural Studies* (1991) and *Wordsworth Now and Then* (1993).

Dave Harker has written about the popular song and cultural practices of labouring and working-class people for twenty years. His books include *One for the Money* (1980) and recent research involves seventeenth-century broadside song and an edition of songs and verse made during the 1844 miners' strike in north-east England, to be called *Pitmen Determined to be Free*.

Andrew Higson lectures in film studies at the University of East Anglia. He has written on British cinema history for *Screen*, *Ideas and Production* and *Film Criticism*, and has chapters in Charles Barr (ed.), *All our Yesterdays* (1986), and Lester Friedman (ed.), *British Cinema in the Thatcher Era* (1992). He is currently preparing a history of British cinema for Routledge's National Cinemas series.

Stuart Laing is Deputy-Director of the University of Brighton. Previous publications include *Representations of Working-Class Life 1957–64* (1986) and the co-authored *Disorder and Discipline: Popular Culture from 1550 to the Present* (1988).

Judith Mackrell is dance critic for *The Independent* newspaper and has contributed regularly to *Dance Theatre Journal*, *The Literary Review* and *Vogue*. She is currently writing a study of British dance since 1968.

Bart Moore-Gilbert lectures in English at Goldsmiths' College, University of London. He is the author of *Kipling and 'Orientalism'* (1986) and co-edited *Cultural Revolution?: The Challenge of the Arts in the 1960s* (1992). He is currently working on a study of the British novel 1945–79.

Willy Maley lectures in English at Goldsmiths' College, University of London. He is the author of *A Spenser Chronology* (Macmillan, in press) and co-editor of *Representing Ireland: 1534–1660* (forthcoming).

Martin Priestman lectures in English at the Roehampton Institute of Higher Education. He is author of *Cowper's 'The Task': Structure and Influence* (1983) and *Detective Fiction and Literature: The Figure in the Carpet* (1990).

Robert Sheppard is the author of several volumes of poetry, including *Daylight Robbery* (1990). He has published a number of articles on contemporary poetry and poetics, and has reviewed for the *New Statesman* and the *Times Literary Supplement*. He is also co-editor of an anthology of new poetry from London, *Floating Capital* (1991).

Stuart Sillars lectures for the University of Cambridge Board of Continuing Education, specializing in the relations between English art and literature. His publications include *Art and Survival in First World War Britain* (1988) and *British Romantic Art and the Second World War* (1991).

Garry Whannel lectures in Sports Studies at the Roehampton Institute of Higher Education. He has worked as a researcher on a number of television documentaries; with Andrew Goodwin he edited *Understanding Television* (1990) and he is the author of *Fields of Vision: Television Sport and Cultural Transformation* (1992).

Dave Harker, Stuart Laing, Judith Mackrell, Bart Moore-Gilbert, Martin Priestman, Robert Sheppard and Stuart Sillars each contributed an equivalent chapter for the companion volume, *Cultural Revolution?: The Challenge of the Arts in the 1960s* (Bart Moore-Gilbert and John Seed (eds) (1992)).

Acknowledgements

The editor would like to warmly thank Rebecca Barden, Peter Humm, John Seed, Sarah-Jane Woolley and Claudia Woolgar for all their help on this project. Special thanks to Shanti for tea and sympathy.

The editor, contributors and publisher would like to thank the copyright holders for granting permission to reproduce extracts from the following:

'An Enquiry into Two Inches of Ivory' by Craig Raine from *The Onion Memory* (1978): by permission of Oxford University Press;

'Punishment' by Seamus Heaney from *New Selected Poems 1966–1987*: by permission of Faber & Faber Ltd;

'Cycle One' by Bill Griffiths from *Cycle* published by Pirate Press (now Amra Imprint) and Writers Forum: by permission of the author;

Stane and *Becoming* by Allen Fisher published by Aloes Books, London (1977 and 1979): by permission of the author;

Lud Heat by Iain Sinclair published by Albion Village Press (1975): by permission of the author;

'The Glacial Question, Unsolved' and *High Pink on Chrome* by J. H. Prynne from *Poems* published by Agneau 2 (1982): by permission of the author.

Permission has been requested from the Four Seasons Foundation, California to quote an extract from 'Oxford' by Ed Dorn from *Collected Poems 1956–1974* (1975). No reply had been received at time of publication.

Chapter 1

Introduction
Cultural closure or post-avantgardism?

Bart Moore-Gilbert

'THE DEVIL'S DECADE'?

Whatever their cultural or political affiliations, contemporary commentators tended to see the 1970s as a watershed. Christopher Booker, the *Daily Telegraph* and *Spectator* columnist, saw them as 'the beginning of one of the most profound shifts in psychological, intellectual and spiritual perspectives to have taken place in Western civilisation' (1980: preface). From the New Left, Tom Nairn argued that:

> the years that witnessed the end of the great struggle in Indo-China, the oil-producers' revolt and the revolution in Portugal will appear in retrospect to mark a turning-point in the history of ideas, as well as in American foreign policy or international relations.
>
> (1977: 361–2)

Such views were echoed in much of the decade's cultural production. Muriel Sparks's *The Takeover* (1976) is fairly representative, seeing the 1970s as 'a complete mutation, not merely to be defined as a collapse of the capitalist system, or a global recession, but such a sea-change in the nature of reality as could not have been envisaged by Karl Marx or Sigmund Freud' (p. 127).

Britain's predicament was only relatively bad in comparison with some other countries, but its steady deterioration in a number of key areas as the decade progressed gave much contemporary analysis an apocalyptic tone. Nairn talks of a 'rapidly accelerating backwardness, economic stagnation, social decay, and cultural despair' (1977: 51) as indicative of a society 'decayed to the point of disintegration' (p. 67). Booker describes the decade as 'a time

when, in politics, in the arts or in almost any other field one considers, the prevailing mood was one of a somewhat weary, increasingly conservative, increasingly apprehensive disenchantment' (1980:5). While acknowledging Kermode's argument (1966) that every era is liable to exaggerate its sense of being a critical moment of cultural transition, there is some reason not to dismiss such analysis as simply melodramatic.

Contemporary observers were right to stress that the problems which plagued Britain in the decade were linked to broader international transformations. First, the stasis in the global political system established by the first Cold War was undermined by America's defeat in Vietnam, followed by a further decline in American prestige as a result of Watergate. This in turn (despite détente in the form of the Strategic Arms Limitation Talks and the Helsinki declaration of 1976) led to a rapid expansion of the Soviet sphere of influence in the Third World (Angola, Mozambique, Ethiopia and Afghanistan). At the same time, however, increasing dissidence within the eastern bloc (Solzhenitsyn, Charter 77) began to undermine the hegemony of Soviet communism and paved the way for the reform programmes of the 1980s. Equally, there was growing dissatisfaction within Western European countries with the status quo provided by the post-war settlement, with effects as disparate as the collapse of quasi-fascist regimes in Spain and Portugal, the rise of urban terrorism (Baader-Meinhof in Germany, ETA in Spain, Red Brigades in Italy, the Angry Brigade in Britain) and the acceleration of political separatism in areas as diverse as Northern Ireland, Corsica and the Basque country.

As was the case elsewhere in a world struggling to come to terms with historically high rates of inflation (in which the costs of the Vietnam war and two sharp rises in oil prices played a prominent role), many of Britain's problems were exacerbated by deterioration in the economic sphere. The middle years of the decade brought the most intractable economic recession since the war (though its impact was to prove considerably less severe than those of the early 1980s and 1990s). Prices trebled between 1970 and 1980 (with house prices, despite the 1973–4 crash in the market, increasing tenfold). Government debt went from zero in 1970 to £9 billion by 1976. The 1973 stock market slump was the steepest since 1929. A series of major industrial failures in the mid-1970s, including Leyland, Ferranti, Rolls-Royce, ICL and Alfred

Herbert, illustrated the vulnerability of an economy which for decades had been declining in competitiveness. By 1975 Britain had sunk to twentieth in the table measuring per capita national product. Economic nemesis seemed imminent. The Labour government increased public spending by 9 per cent in 1974–5 while the rest of Europe was deflating. Despite a 400,000 increase in public sector personnel in the decade – in 1975 administrative staff outnumbered medical personnel by three to one in the National Health Service (NHS) – there was a perceived steady decline in the provision and quality of public services. The year 1975 brought 30 per cent pay increases for power workers, miners and railwaymen – and hyperinflation. Foreign confidence collapsed, leading to the sterling crises of 1976. Humiliatingly, the Labour government was forced to seek an International Monetary Fund (IMF) loan, the price of which was savage pruning of the public expenditure programmes of the previous eighteen months. Burk and Cairncross see the IMF debacle as 'a watershed in postwar economic policy in which full employment ceased to be the overriding object of policy, and control of inflation became the abiding preoccupation of government' (1992: xi).

Thus the IMF crisis not only lent credibility to the monetarist philosophy of the emerging Tory New Right, but also seriously undermined Labour confidence in Keynesian models of economic management. Callaghan's 1976 speech to the Labour Party conference expressed a defensiveness which was to become the hallmark of the remaining term of the last Labour government:

> For too long this country, all of us – yes, this conference too – has been ready to settle for borrowing money abroad to maintain our standards of life, instead of grappling with the fundamental problems of British industry. . . . Higher inflation followed by higher unemployment – that is the history of the last twenty years.
>
> (cited in Whitehead 1985: 188)

According to Williamson, unemployment grew overall from 3 per cent in 1971 to 5 per cent in 1979 (to 12.3 per cent in 1983), while amongst under-25s it mushroomed from 27.3 per cent in 1970 to 44 per cent in 1979 (1990: 202–4). As the threat to living standards mounted, there was industrial conflict on a scale unprecedented since the 1920s. Most significant were the two miners' strikes of 1972 and 1973–4, which brought down the Heath government, and

the 1978–9 'winter of discontent' which undermined Callaghan and was instrumental in the triumph of Thatcher at the 1979 election. The success of the unions in frustrating both Labour and Tory attempts to regulate economic behaviour pointed to the relative weakness of central government during the decade. Both parties were hampered by an inability to win clear electoral mandates. Heath's narrow and unexpected win in 1970 established the pattern. In February 1974, Wilson failed to get an overall majority and won a majority of only four seats in the October election. From 1975 Labour became increasingly dependent on minority parties (most notably the Liberals), forging pacts which, characterized more by expediency than any genuine shared vision, just enabled Callaghan to cling to power.

That this pact seemed to offer the Liberal Party its only real chance of political influence after the Thorpe scandal indicates the degree to which the middle ground in British politics shrank during the decade. The 1970s saw a distinct radicalization in British politics. In the Labour Party this process began in the late 1960s with disaffection at Labour's failure to effect 'any large-scale structural change'. The authors of the 1967 *New Left May Day Manifesto* (re-issued in expanded form in 1968) interpreted the goal of Wilson's administration thus: 'It is to muffle real conflict, to dissolve it into a false political consensus; to build, not a genuine and radical community of life and interest, but a bogus conviviality between every social group' (pp. 7–8). Such disillusion intensified in the 1970s; for the Labour Left, in Whitehead's view, Callaghan's government marked 'the death of Keynesian welfare socialism and the birth of monetarism, the external dictatorship of the markets and the American bankers' (1985: 200). Particularly irritating to the radical Left was the failure to fulfil manifesto pledges on wealth tax, reform of private education and official secrets. Policies to encourage pay restraint were seen as further evidence of a return to the Wilsonian strategy of managing capitalism. New networks such as the Campaign for Labour Party Democracy and the Labour Co-ordinating Committee articulated these frustrations with a vigour which allowed the Left to triumph in policy making during the period 1980–3 (for instance, securing the party's commitment to unilateral nuclear disarmament).

A similar disengagement from 'consensus' politics was evident in the Tory party after the appointment of Margaret Thatcher as leader in 1975. (She was later to describe supporters of 'consensus'

within her first cabinet as 'quislings'.) The ascendancy of the New Right was enabled by the crisis within the Conservative Party after the failure of Heath's corporatist version of Toryism at three out of the four elections since 1964, together with the emergence of a number of factors which could be linked together as perceived threats to authority and the social fabric. Of paramount concern was civil order, perceived to be at risk from sources as diverse as urban terrorism (whether the short-lived and ineffectual Angry Brigade or, much more alarmingly, the Irish Republican Army (IRA), which killed forty-four people in mainland Britain in 1974 alone); industrial militancy, symbolized most graphically by the flying picket; and rising crime, particularly involving violence.

The often crudely drawn links between crime and young people played an important role in the New Right's construction of the youth culture of the 1960s 'as deliberately pushing society into anarchy' (Hall and Jefferson 1975: 73). Accordingly, attempts to contain it were directed at some of the characteristic manifestations of the 'counter-culture'. The Festival of Light (1971) and a variety of 'pro-Life' organizations emerged to contest the liberalization of abortion and censorship laws in the previous decade. As the agitation for prosecution of *Gay News* for an allegedly blasphemous poem in 1977 indicated, cultural production was seen by the New Right as a central source of the perceived moral degeneration of 1970s Britain. The *IT* trial of 1970 and the *Oz* trial of 1971 disabled the underground press. In education, the *Black Papers* and the furore over 'progressive' methods of teaching (for instance at the William Tyndale primary school in 1975) indicated the growing confidence of the New Right, which also reacted with increasing vigour to vestiges of student radicalism, such as harrassment of right-wing speakers in universities.

Above all, the New Right benefited from exploiting fears of a drift towards totalitarian socialism. The apparently unstoppable growth of union power and the 'hard' Left both within and outside parliament (witness the Trades Union Congress's (TUC's) invitation to the head of the KGB to its 1976 conference, the emergence of Militant Tendency and the fourfold growth in membership of the International Socialists between 1970 and 1974) provoked spectacular defections from Left to Right in the decade – most notoriously Paul Johnson, Bernard Levin and ex-Labour Minister Lord Chalfont. This facilitated the defection of four Labour ex-Ministers to form the Social Democratic Party in

1981. Networks of resistance to the perceived threat of collectiv-
ism proliferated, including John Gorst's Middle-Class Association
and the National Federation of the Self-Employed. The authori-
tarian agenda of the New Right was most plainly visible in its own
'lunatic fringe', the sinister and extremist para-military organiz-
ations like General Walker's Civil Assistance or Colonel Stirling's
GB75. Norris McWhirter's National Association for Freedom
intervened decisively in the Grunwick dispute of 1976–7 in defence
of the proprietor's right to sack women workers of Asian origin
seeking union recognition; and, with equal success, to break postal
workers' ban on processing mail to South Africa.

The image of Britain as a fragmenting society was further heigh-
tened in the 1970s by highly visible racial divisions. The 1971
Immigration Act, introducing the overtly racist notion of patrial-
ity, did little to reassure the non-white communities (3 per cent of
the total population by 1976). Despite legislation like the 1976
Race Relations Act, discrimination persisted. In the mid-1970s, 8
per cent of black Britons had non-manual jobs, compared with 40
per cent of whites. Much friction was caused in inner cities by the
'sus' laws (adapted from the 1824 Vagrancy Act). As sections of
the media stoked hysteria over muggings (see Hall *et al.* 1978:
53–165 on the construction of the public discourse relating to this),
blacks were fourteen times as likely to be arrested under 'sus' as
whites. Racial violence became endemic, ranging from assaults on
individuals to mass confrontations such as those at the 1976
Notting Hill Carnival, Lewisham (1977) and Southall (1979). The
National Front profited from this atmosphere. In May 1973 it
achieved 16 per cent of the vote at the West Bromwich by-
election, and 18.5 per cent at Leicester in 1976. In 1977 it came
third ahead of the Liberals at both Stechford and Ladywood. The
increasing frustration and disaffection of the black British popu-
lation (especially its youth) at the often blatant hostility shown
towards them through the decade were to come to issue in the rash
of inner-city riots of the early 1980s.

The tendency towards polarization (and fragmentation) was also
reflected in the rise of separatism in Scotland, Wales and Northern
Ireland – movements which were in ironic contrast to the integra-
tionist and supra-nationalist implications of Britain's entry into the
European Community in 1973. Modern Scottish nationalism took
off in the mid-1960s, fired by disillusionment with Labour and an
increasing sense of economic backwardness relative to England.

The Kilbrandon Commission, set up by Wilson to explore the possibilities of limited devolution, recommended a separate Scottish (and Welsh) assembly in 1973. But the discovery of oil (1969 brought the first strike with the Forties field on stream the following year) at last made the idea of economic independence feasible, particularly after the Organization of Petroleum Exporting Countries (OPEC) increased the price of oil fourfold in 1973. That year Margot MacDonald won Govan for the Scottish National Party (SNP); in February 1974 it had seven Members of Parliament (MPs) returned, and in the October election a further three, by which time the party had captured 30 per cent of the total vote in Scotland. The year 1978 brought three further by-election victories. But by this time it was obvious that the separatist movement was fatally split between devolutionists and those favouring outright independence. Labour successfully exploited this division; but when the devolution referendum disappointed its expectations, the SNP took revenge, voting against the government in the motion of no confidence which led to the election of 1979 – in which, ironically, it lost all but two of its seats.

But if Scottish (and Welsh) aspirations for independence had been temporarily contained by 1979, the challenge to the Union from Northern Ireland was much more serious. After the arrival of British troops in August 1969, IRA membership grew fivefold in 1970. Politically motivated killings rose from twenty in 1970 to 467 two years later, leading to the suspension of Stormont and the imposition of direct rule from Westminster. As Catholic confidence in British rule was increasingly undermined by events like 'Bloody Sunday', when the Parachute Regiment shot dead thirteen civil rights marchers, internment and trial without jury (and more dubious methods of containing the IRA which led to condemnation from both the European Court of Human Rights and Amnesty International) – the separatist momentum remained undiminished as the decade drew to a close.

Such fragmenting tendencies were, in Nairn's view, the inevitable consequence both of Britain's failure to modernize its economic and social institutions and of the long process of withdrawal from empire. His argument that 'neo-nationalism has become the grave-digger of the old state in Britain and as such the principal factor making for a potential revolution' (1977: 89) has not as yet been vindicated (though the tensions he analysed remain unresolved). But he was probably right that the class struggle was

being superseded, if only temporarily, as the main agency for the transformation of British society, at the very moment of its apparent triumph. As Hobsbawm (1978) argues, this was partly because of both the long-term achievements and the contradictions of the Labour movement. But it was also due to the emergence of distinctively new socio-cultural configurations (taking shape outside traditional class and political contours), which were articulated round questions of gender, race, sexuality, region and, more diffusely, ecological issues. Thus the very process of fragmentation and division which is such a feature of the decade provided the momentum for cultural–political realignments which have since consolidated their identity and influence.

The most obvious example, perhaps, is the Women's Movement which established itself in the 1970s. The previous decade had certainly brought some improvement in women's position. The 1967 Abortion Act, more widely available contraception and easier divorce all testify to the success of earlier agitation for greater freedoms for women. But inequality was undiminished in pay and educational and employment opportunities. From the world of advertising to the subordinate roles offered within the 'counter-culture' (see Green 1988), women continued to be exploited as before. Resistance to the push for equality was further represented at a parliamentary level by the failure of Joyce Butler's 1967 Anti-Discrimination Bill and in industrial relations by the TUC's lukewarm support for the women sewing-machinists who struck for equal pay at Ford's in 1968. (In the end they only got 95 per cent of the male machinists' wage and did not win recognition as skilled workers.)

The greater organization and politicization of women's groupings ceated sufficient pressure for the introduction of an Equal Pay Act in 1970 (though this was not implemented until 1975). The year 1970 also saw a major consolidation of the movement at the Ruskin Women's History conference. The publication of texts like Germaine Greer's *The Female Eunuch*, Juliet Mitchell's *Woman's Estate* and Eva Figes's *Patriarchal Attitudes*, together with the foundation of magazines such as *Shrew* and *Spare Rib*, were further signs of confidence. The 1971 marches on International Women's Day mobilized round four basic demands: equal pay with immediate effect, equal job and educational opportunities, free contraception and abortion on demand and twenty-four-hour nurseries. Some legislative reform came out of the Labour govern-

ment in response to this pressure, most notably the 1975 Sex Discrimination Act, policed by the Equal Opportunities Commission, and the 1975 Social Security and Employment Acts enhanced pension provision and job security for women leaving work to raise families. There were advances elsewhere. The 1974 Working Women's Charter was largely adopted by the TUC in 1975 and in 1974 free contraception became available on the NHS. The 1976 Domestic Violence Act gave greater recognition to a widespread problem first brought to national attention by Erin Pizzey's foundation of the Chiswick Women's Refuge in 1972. (By 1980 there were over 200 such refuges; and the parallel development of Rape Crisis Centres foregrounded another aspect of the problem of violence against women.)

Despite the advances indicated above, the 1970s can be seen as a decade of only partial success for the Women's Movement. Persistent inequality remained in every sector of life from Parliament (in the October 1974 election only twenty-seven female MPs were returned) to the work sphere. Despite the Equal Pay Act, at the end of the decade women comprised only 10 per cent of professional occupations and earned an average of 57 per cent of male wages (Williamson 1990: 215). The Equal Opportunities Commission lacked teeth. Between 1975 and 1981, according to Whitehead, it 'initiated only six formal investigations of its own' (1985: 313). The emergence of the New Right also represented a serious check. Partly as a result of the emergence of organizations like LIFE and the Society for the Protection of the Unborn Child, there were three attempts in Parliament during the 1970s to restrict abortion. Moral panic about the collapse of the family and the increasing number of single mothers suggest a backlash was well under way by the end of the decade. As Eva Figes commented in a new edition of *Patriarchal Attitudes* (1978): 'We are in danger of being lulled into a sense of premature complacency: we may have won the first battle, but we are still a long way from winning the war' (p. 9).

Similar doubts can be expressed about the other new sociocultural formations' ability to effect structural change. Despite its appreciable effect on consumer behaviour in the last two decades, the ecology movement has had little impact on mainstream politics. At the 1992 election, for instance, the Green Party fielded less candidates than the Maharishi's Natural Law Party and rarely did better than fifth in any constituency. Regional separatism, while

still a powerful dynamic, has been contained by a mixture of force and concession. Clause 28 of the 1988 Local Government Act, designed to roll back some of the freedoms won by the gay movement since the 1960s, remains unrepealed and the age of consent amongst gays is still the highest in Western Europe. And while some 'New Commonwealth' immigrants have prospered spectacularly in contemporary Britain, the continuing plight of a great many is aptly described by David Lodge's novel, *Nice Work* (1988). Crammed into the ironically named inner-city suburb of Angleside, they function mainly as a reservoir of unskilled labour for factories like Vic Wilcox's, serving in the dirtiest and most dangerous sections like the foundry: 'Most of them . . . were Asian or Caribbean, in contrast to the machine shop, where the majority had been white' (p. 128). These are the lucky ones, for the black British community is now 'bearing the brunt of high unemployment' (p. 32) and in Angleside 'youth unemployment is eighty per cent' (p. 75).

The emergence of newly self-confident and articulate 'sub-cultures' seems on one level to have accelerated the break-down of the 'consensus' which had stabilized (or petrified) British society since 1945. They could also be seen as the realization of the hope expressed in the 1967 *May Day Manifesto* for 'a very broad and strong front, for radical change' (p. 5) in British society. But a more pessimistic interpretation would suggest a fulfilment of the manifesto's fear that rather than constructing a genuine coalition, the new centres of oppositional politics and cultural practice would 'segregate themselves in little magazines and sectarian societies' (p. 35). The cohesiveness of these groups might be represented as fatally undermined on the one hand by internal tensions – thus the growth of a variety of feminisms, for example, as 'it became clear that a notion of "shared oppression" permitted the domination of a white, heterosexual, middle-class definition of that oppression' (Parker and Pollock 1987: 68). And on the other hand by a general strategic hesitation over whether to engage with or remain uncontaminated by mainstream social structures. It is arguable that such fissures within and between both mainstream and 'sub-cultural' configurations seeking to confront the New Right contributed substantially to the latter's monopoly of political power from 1979 onwards.

CULTURAL CLOSURE?

At the start of the 1960s, Raymond Williams confidently antici-
pated a period of expansion and extension both in the volume and
variety of cultural production and in terms of access and partici-
pation in it (1961: 363). Hewison, by comparison, sees the 1970s as
an era of cultural 'closure' (1986: 230). There is certainly evidence
to support the latter argument. Thus, in *Art in the Seventies*,
Edward Lucie-Smith mournfully announced that 'it is now possible
to speak of the end of Modernism' (1980: 8), and the deaths of a
number of the great Modernists – Stravinsky (1971), Pound
(1972), Picasso and Auden (1973) and Shostakovich (1975) – led
other commentators to see the 1970s as terminating a major phase
of achievement in western culture, just as the decade was also
bringing to an end a period of unparalleled political stability and
economic expansion. Contemporary accounts of the state of the
arts in Britain were predominantly gloom-ridden. Peter Ackroyd
ascribed 'our declining national culture' to the fact that 'England is
a dispirited nation' (1976: 8, 146), and it became common-place to
link Britain's cultural decline to under-achievement in other areas
of national life. Brian Aldiss argued in the 1978 *New Review*
symposium on the novel that it 'has shared the wider fortunes of
this country in the Seventies, becoming poorer, more cost-
conscious, and less outgoing' (summer 1978: 16). Hans Keller,
director of New Music at the BBC, spoke for many conservatives
in his analysis of an artistic drift towards *'the dictatorship of
mediocrity*, which more or less hidden collectivism inevitably pro-
duces' (1977: 274; see also Bradbury 1976: 40). Such commentary
supports Christopher Booker's gloomy contention that 'the state
of our arts shows that we have culturally lost confidence on a scale
which is quite unprecedented', and that by the end of the 1970s the
artistic imagination 'had at last reached, for the time being at least,
a more or less gaping void' (1980: 32, 40).

The apparent dissipation of the 1960s 'counter-culture' was one
important reason for pessimism about the state of cultural pro-
duction in the next decade. Lucie-Smith viewed the 1970s as 'the
decade in which the very notion of an avant-garde, of a frontier of
experiment which must always be pushed back, was finally seen to
be untenable' (1980: 121). Huyssen (1986) interprets the 'multiple
1970s exhibitions of the art of the historical avant-garde' (p. xi) as
evidence of a process of canonization which diminished its

relevance for contemporary practice. The argument of Burger (1984) is similar: 'Since now the protest of the historical avant-garde against art as institution is accepted as *art*, the gesture of protest of the [1960s] neo-avant-garde becomes inauthentic' (p. 53). While some cultural critics like Bernice Martin (1981) welcomed the decline of the 'counter-culture' as evidence of a new climate of cultural responsibility and maturity, several of the contributors to the *New Review* symposium, like Brian Aldiss, saw 'the collapse of a genuinely exploratory avant-garde' (summer 1978: 17) inevitably leading to cultural conservatism. This diagnosis is supported by the cult of nostalgia in the decade (exemplified above all in the 1977 Queen's Jubilee), which affected a broad field of cultural politics and practice: the mobilization against Labour's proposed wealth tax in the mid-1970s, a measure seen by many as threatening the artistic heritage embodied and contained in the great country houses; the fivefold increase in National Trust membership between 1969 and 1979; the vogue for Laura Ashley; television series as diverse as *Civilisation* and *Brideshead Revisited*; hugely successful reprints like Edith Holden's *Country Diary of an Edwardian Lady* (1978); and the Booker Prize, awarded three times in the decade to unregenerately realist novels about the vanished empire.

Equally important to the conception of the 1970s as a moment of cultural 'closure' was the effect of economic recession on cultural production and consumption, as the example of publishing suggests. According to the Publishers' Association's *Quarterly Statistical Bulletin* of March 1981, the value of sales in the book trade as a whole was static at 1969 prices for the period 1969–79 (p. 32). In the middle years of the decade especially, printing, wage and distribution costs soared. According to *The Bookseller*,

> the average price for new books in the full twelve months of 1974 was £3.84, increased by just over 25 per cent to £4.82 for 1975, by just over 21 per cent to £5.85 for 1976, and by 14 per cent to £6.67 in 1977.
>
> (14 January 1978: 111)

Literary publishing suffered grievously. Penguin, for instance, faced with a projected deficit of £6 million in 1974–5, cut output of new titles from 120 to 70 and slashed its backlist from 800 to 540, terminating its entire European poetry series amongst others. According to Sutherland, there was a hike of 30–50 per cent in the

cost of fiction in the year 1974–5 alone (1978: xv), and he cited the 'positively apocalyptic' views of the publisher Peter Owen on the risks of introducing new writers in a hyper-inflationary climate (1975: 4). Greenfield (1989) confirms the sense of crisis at mid-decade:

> Milton House, which had published eighty-five novels in the previous two years, suspended all its forthcoming fiction . . . Faber and Faber announced cuts and . . . Cape, noted for its support of new novelists, accepted only one first novel in the autumn of 1975; Deutsch reported 'we have cut back on fiction quite a lot'.
>
> (p. 128)

There was deep anxiety amongst writers as publishers found themselves under ever-increasing financial pressure. The rationalization of the industry is already being lamented in *The Four-Gated City* (1969), where Doris Lessing argues that 'firms are being bought and sold like pounds of sugar, and are tiny parts of great empires' (p. 671). Nine years on, in the *New Review* symposium on the novel, Robert Coover warned that as the once relatively large number of small-scale fiction houses became absorbed by multi-national conglomerates, the traditional preoccupations and skills of both writer and editor would be discounted: 'Literary decisions are now being taken . . . by accountants, lawyers, entrepreneurs' (summer 1978: 35). Avant-garde writing, marginally profitable at the best of times, suffered disproportionately in a time of recession. When Harvester included established experimentalists like Josipovici and Giles Gordon in its first 'new voices' fiction list in 1977, presumably as insurance against the liability of riskier writers, it struck the *New Review* that this was a case of mutton dressed as lamb.

Angela Carter, Michael Holroyd and Isobel Colgate all complained in the *New Review* symposium of the rapidly declining number of good bookshops, a phenomenon which sheds further light on the material problems facing literary culture in the decade. The Publishers' Association's bulletin suggested that the number of retail outlets for books slumped from 6,001 in 1971 to 4,556 in 1978 (1981: Table 11), and pointed out that in the period 1969–79 the profitability of booksellers dropped by 22.2 per cent. (p. 32). *The Bookseller* complained that even London 'is quite extraordinary in its dearth of bookshops' (4 February 1978: 431) and asserted that

elsewhere 'the bookseller has been almost forced out of the High Street' by 'boutiques, hairdressers, betting shops (now 8,000 of them), shoe shops, hamburger bars' (25 February 1978: 1582).

Agitation for greater state support for literature as a counter-measure to such trends intensified. Although primarily a study of the Swedish situation, Per Gedin's *Literature in the Marketplace* (1975) became a source of inspiration for many connected with publishing in Britain. Gedin argued that 'an immediate and size-able contribution by society is needed in order to preserve and continue the literary book – as much for the sake of society itself as for the book' (pp. 239–40). But the fate of the New Fiction Society, launched with a £30,000 subsidy from the Arts Council in 1974 to support 'quality' hardback fiction, suggested the limitation of state intervention along the lines suggested by Gedin. Unable to attract even a fifth of the 10,000 subscribers it needed to be viable, the society folded in 1982. As Sutherland comments caustically: 'It would have been cheaper to buy the novels at full price from a bookshop and give them away to passers-by at Piccadilly' (1978: 145–6).

Within this context new initiatives for support of cultural production were explored. The Local Government Act of 1972 removed historic limitations to local authority expenditure on 'leisure' activities and the Redcliffe–Maud report of 1976, *Support for the Arts in England and Wales*, prodded local authorities to make further provision for cultural pursuits. The report was an important step in introducing the principle of 'matching funds', whereby central support for the arts was made dependent on raising equivalent sums from other sources such as local government or business sponsorship. Private patronage was increasingly co-ordinated by the Association for Business Sponsorship of the Arts (ABSA), founded in 1976. ABSA estimated that such support grew from £600,000 in 1976 to £4 million in 1979 – and £25 million by 1986 (1988: 13). But support for these developments was not unqualified. Some anticipated a trend towards more conservative programming in bodies supported by ABSA, while others interpreted the principle of 'matching funds' as demonstrating that the Arts were becoming a less important priority for central government than had been the case in the 1960s. In any case, inflation and rising competition for resources was unrelenting. It led, for example, to a freeze on the Housing the Arts fund, which had been designed to subsidise capital expenditure on plant

and buildings. More traditional kinds of provision, such as public library budgets, were also eroded. As the total of £149 million for 1978–9 (£6 million less than for 1975–6) was announced, Sutherland warned that government policy 'will undermine the base on which the present production of fiction rests' (1978: 10). And Gedin asserted that in such circumstances there was, inevitably, pressure on public libraries to concentrate on the supply of pulp. But the freeze continued inexorably. In December 1980, the Arts Council announced that it would not renew grants to forty-one organizations, producing the first substantial cut in the gross number of initiatives supported from central funds.

NEW DIRECTIONS: TOWARDS A BRITISH POST-AVANTGARDISM

None the less, as some of the following chapters will argue in more detail than is possible in the homogenizing and compressed discourse of an introduction, the conception of the 1970s as a moment of cultural 'closure' may well be misplaced. First, the 1960s avant-garde did not simply disappear under the pressure of political reaction and economic downturn, leading to cultural conservatism on a massive scale. Rather, the evidence suggests that the mainstream was significantly changed by the legacy of the previous decade's experimental energy. One symptom was the increasing support given by official institutions to some of the kinds of work initiated by the 1960s avant-garde. For example, in 1971 the Arts Council established its Experimental Projects Committee and in 1975 its Community Arts Committee. While the former was soon disbanded under pressure of economic retrenchment, the lasting influence of the Community Arts movement can be seen in the proliferation of local Arts Centres, which grew from thirty-four in England and Wales in 1967 to 174 by 1981 (Baldry 1981: 135). Subsidy played a growing role in the proliferation of fringe theatre in the 1970s. The half-dozen or so groups which existed in 1968 became legion in the 1970s, to the point that fringe, despite its name, perhaps became an institution at the centre of cultural life, as Martin Priestman's chapter suggests.

A second important development in the 1970s was the explosion of theory. Parker and Pollock explain its proliferation in terms of the collapse of consensus described in the first part of this introduction:

The question of the ways in which, in a more affluent society, consent is secured for the maintenance of an unequal and exploitative society led to a reassessment of the effects of advertising, film, television, journalism, as well as literature, fine art and the education system – in short the whole spectrum of those social practices which, producing meaning and images of the world for us, shape our sense of reality and even our sense of our own identities.

(1987: 79)

Since the effects of theory on pedagogy and institutional practices are the focus of Antony Easthope's chapter, a few comments on its role *within* artistic production specifically must suffice here. First, theory infused a broad range of cultural practices. As Martin commented: 'The Word is . . . infiltrating arts whose essential codes are not verbal at all' (1981: 91). Second, the presence of critical theory within a good deal of the artistic practice of the decade, such as in the Conceptual art of the Art and Language group or Cornelius Cardew's music, was a deliberate attempt to erode the discursive boundaries and hierarchies traditionally assumed between critical and creative activity. Thus Harari (1979) argued that 'criticism has reached a state of maturity where it is openly challenging the primacy of literature. Criticism has become an independent operation that is primary in the production of literature' (p. 70). Third, and partly as a consequence of this, theory was itself seen by some commentators as taking over the function of formal experimentation promoted by the 1960s avant-garde – thus Robert Alter's comment that none of Robbe-Grillet's novels 'equals in fascination Roland Barthes's brilliant descriptions of them' (1975: 221). Fourth, and by sharp contrast, the incorporation of theory within the decade's artistic practices excited a good deal of hostility in some quarters. Hans Keller complained thus: 'It is almost unimaginable that there was a time, not so very long ago, when a composer['s] . . . programme note, and/or his pages of instructions in front of the score, did not form part of his work' (1976: 42). (And the preoccupation with theory is read as a symptom of cultural decline in retrospective accounts by Hewison (1986: 209) and Huyssen (1986: 170).)

Finally, there can be little doubt that the fragmenting tendencies observable in British society during the 1970s provided powerful new stimuli to cultural production as habitually conceived. For

instance, issues of regional separatism informed the work of a new
generation of poets like Heaney, the Longleys and Mahon from
Northern Ireland as well as the drama of McGrath in Scotland.
Thus Heaney (1984) has argued that while 'the imaginative gifts of
Northern Irish writers should not be linked too sociologically to
the blemished life of their country' (p. 15), the emergence of this
group was 'itself a new political condition' (p. 5) and there was a
'profound relation here between poetic technique and historical
situation. It is a superficial response to the work of Northern Irish
poets to conceive of their lyric stands [sic] as evasions of actual
conditions' (p. 7). John McGrath has situated the experimental
work of Scottish 7:84 within the policy of 'localism' (1981: 58)
espoused by the group. This led to 'an adaptation of the traditional
form of entertainment of the Highlands, the music was what the
people liked, and the songs, in Gaelic and English, went to the
root of suppressed popular feeling' (p. 122).

The impact of the Women's Movement was equally influential.
As Julia O'Faolain commented: 'An exhilarating side-effect . . .
was the freeing of the female imagination which has, it seems,
been . . . fearing to take certain terms or cast women in roles
reserved for males' (*New Review*, summer 1978: 57). Olivia
Manning spoke for most of the women writers approached by the
New Review in arguing that 'the present age is remarkable for the
preponderance of women fiction writers of such quality that they
have outfaced prejudice' (p. 51). The same is true of other artistic
fields; Margaret Harrison and Mary Kelly in the visual arts, Jo
Spence in photography, Laura Mulvey and Sally Potter in film and
the many playwrights discussed in Elaine Aston's chapter.

The pattern was repeated elsewhere. Thus Lauretta Ngcobo has
written of 'the creation of a new tradition. A few years ago there
was nothing called Black British Art and Culture. Today there is'
(1987: viii). The climate of racism in the 1970s played a crucial role
in this awakening. For instance, the Tara Arts drama group
emerged as a direct response to the stabbing of an Asian youth in
Southall in 1976, taking a lead from earlier initiatives like the
Black Theatre of Brixton, Dark and Light Theatre (founded 1970)
and Temba (1972). The Notting Hill Carnival expanded rapidly in
the 1970s; recurrent violence, most notoriously in 1976, supports
the argument of Owusu and Ross that by then the event had
become 'culturally volatile terrain on which the battle of positions
between the Black Community and the State is ritualised' (1988:

5). In the visual arts figures like Rasheed Araeen and Keith Piper
began to bring the politics of race directly into their work. This was
also evident in the poetry of figures like Linton Kwesi Johnson.
And in 'popular' culture, reggae provided a new genre of black
music which inspired innovative domestic styles like British reggae
and Two Tone at the end of the decade. Both were identified with
the anti-racist struggle not just because, as Hebdige suggests, their
'lyrics refer quite directly to the conditions facing black people in
Britain' (1987: 100), but through their representation in the pro-
grammes of concerts organized by the Anti-Nazi League and Rock
Against Racism.

The difficulty of access to established cultural institutions,
whether as producer, performer or audience, was a major factor in
the cultural struggles of marginalized groups in the 1970s. Parker
and Pollock (1987) describe how mainstream galleries like the
Serpentine and the Royal College of Art rejected early feminist
group shows. The Black Theatre Co-operative (BTC) was founded
in 1979 'to give opportunities to black actors, writers and direc-
tors',[1] the most immediate impulse being playwright Mustapha
Matura's inability to interest any London fringe theatres in pro-
ducing *Welcome Home Jacko*. BTC's production of the play was
finally seen by over 20,000 people, culminating in a tour to New
York. A related sense of frustration lay behind the foundation of
Temba, as current artistic director Alby James recalls:

> In the late 60s the RSC employed black actors, but they were
> always in the equivalent of the chorus or the spear-carrying
> role. They were so talented, some of them, but there was no
> way they were going to get any further. Therefore the setting up
> of Temba was the obvious thing to do.[2]

Such initiatives were complemented by a struggle for a material
base to mediate the cultural production of the new constituencies
in the face of the discriminatory funding patterns revealed in
Naseem Khan's *The Arts Britain Ignores* (1976). Khan solicited
details from seventy-five local authorities with a 'significant
["ethnic"] minority' (p. 10) of the financial support they provided
to 'ethnic' cultural activities in 1974–5. The total of £4,254 con-
trasted starkly with the provision of £48,000 provided by just one
local authority, Tyne and Wear, for support of amateur arts
groups in its area.

Considerable headway was made in the decade towards realiza-

tion of this new material base. Examples might include new artistic organizations and ensembles (The Women's Workshop of the Artists' Union, Gay Sweatshop or Monstrous Regiment); critical fora such as the Marxist–Feminist Literature Collective, the Society for Caribbean Studies or the Women's Art History Collective; networking newspapers and magazines, from those addressing the broad concerns of a marginalized group, including some attention to its cultural output (*Gay News*, *Spare Rib* or *Race Today*), to those devoted to general coverage of the arts within a specific sub-cultural sector (like *The Feminist Review* or *Echo: Living Arts in Britain's Ethnic Communities*) and those specializing in a single aspect of sub-cultural art (in the visual arts, for instance, *Black Phoenix* or *Feminist Art News*); production and performing spaces (the 1975 Women's Free Arts Alliance near Regent's Park or many of the new Arts Centres which privileged production and display of sub-cultural arts); bookshops like Grass Roots and Bogle L'Ouverture (specializing in black-centred subjects) or Sisterwrite; and presses like Blackstaff (for Northern Irish poetry), New Beacon (for black interests), Virago, The Women's Press and The Gay Men's Press.

The success of the marginalized constituencies' cultural struggle can also be seen in the way their initiatives began to be more widely supported (though not without considerable struggle, in many cases) by official institutions of cultural production. As a result of Naseem Khan's 1976 report, the Arts Council gave funding for the Minority Arts Advisory Service, which functioned as a networking and enabling organization for the Black British sector. In 1978 pressure was successfully exerted on the Arts Council to allow five women to select its Hayward Annual in what Parker and Pollock have described as a 'major breach into official culture on behalf of women in Britain' (1987: 23). Educational institutions were also penetrated, with the foundation of courses in Women's Studies and the African and Caribbean Studies with English or French programmes at Kent University in 1976. Specialized mainstream magazines began to take some interest in these developments; examples include the special issues on feminist visual art in *Art and Artists* (1973) and *Studio International* (1979). Commercial institutions started to recognize related new markets, too. Longman began its Drumbeat series of Commonwealth writing and Heinemann both expanded its African Writers series and founded its Caribbean Writers series.

These three developments provide the major evidence that a culture of 'post-avantgardism' was established in Britain during the 1970s. (I use this term to distinguish these trends from 'post-modernism', which can be seen as a fragmented and decentred legacy of the 1960s avant-garde: so that post-modernism repeats the formal and theoretical experimentation of the 1960s, stripped of any coherent or committed political vision. Thus Huyssen sees post-modernism as 'the endgame of the avantgarde' (1986: 168) and a 'kind of affirmative art that could happily co-exist with political and cultural neo-conservatism' (p. 199). For the conflicting relations between feminist and post-modernist art, see Parker and Pollock (1987: 80).)

The term 'post-avantgardism' also implies a contestatory as well as a temporal relationship to the 1960s avant-garde. One way in which this boundary is marked is by their relative positioning *vis-à-vis* established social structures and patterns of cultural practice. As Habermas (1973) suggests, the 1960s avant-garde was 'a counter-culture arising from the centre of bourgeois society itself' (p. 85), and his argument suggests that its threat could be relatively easily contained precisely because it was surrounded by the institutions and apparatus of its opponents. By contrast, post-avantgardism may be understood as a phenomenon of the margins, whether in a literal geographical sense (Scotland, Ulster, 'New Commonwealth' immigration), or ideologically, in terms of dominant discourses of sexuality and gender. This suggests both advantages (relative difficulty of incorporation by a repressively tolerant mainstream) and disadvantages (relative lack of access to political and cultural centres of power) *vis-à-vis* the 1960s avant-garde. And this ambivalent positioning of post-avantgardism explains the crucial debate over strategy between advocates of separatism (see McGrath 1981: 50; and Kelly 1984: 31–6) and integration into the mainstream (see Khan 1976: 129; and Hebdige 1987: 109–10), which remained unresolved at the end of the decade.

At the level of form rather than institution, post-avantgardism often places less of a premium on experimentation than the 1960s avant-garde, which tended to posit a necessary connection between formal innovation and political radicalism. Such ambivalence towards some of the self-reflexive tendencies of the 1960s avant-garde and its post-modern legacy can be related on the one hand to a sense that these experiments may reinstitutionalize

cultural practice as esoteric and elitist and reinforce the divide between art and life which they were originally intended to destroy. Equally, in a consumer society mediated by an advertising industry in which appropriation of the formal techniques of the avant-garde was becoming commonplace from the 1960s onwards, the claim that experimentation was in itself politically revolutionary became increasingly difficult to sustain. Post-avantgardism lends support to Burger's argument that with the avant-garde incorporated or contained, it is no longer possible to privilege experimentalism over more traditional aesthetic models (1984: 63, 87). The context of reception and modes of address offered by a given work of art thus become at least as important as subversion of stylistic norms in determining political effectivity, so that confessional, realist and autobiographical modes in the literature of post-avantgardism and figurative modes in its visual arts (while post-modernism was tending to announce categorically the death of the subject), co-exist productively with more obviously deconstructive modes of representation.

While the three developments described as constitutive of post-avantgardism are distinct from each other, there are areas of overlap. For instance, in some respects the cultural practices of feminism, the gay movement and the Black British community closely resemble the Community Arts movement which got under way at the end of the 1960s. Inspired initially by Ed Berman's Inter-Action, notable later successes included Magic Lantern, Islington Bus Company and Free Form. Usually located in specific communities, often as part of wider community work projects, their aim was to catalyse collective means of artistic expression, thereby broadening the base of cultural production and consumption. Typically, they were organized on a co-operative rather than a hierarchical basis, challenged accepted canons and divisions between 'high' and 'low' forms and cut across the professional/ amateur divide. By rejecting accepted definitions of the purpose of art and habitual modes of its production and reception, the Community Arts movement engaged in running warfare with what Burger (1984) has termed 'the institution art', whether conceived of as the market nexus constructing art as a commodity which fetishized the unique 'aura' of its producer; as the officially sanctioned 'great tradition' playing its part in legitimizing the sociocultural status quo; or as illusory compensation for structural inequities in society.

However, one must be careful not to homogenize post-avantgardism into a unified cultural practice, for the relations between (and within) these three developments are often as conflicting as cohesive. Thus while it may have been appropriate for the Arts Council to support the Notting Hill Carnival through the mechanism of the Community Arts Committee, and Steel an' Skin was an example of a Community Arts group with a specifically black identity, the sub-cultures were often not concentrated in the 'defined geographical area' (Braden 1978: 107) favoured by that movement. Owusu (1986) has gone so far as to claim that in general 'community artists rarely challenge the cultural authority which they derive from being part of a racist national culture' (p. 43). Tensions are evident in other areas. The cultural practices of the Community Arts movement on the one hand and of feminists, gays and Black British on the other, shared a vision of history as shaped by a telos of liberation. But the motor of that struggle as well as the kind of liberation sought were often conceived quite differently. The Community Arts movement (like much early 1970s fringe and ex-fringe) remained broadly committed to what Braden calls 'the revolutionary struggle . . . fought between capitalism and the proletariat' (1978: 146). Whereas for 'sub-cultural' post-avantgardism, this is usually at best secondary to the attempt to transform society through strategies structured by experience of oppression on the grounds of race, national identity, gender and sexuality. Again, one must be alert to complications. McGrath's emphasis on 'localism' (1981: 58) is an attempt to integrate discourses of both class and national oppression. But post-avantgardism often sees the discourse of class struggle as masking these other forms of oppression. This was a further point of reaction against the 1960s avant-garde (see Green (1988) on the sexism of the 'counter-culture'), which was partly shaped by its inheritance from the 'classical' avant-garde of the inter-war period, of which Huyssen observes: 'In relation to gender and sexuality, though, the historical avantgarde was by and large as patriarchal, mysogynist, and masculinist as the major trends of modernism' (1986: 60). (Similar observations might apply to the issue of race.)

The complicated inter-relationship between the various elements of post-avantgardism can also be seen in the disputed status of theory within the cultural practice of the marginalized communities. While theory was fairly readily incorporated into academic

institutions, as the growth of Women's studies in the decade suggests, it met more resistance amongst artists. While the work of some feminist artists like Laura Mulvey and Mary Kelly is, indeed, insistently theoretical, many other such figures within the Women's Movement remained deeply suspicious of its incursions. According to Micheline Wandor, for example, the 'mystification' of the art work by 'academic discourse' did 'little more than expose the ignorance of the [non-academic female] viewer' (Parker and Pollock: 204). Phil Goodall complained that 'mystification in art has already made it nearly impossible for all but a few to work in art and design fields without a sense of inferiority' (Parker and Pollock: 206). (This issue is taken up further in my chapter on the novel.)

CONCLUSION

The negative assessment of the achievements of the 1960s avant-garde offered by critics as diverse as Burger and Martin rests largely on a conviction of the limitless flexibility and power of both the official and commercial wings of the 'culture industry' to either ignore, repress, contain, co-opt or exploit any challenge to them. In many ways their power to do this seemed undiminished in the 1970s, as is suggested on the one hand by the speed and ease with which a phenomenon like punk, despite its ostensibly avant-garde political and musicological character (see Vermorel and Vermorel (1978: 220ff) for the Situationist affiliations of the Sex Pistols, for example), was speedily transformed into a successful sector of the fashion and music industries (Savage 1991: 499–501). At the other extreme, *Echo* complained about the complete indifference shown by ABSA's network of business sponsors to the ethnic arts (December 1977: 3). Official institutions could be seen as operating a similar strategy of containment. John McGrath claimed that the 7:84 theatre company lost its Arts Council grant in 1972–3 because it mounted two plays critical of Britain's role in Northern Ireland. He further argued that subsidy was turning fringe into 'the whimsical experimental department of cosmopolitan bourgeois high culture' (McGrath 1981: 50; see Kelly 1984: 31–6 for a similar analysis of Community Arts). And in the final analysis the state was always ready to intervene in repressive ways. An obvious instance was the violence between the police and revellers at the Notting Hill Carnival. The exhibition

displaying Monica Sjoo's 'God Giving Birth' was threatened with legal proceedings on the grounds of blasphemy and obscenity and Margaret Harrison's 1971 show at Motif Editions was closed after police pressure.

From within the post-avantgardist cultural formation moreover, have come warnings that such success as it has enjoyed, piecemeal as this has sometimes seemed, has had the effect of splintering and diffusing some of its original energies and aspirations (see Fairbairns 1979). On the other hand, there have been arguments that little has changed despite the effort expended in the 1970s. Thus Micheline Wandor argued in 1987: 'I don't think British theatre is any less sexist than it was in 1970, despite a scattering of more visible women writers, directors, et cetera. Nothing has permanently changed' (p. 404). And in 1992 there were still only two buildings-based Black British theatre companies and only two black members in the National Theatre's ninety-strong company. Clause 28 of the 1988 Local Government Act, designed amongst other things to limit the 'promotion of homosexuality', thus rendering the gay constituency's whole range of cultural production technically liable to prosecution, suggests the continuing difficulties faced by post-avantgardism. And the current state of cultural production (including, in the era of a crudely quantified model of research selectivity, academic work such as the present volume) could be seen as prime evidence to support Raymond Williams's contention that 'the containment and eventual cancellation of any real challenge to capitalist society has been, for more than a century, the work of capitalist society itself' (1961: 330).

Pessimism on such questions is particularly tempting at a moment when it can be argued that so fragmented and structurally weak is the opposition to the 'elective dictatorship' of Toryism established since 1979, that the only important and vigorous debates on the politics of culture are taking place *within* the Conservative party. (It is perhaps worth noting that the most sophisticated theories of the 'culture industry's' infinite capacity to suppress real dissent have come from a Left tradition of cultural analysis – from Adorno to the Althusserian *Screen* project – in which the class dialectic has been paramount.) But the sub-cultural manifestations of 'post-avantgardism' in particular, suggest that such pessimism is perverse, requiring us to ignore its success in developing distinctive new voices and practices and its influence on mainstream culture. Not even the most commercial elements of

the 'culture industry' have emerged unscathed from their attempted appropriation of post-avantgardism. Thus Savage (1991: 541) and Hebdige (1987: 107–8) show how both Punk and Two Tone strengthened the position of the artist as producer within the popular music industry. And post-avantgardism itself has not, as yet, accepted the impotence of its own project and retreated to practice negative dialectics in a self-contained and self-sufficient aesthetic realm. Instead it may yet exemplify Parker and Pollock's argument that the 'dominant and the alternative in cultural practice exist *interdependently*' (1987: 99). Therein lies hope, for the most cursory glance at cultural history reveals a process by which the marginal of one epoch can become the dominant of the next.

If what Raymond Williams called the 'long revolution' and, indeed, what continental theory terms 'the project of modernity' (see Habermas 1983) have not been entirely halted by the apparent collapse of socialism since the 1970s, one agency of their continuation perhaps remains in the social and cultural practices of what I have called post-avantgardism, together with a reconstituted politics of both class identity and individual agency. Whether this will ever transpire is beyond the competence of this volume to predict. Rather, it attempts, within the limited purview of the British context, and albeit only partially, the more modest but none the less pressing project identified by Andreas Huyssen: 'The cultural history of the 1970s still has to be written, and the various postmodernisms in art, literature, dance, theatre, architecture, film, video, and music will have to be discussed separately and in detail' (1986: 216).

NOTES

1 Taken from Black Theatre Co-Operative documents supplied to this writer ('A Brief History' and 'Statement of Policy').
2 Transcribed from a taped interview between Alby James and Claudia Woolgar, April 1992.

FURTHER READING

The only single volume history of the decade is Whitehead (1985), which could be supplemented by Morgan (1990: 317–435) and Williamson (1990: 191–229). Burk and Cairncross (1992) is excellent on the economic history of the 1970s. Hewison (1986) is an essential guide to the cultural practices

and politics of the first half of the decade. Baldry (1981) and Hutchison (1982) are useful on arts institutions and policy generally, as are the yearly Arts Council Reports. The introduction to Moore-Gilbert and Seed (1992) provides a way into debates about the British avant-garde of the 1960s and its legacies, while Burger (1984) and Huyssen (1986) offer indispensable theoretical analyses of the avant-garde and post-modernism as institutions. Parker and Pollock (1987) gives an exemplary analysis and archive of the effect of feminism on a single art form, while Owusu (1986) is useful on the emergence of Black British culture. Easthope (1988) and Turner (1990) give clear accounts of the growth of theory in the decade and its effects on institutional practice.

BIBLIOGRAPHY

Ackroyd, Peter (1976) *Notes for a New Culture: An Essay on Modernism*, London: Vision.
Alter, Robert (1975) *Partial Magic: The Novel as Self-Conscious Genre*, London: University of California Press.
Association for Business Sponsorship of the Arts (1988) *A Celebration of 10 Years' Business Sponsorship of the Arts*, London: ABSA
Baldry, Harold (1981) *The Case for the Arts*, London: Secker.
Booker, Christopher (1980) *The Seventies: Portrait of a Decade*, London: Allen Lane.
Bradbury, Malcolm (1976) 'I want it here', *New Review* 3(33), December: 39–41.
Braden, Su (1978) *Artists and People*, London: Routledge.
Burger, Peter (1984) *Theory of the Avant-garde*, trans. Michael Shaw, Minneapolis, MN: University of Minnesota Press.
Burk, Kathleen and Cairncross, Alec (1992) *'Good-bye Great Britain': The 1976 IMF Crisis*, London: Yale.
Easthope, Antony (1988) *British Post-Structuralism since 1968*, London: Routledge.
Fairbairns, Zoe (1979) *Benefits*, London: Virago.
Figes, Eva (1970) *Patriarchal Attitudes: Women in Society*, reprinted London: Virago, 1978.
Gedin, Per (1975) *Literature in the Marketplace*, trans. G. Bisset, reprinted London: Faber, 1982.
Green, Jonathon (1988) *Days in the Life: Voices from the English Underground 1961–1971*, London: Heinemann.
Greenfield, George (1989) *Scribbles for Bread: Aspects of the English Novel Since 1945*, London: Hodder & Stoughton.
Habermas, Jurgen (1973) *Legitimation Crisis*, trans. Thomas McCarthy, reprinted London: Heinemann, 1976.
—— (1983) 'Modernity – an incomplete project', in Hal Foster (ed.) *Postmodern Culture*, reprinted London: Pluto, 1985.
Hall, Stuart, Williams, Raymond and Thompson, E.P. (eds) (1967) 'New Left May Day Manifesto', unpublished.
Hall, Stuart and Jefferson, Tony (eds) (1975) *Resistance through Rituals:*

Youth Subcultures in Post-War Britain, London: Hutchinson.

Hall, Stuart, Critcher, C., Jefferson, T., Clarke, J. and Roberts, B. (eds) (1978) *Policing the Crisis: Mugging, the State, and Law and Order*, London: Macmillan.

Harari, Josue (ed.) (1979) *Textual Strategies: Perspectives in Post-Structuralist Criticism*, reprinted London: Methuen, 1980.

Heaney, Seamus (1984) *Place and Displacement: Recent Poetry of Northern Ireland*, Grasmere: Trustees of Dove Cottage.

Hebdige, Dick (1987) *Cut 'N' Mix: Culture, Identity and Caribbean Music*, London: Methuen.

Hewison, Robert (1986) *Too Much: Art and Society in the Sixties 1960–75*, London: Methuen.

Hobsbawm, Eric (1978) 'The Forward March of Labour Halted?', in M. Jacques and F. Mulhern (eds) *The forward march of labour halted?*, reprinted London: Verso, 1981.

Hutchison, Robert (1982) *The Politics of the Arts Council*, London: Sinclair Browne.

Huyssen, Andreas (1986) *After the Great Divide: Modernism, Mass Culture, Postmodernism*, reprinted London: Macmillan, 1988.

Keller, Hans (1976) 'Music 1975', *New Review* 2(24), March: 17–53.

—— (1977) *1975 (1984 minus 9)*, London: Dobson.

Kelly, Owen (1984) *Community Arts and the State*, London: Comedia.

Kermode, Frank (1966) *The Sense of an Ending: Studies in the Theory of Fiction*, Oxford: Oxford University Press.

Khan, Naseem (1976) *The Arts Britain Ignores: The Arts of Ethnic Minorities in Britain*, London: Calouste Gulbenkian and CRC.

Lessing, Doris (1969) *The Four-Gated City*, reprinted London: Granada, 1972.

Lodge, David (1988) *Nice Work*, reprinted Harmondsworth: Penguin, 1989.

Lucie-Smith, Edward (1980) *Art in the Seventies*, London: Phaidon.

McGrath, John (1981) *A Good Night Out: Popular Theatre; Audience, Class and Form*, London: Eyre Methuen.

Marcuse, Herbert (1937) 'The affirmative character of culture', in *Negations*, reprinted Boston, IL: Beacon Press, 1968.

Martin, Bernice (1981) *A Sociology of Contemporary Cultural Change*, Oxford: Blackwell.

Moore-Gilbert, Bart and Seed, John (eds) (1992) *Cultural Revolution?: The Challenge of the Arts in the 1960s*, London: Routledge.

Morgan, Kenneth O. (1990) *The People's Peace: British History 1945–1989*, Oxford: Oxford University Press.

Nairn, Tom (1977) *The Break-Up of Britain: Crisis and Neo-Nationalism*, London: New Left Books.

New Review (1978) Summer, (5) (1).

Ngcobo, Lauretta (1987) *Let It Be Told: Essays by Black Women in Britain*, reprinted London: Pluto, 1990.

Owusu, Kwesi (1986) *The Struggle for the Black Arts: What We Can Consider Better than Freedom*, London: Comedia.

Owusu, Kwesi and Ross, Jacob (1988). *Behind the Masquerade: The Story of the Notting Hill Carnival*, London: Arts Media Group.

Parker, Roszika and Pollock, Griselda (eds) (1987) *Framing Feminism: Art and the Women's Movement 1970–1985*, London: Pandora.

Publishers' Association (1981) *Quarterly Statistical Bulletin*, March.

Savage, Jon (1991) *England's Dreaming: Sex Pistols and Punk Rock*, London: Faber.

Spark, Muriel (1976) *The Takeover*, London: Macmillan.

Sutherland, John (1975) 'Hard times for the novel', *New Review* 2 (18), September: 3–10.

—— (1978) *Fiction and the Fiction Industry*, London: Athlone.

Turner, Graeme (1990) *British Cultural Studies: An Introduction*, London: Unwin Hyman.

Vermorel, Fred and Vermorel, Judy (1978) *Sex Pistols: The Inside Story*, reprinted London: Omnibus, 1987.

Wandor, Micheline (1987) Interview in Kathleen Betsko and Rachel Koenig (eds) *Interviews with Contemporary Women Playwrights*, New York: Beech Tree Books.

Whitehead, Philip (1985) *The Writing on the Wall: Britain in the Seventies*, London: Michael Joseph.

Williams, Raymond (1961) *The Long Revolution*, reprinted Harmondsworth: Pelican, 1975.

Williamson, Bill (1990) *The Temper of the Times: British Society since World War II*, Oxford: Blackwell.

Chapter 2

The politics of culture
Institutional change in the 1970s

Stuart Laing

INTRODUCTION

The 1970s inherited a rich and confusing mixture of aesthetic debates and cultural developments from the previous decade. The 1960s had seen a first steady, then accelerating growth in both the cultural and leisure market (recorded music, fashion, the paperback revolution, the metropolitan art world) and the public funding of the arts and 'high' cultural institutions (expanding universities, increased support for public libraries and the Arts Council, a re-invigorated BBC). As the decade ended the new opportunities offered by this expansion and the contradictory sets of values embodied within it fuelled a vigorous and confident growth of 'alternative' cultural ideas and institutions (in magazines, design, music, poetry, theatre and mixed-media work) which challenged and offered to re-make many existing conceptions of art and culture.

A common thread to all these developments was the arrival of a new audience for the arts, a new market for popular culture. The children of the war years and (increasingly important by the end of the 1960s) the post-war baby boom were coming to adulthood; their twin experiences of welfare state social security and the material gains of affluence meant that among those under 30 at the beginning of the 1970s there was an almost unconscious certainty that, by its very nature, the post-war world was one of infinitely expanding prosperity and full employment. Whatever the talk, through the 1960s, of economic crises and rising inflation there was the apparently unchallengeable visible evidence of rising prosperity in the spread of television sets, cars, phones, washing-machines, refrigerators and (perhaps above all) the increasing

disposable income and new consumer world of the young. If there was articulate dissatisfaction among the new generation it was about the ethics of consumerism or the various foreign policies which guaranteed it (nuclear bombs, apartheid, Vietnam), not about any failure to deliver the material goods or to finance their cultural aspirations.

The momentum of the 'sixties' cultural revolution with all its associated rising expectations then rolled on into the new decade; almost at once, however, it began to run into two kinds of crisis which threatened, deflected and finally fundamentally altered its character. First, the clearly visible and tangible reality of a new economic situation began to emerge. The experience of the Heath government was of industrial conflict, shortages, threats of rationing (petrol coupons were issued, although not used) and a three-day working week. In particular the oil crisis of 1973 (following the Arab–Israeli war) followed by the miners' strike and the highly symbolic curtailing of hours of television programming together demonstrated emphatically that any idea of quasi-natural unlimited economic growth was illusory. As the decade wore on, even more unthinkably for those who had been taught by their parents that the 'thirties' experience was gone for ever (the 1939–45 war marking some epochal watershed), unemployment began to rise – passing the, again, highly symbolic 1 million figure in 1975 and continuing upwards. Simultaneously soaring inflation undermined the capacity of public spending programmes and individual incomes to sustain cultural expansion. Both the economic and the psychological consequences of these changes finally put paid by the mid-1970s to that (in retrospect) extraordinarily naive confidence which had characterized so much 1960s cultural practice.

Also, and more fundamentally, the character and composition of the nation had begun to change. From 1968 on, and particularly after 1970, the emergence as political and cultural–political issues of race, Ulster, the Women's Movement (and sexual politics in general), major industrial conflict, nationalisms in Wales and Scotland and the gradual re-appearance of the old English North–South split in prosperity and employment, all visibly refused that idea of a singular consensual national culture based on a white male middle-class London which had characterized commercial marketing, the high cultural elite and the underground scene alike at the end of the 1960s. EMI records, Sadlers Wells and *IT* magazine, for example, all had their base in London. Similar

patterns of domination of the different spheres of culture came under increasing challenge during a decade in which the post-war Butskellite political settlement gradually eroded and finally collapsed under the twin attacks of both this diversity of oppositional forces and the re-composition of new groups of much more self-conscious and militant defenders of the national identity and tradition, with Thatcherism as their leading edge.

The effects of these often extreme pressures on existing and emergent cultural institutions varied and worked through at different speeds; the mass media, alternative cultural forms, established arts institutions and public education (the four areas examined in this chapter) each also had their own internal dynamic which shaped their modes of adaptation and survival in what became an increasingly bleak and less optimistic climate as the decade wore on. This conjunction of general politico-economic factors and more local cultural histories produced different stories of failure and success, of stability and change, within a period of particularly uneven development.

THE MASS MEDIA

At first glance the established mass media appear to have been remarkably unaffected by the pressures of the decade. In contrast to the energy and expansion of the 1960s and the volatility of the television and newspaper industries of the 1980s, the 1970s appears to be a period of relative stasis and calm. This seems perhaps to sit oddly with the idea of the decade as a time of crisis and endings. In the case of television at least, however, it was precisely the extent of the political and economic uncertainty which contributed to the 'golden age' decade of broadcast television – a period in which two statutory providers (ITV and BBC) shared more or less equally a captive national audience across their three channels. The two channels held by the BBC enabled them to hold a large audience (and hence justify their licence fee) without having to execute any dramatic downmarket manoeuvres, while a single-channel ITV allowed the franchise holders to dominate the national advertising market from a monopoly position. Despite some occasional problems and the inevitable complaints of insufficient licence income (BBC) and punitive taxes and levy (ITV), both television operations survived the economic switchback of the decade in remarkably good shape. The underlying

conditions which allowed this were to do partly with the internal logic of the television industry at a particular stage of its development and partly with key political decisions (for the 1970s proved yet again that in broadcasting, perhaps more than in any other sphere of contemporary British culture, the national swings of politics and governmental complexion have proved critical to its institutional development).

By the end of the 1960s television had achieved 95 per cent household penetration; not to have a television set in the house had become essentially a conscious choice rather than a matter of cost. From the introduction of BBC2 in 1964 the industry and the consumer had become involved in a process of switching from the old British 405-line system to the European standard 625-line set and from 1967 BBC2 transmissions had also been available in colour; from November 1969 both BBC1 and ITV also transmitted in colour. The main development of the 1970s in the British television industry (and the viewing household) was then the accomplishment of this transition. Ownership of colour sets increased from 1.7 per cent of viewers (under 300,000 sets) to over 70 per cent (nearly 13 million sets) between 1970 and 1980. At the same time the marketing of smaller portable sets was encouraging the spread of television to a range of rooms within the home (most often bedrooms and kitchens); in her study of the popular 'soap' *Crossroads*, researched at the end of the decade, Dorothy Hobson reported housewife viewers 'diving in' to the living room (while simultaneously preparing the tea and watching the kitchen black-and-white portable) to catch crucial moments of the programme in colour (Hobson 1982: 105).

There was, therefore, unlike the situation preceding the introduction of ITV in 1955 or BBC2 in 1964, no pressure in the early 1970s from television manufacturers for the introduction of a fourth channel to boost their markets; this was especially so since all sets from the late 1960s on were in any case produced with a fourth button, following a general expectation that a fourth channel would be authorized by the government within a short time following the arrival of BBC2. In the event this took eighteen years (Channel Four eventually opening in 1982) – despite a good deal of debate and pressure from interested parties.

Following the award of the third channel to the BBC in 1964, it was widely believed that ITV would be awarded its own second channel relatively quickly once it had managed to show to an

incoming (and more critical) Labour government that it could put its house in order following the criticisms of the Pilkington report. The first hurdle to be surmounted was the first-ever round of re-allocation of ITV franchises in 1967. The new contract holders began broadcasting in 1968 under strong competition from the BBC; with the need to invest in colour production and the begin-nings of the economic problems which beset the 1970s, there were a number of severe problems – particularly at the new ITV flagship company London Weekend Television, where promises of con-siderable 'quality' programming quickly came under economic pressure. At the end of the 1960s ITV did not look in especially good shape to operate a second channel.

Despite this, the return of the Conservatives in 1970 seemed to offer the right political opportunity and during 1970 and 1971 there was an intensive campaign to persuade the Heath government to move quickly. One of the problems which became quickly appar-ent, however, was the lack of consensus among those who wanted a fourth channel as to its shape or purpose. Advertisers wanted competition with the existing ITV channel, while the ITV compan-ies felt they had the same right to control two channels as their competitor, the BBC did. The Independent Television Authority (ITA) could not decide whether ITV2 should be competitive with or complementary to ITV1. Yet again, among those working in television (or those who wished they were) there was considerable feeling that there should be opportunities for small production companies or alternative kinds of programmes to have access to national television. Educational and regional (especially Welsh language) television were also strongly supported by some.

In the face of this range of views, in a deteriorating economic situation and with a greater priority being given to changes in radio (see later), the Heath government delayed any decision and, although they indicated a revived interest in 1973, their defeat at the polls in early 1974 again changed the political parameters. The Labour government re-appointed Lord Annan to the broadcasting inquiry which the incoming Heath government had cancelled in 1970, and eventually in March 1977 the Annan report produced a specific proposal for a fourth channel to be run by a new Open Broadcasting Authority. After disagreements in the Labour cabi-net, this proposal (unlike some others in the Annan report – such as that for a local radio authority) survived into a White Paper of June 1978. However, by then the Callaghan government, like the

Heath government before it, was running out of time and yet a further stage of political horse-trading and adaptation to a new ideological climate had to take place before that definitive creation of the 1980s, Channel Four, could come into being. Meanwhile the average viewer (apart from those with access to one of the few local government-sponsored cable experiments) spent the 1970s with a stable three-channel experience – untroubled by the complexities of the video recorders, remote controls, teletext, cable, satellite or computer games of the following decade.

The 1970s also saw the final stages of television's recasting of the role of the other mass media which had begun in earnest in the late 1950s. Cinema's dramatic decline from a mass medium in the mid-1950s continued. Attendances fell from nearly 200 million per year in 1970 to under 100 million in 1980, and there was little outward sign that the spiralling decline in audiences and venues was likely to be halted. However, it was during the 1970s that the major infrastructural changes in arrangements for viewing took place which underpinned the audience stabilization of the 1980s. Between 1970 and 1980 the seating capacity of British cinemas fell from 1.46 million to 0.69 million; at the same time the number of commercial cinema screens marginally increased. This apparent paradox is explained by the fact that between 1970 and 1980 the proportion of cinema buildings with two or more screens rose from under 5 per cent to over 60 per cent, with a very considerable saving in fixed overheads and running costs per screen. This arrangement effectively recognized cinema's new role as a provider of specialist or occasional entertainment for small and diverse sets of audiences.

Radio also had found its established cultural function (as the major domestic entertainment medium) displaced by the early 1960s, but had been more successful in its discovery of new roles as the shop-front for a vastly expanded recorded music industry and as a non-domestic medium; by 1978 an estimated 68 per cent of all sets were either portable or mobile (in cars). Additionally radio was given a further new role by parliamentary order – that of local broadcasting. During the late 1960s, as part of the Labour government's plans to replace pirate radio, the BBC had been charged with the responsibility of developing a network of local stations. However, they were only to broadcast on VHF (which a considerable number of cheaper sets could not receive) and by 1970 only eight had started. The Heath government made the introduction

of commercial radio one of its priorities (being a particularly visible way of demonstrating its difference from Labour) and introduced a structure which in many ways mirrored that first used for ITV – a chain of regional franchises within a broad public service remit to be controlled by an expanded ITA (now renamed the Independent Broadcasting Authority). The franchises however were much more locally based (planned as sixty in number) than the ITV regions, thus (except for news provision) undermining the possibility of a national networked service; and the launch of the first stations in London in 1973 coincided with the oil crisis and the related economic downturn. When Labour returned to power in 1974 there were twenty BBC and nineteen ILR stations in existence and, pending the Annan report, Labour was reluctant to license any more commercial stations. By 1978 twenty-nine BBC and twenty-eight ILR stations had been licensed, but while some of the latter did begin to build up significant audiences, there was no repetition of the situation in the late 1950s when the introduction of commercial television had displaced the BBC dominance. The local character of the ILR stations, their public service remit (which made it difficult, especially with a Labour government in power, to target a particular sector of the audience as advertisers wished them to do) and uncertainties about how to read the development of the popular music industry (as pop, rock and more latterly punk reflected a diversification of taste and an audience of a wide age range) all prevented any major impact on radio audiences in the 1970s. Rather the development of BBC and ILR local radio, taken together, was part of the wider pattern by which radio colonized new areas of the culture following its displacement from the centre by television.

National newspapers too followed a pattern whose overall shape was a reflection of television's role as the dominant news provider. The 1970s saw the completion of the transformation of the shape of the industry from leadership by the middle-market sector to a strong emphasis on a clear break between the qualities and the tabloids. During the decade both the remaining middle-market papers changed format from broadsheet to tabloid – the *Daily Mail* in 1971 (following its merger with the *Daily Sketch*, the only national title to disappear in the decade) and the *Daily Express* in 1977, shortly before the sale of the whole Express Group by the Beaverbrook family to the Trafalgar House property company. By the early 1980s combined daily sales of middle-market papers were

around 4 million – a drop of nearly 3 million compared with the late 1960s when the *Daily Express* sold nearly 4 million by itself and the pre-Murdoch *Sun* was still on the market.

The switch of the *Express* and the *Mail* to tabloid format caused some commentators to argue that the whole middle-market sector had now disappeared. However, there was still a clear distinction between the appeal of these two papers to a readership across all classes (and dominated by older age groups) and that of the downmarket tabloids. It was precisely this general and central cultural space that television news and (more importantly for a newspaper's economic survival) television advertising now occupied. It was the recognition of this that led to the national newspaper success story of the decade, the phenomenal climb of the *Sun* to market leadership. Rupert Murdoch established his first foothold in the British newspaper market in 1968 with the purchase of a stake in the *News of the World*. In 1969 he gained full control and also bought the *Sun* from IPC. Murdoch then used both the printing resources and the editorial philosophy of the Sunday paper to re-launch the daily for a consciously popular market. By 1971 the circulation had doubled to over 2 million. It reached 3 million by the mid-1970s and in 1978 overtook the *Daily Mirror* to become the leading title. From early on the Murdoch *Sun* emphasized sex and sensationalism as its trademark and also recognized that in the television age the role of the popular paper was not to compete with television but to feed off it (with programming details, gossip and scandal); however, a consistent political line was not so quickly established, with the *News of the World* supporting Labour in the 1970 election and the *Sun* supporting the miners in their 1972 strike. It was only after Margaret Thatcher began her re-alignment of the Conservative party in 1975 that the Murdoch papers found a political credo which merged easily into their distinctive style. The success of the *Sun* was acknowledged by Trafalgar House when in 1978 they launched the *Daily Star* (the only new title of the decade) as a Manchester-based imitation of the Murdoch paper and as a way of using the spare printing capacity created by the decline of the *Express*.

Reflecting both this polarization within the national newspaper market and the reshaping of British politics and culture, the other (if much less spectacular) success story of the 1970s was that of the *Guardian*. Despite some setbacks in the mid-1970s, the *Guardian* increased its circulation by over 40 per cent between 1969 and

1983. *Guardian* readers were (or so the paper tried to persuade its advertisers in 1979) 'The Thinking Rich . . . not down-at-heel extremists without a penny to bless themselves with' (Hollingsworth 1986: 16); they were also young. In 1981, 52 per cent of its readers were between 16 and 34 (as against, for example, 32 per cent of *Daily Express* readers). Because of its unique ownership position (by the Scott Trust), as well as its commercial stability, the *Guardian* was one of the few national papers not to be the subject of a takeover bid in a decade when rocketing inflation made it increasingly difficult to sustain newspaper publishing as a separately profitable enterprise. Murdoch unsuccessfully attempted to buy the *Observer* in 1976 (sold instead to Atlantic Richfield) and the *Express* group before buying *The Times* and *The Sunday Times* in early 1981 (following a year-long industrial dispute and closure of all *Times* papers in 1978–9). Both the growth of Murdoch's power and the representative statement from Trafalgar House's Lord Matthews on taking over the *Express* group in 1977 ('my editors will have complete editorial freedom as long as they agree with the policy I have laid down', Curran and Seaton 1988: 82), illustrate how the 1970s saw a resurgence of proprietorial power and an increasing role for large conglomerates within the national press. Overall by 1979 the political balance of the national press had also shifted to the right within a general pattern of greater fragmentation and loss of cultural consensus – preparing the ground for the political and cultural decade to come.

ALTERNATIVE MEDIA AND CULTURAL INSTITUTIONS

By the end of the 1970s there seemed to be very little remaining of the volatile, lively and undisciplined alternative print media of a decade earlier. When in November 1969 (within the space of three days) the seeds of the 1970s media scene were being sown with the opening of colour broadcasting on the two main television channels and the sale of the *Sun* to Murdoch, the counter-cultural publications of the late 1960s (most notably *IT* and *Oz*) were still at the peak of their influence – although already both external pressures and internal divisions were beginning to be experienced. The economics of the marketplace dictated that in the long run only those publications which could command secure advertising and/or professional methods of distribution could survive, while

the likelihood of repressive legal action against the underground press intensified with the return of a Conservative government in June 1970. The directors of *IT* were fined for conspiring to corrupt public morals in November 1970 and the editors of *Oz* jailed for obscenity in June 1971. Taken together these economic and political factors produced pressures on many 'alternative' life-style 1960s publications to adapt or die in the colder climates of the early 1970s.

At the same time such unity of purpose as the 'underground press' possessed began to fragment internally, particularly when faced with the problems of harmonizing the messages of political struggle and cultural revolution. In March 1972 *Frendz*, a fortnightly whose origins lay in a spin-off from the American rock magazine *Rolling Stone*, tried to adapt to changing times by turning its front cover into a collage of a Yorkshire NUM banner and a photo of the current miners' strike. This failed to impress one reader who complained by letter that:

> *Frendz* is in danger of becoming an avant garde Workers Press – fugging boaring. OK, so people want and need to know about Miners, Ireland, claimants and new movements, but it is perhaps an unfortunate fact that most of us have an even greater love of filth, debauchery, rock and roll and dope.
>
> (*Frendz* 31 March 1972)

The split between the underground and the political Left had always been evident from the mid-1960s onwards, but it was now the turn of political and economic events as much as any internal inconsistency in the 'sex, drugs and rock and roll' ethic that made such comments seem dated. A deeper-seated problem was, however, identified by a reader's letter to the short-lived *Idiot International* in October 1970:

> Will you please tell me how you reconcile publishing information on Women's Liberation and adverts which read 'Dave seeks aware chick' and 'the most delicious new cunt on the screen'. You are making me weary and sick of your stupidity.
>
> (*Idiot International* October 1970)

The emergence of a Women's Liberation Movement and analysis which pulled the supports away from the dominantly heterosexual male underground assumptions about the sexual revolution was a further cause of the swift decline of the existing alternative press in

the early 1970s. Between 1970 and 1973 under this combination of pressures, *Idiot International*, *Ink*, *Frendz*, *Oz* and *IT* all closed. The moment of the underground press did, however, leave a number of legacies to the rest of the decade in the success of various publications which either adapted or responded to new opportunities. *Time Out*, originally a spin-off from *IT*, became a regular part of the London scene, while the growth in serious rock magazines (including the transformation of previously teeny-bopper publications such as *New Musical Express*) owed much to styles developed in the underground press. Also, in parallel with moves within alternative arts groups, a network of community papers developed. The most direct descendants of the underground press, however, were those which pursued the issues and constituencies around sexuality and gender which the underground had unwittingly unleashed – such magazines as *Gay News* and *Spare Rib*. *Spare Rib* had begun in 1972 not as the first but as the most influential of the Women's Liberation magazines. The effect of the Women's Movement on the magazines of the 1970s can also be seen by noting the shifts within the commercial women's magazine market within the decade. Sales of women's monthly magazines between 1970 and 1980 rose by over 1 million and the whole of this increase was accounted for by a fourfold rise in sales of young women's magazines (including *Cosmopolitan*, *Company*, and *Over 21*), of which 75 per cent of the readership was under 35. During the same period, sales of the traditional home-maker weekly magazines dropped by over a million.

Other more explicitly feminist cultural institutions also developed. The publishing concern Virago was founded in 1972 by Carmen Callil and was launched as a fully independent company in 1976, while the Women's Press (founded 1977) was publishing twenty books a year by 1980. In the theatre the Women's Theatre Group and Monstrous Regiment began to build reputations from the mid-1970s. By the end of the 1970s feminist works of scholarship, historical and cultural, had also begun to challenge many orthodoxies and the debates and struggles to reformulate traditional patriarchal conceptions of art and culture had moved fully into the academy as issues which had increasingly to be faced and argued with rather than derisively dismissed. In this area of sexual politics, but also in the cases of the more classically political topics of class and race and the more directly aesthetic and cultural issues of artistic styles and their social goals, the legacies of 1960s

alternative culture were increasingly registered through the 1970s not in terms of the creation of a separate and different world (with an uncertain and utopian economic base) but as a series of hard-headed claims upon the resources and objectives of the established cultural institutions – most notably in education and the arts.

MAINTAINING STANDARDS: THE ARTS COUNCIL UNDER PRESSURE

In 1970 Lord Goodman, Chairman of the Arts Council, welcomed the arrival of a new government with a whimsical reference to the incoming Prime Minister's enthusiasm for playing the piano:

> We are much sustained by the knowledge that [Edward Heath] has installed a musical instrument which cannot be operated mechanically. It should encourage the increasing minority cling-ing desperately to alternatives to television as the only home entertainment.
> But the reference to television must remind us of what it is all about. It is about our conviction that the artist's message is a unique commentary on human affairs which, read with under-standing, enriches the lives of the readers. We do not succumb to the error that this message can be understood without effort and study. It may be a mass message but it is not a message to a mass. It speaks to everyone as an individual.
>
> (Arts Council 1970: 5)

This opposition between a supposedly passive mass medium and an active individual artistic experience was a fairly traditional and safe way of defining the particular role of and need for the Arts Council (the implicit reference to the value of classical music and traditional standards as embodied by the interests of the new Prime Minister was one way of defining why a new administration with a more sceptical attitude to the value of public expenditure should maintain the level of support granted by the previous Labour government). What was proving much more difficult was determining how the Arts Council should deal with the rapid growth of new work (in fringe and alternative theatre, perform-ance and conceptual art and mixed-media events), which pro-nounced itself at once as both serious in intention and opposed to traditional definitions of art in its character, venue and content. From 1969 to 1973 the Council dabbled in such areas with very

small amounts of money routed through an Experimental Projects Committee (as well as through some of the bolder decisions of the more established committees). However, the new Conservative government gave early notice of concern at the Council's activities, when Lord Eccles, the new Arts Minister, spoke in the House of Lords in February 1971:

> The question at issue is the use of public money to finance works which affront the religious beliefs or outrage the sense of decency of a large body of taxpayers. I would not listen to anybody who wanted the return of the censor on works wholly financed from private sources. But I am responsible for the grants to the Arts Council, which are made with taxpayers' money. If the Arts Council could reach some understanding with their clients that takes into account the moral views of those who are putting up the money, I should be very glad.
>
> (Longford Committee 1972: 24)

In the 1970–1 annual report Lord Goodman responded vigorously to this moral majority critique as 'an unwonted attack from an unexpected quarter'. 'There is nothing new', he asserted, 'in fringe activities or anti-establishment groups'. He defended,

> the fierce need of some, but not all of them, to express their feeling about modern society by shock methods involving violence and obscenity; some productions will from time to time give offence since they express viewpoints and attitudes at variance with many orthodox opinions.
>
> (Arts Council 1971: 30–1)

This was, however, Lord Goodman's last report; he retired from the Chairmanship in April 1972 to be replaced by Patrick Gibson, chairman of the large publishing company Pearson Longman.

Even such disagreements as these are much easier to handle in times of plenty and the Arts Council was still (just) enjoying these. Roy Shaw, Secretary-General of the Arts Council from 1975, describes the period from the mid-1960s to the oil crisis in the early 1970s as the only period in the Council's history when funds were sufficient for its purpose. The annual grant rose from £5.7 million in 1967–8 to £17.5 million in 1973–4. It was following this that inflation (running at over 17 per cent in 1974–5) began to outstrip the annual grants and cause serious difficulties in sustaining the

considerably increased range of clients that the Council had taken on since the late 1960s.

Throughout the decade the major clients remained the two national opera companies, Sadlers Wells and Covent Garden (whose post-war plight had been a major factor in the Council's origins), and the two national theatre companies, the Royal Shakespeare Company (RSC) and the National Theatre (whose South Bank complex was finally completed in 1976 at a total cost to the taxpayer of £16 million). In the case of theatre, of the £10.2 million allocated in 1977–8, £4.2 million went to the two major companies and another £4.75 million to theatre building (one of the major commitments made in the late 1960s and sustained through the 1970s was to the construction and refurbishment of many provincial theatres); as against this thirty-three touring companies shared £872,000 and fifty-eight 'new projects' received an average of under £4,000 each. By the late 1970s the various attempts to set up separate panels for 'fringe' or 'fringe and alternative' theatre had been replaced by an absorption of such work into either the main work of the theatre panel or the remit of 'community arts'.

Funding of such work by the Arts Council had begun in 1968 with the support of six groups. The number rapidly increased, although the relative amounts received remained small; by 1973 such innovative and oppositional groups as CAST, General Will, Hull Truck, Joint Stock, 7:84 and Red Ladder were being funded. The contrast between the gaining of formal recognition as eligible for public funding and the tiny amounts received (as compared with the RSC and the National Theatre), however, only fuelled the debates about the criteria and processes being employed in making the judgements. The standstill and reduced budgets (in real terms) of the mid-1970s gave a new edge to this debate as did the change of government in 1974, which brought a new Arts Minister, Hugh Jenkins, who made a determined effort to reform the Arts Council by proposing a number of major changes as to how members were appointed – specifically to include some element of democracy. He encountered considerable resistance from Lord Gibson, the Chairman, and eventually from Harold Wilson himself, and before he could push his reforms through he was replaced by the new Prime Minister James Callaghan in 1976.

By the mid-1970s a number of changes had begun to work through in those alternative cultural groups which had developed

out of the anarchic fringe and counter-culture of the late 1960s. In particular many were now clearer about the organizational and institutional models they wished to develop. On the one hand this led to the formation of broad associations (the Independent Theatre Council and the Theatre Writers Union) with national ambitions; on the other, many groups (especially those with commitments towards new modes of performance) began to define more clearly the specific audiences they were aiming at. These could be particular ethnic or gender groups or, in many cases, a particular local, regional or (especially in the case of Scotland) national community. This both paralleled and capitalized upon an important tendency in Arts Council thinking from the late 1960s.

A minor strand of the 1966–70 Labour government's expansion of arts funding was the attempt to answer criticisms of over-concentration on London by providing funds for the emergent English Regional Arts Associations (RAAs). Nine new RAAs were founded between 1966 and 1973 to create almost total national coverage; they were to be 'a systematic partnership between the Arts Council . . . and a large group of local authorities' (Arts Council 1971: 25). During the 1970s the proportion of Arts Council funding allocated to RAAs rose from 3 per cent to 10 per cent and regional devolution was frequently cited as a central plank of Arts Council policy. The idea of 'partnership', however, was only partly realized. In 1970 it was claimed that two-thirds of the funding support came from non Arts Council sources; by 1973 this was reduced to half and by the end of the decade the Arts Council was providing up to 70 per cent of RAA income. By contrast local authority support (although rising in real terms by 26 per cent between 1974 and 1980) had dropped to 15 per cent of RAA income by 1980.

This did not necessarily imply local authority unwillingness to support the arts. Indeed in 1974–5 total local authority spending on the arts (at £26 million) exceeded the total budget of the Arts Council. Support, however, was variable (for example in 1972–3 Norwich spent 200 times more on the arts per head than Havant and Waterloo – both had the same population) and most authorities preferred direct expenditure on their own projects to a 'partnership' model. Larger regionally based Arts Council clients also showed considerable reluctance to be moved from a direct relationship with a large national funding body to a new smaller regional body which, despite the proportion of local authority

funding, was often subject to considerable influence from local councillors. This combination of factors meant that the much-heralded findings of the Gulbenkian funded Redcliffe–Maud report, *Support for the Arts in England and Wales* (1976) – that local authorities should be the chief arts patrons of the future (mediated largely through more generously funded RAAs) – were correctly judged by Norman St John Stevas (soon to become Mrs Thatcher's first Minister for the Arts) to be 'a triumph of faith over reality'.

Nevertheless by the close of the 1970s the RAAs had become significant players in influencing the development of the arts in the English regions and there had been some devolution of particular groups of clients to them. Community arts was one area which was 40 per cent devolved by 1980; in this case the policy of regionalization represented an attempt to find a solution to a particular ideological conflict which significantly troubled the senior officers of the Arts Council in the late 1970s. Matters had begun promisingly. In his first and very short Chairman's Report in 1972–3 Patrick Gibson noted that,

> One field which seems to offer real scope for the involvement of a wide range of people, some of whom have known little of the arts in the past, lies in what is loosely called community arts. These are attempts to engage people, especially young people, in the creative use of their time through artistic activity.
>
> (Arts Council 1973: 12)

Gibson's formulations offered an essentially pastoral and welfare model (the idea of the 'creative use of time' by 'young people'), combined with one of the Arts Council's longstanding aims to increase the audience for the arts as they currently existed. Although neither of these were primary objectives for much of the newer experimental work, a Community Arts Working Party was set up to examine:

> the extent to which the Arts Council should be directly involved in the subsidising of arts work; also to consider the relationship between experimental work and community arts projects, whether a distinction needs to be drawn between these two fields of activity.
>
> (Arts Council 1973: 29)

The second half of the decade was marked, then, by the replacement of fringe and experimental work with community arts as the

main terrain for debate about aesthetic boundaries within the
Council. In 1975 the first full Regional Committee was set up
under Roy Shaw, with a Community Arts Committee (CAC) as
one of its sub-committees; Shaw himself almost immediately was
appointed as Secretary-General of the Arts Council and his adult
education background in a Midlands University also seemed to
assure the future for a regional arts policy. Among the tasks of the
new CAC was to provide for 'the support of artists working in and
with specific communities to achieve their own form of cultural
and artistic expression' (Arts Council 1976: 14). There was, how-
ever, already some concern within the Council as to where this
might lead. In his Chairman's report of 1975–6 Lord Gibson
included a lengthy critique of the new creed of 'cultural democ-
racy' which held that 'there is a "cultural dynamism" in the people
which will emerge if only they can be liberated from the cultural
values hitherto accepted by an elite'. This view was to be rejected.
Rather community arts were of particular interest to the Council
when they were concerned to help people to approach the arts by
encouraging them 'to participate in creative activity rather than
merely to experience it passively' (Arts Council 1976: 7). From
this perspective community arts constituted a transitional form or,
rather, an educational process; this neatly fitted with a central
plank of Roy Shaw's thinking in the late 1970s – that education
should be a central aim of the Council. In the 1976–7 report he
wrote that, 'so long as educational inequalities exist, there is a case
for especially encouraging those parts of our artistic and edu-
cational efforts which speak to the actual conditions of the poten-
tial audience'. He sought then to add a qualification to the
conclusion of the report of the working party on the role of
community arts:

> The working party was right in emphasising that a policy of
> wider dissemination of community arts 'must often involve
> considerations other than immediate high artistic standards',
> but the key word there must be 'immediate'.
>
> (Arts Council 1977: 9)

This idea of a gradualist approach to the arts as traditionally
constituted (not a replacement of them) sat somewhat uneasily
with the view that, as Roy Shaw also put it in 1980, 'community
arts is not simply an artistic movement, but is closely allied to
community and other aspects of social work' (Arts Council 1980:

12). However, the two positions could be resolved by the use of a two-tier system of valuation; community arts projects were to be judged by different criteria – specifically criteria other than the work-in-itself reference which purported to lie at the heart of all pure aesthetic judgement. In 1977 the CAC noted that its assessment was 'not only with the products of community arts projects but with their impact on a community and the response to the opinions and values of the community' (Arts Council 1977: 33). This view opened the door for a clearer recognition of the reality of British society as a multi-cultural society with a plurality of values – a point strongly argued in Naseem Khan's Arts Council pamphlet, *The Arts Britain Ignores* (1976); however, it neatly side-stepped the full frontal attack on established priorities for arts funding which some within the community arts movement wished to deliver. Su Braden's book, *Artists and People* (1978), left little room for ambiguity on this point:

> [The] so-called cultural *heritage* which made Britain great – the Bachs and Beethovens, the Shakespeares and Dantes, the Constables and Titians – is no longer communicating anything to the vast majority of Europe's population – it is a *bourgeois* culture and therefore only immediately meaningful to that group. The greatest artistic deception of the twentieth century has been to insist to *all* people that this was *their* culture. The Arts Council of Great Britain was established on this premise. . . . *People make culture* and it is in this continually developing movement that money should be invested, rather than in the Arts Council's notion of trying to make people cultured.
>
> (Braden 1978: 153–5)

By the time he came to write his report on 1978–9, Roy Shaw could see his attempt to hold a middle ground on this issue beginning to erode. Writing in the wake of Mrs Thatcher's election victory, he launched a major criticism of tendencies within the community arts movement who have proved 'the most difficult clients to deal with', who 'often explicitly repudiate the basic premise of the Arts Council's charter' and whose 'politically inspired philistinism' dismisses 'Europe's cultural heritage' as 'bourgeois culture'. Recalling the problems of the Arts Council at the start of the decade he noted that:

Lord Goodman . . . questioned whether it was the duty of the
state actually to subsidise those who are working to overthrow it
. . . it is a point which the Arts Council will have to consider
carefully when it studies a research report on community arts
later in 1979.

(Arts Council 1979: 9)

Shaw's argument is especially interesting in the significant dis-
placement it makes between the state and the Arts Council. While
some 'community arts' may have had an explicit political content
their major challenge (as formulated by Su Braden) was more
directly aesthetic – an attempt to reformulate what was meant by
artistic quality. This posed more of a threat to the Arts Council, to
educational syllabuses and to other cultural institutions than would
many explicitly Marxist plays (by, for example, Hare, Griffiths or
Brenton) which, whatever their political message, could still be
interpreted as high-quality drama by conventional methods of
assessment.

Towards the end of the decade a number of such explicit differ-
ences of view emerged as the new forms of cultural organization
on the Left began to mobilize their arguments. A particularly
revealing exchange took place in the area of literature between the
Federation of Worker Writers and Community Publishers
(FWWCP) and representatives of the Arts Council Literature
Panel after an application for funds to develop a national organiz-
ation had been refused. The Literature Panel took the view that
while 'on a community level the work is of sound value . . . they
considered the whole corpus of little, if any, solid literary merit'
and referred the application to the Community Arts Panel (Morley
and Worpole 1982: 132). When pressed to define the criteria used
to judge literary merit, Melvyn Bragg, Chairman of the Literary
Panel (and one of the few members who wished to offer some
limited support to the FWWCP), stated that:

I think that serious writing is represented by those who think
they represent it at the time . . . the Arts Council Literature
Panel is full of people who could be said to either be writing or
representing serious literature in various ways.

(Morley and Worpole 1982: 136)

In his study of the operation of the Arts Council Literature Panel
between 1964 and 1977, Jim McGuigan discovered how this

tautologous and circular formulation worked out in practice. He found a significant interchangeability of roles between grant recipients, panel members and sponsors. Eighty-three per cent of recipients lived south of Cambridge and 63 per cent had attended Oxford or Cambridge; in particular, the need for a respected sponsor (normally publishers, other writers or literary agents) created the position of a coterie who moved money around amongst themselves. McGuigan also noted that the advantages of receiving a grant were not merely financial; one successful applicant commented, 'The very fact writers respected enough to be serving on the ACGB Literature Panel had read my work and seen it worthy of encouragement was perhaps the most useful aspect' (McGuigan 1981: 58).

The Literature Panel was somewhat untypical of the Arts Council in its direct distribution of funds to individual artists; it was more usual to fund institutional outlets – thus leaving the direct judgement of artistic value to the institutional management. In fact it was not until the late 1960s that literature was funded in any significant way and as funding grew an attempt was made within the Literature Panel to discover appropriate institutional ways of funding writing – especially fiction (since the funding of the small poetry magazine and poetry reading societies had been in progress since the early 1950s). During the 1970s the Poetry Society, the magazine *New Review* and the New Fiction Society were each given considerable subsidies in an attempt to pump-prime a literary culture and market. None of these had any conspicuous success in commercial terms, although they again played a part in marking out the boundaries between officially labelled serious writing and the rest of the culture's literary production.

Literature, even in the 1970s, received a very small proportion of Arts Council support (less than 1.5 per cent at the end of the decade); it did not have the same institutional needs as opera and theatre because (it was sometimes argued) the public library system already contributed a large measure of public subsidy. Certainly it was the case that since the advent of the practice of the swift move of serious fiction into paperback from the late 1950s on, the public librarian was the most important purchaser of new hardback fiction. During the mid-1970s it seemed for a time as though a combination of inflation and public spending cuts would radically undermine this support mechanism for literary publishing. In fact the economics of hardback publishing had as much to

do with loss-leading for paperback publishing or (in a few cases) film rights as with balancing its own accounts in the short run, and once again dire predictions of the death of the novel proved premature. As with the case of the quality press, beneath the pressures of soaring inflation and the consequent downturn of the mid-1970s lay a more long-term trend of an increase in the proportion of the population whose educational background and consequent cultural aspirations provided the readership for general and 'serious' fiction.

By the beginning of the 1980s the growth of this sector of the cultural market (across a range of art forms) was sufficient to provide some cushion against the difficulties of sustaining public funding of the arts in a new ideological climate – a climate which saw a conscious attempt to rein in what was depicted as the excessive state interference of the 1970s in many areas of public life. Like other public utility inventions of the post-1945 welfare state settlement, the Arts Council now saw its consensual political base being undermined from both ends of a political spectrum in which the balance of power was shifting away from the centre.

EDUCATION AND CULTURE

Of all the areas of cultural struggle during the 1970s it was in education that the growing signs of that great forced march back towards the past, which was to constitute such a major branch of the Thatcherite project, were most evident. Equally, however, the consequences of the major reforms in higher education which had been set in train in the mid-1960s provided the basis for an increasing number of courses, lecturers, students and graduates who (especially in subjects dealing explicitly with aesthetic and cultural questions – literature, art and design, sociology and a rapidly expanding field of interdisciplinary and combined studies in humanities and social studies) provided a powerful constituency for many kinds of cultural change. Somewhere to one side of both camps (typically stereotyped as the 'traditional' and 'progressive' respectively) lay what at times seemed a separate debate where educationalists and employers discussed the need to change educational practices radically to produce a more skilled workforce; this debate assumed greater significance as unemployment rose throughout the 1970s and eventually recast the educational agenda for the following decade.

The 'traditionalist' position was articulated during the decade most eloquently by a series of 'Black Papers' published between 1969 and 1977 – three very close together in 1969 and 1970 and a further two in 1975 and 1977. The gap between the third and fourth coincided with the period of the Conservative government (and with Mrs Thatcher's period at the Ministry of Education, although not with an especially 'Thatcherite' reform programme), when the Black Paper sympathizers had some hopes that their cause was in the ascendant. The first three Black Papers were edited jointly by C. B. Cox and A. E. Dyson, both university lecturers in English literature, who had together founded the mildly progressive journal *Critical Quarterly* in 1959 and voted Labour in 1966, but were now taking up new positions in relation to the student protests of the late 1960s. In their introductory 'Comment' to the first Black Paper they linked together all sectors of education as part of a single problem:

> the introduction of free play methods in primary schools, comprehensive schemes, the expansion of higher education, the experimental courses at new universities. . . . Anarchy is becoming fashionable . . . students are claiming the right to control syllabuses, to abolish examinations.
>
> (Cox and Dyson 1969: 1)

Such developments were to be resisted on the grounds that they flew 'in the face of human nature' by implying that 'children and students will work from natural inclination, rather than the desire for reward'. In 1975 Rhodes Boyson MP (having replaced Dyson as co-editor and soon to become a Shadow spokesman on education in Mrs Thatcher's new team) wrote that 'Children are not naturally good. They need firm, tactful discipline. . . . Too much freedom for children breeds selfishness, vandalism and personal unhappiness' (Cox and Boyson 1975: 1). With regard to higher education the general stance of the Black Papers was especially reactionary and elitist – particularly in the re-affirmation of what was taken to be the core of Matthew Arnold's arguments in *Culture and Anarchy* a century earlier. Kingsley Amis, for example, dismissed arguments for vocational training at university:

> The student who is himself looking for relevance is looking for vocational training, a harmless desire in itself, though anti-

academic and therefore not to be indulged at a university; the teacher who wants to impart it is an enemy of culture.

(Cox and Dyson 1969: 10)

'Relevance' here collapsed two positions themselves often fundamentally opposed – the idea of specific vocational training (especially if for employment in private enterprise) and the perceived need for a critical understanding of contemporary society. In the Black Papers the latter was often taken to be synonymous with the subject of sociology – which Amis declared to be a 'non-subject' and Robert Conquest to be the 'bastion' of 'barbarism'. In their ironical 'Short Educational Dictionary' in Black Paper 3, sociology was defined as 'a polysyllabic briefing on the decadence of Western society and the means to overthrow it' (Cox and Dyson 1970b: 70). As well as the progressive syllabus, students themselves and their culture were in the dock, although the situation was perhaps not entirely their fault. It was 'permissive education' (wrote the editors of Black Paper 3) which had led to 'a vacuum into which all the worst features of the pop and drug world can enter' (Cox and Dyson 1970b: 8). In Black Paper 1 complaints were made about the relaxing of visiting hours in women's halls and also the more substantial point that there had emerged a 'distinctive sectarian culture among students, which sees its interests as aligned with the young rather than those of intellectual culture' (Cox and Dyson 1969: 61). Bryan Wilson made a revision of Kingsley Amis's earlier objections to university expansion when he identified the problem as one of the social affiliations of the new students:

> More *has* meant worse. This has been not so much a matter of admitting people with less intellectual capacity, but of admitting people who were less committed, had less self-control and who were less adequately socialised for the university experience.
>
> (Cox and Dyson 1969: 73)

Through all the Black Papers there was a consistency of position, varied predominantly by differences in tone. The first two, occurring in the wake of the student unrest of 1968, conveyed an atmosphere of crisis and urgency. This became somewhat moderated in the third (published in the wake of the 1970 Conservative election victory and titled 'Goodbye Mr. Short', Edward Short being the outgoing Labour Minister of Education) with the belief that 'We can now build the best secondary system in the world in

Britain, and Mrs. Thatcher's first policy statement gives every hope that this will be done' and the further hope that 'by 1974 the Labour Party will have had the sense to abandon extremes' (Cox and Dyson 1970b: 8, 13). The 1975 Black Paper was not convinced that either hope had been realized. Between 1970 and 1975, 'it is doubtful if there has been any advance in real terms', although it was suggested that 'the progressive bandwagon' was in a 'slowing-down phase' (Cox and Boyson 1975: 3). In 1977 a more confident tone was struck; the editors cited the 1976 Ruskin College Great Debate speech of the new Prime Minister James Callaghan as endorsing their assertions that 'money is being wasted, standards are too low and children are not being given the basic tools of literacy' (Cox and Boyson 1977: 1). As the similar debates over teaching training in the early 1990s were to show, however, neither the last years of the Callaghan government nor a decade of Thatcherism were to find these generalized assertions a productive way of settling the education question.

The Black Papers were sparked off by events in the universities, yet their awareness of what was actually happening to higher education in the 1970s was extremely limited. Expansion in the older and the new universities was taking place alongside a parallel and much faster growth in newer forms of institution. The Open University opened in 1970, and from the beginning (for both educational and budgetary reasons) set out to offer inter- and multi-disciplinary degrees. The new polytechnics (set up as a consequence of Labour policies of the mid-1960s) began to func-tion across increasingly wider subject areas – as they swallowed the art schools and, later in the decade, many of the teacher training colleges (once entry to the teaching profession became all gradu-ate). The numbers of students enrolled on Council for National Academic Awards (CNAA) degrees rose from 20,000 in 1969 to over 120,000 by 1980 – by which time they represented a third of all British degree students. Amidst the often chaotic growth of such hybrid institutions, and within a CNAA system of course development which forced unquestioned traditional assumptions into the open, opportunities arose to pursue some of the more substantial ideas let loose in the intellectual ferment of the late 1960s university self-critiques into new courses and degree programmes.

The intellectual fuel for much of this development often came from within older institutions. The Centre for Contemporary

Cultural Studies at the University of Birmingham shifted into a more radical and theoretical phase when Stuart Hall took over from Richard Hoggart as Acting Director in 1970. Throughout the decade the Centre and its publications became a focus and a resource for much new course development in literary, sociological and media studies throughout the country. A similar point of reference became the film journal *Screen*, operated by the Society for Education in Film and Television, which pioneered much of the psychoanalytic and semiotic theory that was to become increasingly important in providing the basis for major challenges to traditional modes of literary study, especially when linked to feminist questions. Throughout the higher education system new theoretical positions in Marxism, structuralism and feminism permeated the research culture of a new generation of scholars and critics in a wide range of subjects, feeding through into the teaching of a new cohort of students as many new lecturing posts were filled in a still buoyant job market.

There was little common intellectual ground between (on the one hand) the historical materialism of culturalist Marxism or the de-centring of the human subject of semiotic theory and (on the other) the universal and unregenerate human nature of the Black Paper child – even if, at times, proponents of all these views could co-exist in a university Arts Faculty world largely remote from the increasingly difficult question of how to equip a comprehensive school leaver to find a job in a crumbling economy. Within education, as elsewhere within the national culture, the 1970s saw the simultaneous growth of increasingly incompatible ideas within common institutions whose inherited consensual positions were left marooned on a visibly narrowing political and social base.

CONCLUSION

In the summer of 1970, taking advantage of the 1968 abolition of the censorship powers of the Lord Chamberlain, Kenneth Tynan opened a new show in London, the sex revue *Oh! Calcutta!*. In his introduction to the book edition of the Longford Report on Pornography (published in 1972), Lord Longford cited this as the moment which had made clear to him and many others the need for an inquiry into pornography and a public campaign against its influence. He recorded a growth of the campaign from 1970 to 1972, noting the pronouncements of religious leaders, the speech

of the new Arts Minister, Lord Eccles, warning the Arts Council of its responsibilities, the *Oz* trial, the growth of the Festival of Light campaign (with its series of national meetings in November 1971) and the continuing role of Mary Whitehouse's Viewers and Listeners Association in monitoring broadcasting.

Such a 'moral majority' constituency had a coherence and social base which could be easily grasped. However, the detail of the Longford report (the work of a privately constituted Committee whose members included Kingsley Amis, Cliff Richard and Jimmy Savile as well as churchmen, politicians and some 'ordinary' citizens) revealed some more complex oppositions and alliances forming in the wake of the diverse cultural revolutions of the late 1960s. Among those in the dock was the popular press, notably the *Sun* whose success was already felt to be having a 'depressing effect' on its rivals and was attributed to its recipe of 'sex and punchy radicalism' (Longford Committee 1972: 322–3). Among submissions close to the views of the Committee were those from Women's Liberation Groups which argued that, 'Anything which treated women as objects, particularly where fantasy is used to portray them as male-dominated, was to be deplored and advertising which used sexual overtones to sell products to either sex was almost as offensive as pornography' (Longford Committee 1972: 88). Such an argument pushed to the next stage could, however, lead to a fundamental critique of those 'normal' male–female power relationships which lay at the heart of the traditional family – thus, as far as (for example) the Festival of Light supporters were concerned, aligning Women's Liberation with the *Sun* in the undermining of 'purity and family life'.

It is hardly surprising that by the end of the decade such debates and confusions remained unresolved. More surprising at first sight is that all three positions seemed to have strengthened their social base since 1970. The 'moral majority' dimension of the Longford report had become a major aspect of the public face of the new Conservatism – that emphasis on the family, moral standards and 'Victorian values' which the 1979 election propelled into the heart of government social policy. Equally the *Sun*'s mixture of anti-statist rhetoric, chauvinism and celebration of male voyeurism constituted the less openly acknowledged basis of that new populist individualism which did sufficient damage to Labour's traditional political support to lose them the 1979 election. Against both these developments must be set the impact of the women's

movement on social patterns and attitudes – in areas of legislation (equal opportunities, maternity allowance and domestic violence), employment (increased pay and unionization), education, consumption and general cultural presence.

It is tempting to invoke the figure of Mrs Thatcher herself as evidence of these three diverse social forces coming together in a way which presents the Thatcherite successes of the 1980s as the inevitable outcome of the fragmentations of the 1970s – the particular historical form in which the dominant power bloc re-asserted its authority. From this perspective the 1970s appear as a decade of decline and transition – from the high and unrealizeable hopes of the 1960s to the dark night of cultural closure as economic recession and political reaction took their toll. Such a view, however, quite apart from its writing off much too quickly the vigorous cultural struggles of the early 1980s, has to be balanced by the recognition that what lay beneath the cultural conflicts and fissurings of the 1970s were longer term social changes and the construction of new cultural constituencies – a more volatile and less traditional mass market, a much expanded graduate population, a differently constituted women's market and a variety of ethnic, regional and gender groupings. It was this social re-composition as much as the immediate economic and political imperatives which increasingly suggested during the decade that the existing cultural institutions in their inherited forms would no longer do.

FURTHER READING

Hewison (1986) provides a useful overview of the first half of the decade, while Hall *et al.* (1978) gives a powerful contemporary account of the underlying pressures. On the mass media Tunstall (1983) contains a comprehensive survey; Lambert (1982) describes the pre-history of Channel Four and Barnard (1989) is concise on the changes in radio. The decline and fall of the underground press is charted in Fountain (1988), while Itzin (1980) chronicles the continuing expansion of alternative theatre. For the Arts Council the annual reports supply necessary background, while Shaw (1987), Jenkins (1979) and Braden (1978) provide accounts from those involved. McGuigan (1981) gives an insight into the workings of the Literature Panel, while Sutherland (1978) sketches the broader context of the literary market. Cox and Dyson and Cox and Boyson (1969–77) in the Black Papers embody one pole of the educational debate which in its broader terms is described and analysed in the Centre for Contemporary Cultural Studies (1981). Widdowson (1982) both records and embodies the radical challenge within higher education, while

the Longford Committee (1972) remains an instructive text for the understanding of how 1960s revolutions turned into Thatcherism.

BIBLIOGRAPHY

Arts Council (1970) *Annual Report 1969–70*, London: Arts Council.
—— (1971) *Annual Report 1970–71*, London: Arts Council.
—— (1973) *Annual Report 1972–73*, London: Arts Council.
—— (1976) *Annual Report 1975–76*, London: Arts Council.
—— (1977) *Annual Report 1976–77*, London: Arts Council.
—— (1979) *Annual Report 1978–79*, London: Arts Council.
—— (1980) *Annual Report 1979–80*, London: Arts Council.
Barnard, S. (1989) *On the Radio*, Milton Keynes: Open University Press.
Braden, S. (1978) *Artists and People*, London: Routledge.
Centre for Contemporary Cultural Studies (1981) *Unpopular Education*, London: Hutchinson.
Cox, C. B. and Dyson, A. E. (1969) *Fight for Education: A Black Paper*, London: Critical Quarterly Society.
—— and —— (1970a) *Black Paper 2: The Crisis in Education*, London: Critical Quarterly Society.
—— and —— (1970b) *Black Paper 3: Goodbye Mr. Short*, London: Critical Quarterly Society.
Cox, C. B. and Boyson, R. (1975) *Black Paper: The Fight for Education*, London: Dent.
—— and —— (1977) *Black Paper 1977*, London: Temple Smith.
Curran, J. and Seaton, J. (1988) *Power without Responsibility*, London: Routledge.
Fountain, N. (1988) *Underground*, London: Routledge.
Hall, S., Critcher, C., Jefferson, T., Clarke, J. and Roberts, B. (1978) *Policing the Crisis*, London: Macmillan.
Hewison, R. (1986) *Too Much: Art and Society in the Sixties 1960–75*, London: Methuen.
Hobson, D. (1982) *Crossroads*, London: Methuen.
Hollingsworth, M. (1986) *The Press and Political Dissent*, London: Pluto.
Itzin, C. (1980) *Stages in the Revolution*, London: Eyre Methuen.
Jenkins, H. (1979) *The Culture Gap*, London: Marion Boyars.
Khan, N. (1976) *The Arts Britain Ignores*, London: Arts Council.
Lambert, S. (1982) *Channel Four*, London: British Film Institute.
Longford Committee (1972) *Pornography: The Longford Report*, London: Coronet.
McGuigan, J. (1981) *Literature and the Arts Council*, London: Arts Council.
Morley, D. and Worpole, K. (eds) (1982) *The Republic of Letters*, London: Comedia.
Shaw, R. (1987) *The Arts and the People*, London: Jonathan Cape.
Sutherland, J. (1978) *Fiction and the Fiction Industry*, London: Athlone Press.
Tunstall, J. (1983) *The Media in Britain*, London: Constable.
Walker, A. (1985) *National Heroes*, London: Harrap.
Widdowson, P. (ed.) (1982) *Re-Reading English*, London: Methuen.

Chapter 3

The impact of radical theory on Britain in the 1970s

Antony Easthope

> Anything that happens to mind in England has usually happened somewhere else first
>
> Ezra Pound, *How to Read* (1931)

> According to the inexorable logic of my theory, that fact is impossible
>
> Speaker defending paper on Lacan and cinema at the Essex 'Sociology of Literature' Conference (1976)

INTRODUCTION

It seems to be part of England's uneven development that for nearly a century new ideas have originated in the rest of Europe and have arrived here in England some time later. Such was the case with the French Revolution of 1968 which got to England – in a drastically diminished form – around February 1974 when the miners' strike forced the Heath government into a General election which was won by Harold Wilson's right-wing Labour government. Similarly, the new and radical theoretical innovations made in France during the mid-1960s (and apparently reaching apotheosis in 1968) began to get across the Channel and past the mental import controls increasingly during the 1970s. These theories – now referred to as 'structuralism' and 'post-structuralism' – offered, I believe, a radical challenge to the inherited English national culture with its ingrained vices of *empiricism, moralism* and (epistemological) *humanism*. That challenge was typically ignored or, where it was acknowledged, responded to with hysterical denunciation. Radical theory made little headway in England during the 1970s except in the academic fields of film studies,

cultural studies and – to a lesser extent – literary criticism. Looking briefly at these and the kind of challenge such theory made to the traditional version of English culture will afford a vantage point from which to assess something of the state of that culture in the 1970s.

What was at stake over French theory might be outlined as follows. Since Plato's account of human reality as a copy of the ideal world of Forms, the Western tradition has advocated that we should try to imitate a pre-existing Nature. Knowledge has been envisaged as the attempt to represent Nature accurately, society as needing to find out what is natural for human beings and organize itself accordingly, individual human identity as capable of knowing and rationally conforming itself to the moral dictates of Nature. In Samuel Beckett's play *Endgame*, first performed in 1957, the central character, Hamm, exclaims at one point, 'There's no more Nature', an assertion which well characterizes the starting point of the new forms of thought developed in France after 1945. The Marxist philosopher Louis Althusser argued that knowledge of the real did not arise through any attempt to transcribe it into discourse – rather scientific knowledge was attainable only through a process of human construction. At the same time he proposed that society could not be understood as variable derivations from a single point of origin (Marx referred to 'the real foundation' of society as its economic production (Marx and Engels 1950 v. 1: 329)), but rather had to be seen as consisting of a decentred structure in which no feature was simply determinant.

Althusser's account of knowledge was taken further by the philosophic writer Jacques Derrida, who asserted that '*il n'y a pas de hors-texte*' (1976: 158), that for human beings everything becomes available in the form of textuality, even forms of knowledge. Althusser's advocacy of the need to analyse the social formation as decentred was enormously developed by the historical writings of Michel Foucault, particularly in showing the ideological effect of various modes of scientific and sociological practices. If physical and social reality could not be known except as construed in discourse, neither could there be a fixed and universal human nature realized in the self-conscious individual. Following Freud, the psychoanalyst Jacques Lacan influenced all the other writers of his generation in demonstrating how far 'it is the world of words that creates the world of things' (1977: 65) and how we need to think of the individual subject as an effect of

modes of discourse. His work is committed to the view that (1) the real does exist independently of human consciousness but that (2) as speaking subjects we can never approach or touch it except from within the envelope of discourse. Instead of a Nature which determines life for us, post-structuralist theory affirms that for us everything is a construction, and so can be changed (a revolutionary implication quickly snatched up in 1968). Women writers such as Julia Kristeva and Hélène Cixous showed how such arguments could be turned against masculinist definitions of gender as fixed by Nature, especially the assumption that the physical body determined who you were and what you did. In post-structuralist thought Man – essential, universal, natural, god-like Man – died. Even summarized as drastically as this it can be seen that the new theories threaten something of a crisis for traditional English intellectual attitudes. During the early 1970s the film journal *Screen* actively promoted this crisis in its chosen area.

FILM CRITICISM: *CLOSE ENCOUNTERS* AND *JAWS*

The institutional and sub-cultural practice of *Screen* may be as significant as the content of its theory. Financed with a grant-in-aid from the British Film Institute and published with its companion journal *Screen Education* by the Society for Education in Film and Television (SEFT), *Screen* in its heroic days (1973–7) was promoted through regional groups and reading groups (see Easthope 1977 and Thompson 1977), the BFI summer school, readers' meetings in London, weekend schools and the film 'event' at the Edinburgh Film Festival. In all these, because of *Screen*'s firm commitment to a feminist politics, the proportion of women not only present but actively taking part was much higher than in most organizations, even organizations of the Left. In general, the kind of collective intellectual activity *Screen* fostered in the 1970s recalls the old Left Books and Left Book clubs of the 1930s; the force and effectivity of *Screen*'s theoretical intervention was intimately linked to the amount of direct participation it encouraged (at least before 1980 when such activity was left to wither as the sense grew both that *Screen* had fulfilled its project and that the political framework for that project was no longer firmly in place).

Screen's rationalist and Althusserian intervention was not without precedent in England in the 1970s, since in political analysis

many of those ideas had made their appearance from the mid-
1960s in work associated with the New Left and the *New Left
Review*. Thus the critique of the English empiricist tradition had
been broached earlier in the 1970s, for example by Gareth
Steadman Jones who, in a famous essay on 'History: the poverty of
empiricism' argued that:

> Those who tried to create theory out of facts, never understood
> that it was only theory that could constitute them as facts in the
> first place. Similarly those who focused history upon the event,
> failed to realise that events are only meaningful in terms of a
> structure which will establish them as such.
>
> (1972: 113)

Nevertheless, *Screen* certainly could claim some novelty for the
way it had turned ideas of the New Left to the general critique of
aesthetic texts and thought through their specific application to
cinema. How far its theory challenged and disrupted prevailing
modes can be seen in the difference between reviews of two films
by the American director Steven Spielberg.

On 14 March 1978 the *Guardian* newspaper (p. 17) published a
film review by Tim Radford of a new film, *Close Encounters of the
Third Kind*. The review has four sections. In the first, Steven
Spielberg as the director of the movie is compared and contrasted
with other directors (he 'isn't Eisenstein or Renoir'), and the story
told of his strategies in making the film (he has managed his latest
film without 'big stars, war, sex, violence, exciting car chases or
romantic interest'). A second, long section recounts the plot, while
a third discusses some of the specifically filmic effects of the text,
concluding that these are related to 'the exuberance of Spielberg's
imagination'. Finally, the director, the narrative and the visual
techniques are rounded up by the assertion that: 'It is a film firmly
rooted in the mundane: what we see is happening to people who
seem real, and we see it from something like their standpoint.'

Phrased as it is in the effortlessly commonsensical yet ironically
elitist style typical not only of the *Guardian* but of mainstream
English critical discourse descending from Dryden and Pope, a
review such as this is not so untheoretically straightforward as it
pretends. Its reading of *Close Encounters* rests on a well-known
paradigm and grounds itself in a series of unspoken assumptions
which, at the price of a certain tendentiousness, I shall try to tease
out:

1 the aesthetic text is primarily a *reflection* of the real (*Close Encounters* is good because it shows 'people who seem real');
2 all forms of representation (narrativization, photography, editing and so on) not obviously already present in this real are to be understood as the work of the Author (Spielberg) or rather his 'imagination' working on the real to bridge the gap between it and its representation;
3 the text is therefore always already *there*, a given to be passively consumed by the reader identifying with what is represented ('we see it from something like' the 'standpoint' of the characters in the narrative).

Though aspects of them are shared with other cultures, these assumptions in turn reproduce the foundational structuring of English national culture as it has developed since the seventeenth century. This structure or discursive formation is as follows.

1 *Empiricist.* It assumes that representation – signification – can reproduce the real without any serious material intervention of its own. Thus the film reproduces the real apparently without mediation and readers reproduce the film apparently without mediation. Radford admits to no problem about the process of reproduction at all and casually reproduces both the real and the film supposedly corresponding to it as though he had access to them through a transparent pane of glass.
2 *Moralistic.* What is thought to matter is a supposedly free individual's choice between the pleasure-seeking demands of fantasy and the necessities imposed by the real (Spielberg is judged between 'selling out' and 'integrity', and approved because his imaginative exuberance has negotiated adeptly between providing 'gripping, spectacular entertainment' through fantasy while holding on to a sense of the real so the film remains 'rooted in the mundane').
3 *Humanist.* The ontological priority of some universal human nature is assumed such that to partake of it (it's everywhere) is to be placed in a position of epistemological certainty. So, in Radford's review the universal reality of the represented characters is matched by the similarly universal 'imagination' of the text's Author, Steven Spielberg, of the film's supposed viewers and indeed of the reviewer himself who has absolute, immediate and unconstrained access to all these subjectivities. Why after all should there be a problem since they all –

characters, author, viewers, reviewer – are somehow in the same place and have *the same identity*?

The film theory injected into English culture during the early 1970s by the journal *Screen* worked to transform the established paradigms of film criticism but – much more significantly – did so in terms which radically challenged and cut through the assumptions of the ancient, entangling and all but imperceptible web of English national culture. Under the editorship of Ben Brewster (1974–6) and then Geoffrey Nowell-Smith (1977–8), *Screen* drew its impetus from French post-structuralist theory. A leading writer in the group which contributed to the journal was Stephen Heath. In 1976 he was invited to represent the new film theory with an article on *Jaws*, an earlier film made by the director of *Close Encounters*.

Published in the *Times Higher Education Supplement* (p. 11) on 20 March 1976, Heath's article on ' "Jaws" ideology and film theory' summed up the *Screen* project as an endeavour to theorize 'the study of film as *specific signifying practice*' by drawing on 'the encounter of Marxism and psychoanalysis on the terrain of semiotics'. These are terms which may need a little unpacking. The concept of *signifying* practice breaks completely with the view that the aesthetic text is to be judged on the basis of its supposed relation to the real, a relation to be judged as true or false, 'imaginative' or unimaginative reflection. Instead of taking representation as essentially a means or vehicle by which the real is reproduced more or less transparently, *Screen*'s version of post-structuralist theory makes representation its point of departure, regarding a text as an act of intervention in the present so, in Heath's words, envisaging 'film as a work of production of meanings' (not reflection). These meanings, however, are not simply those of some generalizeable theme represented by the narrative (*Jaws* as a story about killing sharks and man's struggle with nature), but arise from what Heath terms 'the ideological *operation* of the film', i.e. the 'form' and 'content' are active together in organizing a point of view for the viewer. For this reason, while Radford's *Close Encounters* is written of very much as a kind of literature (even involving an author and his imagination), Heath's *Jaws* is an analysis of film as film, what is in this sense *specific* to it as a formal medium, and calls on work in structuralism and semiotics.

But *Screen* theory as instanced by this article is also Marxist, or

more precisely, a Marxism as rethought by Louis Althusser and (in England) by the 'New Left' (centred on the *New Left Review*). The particular text (*Jaws*) is treated as an instance of a *practice* which is, within the social formation, relatively autonomous. As an instance of ideological practice this film acts autonomously and specifically as film (it is not, for example, a novel or a poem) while also being dependent on economic practice and intervening in relation to it. According to this necessity, in providing pleasure to the consumer *Jaws* carries out the function of the Hollywood film industry as a form of capitalist production. While Radford imagines (naively, I think) that the audience for *Close Encounters* will 'see' what is happening 'from something like' the standpoint of the characters in the narrative, Heath follows the *Screen* project when he draws on psychoanalysis to examine the way the operation of the text as a whole made through narrative and filmic technique seeks to act on the viewer both consciously and unconsciously (whether it does or does not in fact produce the pleasure effect would not affect the analysis).

Accordingly, in Heath (and *Screen* theory in general), because there is this special concern with the way the aesthetic text *addresses* its viewer, there is the possibility of a feminist politics. In *Screen* in 1975 the film-maker Laura Mulvey had drawn on psychoanalysis to argue, brilliantly and persuasively, that Hollywood constituted a visual regime in which texts typically offered the spectator a position as a man identifying both with the look of the camera and with the active gaze of men within the narrative, while women were accorded a marginal position in identification with the women on the screen who were being looked at (by the camera, by the hero and his friends). It is out of sympathy and solidarity with this kind of gender analysis that Heath writes of 'one inexorable movement' of *Jaws* as being 'to get rid of women' – from the opening sequence in which the naked woman is dismembered by the shark to the final pursuit in which the three men bond together to destroy the (castrating) beast.

Of gender politics Radford's liberal-mindedness knows nothing and in fact his criticism throughout is politically conservative. It has to be, because its protocols exclude any possibility of transformation or change. Since a film is always already *there*, more or less adequately reflecting the real (which is also just there), the question of its collective production and distribution by a capitalist enterprise simply cannot arise. Since, for the same reason, it is not

visible at all as a *construction*, as something which could be other-wise, it cannot be discussed in terms of its ideological meanings. Since it 'belongs' symbolically to the Author (and viewers sharing his imaginative vision) it cannot be interrogated for the way it works on its readers and its political effects. *Screen*'s project is certainly not unproblematic but Heath's reading of *Jaws* (which doesn't even mention Spielberg) is resoundingly and radically political. Further, it represents in film theory (*née* criticism) three things which are wonderfully *unEnglish*.

First, there is a determined attempt to replace empiricism with the recognition that the real becomes available only on the grounds of and within discourse, whether the real of a movie as represented by means of its textual operation or the real referred to by a discourse of knowledge. Second, *Screen* theory aimed to replace English moralism with a framework for political judge-ment, touching – in the case of film – not only the theme and formal organization of a particular text but also film in its social and economic function. And further, perhaps most obviously, where we (we English) are habituated to expect an ontological and epistemological humanism, *Screen* replaced the hallowed sense of the supposedly free-standing and freely choosing *moral* individual with a conception of the individual as a subject, as (1) always collectively situated and always historically *different* and (2) con-structed through ideology and the processes of the unconscious.

From the mid-1970s, *Screen* film theory was making a very successful and long-lasting intervention in academic film theory, in fact it was helping to found it. There were two reasons for this. One was that the expansion of university education in the 1960s had led on in the 1970s to the development of a cheaper 'sector' of degree-level higher education in colleges of education and the polytechnics. With the brief of making education more 'relevant' to commercial life, these institutions moved beyond traditional 'Englit.' by introducing courses in 'film', 'communication studies', 'media studies' and 'cultural studies'. So, the institutional possi-bility was there but, reciprocally, it came to be seen as something people would put effort into because work in *Screen* theory demonstrated that there was now a serious way to teach the analysis of 'specific signifying practices', particularly the visual practices of cinema, television and advertising.

CULTURAL STUDIES

In addition to a direct input in terms of film courses and film theory the wider applications of *Screen* theory were disseminated in higher education on the back of new programmes of study associated largely with the Birmingham Centre for Contemporary Cultural Studies. This was established in 1964 and led during the 1970s by Stuart Hall. However, relations between *Screen* and the Centre during this decade became slightly fraught, essentially because of reservations felt by Marxists at the Centre about various aspects of *Screen* (its concern with subjectivity, with feminism, with psychoanalysis). A good *topos* for considering this is the long exchange between Roz Coward and representatives of the Centre that took place in 1977 and 1978 in the pages of *Screen* (see Coward (1977) and the joint reply by Chambers *et al.* (1977/8), as well as Coward's 'Response' to this (1977/8)).

Increasingly from the late 1970s the work of the Centre was influenced by *Screen*'s synthesis of Althusserian Marxism, psycho-analysis and semiology. In view of the tension between the Centre and *Screen* it is significant that *Screen*'s 'line' is worked out, not in the Centre's own work, but rather in a book produced by two people who had been there, Roz Coward and John Ellis – whose *Language and Materialism* was published in 1977. While *Screen* had remained committed, however tenuously, to the specific discussion of film, *Language and Materialism* is an exposition of pure theory, advocating a synthesis of semiology and the Lacanian model of the subject as a theory of and for radical political change. Since a crisis in the subject is a precondition for revolutionary conflict, then 'the encounter of psychoanalysis and Marxism on the terrain of language leads to an analysis of the place of the unconscious as a vital element in ideological struggle' (1977: 156). Another instance of the way cultural studies fell under the influence of *Screen* is *Decoding Advertisements* by Judith Williamson (1978), who learned her theory on an MA course on Film at the Royal College of Art. *Decoding Advertisements* consists of detailed analysis of 116 visual and verbal texts. In the main, advertisements are read in terms of an ideological theme under four categorizations: science and cooking, nature, magic, narrative and history. But *Screen*'s post-structuralism is mobilized especially in the way the consumer, viewer or reader is considered as a positioned subject and so as an effect of the text.

An advertisement's mode of address, it is argued, interpellates or hails the reader 'as a certain kind of person' (Williamson 178: 51): 'Your Pentax becomes part of you'; ' "farouche" – The perfume created by NINA RICCI, Paris, for all the women you are.' And Lacan's account of the mirror stage as the way that the infant comes to identify itself as an idealized and imaginary unity is said to be 'very similar to the process of advertising which offers us an image of ourselves that we may aspire to but never achieve' (p. 64). Examples include an advertisement for 'Glow 5' showing a woman full-face in a mirror smiling at the viewer and the words, 'When did your skin last smile back at you?'. Williamson comments that 'this mirror image involves a separation – between you, "not happy with your skin", and the version of you with perfect skin, shown actually *in* the mirror within the ad: a situation where your skin smiles back *at* you indicates a gulf between *you* and *your skin*' (p. 67). The advertisement acts to anneal the gap it has opened up – between your perfect self and you – by inviting the viewer to merge with the image in the represented mirror: separation is recuperated on condition that the viewer becomes a 'Glow 5' woman.

The most public evidence of the impact *Screen* theory made in cultural studies is the Open University Course, U203 'Popular Culture', which adopted the encounter of Marxism and psychoanalysis on the terrain of semiotics to provide its analysis of the texts of popular culture. U203 was first planned in the late 1970s and taught – to mature students – between 1981 and 1987 to over 5,000 students, more than graduated in that period from all the other media and cultural studies courses in the whole of England. It formed an institutional link between intellectuals who had been involved in *Screen* reading groups, members of the British Film Institute, academics in polytechnics and some universities and film and television practitioners, thus, quite apart from students, performing a re-education for several hundred teachers besides an uncounted number of the general public who eavesdropped on its television transmissions. The course was intended to run and run but as an interdisciplinary course it had no empire to defend it within the university bureaucracy and so in a time of cut-backs, it was terminated (with minimal prejudice) in October 1987.

LITERARY THEORY

The post-structuralist project associated with *Screen* gained a lot of its interest and effectiveness because the object under study, contemporary visual media, was deeply involved with popular culture, for which there was relatively little critical and theoretical work. But if film is open territory, literary study is not. In the twentieth century the study of literature has been defined by and predicated on its antagonistic other, popular culture. *Screen* was able to elude what Raymond Williams referred to as the 'perfect and virtually unbreakable circle' (1977: 45) within which literary criticism has performed since the 1930s, pressed down upon by densely packed generations of previous scholarship, journalism and literary impressionism. Moreover, literary study, particularly in England, is close to the ideological heartlands of Englishness and closely bound up with a cultural formation structured by empiricism, moralism and humanism.

Selected almost at random to represent the discourse of Englit. is an extract from a book on Wordsworth published in 1978, an account of 'Tintern Abbey'. This, it argues, is:

> supported throughout by a further insistent stress on the power of affection, infused not merely into the repetitive use of particular words but into the tender conversational tone, the gentle, even rhythm, and the patient unfolding of the argument, all working expressively to reveal the persona of a poet who has learned to devote himself to the affections of the heart and who invites the reader, by participating in the same processes, to share what he has discovered.
>
> (Beer 1978: 74)

Instead of being a text consisting of a set of traces (signifiers) from which the reader must actively produce meaning, the poem has disappeared into equivalence with a human experience ('the power of affection'), every aspect of its textuality (tone, rhythm, argument) having become 'expressive' of personality. In this *empiricist* scenario the literary text is supposedly 'there', available as an immediate experience to the imaginative and unprejudiced reader to whom it returns a confirming reflection of eternal and universal Man (*humanism*) ('the poet' is simultaneously William Wordsworth, who died in 1850, *and* the speaker of the poem as performed by the reader in the present day). This process leads to

the production of more humane and more understanding readers (*moralism*).

Supported as they are by the hugely powerful academic practice of Englit., these assumptions about literature pervade the English mental landscape as rain does its physical landscape, producing an encirclement almost impossible to break out of. Nevertheless, in the 1970s, the difficulty of the task only made the attempt more imperative. As a politicized critique, post-structuralist *Screen* theory inevitably carried over into the area of literary studies, and, as it did so, joined up with the pioneering Marxist work of Terry Eagleton, whose *Criticism and Ideology* appeared in 1976. Colin MacCabe, whose first work (on cinema) had appeared in *Screen* in 1974, published *James Joyce and the Revolution of the Word* in 1978, and this was followed at the end of the decade by the enormously successful *Critical Practice* by Catherine Belsey (1980) (this has now sold 35,000 copies).

Radford's review of the Spielberg film is very close in its assumptions and protocols to a literary reading (one of the very things wrong with it), and so the content of the argument in literary studies is very much the same as that at issue between Radford and Heath on film. But two things have made the outcome very different. Because literary study has a much more privileged and institutionalized position in England than film study, the struggle over literature was far more bitter than that over film; and, again because of that ingrained and established power, the critical debate over literature was delayed until the period 1980–2.

The advance of post-structuralism into the territory of Englit. suffered its first serious casualty in 1980. In that year Colin MacCabe, a contributor with Stephen Heath to *Screen* and with him a lecturer in English at Cambridge, was dismissed (or rather – this is how we do things in England – he did not have his lectureship confirmed). The expulsion of MacCabe by Cambridge signalled a defeat for the new ideas which the study of literature in England has barely got over even now. The universities of Oxford and Cambridge exercise vast cultural power in England. It was the Cambridge Faculty which, after Quiller-Couch, had originated modern English studies with William Empson, I. A. Richards and F. R. Leavis during the 1930s. And in the two decades after 1950, with Leavis and C. S. Lewis, Graham Hough and Donald Davie, Basil Willey and Raymond Williams, the department was arguably

one of the most far-seeing and progressive in the world, certainly the leading department in England. If in 1980 it had been able to take on board the challenge of the contemporary, the intellectual history of England in the past decade would have been markedly different.

A second incident, the reception of *Re-Reading English*, shows some of the issues at stake and reasons why the new theory was resisted. In 1982 Peter Widdowson edited a collection of essays which called on contributors to apply the new theory to literary studies. In the *London Review of Books* issue of 17–30 June 1982 (p. 14), Tom Paulin called it 'a nightmare of subsidised nonsense' and perceptively characterized it as promoting an attitude which was 'unEnglish' (!):

> This new attitude is interested in ideas and issues, committed to revolution, self-consciously critical of sexual tokenism, sympathetic to structuralism, and hostile to 'bourgeois poetry', liberalism and the concept of sensibility. . . . The contributors . . . appear to be members of a dissident intelligentsia which is preparing the theoretical ground from which an English National Liberation Army may one day emerge. . . . Unfortunately, Dr Widdowson and most of his contributors appear to share a deep hatred of art and to be united in a desire to abolish both texts and authors.

Paulin (who has since changed his position) here writes a review evidencing the way post-structuralism undermines English national culture. To be 'self-consciously critical' is to interrogate what empiricism assumes is merely given; to be not merely an 'intelligentsia' (the word is Russian) but 'dissident' as well locates the contributors outside the pale of normal (English) humanity; and finally they are condemned on the moral grounds that they hate art and want to abolish it. In this review's imaginary world *Re-Reading English* appears as a hideous Other produced by intellectual Bolsheviks.

In the summer of 1982 the *Times Literary Supplement* commissioned a review of *Re-Reading English* which turned out to be generally favourable. For reasons never satisfactorily explained, this review was rejected and another solicited from Claude Rawson, which appeared on 10 December 1982 (p. 1371; for the whole sad story, see Green and Hoggart 1987: 91–102). Reviewing in England does not often reach for the kind of pseudo-Swiftian

language used in this sneering and contemptuous notice, which referred to the book as 'billowings of sheer untalented modishness' and, in chilling tones, queried 'the process (blinkered impercipience? or cynical lucidity?) which got this book passed for publication'. Other comment followed, as is reported by Brian Doyle:

> The torrent of abuse unleashed on *Re-Reading English* both in print and on the broadcast media serves to reveal some characteristic responses to such pressures from inside the English studies academic establishment during the mid-1980s. The terrifying calls for the abolition of dissident books and courses, together with the reactionary retreats into the narrow professional study of the approved national canon, dramatically enunciates the deep crisis of identity within a profession which feels itself under threat from all sides.
>
> (1989: 138)

As Doyle suggests, it is because Englit. is so close to the centre of Englishness that a perceived threat to it becomes so enormously magnified. A whole range of forces, both intellectual and practical, can be mobilized in defence of what is seen as English national culture (empiricism, moralism and humanism). This is very clear to anyone who has tried to explain the dismissal of MacCabe or the academic stink over *Re-Reading English* to a sympathetic citizen of the United States or Canada. (A personal footnote and to declare an interest: both Brian Doyle and the present writer were among the contributors to *Re-Reading English*.)

CONCLUSION

It would exceed my adopted stance as cultural historian here to try to include a full evaluation and critique of *Screen* theory. In the Heath article cited earlier there is a tone of enthusiastic and untroubled confidence which reads strangely now, not least because nearly twenty years of theory wars have been fought over such issues since 1976. But *Screen*'s mixed cultural impact in the 1970s can, I think, be assessed in relation to three areas. Conventional and mainstream film criticism – that represented by the *Guardian* and other upmarket newspapers, the weekly journals (such as *New Statesman* and *Spectator*) and more journalistic film journals (such as *Sight and Sound*) – continued throughout the 1970s as they continue today, virtually unaffected (a film review

from this week's *Guardian* would differ little in assumptions from Tim Radford on Spielberg). Occasional sneers at 'the jargon of semiologists' broke the unruffled surface of some reviews and once or twice in programmes about cinema on television; the Marxist film director Lindsay Anderson published a long attack on *Screen* theory in the *Guardian* but the reaction in the main – if there was any – can be summed up by Alan Parker's later remark (made on Thames Television on 12 March 1986) that 'Film needs theory like it needs a scratch on the negative' (cited in Lapsley and Westlake 1988: 1).

A second strand of reaction came from the Left. Here, *Screen* was read seriously, even sympathetically, but criticized by New and Old Left on different grounds. In 1976 Raymond Williams arraigned *Screen* for formalism and referred to its work on film as 'being forced beyond the closed categories of structuralist linguistics into analysis of a cultural system which it cannot fail (though the signs are that it will try) to recognize in the end as historical' (1976: 504); and Terry Eagleton published a similiar attack in *New Left Review* in 1978. Representing the Old Left in the Communist Party Literature Journal, Arnold Kettle polemicized against what he saw as the jargon of *Screen* on the grounds that its 'incomprehensibility' made it 'hopelessly undemocratic' (1976: 5). Trying to hold on to both Old and New Left positions and struggling to keep the insights of *Screen* theory in touch with the discourse of conventional serious journalism was the work of Colin McArthur, who reviewed regularly for the radical newspaper *Tribune* throughout the 1970s. But *Tribune* is (sadly, was) a marginal left-wing weekly, and the centres of cultural power in England lie elsewhere.

Undoubtedly post-structuralist theories have gained some purchase in England since the 1970s, particularly in the academic domain. There are new courses in film studies, communication and women's studies, each of which has been influenced by radical theory. Publishers such as Routledge with its 'New Accents' series have marked up considerable success, in some instances the publishing houses being well in advance of syllabus design in higher education (though a lot of what's published here sells mainly in the North American market). Even in Englit. it is now rare (though far from impossible) for a student to study the received canon without some enforced acknowledgement, however uneasy, that, intellectually, all is not as it was on 1 January 1970. But if you turn from the academy to what is left of a public sphere in England –

that arena of interchange between higher journalism, weeklies such as the *Spectator*, BBC 2 and Channel 4 – things look very different.

In the 1990s England remains a country in which James Wood, a young literary journalist widely praised as one of the most enterprising and able of recent years, can seriously write an essay in our leading literary review arguing that we don't need any theories because good criticism should be aware that 'literature is its own best theory'; that in fact good criticism 'would let, as it were, literature interpret itself' (James Wood, 'Literature its own best theory?', *TLS* 7 June (1991: 16). The unreflecting and utterly traditional empiricism of this is obvious and one wonders only about the momentary doubt which interposed an 'as it were' to stop him writing simply, 'would let literature interpret itself' (look, here comes *Hamlet*, interpreting itself).

Claude Rawson, in a long review article, 'Old literature and its enemies' (*LRB* 25 April 1991: 11–15), recently repeated his reactionary views, showing that his prejudices have merely intensified since 1982. Scenting a prevailing wind, Edward Pearce, usually a political commentator, added his voice in an article on 'Prose and cons of Eng Lit' (*Guardian* 25 September 1991: 20), defending Great Books and attacking those who are 'contemptuous of literature', there being 'no dog-turd which a certain kind of academic will not perceive to glitter'. Frank Kermode was once one of the most informed and enlightened defenders of an admittedly somewhat depoliticized version of the new theories but in the past few years has become, for reasons that remain unexplained, a staunch defender of entirely traditional attitudes towards Great Literature. His views have had full coverage in a recent article on 'The decline and fall of the readable literary critic' (*Guardian* 10 October 1991: 25) and again in 'Theory and truth' (*LRB* 21 November 1991: 9–10). Meanwhile John Gross's essay 'The man of letters in a closed shop' (*TLS* 15 November 1991: 15), savages 'theorists' on the grounds that they insist on 'the priority of theory over literature' and that their work is 'devoted not so much to illuminating literature as to undermining it, robbing it of its autonomy'.

Certainly, the very fact of these continuing denunciations is an indication that post-structuralist theory is here and won't go away. But the confusion and absence of some fairly basic information is equally symptomatic of a culture so sure of itself it doesn't feel a need to understand what it's resisting. In a strange irony, the only

thing many people in England know about the new theories is that they have been widely condemned. Whatever inroads radical theory has made in the separated and specialized world of the academy I see no reason to believe the public sphere as represented by higher journalism is going to change soon. It is that same culture which, in another area, promotes the novels of Martin Amis over those of Christine Brooke-Rose or Michael Westlake, and prefers the poetry of the haitches (Hughes, Heaney, Hill, Harrison) to that of Tom Raworth or Steve McCaffery (but that's another story).

Since this essay has assumed (1) that post-structuralism provides a better analysis, a better knowledge, of the aesthetic text than the moralizing impressionism of conventional humanist criticism; and (2) that such analysis is linked to a politically progressive tendency in the degree to which it subverts and offers to rethink the founding structures of English national culture (empiricism, moralism, humanism), I have to ask, 'What went wrong?'. Two things, I believe. One is very well set out by Arnold Kettle in the review already mentioned. Kettle attacks the language or discourse of Althusser-inspired theoretical writing (his actual target is Eagleton's *Criticism and Ideology*). Kettle accepts that such writing may be 'trying to evolve a more scientific way of seeing things'; and he concedes that there are real problems involved in any would-be radical use of language, noting that:

> This is particularly true in a country like Britain in which the ruling class has been strong enough to adopt a purely empirical, 'commonsense' approach which seeks all the time to undermine and discredit *all* 'theory' and especially 'foreign' theory. There are therefore real dangers in strengthening in any way that insular (yet also deeply imperialistic) philistinism which is one of the curses of certain areas of the the Labour movement as well as of British capitalist society in general.
>
> (1976: 5)

Having said this, Kettle goes on to dismiss the 'incomprehensibility' and 'jargon' of theoretical discourse in the '"New Left" idiom' as 'hopelessly undemocratic' because it confirms 'at every point the sectarian division between "theoretical" intellectuals and "ordinary" workers' (p. 5).

This argument has the merit of pointing out the degree to which cultural practices in England in the 1970s had become

professionalized and academicized since the 1930s. In the Depression decade (a time Kettle well remembered) there remained something of a dominant public sphere, allowing ideas to circulate with a degree of freedom and accessibility between literary magazines, the universities, publishing and higher journalism (the careers of Cyril Connolly, W. H. Auden or Graham Greene would illustrate this well enough). Following the massive expansion of higher education during the 1960s the academic world, by the 1970s, had become largely cut off from the rest of cultural life (and, reciprocally, higher journalism from the academy). In one way Kettle is right to point to an undemocratic form of discourse as in some respects symptomatic of this professionalization.

But at the same time Kettle is profoundly wrong. For what makes him suppose that the majority of people in England can even read his own educated English or thread their way through the velvet ironies of a typical *Guardian* review, such as that of Tim Radford? The answer is of course that in supposing this Kettle is subject to the hidden seduction of the residual English public sphere and the claim the discourse of the gentry has been able to make since the seventeenth century that its 'plain style' is universally available, even to ordinary workers. It's not, and what this misrecognition conceals is the complicity of that discourse with empiricism, moralism, humanism – this triple evil to be condemned for the reason given earlier – that in affirming nature and denying construction it renders change *unthinkable*. Post-structuralism has encouraged its readers to attend to the seemingly irrelevant, the apparently marginal, the footnote. At the very moment Kettle makes the sound point that empiricist 'common sense', distrust of theory, insularity and philistinism characterize the English tradition, and by implication that these are things that have had their day and need to be overthrown, he appends the following note:

I'm well aware that the idiom I adopt myself isn't beyond criticism or outside the struggle. It's an idiom that any sectarian will be quick to categorise as 'bourgeois'. I'm aware of this but think the advantages of being fairly widely comprehensible in a given social situation greatly outweigh the disadvantages. All the time one has to try and hold a balance between a recognition of things as they are and the need to change them. But one has to *start* from things as they are.

(1976: 5)

In the very act of attacking a radically alternative mode Kettle is compelled to admit why his own preferred discursive form is compromised, and *then* goes on to perform Operation Margarine, in a gesture of recuperation ('all the same, there's no alternative'). All in the very tones of the gentry (weighing advantages against disadvantages, seeking to hold a balance, keeping in mind things as they are). Why? Because the inherited weight of a discursive tradition, the view that English plain speech, the language of common sense, is equally available to all citizens, drags him down.

This textual moment is deeply symptomatic, I think, because it points to a second reason for the relative defeat of post-structuralism in England compared with the situation in Australia and New Zealand, in Canada, or at present in the United States where a fierce, important and utterly unEnglish intellectual struggle is taking place over the question of 'political correctness'. This is an endeavour within university communities to establish rules against the public expression of sexist and racist attitudes, a struggle which has begun to move beyond the academy, for example in the demonstrations that accompanied the opening of the film *Basic Instinct* (a film which chooses as its killer a bisexual icepick-wielding woman).

The challenge of post-structuralism was deflected during the 1970s by the age, thickness and invisibility of English national culture, that specific tradition which stretches back in relatively undisturbed continuity to the post-Revolutionary period of the late-seventeenth century: empiricism, moralism, humanism. What I have called 'the new theory' has been effectively marginalized, not by the vitality of a culture which has actively engaged with and defeated the new ideas in reasoned debate, but by a culture able to ignore and resist the new simply through the sheer, sodden impermeability of its antique intellectual heritage. This English cultural tradition is now in what looks like terminal decline, unable to respond to the new, unwilling to rethink the realities of a post-imperial, Europeanized, firmly social-democratic national identity. Although I would certainly deny any causal links between the chronic weakness of the British economy, the reactionary complacency of dominant English culture and the rejection of post-structuralist theory, the failure of such theory – with its promise of cultural alternatives – to break out of an academicized enclave either in the 1970s or since simply confirms this general decay.

FURTHER READING

The number of books on post-structuralist theory is vast and growing,
but Belsey (1980) and Eagleton (1983) must count as better ways to
pick up the trail. On English culture in the 1970s there is virtually
nothing except primary sources, which is why this present volume is
such an interesting one. Easthope (1988), while trying to do something
else, does deliberately include something of a preliminary history of
the British developments in the decade. On *Screen*, far and away the
best book is Lapsley and Westlake (1988).

BIBLIOGRAPHY

Beer, J. (1978) *Wordsworth and the Human Heart*, London:
Macmillan.
Belsey, C. (1980) *Critical Practice*, London: Routledge.
Chambers, I., Clarke, J., Connell, I., Curti, L., Stuart, H. and
Jefferson, T. (1977/8) 'Marxism and culture', *Screen* 18 (4) (Win-
ter): 109–19.
Coward, R. (1977) 'Class, "culture" and the social formation', *Screen*
18 (1) (Spring): 75–105.
—— (1977/8) 'Response', *Screen* 18 (4) (Winter): 120–2.
Coward, R. and Ellis, J. (1977) *Language and Materialism*, London:
Routledge.
Derrida, J. (1976) *Of Grammatology*, Baltimore, MD: Johns Hopkins
University Press.
Doyle, B. (1989) *English and Englishness*, London: Routledge.
Eagleton, T. (1976) *Criticism and Ideology*, London: New Left Books.
—— (1978) 'Aesthetics and politics', *New Left Review* 10 (January/
February): 21–34.
—— (1983) *Literary Theory: An Introduction*, Oxford: Blackwell.
Easthope, A. (1977) 'Manchester SEFT group', *Screen Education* 23
(Summer): 71–2.
—— (1983) *Poetry as Discourse*, London: Routledge.
—— (1988) *British Post-Structuralism: Since 1968*, London: Routledge.
Green, M. and Hoggart, R. (1987) *Broadening the Context*, London:
John Murray.
Jones, G. Steadman (1972) 'History: the poverty of empiricism', in
Robin Blackburn (ed.) *Ideology in Social Science*, London:
Fontana.
Kettle, A. (1976) 'Literature and ideology', *Red Letters* 1: 3–5.
Lacan, J. (1977) *Ecrits: A Selection*, London: Tavistock.
Lapsley, R. and Westlake, M. (1988) *Film Theory: An Introduction*,
Manchester: Manchester University Press.
MacCabe, C. (1978) *James Joyce and the Revolution of the Word*,
London: Macmillan.
—— (1985) *Theoretical Essays*, Manchester: Manchester University
Press.

Marx, K. and Engels, F. (1950) *Selected Works*, 2 vols, London: Lawrence and Wishart.

Mulvey, L. (1975) 'Visual pleasure and narrative cinema', *Screen* 16 (3) (Autumn): 6–18.

Thompson, J. O. (1977) 'Report: SEFT Glasgow Weekend School', *Screen Education* 23 (Summer): 69–70.

Widdowson, P. (ed.) (1982) *Re-Reading English*, London: Routledge.

Williams, R. (1976) 'Developments in the sociology of culture', *Sociology* 10 (3) (September): 494–506.

—— (1977) *Marxism and Literature*, Oxford: Oxford University Press.

Williamson, J. (1978) *Decoding Advertisements*, London: Marion Boyars.

Chapter 4

Cultural devolution?
Representing Scotland in the 1970s

Willy Maley

INTRODUCTION: REPRESENTING SCOTLAND

Any attempt to characterize the cultural politics of a decade is inevitably susceptible to generalization, and to the energetic ironing out of cultural differences. And when one endeavours to condense an accumulation of traditions and innovations into a single frame, continuities are always going to be overlooked in the search for developments which can decisively be said to belong to a particular historical moment. This tendency to draw a clear dividing line between two epochs is especially tempting in the case of the 1970s. The radicalism of the previous decade has become so much a part of the mythology of cultural studies that it is almost impossible to distinguish truth from fiction. Whether or not one believes that the 1960s saw a liberating explosion of creative energy, it is all too easy to interpret the ensuing ten years as one of decadence, reaction and stagnation. This stems in part from a nostalgic longing for the excitement and glamour, real or perceived, of the 1960s. The dead generations can rise like a dream as well as weigh like a nightmare on the brains of the living.

Moreover, just as nations alter from decade to decade, so one nation's decade is different from that of another. There is a strong argument that things tend to come to Scotland after they have been tried out in England, in much the same way that American innovations cross the Atlantic to be taken up at a later date by England. This time-lag theory has some historical evidence to support it. The Reformation in Scotland came later than in England, so why not the Revolution? But the belief that Scotland trails England can only be sustained if political and cultural changes in the two countries are seen as identical. Thus the 1970s

might be seen as a decade in which Scotland caught up with developments already falling into decay south of the border when in fact what was happening in Scotland was quite distinct from what happened in England. The Bay City Rollers were not the Beatles. Their appeal had overlapping features, but their national identity – the incorporation of tartan into casual clothes, waistbands, seams, scarves – was a prime factor in their popularity.

If periodization has its problems, these are exacerbated by the effort to cover a wide geographical area. There is a pervasive and subtle cultural imperialism implicit in the project of a British identity. From one perspective, Britain is not a nation but a state composed of four nations and many nationalities. Moreover, if a so-called national culture is always the culture of the dominant class, then Scotland's position was complicated by the fact that it had to contend with a dominant nation as well as a dominant class. The state may have contrived to suppress rather than support cultural and national differences through central funding of the arts. The resultant 'British' product does not constitute a national culture, but a state culture. Unfortunately, most histories of British culture are in essence histories of English culture. When English and American critics do look at changes in the British political system which directly affect Scottish culture, they tend not to analyse the different impact of these changes within a Scottish milieu. Janet Minihan's authoritative study *The Nationalization of Culture: The Development of State Subsidies to the Arts in Great Britain* (1977) is a perfect example.

Britishness, and the separate national identities that both feed into and are swallowed by it, makes a complex and heterogeneous phenomenon which cannot be reduced to a recognizeable whole. Local storylines tend to get lost in the grand narrative. Most accounts of British culture, and analyses of British politics, are inclined to take the metropolis as their starting-point, then work their way out into the margins. This is of course understandable, given that London is the massive and dominant cultural and political centre of Britain. Scotland, lying beyond the vaguely defined 'North', seldom warrants the same attention grudgingly given to the Midlands or the north-east. When Scotland is incorporated into histories of the development of British culture, the specificity of the Scottish experience is, if not entirely obliterated, then at least mediated through an English lens. The artists and

cultural producers who matter are those who have made a name for themselves south of the border.

But it is easier to complain of neglect of the Scottish dimension of British cultural politics than it is to say exactly how Scotland differed from the rest of Britain in clearly identifiable ways. Bearing in mind that Scotland itself was divided north and south, east and west, Irish and Scottish, protestant and Roman Catholic, rich and poor, what were the specific features of the arts in Scotland in the 1970s? What problems and prospects existed that were different from those encountered in England, Wales and Northern Ireland? What contribution did Scotland make to British culture? What artists and events were of international significance? With what do you compare Scotland? The North of England? Catalonia? Northern Ireland? Wales?

Now that nationalism is at the top of the political agenda throughout Europe, it seems fitting to begin the slow process of uncoupling the history of Scottish culture from the overweening influence of a 'British' culture which was often no more than another word for English. In this chapter, I want to attempt a cultural cartography of Scotland in the 1970s, charting the ways in which the country was read, written about and represented – politically and artistically – in the decade. I shall be tracing the contours, not always coincidental, of political culture and cultural politics. My concern is with the manner in which Scotland was represented both by those artists who lived and worked there and by those institutions which, while having a pronounced Scottish existence, might be seen to be engaged in imposing a 'British' vision. In other words, I am interested in what was being offered and what was being argued for from within and outside Scotland. I do not presume to capture the entire decade, to impose a unifying chronology or to cover the issues or the country as a whole, blanket fashion. Instead, the focus will be on a necessarily limited selection of individual artists, events, achievements, innovations and institutions which constitute aspects of a narrative that continues to be contested rather than accepted features of an hermetically sealed past. A provisional critique of the notion of 'cultural closure', the chapter will attempt to articulate, across a range of media, the convolutions and devolutions that were involved in representing Scotland in the 1970s.

THE STATE OF THE NATION

One version of recent history would stress that the key feature of British society in the 1970s was the eclipse of class politics by nationalism and by a collection of alternative affiliations and identities – gender, race, ethnicity, sexuality. If class was waning as a force for social cohesion, then nationalism offered another collective framework within which to organize for change. There may be some truth in this as far as British nationalism is concerned. Entry into the European Community and the rise of 'regional nationalisms' within the British state meant that the integrity and sovereignty of the United Kingdom was being attacked on two fronts. This paved the way for the militant British patriotism of the Thatcher years. But to claim such a shift from socialism and the class struggle to nationalism and the struggle for self-determination in a Scottish context is to ignore some of the most important cultural moments and movements of the decade.

It could be argued that one of the main elements of Scottish culture in the 1970s was not a shift from revolution to devolution but a productive conjunction of class and nation. The collapse of Upper Clyde Shipbuilders in 1971 and the general decline of heavy industry, read alongside the rising fortunes of the Scottish National Party (SNP), might lend credence to the view that the patriot was displacing the proletariat, rather than giving the Scottish workers a way of expressing their discontent in a different language from that of labourism. But the miners' strikes of 1972 and 1974, and a strong communist presence in the Scottish National Union of Mineworkers (NUM), gave notice that the 1970s were going to be a battle-ground as far as industrial relations were concerned. And Scotland was electing communist councillors on a scale that suggested that Red Clydeside was more than a myth and that class politics were alive and kicking north of the border. The setting up of the first workers' co-operative-run mass circulation daily newspaper in Britain, the *Scottish Daily News* in Glasgow in 1975, also gives the lie to the argument that socialism was yielding in any clear-cut way to a new form of allegiance. The fact that the venture was ultimately unsuccessful, though, may have given support to the nationalist argument that progress in a British context was destined to be frustrated. The 1970s saw the crystallization of an idea that had been forming in Scotland for some time, namely that socialism could profitably be harnessed to

a developing Scottish political identity. The Scottish socialist historian James D. Young produced a number of challenging essays on Red Clydesider John MacLean, and his *The Rousing of the Scottish Working Class* (1979) ably illustrated the links between Scottish radicalism and the struggle for independence. Thus the raising of national consciousness in the 1970s did not necessarily entail the lowering of class consciousness.

There is another argument that, while accepting that a *rapprochement* between class and national identity did take place, would maintain that this composite cultural formation works in the same ways as the individual discourses which constitute it – homogenizing, simplifying, unifying, making one voice out of many. It is not only in times of revolutionary turmoil that differences are sunk. Periods of intense reaction are marked by the politics of one-nation or of classlessness. Suspicion of the conflation of class politics with nationalism is to be expected. These are powerful discourses that threaten to overwhelm other differences, other identities. Socialist nationalism, whatever its positive force in the Scotland of the 1970s, carries within it the memory of Germany in the 1930s and the knowledge that a nation that feels itself aggrieved and seeks scapegoats within and enemies abroad can be a chillingly reactive power. However, it is not sufficient to either oppose or endorse nationalism *per se*. In the same way that there are socialists who strive to achieve a genuinely classless society, there are nationalists whose aims are not narrow or exclusivist but internationalist.

The problem for Scotland was how to assert a national identity against the grain of British nationalism. Just as the Soviet Union and Russia had become virtually interchangeable in the language of international politics, so Britain and England were used in place of one another in a way that not only marginalized but nullified Irish, Scottish and Welsh national cultures. With British nationalism came the politics of regionalism for the 'Celtic fringe'. If 'the Nation' was Britain, how could the smaller nations which composed it preserve their identity? Their suppression fostered a smouldering resentment which the 'revolutionary' years of the 1960s failed to extinguish. Drawing on Michael Hechter's concept of 'internal colonialism', we can say that 'internal devolution' was high on the political agenda in the 1970s, but that certain devolutionary strategies may have served to strengthen rather than weaken the power of central government. 'External devolution',

or national devolution, was markedly less successful.

In the early 1980s, two Labour Members of Parliament (MPs) argued that the 'real divide' in Scotland was social, and that class rather than national identity lay at the heart of the country's problems. Although social inequalities were more pronounced in Scotland than anywhere else in Britain, they maintained that Scotland's poor are:

> not poor because they are Scottish; they are poor because, if they are not unemployed, they are in the wrong job, sex, or class – and because our welfare state fails to compensate them for it. In other words, Scotland's high levels of poverty are not the result of fecklessness, incompetence, poor household budgeting, excessive drinking or smoking or personal deficiencies amongst 'the poor': they are rooted in the industrial and occupational structure of the Scottish economy and, in particular, they arise from the highly uneven and uncontrolled character of Scotland's economic development.
>
> (Brown and Cook 1983: 12)

This recalls Franz Fanon's famous reformulation of Marxism: 'You are poor because you are black; you are black because you are poor.' If the definition of Marxism needed to be stretched, in Fanon's view, to accommodate colonialism, then labourism had to be stretched to address the problem of Unionism, the British problem. Labour Unionists insisted that poverty rather than nationalism was the key issue. Was Scotland's position within the Union the cause of its economic ills, as the SNP maintained? There is certainly evidence to support this. Between 1971 and 1982 the total number of employees engaged in manufacturing fell by 32 per cent. In the 1960s and 1970s 200,000 skilled jobs in Scotland, one in three, were lost. The decline of heavy industry was particularly marked in this period (Kendrick 1983: 47). But if Scots are not poor because they are Scottish but for other reasons then how do you explain the fact that the Scots poor are poorer than the English poor? 'Economic mismanagement', says Labour. 'Economic mismanagement', says the SNP. But the solutions differ. One is a British solution – transform the state. The other is a Scottish solution – withdraw from the state.

The response of Westminster to such discontent was partly a reorganization of its relationship with Scotland as a whole and partly a reorganization of local government *within* Scotland. The

Kilbrandon Commission (1969–73) was set up to look at the whole question of constitutional change. The Kilbrandon report, published in 1973, did not in itself accelerate the discussion on devolution, but with the electoral success of the SNP in February and October 1974 the report became a key document in the arguments around self-government for Scotland. Devolution was finally debated in parliament on 3–4 February 1975. At the same time, the Local Government (Scotland) Act (1973), following on from the Wheatley report (1969), established a number of regional authorities in Scotland. Elections took place in 1974, with the transfer of power being effected in May 1975. Historically, local government had developed along different lines in England and Scotland, and reorganization in Scotland came a year later than in England. From a Westminster standpoint, these new local authorities north of the border became regions within a region, and the layers of bureaucracy between Scots and the source of governmental power thickened. Local, regional, Scottish and British. The addition of an extra tier of government did nothing to improve the proximity to power of Scots. Centrally, Scotland continued to be represented as a region in parliament, with its proportion of MPs linked to population rather than national status as a full partner in the Union. The Scottish identity of its MPs was strong though. Of the seventy-one Scots MPs elected to Westminster in 1974 only three were not Scottish by birth. It was also increasingly nationalist as the decade progressed. In 1974, the SNP became the second party in Scotland. In the February election, the SNP won seven seats and polled 22 per cent of the Scottish vote. At the October election it won eleven seats and 30 per cent of the vote, outstripping the Conservatives and coming second to Labour in thirty-five out of its forty-one seats. It has been argued that one of the distinctive features of support for the SNP was that it came neither from industry nor management – which remained loyal to Labour and Tory – but from the 'purveyors of traditional cultural values – the churches . . . the culture and language societies, the school teachers and the solicitors' (Drucker and Brown 1980: 76). A poll for the *Sunday Mail* on 27 February 1977 showed the SNP enjoying the support of 36 per cent of Scots. From then until August the SNP was the most popular party in Scotland. However, on 1 March 1979, the referendum on devolution in Scotland failed to secure the 40 per cent of the electorate needed to implement the Scotland and Wales Act, although the pro-devolution vote in

Scotland was greater than in Wales – 32.5 per cent compared with 11.8 per cent of the Welsh electorate.

If devolution, in the 1970s and in a Scottish context, came above all to be identified with the establishment of a Scottish parliament and the diffusion of power from Westminster, the concept also involved questions of local control of, and involvement in, cultural production. Indeed, it would probably be fair to say that cultural nationalism, allowing for the fact that nationalism is always cultural, was behind much nationalist political activity and success in the decade. The rising tide of cultural nationalism did not precisely match the ebb and flow of political nationalism. But cultural devolution was arguably a prerequisite of political devolution.

THE STATE OF THE ARTS

The uneven success of Scotland's attempts to achieve a distinct cultural identity, or even autonomy, in the decade can be attributed in part to the ambiguous status of its cultural institutions, as serving both 'regional' and national aims. A number of British institutions have their Scottish counterparts. Scottish Opera, founded in 1962, the Scottish Film Council (SFC), the Scottish Arts Council (SAC), the Scottish Football Association, The Royal Scottish Academy of Music and Drama, the STUC – all of these institutions operate within a distinctively Scottish context. But it would be naive to accept at face value Baldry's claim (1981: 105) that the Scottish Arts Council, for instance, represented a form of devolution rather than the arm of a centralized control of cultural production from Westminster, the ACGB. In 1977 Lord Balfour, Chair of the SAC, articulated the ambiguity of Scotland's 'national regional' status: 'We reflected that the Scottish population is in fact smaller than the population served by the larger English Arts associations, and perhaps, after all, we were uniquely fortunate in having already not simply a regional arts association, but a fully fledged Arts Council' (Baldry 1981: 98. Balfour was wrong in so far as Wales had its own Arts Council.).

Scotland did not get a raw deal from the Arts Council in terms of its population. In 1981–2 Scotland, with a population of 5.2 million, received £9,344,000 or 12 per cent of the ACGB total, while Wales, with a population of 2.8 million, got £5,483,000 or 7 per cent. Yet if Scotland was seen as a nation and not as a region, it was being short-changed. It is 10 per cent of Britain in terms of

population, but 25 per cent in terms of its political presence within the Union. In this sense, the SAC can be seen as a Trojan horse, perpetuating the Westminster notion of Scotland as simply one region amongst many.

Similar ambiguities attended the BBC's relationship with Scotland. BBC Scotland, with offices in Glasgow, Edinburgh and Aberdeen, originated ten of its 130 hours a week output in Scotland. Significantly, half of BBC Scotland's output was made up of political programmes. In 1969–70, sixty-two hours of the 534 hours of TV originating in BBC Scotland went to the network. This has to be set against BBC Midland with 318 out of 551 hours, BBC North with 243 out of 574 hours and BBC South and West with 241 out of 543 hours. On the one hand, this may have enhanced Scotland's separate identity, but on the other hand it meant that Scottish programmes and Scottish culture were not being seen by audiences in England. Nine-tenths of Scottish viewing was composed of network or other non-Scottish programmes. Unlike the press, broadcasting emphasizes Britishness rather than Scottishness, with the network news particularly important in addressing and informing 'the Nation' (i.e. Britain).

Radio listening in Britain has always been low. In the early 1970s it averaged nine hours per head per week, a little over half that of the United States. With the demise of off-shore 'pirate' radio stations in 1967, Radio Luxembourg was the only commercial station available to Scottish listeners until the mid-1970s. Listening levels in Scotland to the English-language broadcasts of Radio Luxembourg were the highest in Britain, which is significant considering the greater distance from the transmitter. This contact was especially important among the young – half of Radio Luxembourg's audience was under 25 (Murray 1973: 231).

Two major independent local radio stations were established in the middle of the decade, Radio Clyde in 1974 and Radio Forth in 1975. BBC Scotland had a substantial output, around forty hours, of which some thirteen hours was Scottish news, comment or educational matter. In Scotland the BBC did not do as it did in England and replace its regional radio stations with local ones. The National Broadcasting Council for Scotland obstructed such a fragmentation of radio output as a threat to the identity of the nation (Kellas 1975: 180).

But while the Britishing (or regionalization) of Scotland was accelerated by the advent of the mass media, they also contradic-

torily played a part in developing a new and specifically Scottish culture. The BBC in London provided writers whose future work was important to Scotland with valuable television experience. John McGrath and Bill Forsyth were both blooded on *Z Cars*, for example. And while Scottish television's homegrown product was predominantly news and current affairs, Scottish drama became an increasingly visible contribution to the network. In some cases, pieces of popular Scottish political theatre were subsequently produced for television, as with John McGrath's sweeping history of the Highlands, *The Cheviot, the Stag, and the Black, Black Oil* (1974). In other instances, Scottish writers produced distinctive pieces of television drama, as with Peter MacDougall's powerful critique of sectarianism, *Just Another Saturday* (1975), produced by the BBC in London for the 'national' (British) network. Like John Byrne after him, Peter MacDougall proved that Scottish writers could compete with the best of British.

ITV carved Scotland up into three regions. Its output is divided between Scottish Television (STV), Grampian Television and Border Television. STV, operating from Glasgow and Edinburgh and catering for central Scotland, originated ten hours in Scotland. Grampian Television, quartered at Aberdeen and serving the north-east, originated six hours, and Border Television, operating from Carlisle in England but broadcasting to parts of south-west Scotland and the Borders, originated four hours. Sixty per cent of Border Television's viewers were in England and the Isle of Man. Even lower British network contributions were made by STV and Grampian than were achieved by BBC Scotland, reinforcing the sense of a limited representation on the small screen.

Cinema was another institution which occupied an ambiguous position in Scottish culture. It has long been remarked that Scotland, especially central Scotland, has a higher cinema-going audience than the rest of Britain. The proportion of people going to the cinema at least once a year is second only to London. The Edinburgh International Film Festival, from its founding in 1947, had established Scotland as a key arena for contemporary European and world cinema. It is ironic, then, that Scotland lacked a home-grown Scottish film industry to meet the needs of its native audience. As with other forms of cultural activity in the country, consumption outstripped production.

While the talent for film-making was indubitably there, the sources of funding were not. The Independent Film Association

(1974–90) had no role in Scotland. The Association of Independent Producers did have. From 1977 to 1979 it gave Scottish film producers both an identity and a passage to England, for the ACTT and the British Film Institute were ostensibly British organizations.

Two major events, Film Bang, a gathering of film producers and freelancers aimed at promoting the idea of Scottish film in 1976, and a conference entitled 'Cinema in a Small Country' in 1977, concentrated the calls for a publicly funded Scottish film industry which would harness the considerable energies and abilities that palpably existed. Scots filmmakers abjured the overtly nationalist standpoint that the SFC urged them to adopt between 1976 and 1982. The SFC suggested that Scottish filmmakers ask for a comparable level of funding to that provided for the arts in Scotland by the SAC, and that they duly demand a 13 per cent quota from the British Film Institute. Not only did Scottish filmmakers resist this course of action on the grounds that it would lead to ghettoization, they also refused to pursue it as an option when Channel Four came into being in 1982, at a time when arguing for Scottish representation on screen as a matter of principle with respect to Scottish culture as a minority culture might have made sense. Instead, Scottish filmmakers preferred to advance on merit. As well as being resistant to ghettoization, Scottish filmmakers were rightly wary of the kinds of Scottishness available to them. They did not wish to represent the Scotland of *Brigadoon*, of sleepy villages, kilts and mist-enshrouded landscapes. That may have appealed to the Highlands and Islands Development Board, a major source of sponsorship. It did not wash with the rising generation of Scottish directors, searching for new varieties of Scottishness, new ways to view the country.

In the late 1970s there was an attempt to bring together the SFC, which had a remit but no remittance, and the SAC, which had remittance but no remit with regard to film production, in order to create a combined Film Panel. In 1979, the SFC put up £5,000 for film production, and attempted to persuade bodies such as the Scottish Education Department to make a similar contribution. In 1982, the Scottish Film Production Fund was set up with a mission 'to foster and promote film and video production as a central element in the development of Scottish culture, by the provision of financial assistance to such individuals, production companies, production groups or cultural bodies as are deemed appropriate'

(Lockerbie 1990: 172–3). Scottish culture, then, was not something self-evident that was simply there to be represented or transmitted. Cinema was recognized as an active intervention in the cultural politics of the nation, a medium which could develop as well as project.

Another Scottish cultural institution which was undergoing change in the decade was the press. Scotland in the 1970s was one of the largest newspaper-publishing centres outside London, with six daily, six evening, two Sunday and over one hundred weekly or twice-weekly newspapers. Most were either independent or autonomous members of London publishing companies. In 1973 Fleet Street dailies were read by around 6 per cent of Scots adults, and London Sundays by 23 per cent. The most widely read daily was the *Daily Record* (48 per cent) with most of the rest of the market absorbed by the *Scottish Daily Express* (43 per cent). The two dominant Scottish Sundays were the *Sunday Mail* with 52 per cent and the *Sunday Post* with 77 per cent, both replete with Scottish kitsch. Middle-class readers were catered for by the Edinburgh-based *Scotsman* (5 per cent) and the *Glasgow Herald* (6 per cent) (Criddle 1978: 45).

On 18 March 1974, following months of speculation, Beaverbrook Newspapers decided to shut down its Glasgow plant, transferring production of the *Scottish Daily Express* to Manchester, selling off the *Evening Citizen* and throwing 1,850 employees out of work. The print workers organized to produce their own newspaper. An action committee was set up. On 5 May 1975, the *Scottish Daily News* commenced publication with a circulation on its third day of existence of 330,000. The paper created 500 jobs but ceased publication after six months, beset by problems with a declining circulation, the recession in advertising, arguments over content and disagreement about the role of Robert Maxwell (McKay and Barr 1976). The venture stands as a notable effort to ward off 'closure' which was distinctively Scottish but with wider political implications.

I want to turn now from a broad survey of cultural institutions to the specific achievements of individuals and groups. In setting up 7:84 in 1971, John McGrath was intent on instituting a socialist rather than a nationalist theatre, but his commitment to Scottish independence fuelled a number of his best dramatic works. In 1973, the newly formed 7:84 Scotland produced John McGrath's highly successful *The Cheviot, the Stag, and the Black, Black Oil,*

structured like a *ceilidh*, with song, dance and storytelling. This play, dealing with the impact on Highland society of economic 'progress', from the Clearances to the exploitation of North Sea Oil, was hugely popular with precisely those people it was aimed at – the inhabitants of the Scottish Highlands. Its longevity was guaranteed by a 1974 BBC-TV production and a Methuen publication.

In 1974, when 7:84 England was in limbo, 7:84 Scotland staged two new plays by McGrath. *Boom* dealt with the effects of the oil business on Scottish society, while *The Game's a Bogey* explored the relevance of Red Clydesider John MacLean to contemporary Glasgow. The year 1975 was a boom year for McGrath, with several of his most acclaimed plays being produced, including *Little Red Hen*, set in the Red Clydeside of the 1920s, *Fish in the Sea*, set in Liverpool in the 1970s, about a factory occupation and an encounter between a Glaswegian anarchist and a daughter of one of the factory workers, *Yobbo Nowt*, about a woman thrown out of her home by her husband who goes on a voyage of self-discovery and politicization in contemporary England, and *Soft or a Girl?*, about class difference coming between a middle-class woman and a working-class man.

In 1976, 7:84 Scotland produced McGrath's *Out of our Heads*, drawing an analogy between alcoholism and political inactivity, while 7:84 England did his *The Rat Trap*. In 1977, 7:84 Scotland staged McGrath's *Trembling Giant*, written for 7:84 England, a political pantomime calling for Scottish independence. In 1978, 7:84 Scotland produced Dave Anderson's *His Master's Voice*, an eloquent attack on the political and media establishment using the device of a punk up against the record industry.

Outside of 7:84 there were other important theatre productions. Hector MacMillan's *The Sash*, a telling account of Orangeism in the West of Scotland, was staged at the Edinburgh Fringe in 1973 and revived in Glasgow in 1974. The message of these and sub-sequent productions of the play was sometimes lost on audiences. The author suggested that:

> in the right theatre and with the right audience, the cast, after making their bows, might sing together the last chorus of 'The Men of '98':
>
> Tell – them – to Hell! with Orange and Green!
> Tell them to hell with Orange and Green!

Our banner like our common blood
Should be Red! – not Orange, not Green!

Like Peter MacDougall's BBC play *Just Another Saturday* (1975),
MacMillan's drama touched on an area of Scottish life that miti-
gated against the kind of unity hoped for by nationalists. Scotland,
the West of Scotland in particular, had not been a kind host to its
largest immigrant community, the Irish. Religious bigotry, con-
centrated in Glasgow but prevalent elsewhere, was a barrier to
'one-nation' Scottishness. Loyalism and Orangeism draped them-
selves in British colours, and the sectarian divide created a situ-
ation in which any sense of a peculiarly Scottish identity was
squeezed ruthlessly between the Irish Tricolour and the Union
Jack.

Socialism allied to an inclusive Scottish nationalism offered a
possible antidote to sectarianism and to the xenophobic tendencies
of British nationalism which was to provide a foundation for later
developments in Scottish drama. The socialist nationalism em-
bodied by John McGrath in the 1970s inspired the popular theatre
of the 1980s – Borderline and Wildcat took up where 7:84 Scotland
had left off – and in the 1990s it engendered Artists for
Independence, an organization of Scottish writers and artists dedi-
cated to a separate Scotland. The spread of local community arts,
and community theatre in particular, led to the setting up of
Glasgow's Mayfest in the early 1980s, a very different kind of event
from the Edinburgh Fringe but with a strong international outlook
coupled with a commitment to local community arts.

If there was no substantial Scottish film industry in the 1970s,
then there were certainly some sterling Scottish films. The moving
trilogy directed by Bill Douglas stands out like a beacon in the
dark. These monumental movies, covering the years during and
after the Second World War, contained elements of working-class
autobiography, but possessed an appeal that was anything but
parochial. The pain of the *Trilogy* cut through local, national and
international differences. The films were produced in spite of a
funding framework rather than because of it. The *Trilogy* con-
sisted of *My Childhood* (1971), *My Ain Folk* (1973) and *My Way
Home* (1979). *My Childhood*, the story of a young boy, Jamie,
growing up in a Scottish mining village, Newcraighall, was a
poignant recollection of life in rural–industrial Scotland. Jamie,
living in squalor with his half-brother Tommy and his maternal

grandmother, befriends Helmuth, a German prisoner-of-war, who acts as a surrogate father. The boy's relationship with his captive friend and his family are represented through a series of moving scenes of tragic documentary realism. By the end of the film, Helmuth has been repatriated and both Jamie's mentally ill mother and his granny have died.

My Ain Folk finds Jamie living a life of penury with his paternal grandmother, in the immediate aftermath of the war, and takes the narrative up to the point where Jamie is incarcerated with Tommy in a children's home in Edinburgh. *My Way Home* picks up Jamie's story from the time he leaves the home, and records his experiences doing National Service in Egypt and his friendship with Robert, an Englishmen who assumes, like Helmuth, the role of paternal stand-in. These three short films – forty-eight, fifty-five and seventy-eight minutes respectively – eschewed the mawkishness, the sentimentality, the romanticism and the deeply unhistorical nostalgia which had dogged Scottish culture and nationalist discourse for most of the previous century. J. M. Barrie's idealization of childhood was mercilessly deconstructed. As Andrew Noble has succinctly observed: 'Jamie, who never had a childhood, is the exact opposite of Peter Pan' (Noble 1990: 148). What Bill Douglas achieved with his *Trilogy* was a form of Scottish cinema which could stand comparison wth the best contemporary European film, and anticipated the work of English directors like Terence Davies. Such cinema has its detractors, and there are those who might see in the portrayal of working-class suffering an aestheticization or fetishization of poverty, but brutal social realism can speak to brutal social realities.

Bill Forsyth was another Scottish writer–director of some stature. His low-budget 16 mm film, *That Sinking Feeling* (1979), was an outstanding hit at the Edinburgh Film Festival. Forsyth followed this success with two internationally acclaimed films, *Gregory's Girl* (1981), a quirky love story with a woman footballer as the titular heroine, and *Local Hero* (1983), about a young American oil executive who comes up against strong local resistance to his company's plans to purchase land in a Scottish coastal village to make way for a proposed refinery. The presence of Burt Lancaster and some beautiful Highland panoramas make this quite a different project from John McGrath's *The Cheviot, the Stag, and the Black, Black Oil*, but the film none the less manages to say some sharp things about American influence in the Scottish

oil industry which could be seen to complicate the knee-jerk anglophobia of certain Scottish nationalists.

Not everyone agreed at the time that the moves to establish a worthy Scottish film industry in the 1970s were inextricably linked to the fortunes of political nationalism. Artists are understandably reluctant to see their work as a mere reflection of politics. Forsyth himself was unsure about the patriotic impetus behind Scottish filmmaking: 'I'm not so much convinced it was Scottish National-ism. But, maybe it was. Maybe that resurgence in Nationalism meant that we were forced to look at ourselves as a nation because we had this event in 1977 called "Cinema in a Small Country" ' (Hunter 1990: 155).

Representations of working-class life, as Bill Douglas proved, could say something about Scotland and Scottishness that went beyond the banalities of traditional nationalist discourse. I want to look at another expression of Scottish culture in the 1970s which helped put pay to the parochialism and romance of the past. Penal reform is not a platform of any specific political party. There are no votes in prisons, but there are votes in law and order. Paradoxically, it was in a Scottish prison that arguably one of the most significant developments in terms of cultural politics took place, the opening of an institution which offers a compelling sidelight on Scotland in the 1970s. The abolition of the death penalty in 1965 led to a rapid increase in the number of lifers in British prisons. In Scotland, where the prison population was proportionately higher than the rest of Britain, this placed intoler-able pressure on penal institutions. Barlinnie Special Unit was opened in February 1973 in order to cope with a growing crisis within the Scottish prison system caused by overcrowding and the rising number of lifers. A unique penal experiment, the Special Unit was a small, segregated unit designed to contain a maximum of ten inmates within Barlinnie prison in Glasgow. The Unit, a form of devolution within the mainstream prison system, was housed in a building which had previously been home to women prisoners. It began life with five prisoners, most of whom had been involved in incidents in Peterhead prison in the far north-east of the country. The emphasis in the Unit was on personal develop-ment through creativity.

One prisoner in particular, Jimmy Boyle, became the focus of intensive media interest. The concept of art therapy in a relaxed regime for Scotland's most dangerous and violent criminals did not

appeal to everyone. The 'hard man' turned author and sculptor was baited by the tabloids but taken seriously by the broadsheets. Boyle, shrugging off the pressures, emerged as a powerful writer, and his 1977 autobiography, *A Sense of Freedom*, published five years before his release from prison, became a classic of penal reform literature. The 1981 television production of the same name, directed by Jeremy Isaacs, with David Hayman playing the part of Jimmy Boyle, was a landmark in small screen drama. Boyle's working-class autobiography, like Bill Douglas's *Trilogy*, demolished the myth of lost childhood innocence that had haunted Scottish culture, and brought home the bitter reality of social division by using individual portraits to epitomize the suffering of a class. Not for them the lost dignity of childhood, labour or a mythologized national past.

CONCLUSION: CULTURAL DEVOLUTION?

A cynic might suggest that the changing fortunes of both political and cultural nationalism in the decade were mirrored in the national side's performance on the football field. In 1974 a gritty Scotland side, increasingly the focus and symbol of nationalist aspiration, managed by Willie Ormond, came back from Munich undefeated, beating Zaire 2–0 and drawing 0–0 with Brazil and 1–1 with Yugoslavia. Their achievement was made sweeter by the fact that England had failed to qualify. In 1978, with England again out of the running, the outspoken Ally MacLeod, hailed as a national messiah, promised the Scottish supporters – dubbed Ally's Tartan Army – more than he or the team could deliver. After a Scottish press campaign of unparalleled patriotism – shot through with anglophobia and even xenophobia – Scotland came home in disgrace, losing 3–1 to Peru and drawing 1–1 with Iran, before beating Holland, the eventual runners-up, 3–2. Despite the brave show against the Dutch, windows were smashed in the Scottish Football Association offices in Glasgow, and there was a general feeling amongst Scotland's ninety-minute patriots that the nation had been let down.

But such an account needs to be set against the evidence of some degree of a Renaissance in Scottish arts, which had important reverberations for the nationalist movement. If Douglas and Forsyth, to take two examples, did much to make the notion of a Scottish cinema of European and even world stature a realizeable

aspiration, they did much more to deconstruct the stereotypical images of Scotland and Scottishness available in British films – the bucolic village, the drunken thug, the over-romanticized scenery. A similar pattern emerges in fiction. With the publication of *Docherty* in 1975, William McIlvanney quickly established himself as one of that emerging group of Scottish authors who, concerned with questions of language and history, attributed the national stereotypes that had been foisted upon Scotland to English domination. Characters like Tam Docherty owed their identity to their country as well as their class. The toughness, the political nous, the humour in the face of poverty, the violence – all of these Scottish characteristics appear in McIlvanney's work, but the stereotypes are transformed and the roots of the violence and the desperate comedy are exposed.

More important still, perhaps, was the change in Scottish self-image effected by the new patterns of representation in the 1970s. The 'hard man' was one particularly crucial stereotype that underwent a transformation in the decade, and it happened as a process of self-analysis that was also social critique. Tom Leonard's incisive poem *The Hardmen*, for instance, wittily exposed the homophobia and shame of sex – whether Calvinist or Roman Catholic – that undergirded the hard man (Leonard 1984: 58). The 'hard man', it has been argued, drew on the discourse of masculinist workerism:

> The gritty hardness of urban life parades itself as an antidote in the real world of today to all those legends of tartanry and couthy tales of kailyard. It turns out, nevertheless, in most of its available forms, to be just another mythology . . . when masculinity can no longer define itself in 'hard work' it increasingly identifies itself with the 'hard man' for whom anguish, cynicism and violence are the only ways to recover the lost dignity of labour.
>
> (Caughie 1990: 16)

My own feeling is that this type of analysis is guilty of blaming the victim, or treating the symptom without thinking about the cause. It is also ahistorical, in so far as the 'hard man' and 'hard work' are inextricably bound up with one another. There were razor gangs and so-called hard men on the streets of Glasgow when heavy industry was in its heyday. Manual labour and notions of 'hardness' go hand in hand. It is not a question of recovering the

lost dignity of labour but of analysing the effects of the objectifica-
tion of labour.

The deconstruction of this stereotype cut across a broad range of
cultural production, as is suggested by the integration of Jimmy
Boyle into the Scottish artistic community. Boyle collaborated
with playwright Tom McGrath on the acclaimed *The Hardman*,
staged at the Traverse Theatre in Edinburgh in 1977, and broad-
cast on BBC Radio Scotland in 1980. With Jimmy Boyle, and the
Barlinnie Special Unit – viewed as a microcosm of Scottish society
– the country started to come to terms with a national stereotype
that sprang from a culture of poverty. But there is an irony in the
concept of art therapy as a solution to the aggression that springs
from need. The 'hard man' was what Scotland had become. The
arts were the answer. What was needed was music to soothe the
savage breast. The opposition to Glasgow's year as European City
of Culture in 1990 stemmed from the recognition that cultural
activities were part of, but had to be supplemented by, political
freedom.

In evaluating the achievements of the decade one also needs
to take into account the foundations which were laid for sub-
sequent achievements, as has been seen in the case of drama. In
the field of fiction, for instance, Philip Hobsbaum, an English
lecturer at Glasgow University who had previously convened
writers' groups in London and Belfast, started a similar group in
Glasgow. Liz Lochhead, Alasdair Gray and James Kelman were
amongst the writers who met and discussed their work. Gray's
Lanark (1981), Leonard's *Intimate Voices* (1984) and Kelman's
Busconductor Hines (1984), all quite different works, were signs
of a coming of age of Scottish literature. All three have argued
for Scottish independence and against the preponderance of
English culture. Although their relationship with the universities
is ambiguous, they have benefited from institutional support,
having their work sustained by the SAC. Small local publishers
like the Molendinar Press, which published Hector MacMillan's
The Sash (1974) and Carl MacDougall's *A Scent of Water*
(1975), helped promote the work of new Scottish writers. In the
1980s, a number of Scottish publishing ventures flourished, from
the larger presses such as Mainstream, Canongate and Polygon
to smaller enterprises like Dog and Bone and Clydeside Press.
Scotland had its literary journals too, to promote a cultural
identity commensurate with nationhood, with *Cencrastus*,

Chapman and the *Edinburgh Review* proving to be particularly influential.

Perhaps the most important development in the 1970s in a Scottish context was the effect of a configuration of socialism with nationalism. In the process there was a devolution of nationalist sentiment from politics to culture. In the social realist films of Bill Douglas, the Glasgow vernacular poetry of Tom Leonard, the prose fiction of William McIlvanney, the prison writings of Jimmy Boyle and the political theatre of John McGrath, there are the signs of a struggle to come to terms with the vexed relation between 'culture' and 'nation'. This did not add up to a coherent, much less monolithic, 'cultural nationalism'. Rather, these sign-posts on the cultural map of Scotland in the 1970s denote local points of resistance to the great British narrative, obstacles in the path of the myth of unity and the imperial dream of cultural closure.

FURTHER READING

Nairn (1977) remains a key text in terms of the political implications of devolution for the disunited kingdom. Drucker and Brown (1980) offer an excellent point of entry for a political understanding of devolution. Kellas (1975) provides a detailed account of the workings of the Scottish political system. McGrath (1981) is an excellent guide to aspects of contemporary theatre. One of the best routes into the Scottish cinema in the 1970s is Dick (1990). Carrell and Laing (1982) give the reader an opportunity to get acquainted with what was arguably one of the boldest and most controversial developments in Scottish cultural politics in the decade, the Special Unit at Barlinnie prison.

BIBLIOGRAPHY

Baldry, Harold (1981) *The Case for the Arts*, London: Secker & Warburg.
Brown, Gordon and Cook, Robin (1983) *Scotland: The Real Divide: Poverty and Deprivation in Scotland*, Edinburgh: Mainstream.
Carrell, Christopher and Laing, Joyce (1982) *The Special Unit, Barlinnie Prison: Its Evolution through its Art*, Glasgow: Third Eye Centre.
Caughie, John (1990) 'Representing Scotland: new questions for Scottish cinema', in Eddie Dick (ed.) *From Limelight to Satellite: A Scottish Film Book*, London: Scottish Film Council and British Film Institute.
Cornish, Roger and Ketels, Violet (1985) *Landmarks of Modern British Drama*, vol. 2, *The Plays of the Seventies*, London: Methuen.
Criddle, Byron (1978) 'Scotland, the EEC and devolution', in Martin Kolinsky (ed.) *Divided Loyalties: British Regional Assertion and*

European Integration, Manchester: Manchester University Press.

Dick, Eddie (ed.) (1990) *From Limelight to Satellite: A Scottish Film Book*, London: Scottish Film Council and British Film Institute.

Drucker, H. M. and Brown, Gordon (1980) *The Politics of Nationalism and Devolution*, London: Longman.

Hayman, Ronald (1979) *British Theatre since 1955: A Reassessment*, Oxford: Oxford University Press.

Hunter, Alan (1990) 'Bill Forsyth: the imperfect anarchist', in Eddie Dick (ed.) *From Limelight to Satellite: A Scottish Film Book*, London: Scottish Film Council and British Film Institute.

Itzin, Catherine (1980) *Stages in the Revolution: British Political Theatre since 1968*, London: Methuen.

Kellas, James G. (1975) *The Scottish Political System*, Cambridge: Cambridge University Press.

Kendrick, Stephen (1983) 'Social change in Scotland', in Gordon Brown and Robin Cook (eds) *Scotland: The Real Divide: Poverty and Deprivation in Scotland*, Edinburgh: Mainstream.

Leonard, Tom (1984) *Intimate Voices: Selected Work 1965–1983*, Newcastle: Galloping Dog Press.

Lockerbie, Ian (1990) 'Pictures in a small country: the Scottish Film Production Fund', in Eddie Dick (ed.) *From Limelight to Satellite: A Scottish Film Book*, London: Scottish Film Council and British Film Institute.

McGrath, John (1981) *A Good Night Out: Popular Theatre: Audience, Class and Form*, London: Methuen.

McKay, Ron and Barr, Brian (1976) *The Story of the* Scottish Daily News, Edinburgh: Canongate.

Minihan, Janet (1977) *The Nationalization of Culture: The Development of State Subsidies to the Arts in Great Britain*, London: Hamish Hamilton.

Murray, George T. (1973) *Scotland: The New Future*, Glasgow: STV and Blackie.

Nairn, Tom (1977) *The Break-Up of Britain: Crisis and Neo-Colonialism*, London: New Left Books.

Noble, Andrew (1990) 'Bill Douglas's *Trilogy*', in Eddie Dick (ed.) *From Limelight to Satellite: A Scottish Film Book*, London: Scottish Film Council and British Film Institute.

Rowell, George and Jackson, Anthony (1984) *The Repertory Movement: A History of Regional Theatre in Britain*, Cambridge: Cambridge University Press.

Taylor, John Russell (1971) *The Second Wave: British Drama for the Seventies*, London: Methuen.

Chapter 5

Finding a voice
Feminism and theatre in the 1970s

Elaine Aston

INTRODUCTION: DISCOVERING FEMINISM

'We can no longer ignore that voice within women that says: "I want something more than my husband and my children and my home" ', wrote Betty Friedan in 1963 in her influential feminist study *The Feminine Mystique* (p. 32). The naming of 'the problem that has no name' was a self-discovery process which women in the 1970s, on both sides of the Atlantic, pursued as they began to ask for that 'something more':

> What is positive for women, and what I keep remembering, is that it is now possible for women to find some affirmation of their selves. Our current play, *Love Story of the Century*, is about a woman discovering feminism. That is really a phenom-enon of the '70s, though. If you were fighting your way out of something in the '70s there was feminism there for you to find.
> (Unpublished interview with Mary McCusker of Monstrous Regiment, 1990)

It was the radical politics of the 1960s which set the climate and agenda for the development of the Women's Liberation Movement in the 1970s. Retrospective overviews of feminism in the late 1960s and early 1970s cite, for example, the ways in which women were influenced by the Black, New Left and anti-Vietnam movements in America; the student politics of 1968 in France; writings on the cultural revolution in China or the Algerian revolution; and, at home, the equal pay campaigning of the Labour Movement (see Wandor 1986: ch. 1). While these movements generally represented oppressed interests *other* than those of women, they none the less provided essential inspiration for the modern Women's Movement:

The way in which many women came to articulate their oppression as women, to perceive their subordination in the world of men, was *partly* through empathy with others' struggles. By the late 1960s the politics coming out of such struggles included observations, analysis and practice which women in turn seized hold of to help them define themselves.

(O'Sullivan 1982: 72)

One of the key ways in which this was achieved was through the formation of consciousness-raising groups which became a widespread phenomenon of the early 1970s. These groups enabled women to meet together in a non-hierarchical and supportive context; to discuss and share experiences at a grass roots level:

Taking its cue in part from the new left the WLM developed a style of politics which was different both in its content and in its organisational forms. The political agenda was broadened to include an analysis of power relations in 'personal' life – in reproduction, sexual relationships, the household division of labour. Consciousness-raising groups were set up as a means through which women could come to a political understanding of their situation by sharing their personal experiences with others.

(Harriss 1989: 35)

This accounted for the slogan widely adopted by women in the 1970s, 'the personal is political'. Suddenly there was a space in which to meet and challenge the private and domestic roles and spheres to which women had previously been confined. Michelene Wandor, for example, recollects how the climate of feminism provided her with a context in which to express her dissatisfaction with motherhood, one of several major talking points in the early days of the Liberation Movement (see, for example, Rowbotham 1989: 82):

One of the liberating discoveries feminism brought me in 1969/70 was that it was all right to complain, to be bitter, frustrated, angry; subterranean discontents, previously only spoken about collusively, half-jokingly to other mothers, suddenly erupted. The discovery that one could develop a critique of the family, the proud defence by many women of their independence, were sources of immense support to me.

(Wandor 1980, quoted in Beechy 1982: 16)

At no point did the Women's Liberation Movement structure itself into an organized party with a leader. It relied on the kind of bonding between women that was generated by the democratic structure of the women's groups. The event which is now labelled as the first national conference of the Women's Liberation Movement did not, for example, set out to be the forum it became. First conceived as a women's history workshop weekend in February 1970 at Ruskin College, Oxford, it became the moment during which the women, who came from up and down the country, established their four basic 'demands': (1) equal pay; (2) equal education and opportunity; (3) twenty-four-hour nurseries; and (4) free contraception and abortion on demand. Zelda Curtis reflects on the atmosphere of this first and subsequent national conferences:

> I remember the early and heady days of national conferences with all the discussions around the demands – not all sweetness and light, sometimes harsh and searing, but always exciting and relevant to our future. Those first four demands from the Women's Liberation conference at Ruskin College, Oxford, in 1970 . . . were debated hotly enough. The temperatures soared to boiling point over the next two demands at Edinburgh in 1974, for financial and legal independence and an end to discrimination against lesbians. By the Birmingham Conference in 1978, with the seventh demand for freedom for all women from intimidation by the threat or use of male violence and an end to the laws, assumptions and institutions that perpetuate male dominance and men's aggression towards women, the heat had become too great. That was the last of the national conferences. But the arguments continued to rage throughout the political institutions.
>
> (Curtis 1989: 144–5)

While all women involved in the Liberation Movement shared in the desire to challenge patriarchy, what made some of the debates so heated were the different positions from which women launched their attacks. Some wanted to argue from the radical feminist position, i.e. that the cause of oppression lies in the unequal power relations between men and women (see, for example, Millett 1970). Others argued from a Marxist–feminist base citing the historical and class-related dimensions of oppression (see, for example, Rowbotham 1973a). Eventually, these

theoretical differences were to splinter the initial phase of 'sister-hood' (see later), but, in the beginning, differences were con-cealed by grass roots politics.

The link between the personal and the political was crucial to this bonding. The demands for equality were firmly linked to the everyday fabric of women's lives which formed the focus of the consciousness-raising groups:

> Women did not simply burn bras, as the media would like us to believe, but instead they linked up the issues of the division of labour and unequal job opportunities with the formation of women as sexual beings – with makeup, bras, high-heeled shoes.
>
> (Haug 1989: 113)

The 'intuitive' connections between 'female body experiences' and 'the big questions of social structure', 'electrified the movement' as it advanced the 'dream of a different society' (Haug 1989: 114).

In addition to the meetings of the newly formed women's groups, the feminist debate in the 1970s was also advanced by the growth in women's writing. In the course of 'naming' the 'problem with no name' women were writing from a number of feminist positions on a variety of topics in order to establish women as subjects in their own right. Hence, women's writing during the 1970s expanded rapidly and in all directions. Discussions ranged from women as 'the second sex' (de Beauvoir 1949) to woman as 'female eunuch' (Greer 1970). The Movement also established its own written channels of communication:

> By 1972 the Women's Liberation Movement was beginning to establish its own communications network. That year four jour-nals started: the monthly *Spare Rib*, launched by women who had mainly worked for the 'underground' press and who wanted to put their skills to use in a cause with which they could identify; the bi-monthly *Women's Report* which collated news and comment about other women; *Women's Voice*, produced by women in the International Socialist group; and *Red Rag*, put out by an editorial collective of women within the Communist Party and unaligned socialist-feminists.
>
> (Wandor 1986: 14)

The 1970s also saw the rise of a number of feminist publishing houses. The first of these, Virago, was established in 1975, and was

closely followed in 1977 by The Women's Press. Virago's venture in 1978 to create a list of 'lost' 'Modern Classics' by women authors is typical of the way in which there was a general concern for women to rediscover all the areas from which they had been 'hidden' or oppressed whether this was history (see Rowbotham 1973b), psychoanalysis (Mitchell 1974) or literary criticism (Moers 1978) etc. And in theatre, too, the artistic practices of this profession were challenged by the feminist re-charting of the socio-political and cultural map.

TOWARDS A FEMINIST THEATRE

During the early 1970s women brought a performance element to the demonstrations and rallies which made the events cheerful and colourful. As Zelda Curtis recollects:

> Through all those years what imagination and determination women showed as they set out to change the face of politics. Demonstrations became fun. Women musicians sent us dancing along the route; women's choirs sang songs by women for women; women's theatre groups dressed up as brides and house drudges to confront the onlookers; new, bright and cheerful banners flew, green and purple everywhere; and 'choice' became the core word of our campaigns.
>
> (Curtis 1989: 144)

This was not unlike the suffrage demonstrations at the turn of the century, which had also been coloured by a heightened sense of spectacle:

> The WSPU organised a mass demonstration for Midsummer's Day, 1908. The suffragettes, who were transported to London by thirty special trains, were instructed to wear white dresses and carry banners in the WSPU colours of purple, white and green. Seven processions, each headed by a well-known personality in a four-in-hand coach . . . marched through the city to converge in Hyde Park.
>
> (Holledge 1981: 53)

The parallel might be taken further, given that both of these demonstration contexts provided a platform for an upsurge of women's street theatre. Women working in theatre during the First Women's Liberation Movement pledged their support to the

cause by joining the Actresses' Franchise League (AFL). AFL members offered sketches, monologues, playlets etc. to suffrage rallies and meetings (see Holledge 1981: 49–101). Where, however, this early phase of women's street theatre was directly concerned with the issue of suffrage, the street theatre of the 1970s, and the work of the women's groups which grew out of it, centred on the 'demands' as well as the broader issues of female identity (see Bassnett 1984: 447–8).

In order for women to begin to name themselves, they needed to reject the marginal state into which they had been conditioned and confined, and body-politics were high on the agenda. As women began to understand that there was a constructed 'cultural ideal' of a ' "perfect" female body', whether this was 'Twiggy or Julie Christie in the sixties' or 'Maria Schneider in the seventies', then they could begin to resist it (Coward 1984: 39). The demonstrations over the Miss World Contests (1969–71), for example, highlighted women's rejection of objectification and heralded explorations of sexual politics which were to continue throughout the 1970s. In one sense the demonstrations themselves were a spectacle, or rather posed an alternative spectacle to the contest. Demonstrators in 1969 wore their own sashes with slogans such as 'MIS-FIT REFUSES TO CONFORM', 'MIS-CONCEPTION DEMANDS FREE ABORTION FOR ALL WOMEN' or 'MIS-NOMER DEMANDS A NAME OF HER OWN' (O'Sullivan 1982: 80). Women in the beauty queen demonstrations of 1970 marched with a 'shopping bag, vest and apron on a crucified tailor's dummy' (O'Sullivan 1982: 82). The Women's Street Theatre Group, subsequently renamed the Punch and Judies, was probably the best known of the street theatre groups. In 1971 their *The Flashing Nipple Street Theatre Show* offered the alternative 'sight' of women with flashing lights attached to their clothing at the crotch and breasts (for photographic documentation of these demonstrations see O'Sullivan 1982: 82–3). They continued to organize *agitprop* events which included a piece in the women's toilets in 'Miss Selfridge', Oxford Street, and *Sugar and Spice* performed in Trafalgar Square at the International Women's Day event in 1971, which featured a display of 'such intimate objects as a huge deodorant, a large sanitary towel, and a gigantic red, white and blue penis' (Wandor 1986: 38). Before disbanding in 1972 they toured a show called *The Amazing Equal Pay Play* which took a satirical look at the recently passed Equal Pay Act.

What this early type of street theatre event appears to have raised for women working in theatre is a questioning not just of sexual politics at large, but more specifically the sexual politics of theatre itself. This was registered in 1973, when women from the early street theatre events became instrumental in the realization of Ed Berman's Almost Free Theatre Festival:

> In 1973 members of that early group were approached by Ed Berman of Inter-Action's Almost Free Theatre who wanted to hold a 'Women's Festival'. The ensuing lunchtime season was a 'success' – measured by the featuring of women playwrights produced by women directors with women stage-management in a context in which workshops and crèches were provided as well as productions, and by the fact that two companies of women were catalysed by the season – the short-lived Women's Company and the Women's Theatre Group.
>
> (Itzin 1980: 230)

That the early phase of street theatre gave rise to the birth of several feminist theatre groups such as The Women's Theatre Group (1974) or Monstrous Regiment (1975) may be read as a critique of both alternative and mainstream theatre's general failure to provide sufficient 'space' for women to work in. Itzin, for example, goes on to explain how the 'success' of the Almost Free Festival was tempered by the chaos which ensued as women rushed to claim the 'space' which the Festival offered them:

> The meetings attracted more and more women, some professionals with considerable experience of establishment theatre, some professionals from fringe theatre, and some altogether or relatively new to the theatre. The response was indicative of the neglect of women in theatre and it created 'absolute bedlam' as far as the organisation was concerned. Finally, the pressures of deadlines militated against that 'experimental' process, relatively 'safe' scripts were chosen, and the season was cast and set up in a conventional way.
>
> (Itzin 1980: 230–1)

Mainstream theatre, as ever, maintained its sexist hierarchical organization in which the status roles such as that of director or playwright remained male-dominated. The 1970s is of course the decade which, in mainstream terms, is heavily preoccupied with the rivalry and establishment of the two 'national' theatres, the

Royal Shakespeare Company (RSC) and the National Theatre (see Elsom 1976, revised 1979: 161–81), but there was little space to register women's concerns here. Only when young directors had the opportunity to experiment in 'other spaces' such as the RSC's The Other Place, is there a glimpse of women on the horizon. Buzz Goodbody's *Hamlet* (1975), for example, 'marked a change in style and working methods at the RSC' (Elsom 1979: 175). She brought an imaginative and experimental approach to the spartan 'temporary shed of The Other Place', making use of the 'lights shining through the supporting structure of the roof to create the shadows of bars and prison walls' for her *Hamlet* setting. However, 'Goodbody's suicide shortly after that production robbed the theatre of one of its most promising directors' (Elsom 1979: 175). Writing in 1986, Wandor comments that the RSC has 'had no woman director on its staff since Buzz Goodbody' (though concedes that 'in 1981 they had two women assistant directors'). 'When challenged,' she states, 'these theatres (and, to be fair, many others) answer that it is always the best person who gets the job. Such an answer inevitably defends a status quo which refuses to question the reasons for male dominance in the theatre' (Wandor 1986: 110). Even more progressive establishments like the Royal Court have poor track records when it comes to the representation of women's writing or directing. (Wandor states that 'between the years 1956–1975, only 17 out of 250 produced plays at the Royal Court Theatre . . . were written and/or directed by women' (1982: 11).

This status quo also went unchallenged on the alternative, political circuit. Retrospective accounts of the 'new' political theatre and its writers from the 1970s reflect the inequalities which women working then (and now) in the theatre suffered from. A brief glance at *New Theatre Voices of the Seventies: Sixteen Interviews from Theatre Quarterly 1970–1980* edited by Simon Trussler (1981) reveals that not one single woman practitioner from any area of the profession is interviewed. Equally, Ronald Hayman's *British Theatre since 1955: A Reassessment* (1979), which purports to offer an answer to the question ' "How much has been achieved in the British theatre since *Waiting for Godot* had its London premier in 1955?" ', has only one sub-section devoted to a woman: Joan Littlewood (p. 1).

Drama by the new male playwrights was one area where women might have expected to see changes for the better. In her survey of

'radical plays before 1968', which includes plays by men and women, Wandor concludes that 'written in a climate of stage censorship and before sexuality had been identified as having a political dimension, all these plays struggle to express imaginatively an issue which at the time had no name' (Wandor 1986: 149). Her survey of 'men playwrights in the 1970s', however, also reaches a rather negative conclusion. Looking through her examples, it seems that feminism had relatively little impact on male writing in the 1970s. Her comments include the following observations: John McGrath's *Trees in the Wind* (1971) – 'the women have no visibly significant relationships with each other' (p. 153); Portable Theatre's *Lay By* (1971) – 'women are shown to be the victims of male sexual violence, but . . . the sex and violence in the writing itself often comes dangerously close to being simply titillatory' (p. 154); and David Hare's *Plenty* (1978) – 'women are essentially innocent bystanders to the main events of history' (p. 156). Wandor concludes that in the 1970s 'most of the plays by male playwrights still define women either by containing them as the feminine, or, if they enter the female sexual arena, by imaginatively "punishing" them' (p. 159).

It is clear that the alternative political groups of the 1970s did not significantly revise the gender inequalities which existed within their socialist frameworks (see, for example, Greig on General Will, quoted in Wandor 1986: 195). Gillian Hanna, a founder member of Monstrous Regiment, writes about the idea for a women's company arising out of the lack of parts available for women in the socialist company Belts & Braces, for whom she was working at the time:

> I had been working with the socialist touring company Belts & Braces. We were recasting a play about the Kent coalfields in the 1930s. Naturally enough, there wasn't an enormous number of parts for women in it. Two, in fact. And I had the only good one. The other one was a cough and a spit. At the auditions, I was amazed at the women who came to see us. They were so talented, so full of energy and ideas. It was outrageous that the scarcity of work for women meant that they were prepared to audition for what amounted to a 'bit part'.
>
> (Hanna 1991: xx)

Hanna's 'naturally enough' is a damning indictment of the ways in which left-wing interests, dominated by men, frequently

overlooked the concerns of women. The point was tellingly made in Monstrous Regiment's own production, *Teendreams* by David Edgar and Susan Todd (1979). The play takes a critical look at society from the 1960s to the mid-1970s. At the close of Scene 3 a political meeting is taking place offstage, while the women who have helped in its organization remain alone, onstage:

> RUTH: It is indeed 1968. And everything's in question. Everything is challenged, everything is new. We don't demand, we occupy, because the plastic culture's melting on the stove of history.
> *Slight pause.*
> So one does just wonder . . . why the fuck we're still doing the typing and making the tea.
> FRANCES *a little shrug.*
> FRANCES: Now there you have me.
> *Blackout.*
>
> (Edgar and Todd 1979: 11)

Women, therefore, had much to do in terms of resisting 'male-determined' stereotyping of women. When working in left-wing mixed groups they found that they had to insist that their interests were represented. The political company *Red Ladder*, for example, floated the idea of a 'Women's Play' in 1972. This was, as Chris Rawlence explains in an introduction to the play *Strike While the Iron is Hot*, the result of what the women in the group wanted and was also a response to the Labour Movement's demand for a piece on equal pay and job opportunities (Rawlence 1980: 17). Significantly, however, 'women' were just one issue among many, and were certainly not top of the list:

> Initially the play was conceived as one of several 'units': a collection of fifteen-minute theatre pieces on a wide range of subjects – the uses of technology, housing, Ireland, racism etc. . . . women (!) . . . The third of these new units was the Women's Play. That it should have been relegated to third place was pointed to by the women in Red Ladder as symptomatic of its priority for Red Ladder men.
>
> (Rawlence 1980: 17)

Even when 'space' was accorded to women to register their interests, it became apparent that much of what women wanted to say could not be said with men present. Jill Posener was invited by

Drew Griffiths and Gerald Chapman, founder members of Gay Sweatshop, to present her 'coming out' piece *Any Woman Can* for a lunchtime season at the ICA (see Posener 1987: 24–5). Gay men and women worked briefly together in the company, but then formed two separate groups in order to best represent the interests of each. Itzin comments as follows:

> The women joined the group by invitation. None had come forward at the time of the Almost Free season and the men members of Gay Sweatshop felt that there was an imbalanced view of human homosexuality in the company, that gay women had to be included 'to give a fair view'. The women mounted *Any Woman Can*, and the men and women then went on later that year to produce a gay panto *Jingle Ball* together. But they found their methods of working were incompatible, and by 1977 the men and women had become two artistically autonomous companies sharing the same administration. Griffiths: 'We had a policy of non-interference. We offered criticism and mutual help, but left each other alone artistically.'
>
> (Itzin 1980: 235)

The women's company produced *Care and Control* in 1977. Scripted by Michelene Wandor, the piece concentrated on lesbian mothers and custody issues, which reflected the need to work on a topic specific to the interests of gay women (Wandor 1980). Lesbians working for the company still argue that they 'have more to lose – like custody of their children' than gay men, 'are seen as more of a threat to society' and take a greater risk to come out as gay women, either as writers or performers (Woddis 1987: 18).

A FEMINIST PRACTICE

As neither the mainstream theatres nor the activities of a male-dominated fringe were going to give women the 'space' they required to explore issues relevant to themselves as women, it was inevitable that women would move towards creating their own all-female working environments. Not all groups began as just women, but most ended up that way. Monstrous Regiment, for example, started out with men in the company, though it was written into 'the company's Memorandum and Articles of Association: that Monstrous Regiment would never contain more men than women' (Hanna 1991: xxix). In the climate of feminism

in the 1970s the presence of men was seen by the company as part of the gender struggle:

> When we started out we did have men in the collective. They were there on stage, there everywhere. After we'd formed the company we invited men to join us because we saw that as part of the process of grappling with feminism, of grappling with life. They were part of the problem, so they had to be part of the answer as well. The things that we wanted to dramatize involved men, and we wanted them to be there on stage with us. But over the years the men in the company seem to have left and we haven't recruited any new ones . . .
>
> (Unpublished interview with Mary McCusker of Monstrous Regiment, 1990)

This position is shared by other groups. The women who eventually became Siren, the lesbian theatre collective formed at the close of the decade in 1979, came from a 1970s Brighton-based background in mixed street theatre, organized to protest against the Corrie (abortion) bill. When the idea of forming a group was taking hold, one man was still working with the three women who became the founder members of Siren. Gradually these women came to realize 'that there was no way that we could say some of the more radical things we wanted to say as a mixed theatre group' (Unpublished interview with Jude Winter of Siren, 1989).

Moreover, an all-female environment had wider implications in terms of groups' lifestyles and the development of skills. For women involved in women's theatre groups in the 1970s their theatre was a way of life. The collective style of management was in keeping with the mode of the consciousness-raising discussion groups. In theory it gave women an equal say on all matters and an equal input into all tasks. In practice it could make organizational and discussion matters a lengthy process (see later for a further comment on this point). Trying to allow everyone an equal share in decision making could be as problematic as appointing decision makers. But it did provide a welcome release from and contrast to the competitive base of mixed groups which tended to marginalize women's interests. Katina Noble, a founder member of Spare Tyre which, like Siren, was established in 1979, recounted her first experience of all-women projects with Berman's Inter-Action group:

Just before I left, Janice Honeyman, a South African director, . . . came to Inter-Action at a moment when the men disappeared off on their own projects and we were left as an all-women company for a year. This time was spent on educational projects, e.g. sessions for children with learning difficulties. Janice was a great inspiration. Suddenly, in this all-female environment, we found ourselves writing things and not being put down, and feeling more confident. That gave us a taste for an all-women company.

(Unpublished interview with Katina Noble of Spare Tyre, 1989)

The opportunities for acquiring new skills and confidence were therefore very important to women in these groups. In clause ten of The Women's Theatre Group's general policy statement, for example, the members document their intention 'to offer women the opportunity to gain, through participation in the running of the company, management skills and confidence'.

Equally important was the question of audience. Like many of the companies on the alternative circuit, the women's theatre groups of the 1970s wanted to reach a non-theatre-going audience and set about playing in non-designated theatre spaces: community centres, schools, colleges etc. However, they also drew on the networking of the women's groups which had sprung up in the wake of the Liberation Movement to get bookings for shows which would reach a predominantly female audience. They played to women's groups, mothers' meetings or organized lunchtime performances in libraries with crèche facilities provided, so that women who were normally prevented from going to the theatre because of childcare commitments could attend. In this way they were able to communicate the benefits of their all-female working environment to a predominantly female audience: to realize, at long last, a growth in the productions of plays by women, for women.

Most important of all, perhaps, was that theatre projects often evolved from current readings on women's issues. Women making their own theatre wanted to explore specifically feminist preoccupations:

I got hold of a copy of *The Female Eunuch* – me and five million other women – stayed in bed, for days reading it, thought, Ah, the scales have now fallen from my eyes, I can see what it's all about now. Then Shulamith Firestone; it was like finding the

pot of gold at the end of the rainbow, finding something that
suddenly made sense of my life, everything I had felt was wrong
with my life and the world . . .

(Hanna 1989: 48)

We came to think more about styles of theatre after the initial
explosion, the desire to speak, to say what we had to say. There
was so much electricity and excitement and energy that came
from the ideas, we had to get them out, we had to talk about
Mary Daly, we had to talk about radical feminism, we had to
talk about being lesbian.

(Unpublished interview with Jane Boston of Siren, 1989)

As a life-time dieter I was stunned, absolutely amazed by *Fat is
a Feminist Issue*. After reading it, I kept scanning *Time Out* . . .
for the theatre board, thinking someone was bound to start a
group to do a play about *Fat is a Feminist Issue*. I kept looking
every week. Then I thought, 'I'm going to start that group.'

(Unpublished interview with Clair Chapman of Spare Tyre,
1989)

Talking to issues was in turn setting the agenda for a political,
issue-based type of theatre. It also accounts for why so many of the
1970s pieces were devised by the groups themselves. From meet-
ing together in the style of a consciousness-raising group, the
women could then move from a collective discussion of issues into
workshopping methods which would result in the encoding of their
ideas in a performance context. The Women's Theatre Group
productions, for example, were all company devised up until they
engaged their first commissioned writers, Eileen Fairweather and
Melissa Murray, who created *Hot Spot* (1978–9). Mica Nava de-
scribes how the company went about writing *My Mother Says I
Never Should* (1974), which was a play written specifically for a
teenage audience about young people, their sexual behaviour and
society's double standard of sexual morality:

Having decided on the general issues that we wanted to raise,
we did a lot of research: we talked to girls, teachers and parents
(and were amazed at the levels of fear, prejudice and ignor-
ance), we studied contraceptive techniques and the dissemina-
tion of advice to young people. Then we pooled our
information, created characters and a plot, improvised, and
finally went off in twos and threes to write and rewrite. Writing
was a long and often painful business, inevitably there were

disagreements and compromises, but we also gave each other confidence and took greater risks. Ultimately we felt that the group process distilled a clarity not obtainable by us individually.

(Nava 1980: 115)

In this way, groups were able to include their audiences in the debate which had begun with their own talking and research. For this reason many of the 1970s productions by women's theatre groups included after-show discussions. These would provide women in the audience with a further opportunity for discussing the issues raised in performance. Spare Tyre, for example, cite the importance of the discussions which followed the performances of their first show *Baring the Weight* (1979), which criticized stereo-typical attitudes towards the appearance of women and body size:

Performances of *Baring the Weight* were always followed by a discussion. We had a very good review in *Time Out* which claimed to enjoy the discussion as much as the show. Discussions tended to be very energetic. For example, in our first two weeks in Croydon, where there were a lot of house-wives and slimmers in the audience, the discussions were very heated. There were people standing up and saying 'I've lived on Carnation Slender all my life, I'm never going to ever eat it again,' and somebody else would cheer them. People would talk about the things they'd done – stuff like binges on raw bread dough. It was like one of those 'I'm-going-to-get-up-evangelical-release-my-sins-to-the-world' meetings, but all about eating problems.

(Unpublished interview with Clair Chapman of Spare Tyre, 1989)

PLAYS BY WOMEN

It would be impossible to construct an exhaustive list of the plays and shows that women's groups and dramatists offered in the 1970s. But, one can take the first volume in the Methuen series of *Plays by Women* (1982) as a sample of the kinds of issues which were preoccupying women both in the theatre and in society at large. The four plays in this volume were all performed between 1976 and 1979. Caryl Churchill's *Vinegar Tom*, first performed by

Monstrous Regiment in 1976, offers a socialist–feminist critique of women as 'witches', and Louise Page's *Tissue*, presented at the Studio Theatre, Belgrade, Coventry, in 1978, explores the issue of breast cancer. Central to both of these plays is the deconstruction of man-made myths surrounding female sexuality. *Tissue* exposes the notion of the 'perfect' female body; and the way in which women are punished by men, are labelled as 'witches', for being independent and sexually active is thematically treated in *Vinegar Tom*. Michelene Wandor's *Aurora Leigh* is a transposition of Elizabeth Barrett Browning's verse–novel into dramatic form, a 'rediscovery of a work by an undervalued English writer' (Wandor 1982: 135). Its 'rediscovery' strategy is reflected in the company who first performed the play at the Young Vic in 1979: Mrs Worthington's Daughters. This was a company formed in 1978 to specifically rediscover 'lost' plays either written by or concerned with women from the past. Pam Gem's *Dusa, Fish, Stas & Vi*, first presented by the Hampstead Theatre Club, London, in 1976, like *Teendreams*, is set in the present and treats the problematic dynamics of women, feminism and politics of the 1970s:

> It seemed to me when I was writing the play that for all the rhetoric, and the equal opportunities, and the Sex discrimination Acts, that society had not moved one step towards accommodating the other fifty percent of us and our needs.
>
> (Gems 1982: 71)

What all of these four plays have in common is that they place women and their concerns centre-stage, and, in very different ways, take a woman-centred as opposed to male-determined perspective. The four women in Gems's drama, for example, inhabit a space from which men are excluded. The space is constantly under threat from the outside, the offstage fictional men, but it is the onstage women, their concerns, anxieties, hopes and dreams which engage the spectator. Focusing on a group of women, as opposed to one main female character, further reflects the collaborative nature of women's drama; a de-centring of the 'hero' figure, so typical of mainstream, masculinist work.

The women dramatists in this volume come from different generations and backgrounds, but they all talk, either in the afterwords to the plays or elsewhere, of the impact of the 1970s and feminism on their dramatic writing:

I'm very conscious of trying to incorporate feminism in my writing: The time I started coincided with the beginnings of the Women's Liberation Movement and my commitment to feminism is of a very particular kind. I'm committed to it as a political force that is actually going to change not only the position of women in society but that society as well . . .

(Wandor 1977: 13)

For years and years I thought of myself as a writer before I thought of myself as a woman, but recently I've found that I would say I was a feminist writer as opposed to other people saying I was. I've found that as I go out more into the world and get into situations which involve women what I feel is quite strongly a feminist position and that inevitably comes into what I write.

(Churchill 1977: 13)

When women dramatists began to work with women's groups they frequently found that they were drawn into the collective group structures in ways which could benefit their writing. Churchill, for example, comments positively on the collaboration with Monstrous Regiment on *Vinegar Tom* (1982: 40), and Page talks about the processes of re-writing as a result of discussions with the company working on *Tissue* (1982: 100–1). Both writers represent the experience of collaboration as a beneficial and supportive one.

It was not just a question of *what* women wanted to say in their theatre of the 1970s which was important, but *how* they wanted to say it was equally as exciting and challenging. From the outset it was clear that what women wanted to say could not be said in dramatic forms which belonged to the 'phallic experience' of 'organisation of plot – complication, crisis and resolution' (Case 1988: 129), or as Churchill expresses it 'the "maleness" of the traditional structure of plays, with conflict and building in a certain way to a climax' (Fitzsimmons 1989: 90). The dominant mode of realism in contemporary British Theatre, and its linear structure – exposition, complication, crisis and resolution – was identified by women practitioners as oppressive to their quest for identity. In terms of this dramatic mode women were only represented as objects in relation to male subjects and were oppressed by its phallocentric systems of male 'closure'. Jane Boston of Siren

explains, for example, how naturalism was alien to the group's exploration of a lesbian aesthetic:

> Because we were always dealing at the level of language, at the level of politics, at the level of the family, because our reading was so diverse, because our intense discussions ranged across so many topics – there just didn't seem to be a way in which all that could be looked at and dealt with imaginatively or creatively in a naturalistic setting or with a narrative that just went beginning, middle, end, or a one-act play. What we needed were slicing techniques, ways of suspending belief, to get the imagination and the emotions operating on many different levels.
>
> (Unpublished interview with Jane Boston of Siren, 1989)

It is recognition of this rejection of dominant dramatic conventions which, for instance, leads Christopher Innes, in his recent study *Modern British Drama 1890–1990*, to offer a survey of feminist drama which is quite separate to his main study of male-authored plays: 'the feminist playwrights consciously reject conventional forms as inherently masculinist, and as a consequence their criteria demand separate treatment' (Innes 1992: 7).

What women desired was an opening up of forms which, in the first instance, involved the breaking up of dramatic structures. Gillian Hanna, speaking about Monstrous Regiment's production of Churchill's *Vinegar Tom*, expresses this as follows:

> We knew that we had to have the music to smash that regular and acceptable theatrical form. We didn't sit down and say deliberately that we needed to smash that form, but that is what we did none the less; I think we unconsciously felt a need to do that. As a feminist, I think it also has to do with feeling that you are running, acting, moving counter to the prevailing culture, which is why when some people say 'fringe' we begin to think that what we would rather be called is 'counter-cultural'.
>
> (Hanna 1978: 9)

The 'counter-cultural' challenge of form 'smashing' was a dominant feature of women's theatre as it emerged in the 1970s. Initially, the use of music presented itself as one way of beginning to break down canonical classificatory systems (what is a play, what is a musical, what is serious theatre, what is popular theatre etc.). In Monstrous Regiment's case, for example, the use of music was included in early policy statements:

Monstrous Regiment is a company of eight women and two men, formed in 1975, drawing on a wide range of performing skills, and committed to exploring new ways of relating music to theatre as part of our policy to present the highest standard of work to the widest possible audience. The company sees itself as part of the growing and lively movement to improve the status of women. Its work explores the experience of women past and present, and places that experience in the centre of the stage, instead of in the wings.

(Company 'Note', in Edgar and Todd 1979: 5)

For some women practitioners part of the attraction of working with music resided in the possibility of infiltrating male-dominated fields: the women who eventually became Siren, for example, in addition to their street theatre background, had also been part of the punk movement. They had their own women's rock band which was a challenge to the male domination of electric music. The musical skills with which the women began were subsequently encoded in their theatrical practice and have made a significant contribution to the group's ethos of working against genre. Similarly, Spare Tyre's first show *Baring the Weight* (1979) was a 'play with music' in which the action of the piece was punctuated with 'bouncy songs'. Spare Tyre have gone on to develop their musical skills both in the hybrid form of musical and dramatic elements and in the field of cabaret.

Cabaret, by tradition, is a male-dominated form of popular entertainment, which made it an attractive target for women in the 1970s. Women practitioners felt a strong need to resist the gender stereotyping in this and other popular forms, which was (and still is) degrading to women. Gillian Hanna, when talking about Monstrous Regiment's 1977 show *Cabaret*, stated:

What we have done is to take a form which is quite comprehensible to everybody but one which is normally extremely stereotyped. It's to do with male magicians doing the tricks and the ladies in sequins bringing in the hoops – a whole area. What we've done is to try to do something completely different in that it is women standing up telling jokes and it's blokes being a bit daft.

(Hanna 1978: 10)

It was not just a question of reversing sexist forms of male humour,

but the challenge to cabaret also involved showing that women had a sense of humour and could tell jokes about themselves, their lives and their experiences in a way which was celebratory. The Spare Tyre songs, whether in the plays with music or the cabaret shows, for example, are clearly written by women *for* women. This places the female spectator, who in terms of mainstream comedy is generally placed in the uncomfortable position of having to collude with the joke against herself, i.e. is forced into a position of having to laugh in spite of herself, in a radically different position:

> We always wrote songs out of our own experience. All of us had been that woman sitting in her room, feeling fat, unable to do anything with her life until she'd slimmed down to the magic weight.
>
> We've moved on to other subjects and we've kept that personal link. We write songs about our lives – about children, loneliness, parents, men, guilt. . . . And sure enough, women in our audiences respond with tears of laughter and recognition.
>
> (Spare Tyre 1987: 7)

Working through popular entertainment forms like cabaret meant that women were not only breaking new ground but were also warming to an *agitprop* style of entertainment which aimed to instruct in an accessible way. One of the key influences on women's groups and writers for the development of this was the theories and theatrical practice of a Brechtian style of theatre. 'It was Brecht's play *The Mother*, performed a number of times in the early 1970s, which became an unofficial fringe model for the process of politicisation in general' (Wandor 1987: 91). Whereas working along Brechtian principles in this context involved a socialist exploration of class-based issues, the combination of this approach and a feminist perspective extended the dialectics of class to gender. This is shown, for example, in Red Ladder's 'Women's Play', *Strike While the Iron is Hot* (1972). The play took its cue from Brecht's *The Mother*:

> The Red Ladder Theatre which developed *Strike* began as an agit-prop group committed to the Labour Movement. They had looked to Brecht as a model for some time, and deliberately used *The Mother* as an early reference point for this script. In both plays, a central woman character has her consciousness raised and undertakes direct political action because of her experience of injustice. However, Brecht's play is male-biased

and confirms traditional sex-role stereotyping while *Strike* challenges the distinctions between public and private spheres and the whole gender/class system.

(Reinelt 1986: 156)

What was highlighted in this critique of class and gender was the 'unhappy marriage' of socialist and feminist concerns, that working-class men did not consider a 'woman's wage' to be the same as theirs. 'The Disputed Pint', a pub scene in which 'beer glasses provide the basic social gest' (Reinelt 1986: 158), 'teaches' about parity and equal pay, and Helen, the central character, gradually learns how she is doubly oppressed (Wandor 1980: 38–43). As she begins to understand her position she switches from drinking half pints to full pints, like the men. What is gestically demonstrated here is the need for women to concentrate on the problematics of their own oppression that men, of all classes, were so quick to overlook.

CONCLUSION: THE 'COUNTER-CULTURAL' CHALLENGE?: THE LEGACY OF THE 1970s

Gillian Hanna's sense of women's theatre operating from a counter-cultural position in the 1970s is an important one. Now that British culture is taking stock of the blows which a decade or more of Thatcherism has dealt it, the impoverished state of the arts is easily blamed on the 1980s and the regressive and reactionary climate of that decade. One would not wish to deny that this is the case, but it is not the whole story. One of the consequences of adopting this oversimplistic retrospective view is that the 1970s are looked at through rose-coloured spectacles. In terms of politics and art, in theatre at least, it is seen as the decade of challenge which the 1980s were to contain. But the reality is more complex, and it is possible to see how the organization of theatre and of feminism in the 1970s also contributed to the difficulties of the 1980s.

Although it is true that the 1980s have brought about substantial cuts in the public subsidy of theatre, at the same time as increasing private patronage, it would be wrong to assume that funding in the 1970s was plentiful. Of the women's companies who set up in that decade the only two groups to receive Arts Council funding were The Women's Theatre Group (first funded for £3,500 in 1975) and

Monstrous Regiment (first funded for a guarantee against loss tour in 1976). In neither case, however, did Arts Council funding keep pace with inflation. Gillian Hanna of Monstrous Regiment described the excitement of first receiving the guarantee against loss, and the pattern of funding which followed:

> We got it. It was a big risk! I have this distinct memory of when the contract came through from the Sheffield Crucible which stated that if for any reason we failed to appear, the signer of this document was personally responsible for five hundred pounds. Five hundred pounds in 1975 was an enormous amount of money and none of us had fifteen, let alone five hundred! . . . We took huge risks that we would never take now. But we got the guarantee against loss, and the first and the second show were both hits. That was it! Normally, what would happen was that you had to be on a guarantee against loss for three years, I think, before they then put you on revenue. They put us on revenue after *Vinegar Tom* (1976/7) which was after one year or eighteen months. They have continued to support us since that time. Our problem is that in those first years we seem to have had much more in real terms than we have now. . . . In those days we supported eleven people full-time fifty-two weeks of the year. Now we have one person full-time.
> (Unpublished interview with Gillian Hanna of Monstrous Regiment, 1990)

Although the Arts Council increased its subsidy of alternative theatre throughout the 1970s, there were far more groups competing for funding which, given the rate of inflation, even from the mid- to late 1970s, was worth much less in real terms. Sandy Craig, for example, points out that the few part-time companies on the alternative circuit in the late 1960s had mushroomed by the late 1970s to around sixty full-time groups being funded by the Arts Council (Craig 1980: 176). So, whereas the 'total public subsidy' for 1978–9 was 'in excess of £2 million', as compared with £15,000 in 1969–70, it had far more many mouths to feed (Craig 1980: 176). That the Arts Council could not increase its funding of the fringe in line with this expansion, even if it had wanted to, was due in part to the way in which, by the mid-1970s, it was finding it hard to continue its support, which began in the 1960s, of several of the ailing building-based managements:

It was Arts Council policy in the 'sixties to pour money into things material – usually things concretely conspicuous, often just concrete. This is 'the theatre' which has received the lion's share of subsidy: this is 'the theatre' which it is now too costly to subsidize in the same way'.

(Itzin 1975: 4)

Given the rapid expansion of alternative theatre it was inevitable that several women's groups were going to find it difficult to survive financially. Several of the late 1970s groups such as Clapper Claw (1977), Cunning Stunts (1977), Beryl and the Perils (1978) or Mrs Worthington's Daughters (1978) did not survive. The few that did, like Spare Tyre (1979) and Siren (1979), have never received regular Arts Council funding. Although impossible to prove, it is generally the feeling for those involved on the small-scale touring women's circuit that the Arts Council felt its funding of two women's groups was adequate support for a theatre of 'minority' interest.

It was also evident at the close of the decade that there was much more of a 'graduation' of practitioners from alternative to mainstream theatre (see Craig 1980: 178). Craig quotes John Faulkner in the 34th Annual Report of the Arts Council of Great Britain, 1979:

one need however only to look back over the recent past to see how quickly what was initially regarded as experimental has been assimilated into the fabric of today's theatre. The aim for the future must be to maintain this integration and not to create more and more new categories!

(Craig: 181–2)

In the mid-1980s when John McGrath's company 7:84 was cut, McGrath spoke out against what he saw as the Arts Council's past and then current policy of containing left-wing theatre groups:

We have had no sane perceptive arts bureaucrats for many a year. Mr Tony Field, ex-Head of Finance at the Arts Council, actually wanted these companies to have the life-span of a butterfly, then rapidly die. There were so many of them, he argued, expecting regular support, that they were becoming a burden, to be chopped off. Mr Field has now left to join a commercial management.

(McGrath, *Guardian* 5 October 1984)

The desire to see alternative theatre 'have the life-span of a butterfly' was keenly felt, even in the 1970s. This reactionary view, whilst more covertly held by bureaucrats in the Arts Council, was more openly voiced in, for example, publications such as Hurren's *Theatre Inside Out*, which appeared in 1977:

> The few worthwhile talents that worked in the 'fringe' theatres graduated at early opportunities to 'establishment' theatres – even if only, so as not to feel entirely respectable, to the experimental sections of the Royal Court, the Royal Shakespeare and the National Theatres, where no doubt they sometimes contribute valuably to the creative processes. Left behind in the padded cellars are the dregs, the actors who could never be bothered to learn technique (and sometimes not even lines, since 'improvisation' is the preferred working method in many instances), the writers who decline to accept the formal disciplines of the craft. The 'fringe' was always overloaded with this anti-talent; now it is swamped by it.
>
> (Hurren 1977: 191–2)

Hurren might also have added in this extraordinarily bigoted analysis that the graduation to the 'establishment' was predominantly male orientated (a thought which might have afforded him some comfort) – at least as far as the 'status' roles of artistic director, dramatist etc. were concerned. Funding studies in the 1980s have shown that women practitioners in theatre remain clustered in the alternative, non-building-based groups who receive far less funding than the mainstream, building-based companies/venues dominated by men (for details see Gardiner 1987: 3).

That women's work did not 'graduate' to mainstream theatre to any significant or widespread degree is indicative of a male reaction to feminism in the 1970s. The excitement of women in the 1970s in their quest for identity was not a cause which main male-managed theatres wished either to share in or to portray. In a recent article by Betty Caplan, Jules Wright, director of the Women's Playhouse Trust, is quoted as saying: 'Women write very often about different things, and the dominant culture doesn't find that perspective interesting, and therefore assumes it will not interest other members of society' (*Guardian* 13 January 1990). That said, one of the ways in which 'dominant culture', as prevalent in mainstream theatre, might have been challenged and changed in the 1970s was through the activity of reviewing. But

this was precisely where a lack of concern for, or rather a refusal to engage with, the dramatization of women's issues in the 1970s was clearly evidenced.

Given the male dominance of theatre reviewing it was inevitable that the voices of female critics would be sidelined. The regular reviewing column of the feminist magazine *Spare Rib* was hardly in a position to compete with the drama columns of the big national papers. A glance at Monstrous Regiment's 'choice' selection of male reviews of their productions over the years indicates the 'incomprehension' with which much of their work was greeted by male critics (Hanna 1991: xvii–xix). Similarly, through her survey of male critical reactions to the work of Sarah Daniels which are contrasted with critical reactions from women, Mary Remnant is able to establish a 'gender-split' in the reviewing. From her findings, Remnant deduces a refusal on the part of men to approach work which 'speaks particularly to women' (Remnant 1987: 10). The only way in which women's concerns have been of significant interest to men is if they have been portrayed by men. An indignant Gillian Hanna declared in interview: 'I could cheerfully have shot Michael Billington when he told us that Alan Ayckbourn is the best feminist playwright that we have!' (Unpublished interview with Gillian Hanna of Monstrous Regiment, 1990).

Given the climate of feminism in the early 1970s, and the excitement and energy which fuelled women both within the profession and at large, women's oppositional stance to the cultural dominant seemed, in its early stages, the right and only course to follow. But one of the problems which women faced once they had begun to explore ideologies and theories of feminism which were new to them was how to translate them into practice. This applied particularly to the collective structures which the women's groups adopted. Although women's groups are currently lamenting the 1990s management style of adminstration, collectives in the 1970s, though essential in terms of the experience of non-hierarchical organization which they offered to women, proved difficult to adminstrate in practice and also posed artistic problems in terms of collectively devising shows. Clair Chapman of Spare Tyre, for example, talked about the difficulties she found in writing as part of a collective: 'Often, when you go to see shows which have been group-devised, you can tell the group tensions by the way the play is written' (Unpublished interview with Spare Tyre, 1989). For

Spare Tyre, this eventually meant finding a 'framework' in which everyone could contribute, but individual women took responsibility for different creative areas. Hence, through the mid- to late 1970s women's theatre groups found ways of shifting skill distribution away from an any-woman-can-do-anything policy to a concentration on the development and promotion of individual skills. The consciousness-raising style of operation was already moving towards a more orthodox distribution of tasks, as further illustrated, for example, in The Women's Theatre Group's commissioning of writers by the late 1970s.

The excitement generated by the Women's Movement at the start of the decade gradually gave way to a consideration of the complexities which feminism posed. The all-important sense of bonding and sisterhood was, for example, questioned more closely for its inability to consider difference, most especially in relation to class and race:

> The self-organized groups within the WLM were finding it difficult to sustain their own cohesion, since many of them failed to accommodate internal difference. These groups began to split as women set up their own, smaller groups in search of a place where their particular identity would not be overlooked or undermined. So Black lesbians began to organize separately, then working-class lesbians, Black working-class lesbians, Jewish working-class women, older lesbians and so on. This scenario was made more complicated by the fact that since the mid-seventies the WLM had become divided between the politics of socialist-feminists and radical-revolutionary feminists.
>
> (Harriss 1989: 37)

The marked change from a politics of bonding to a politics of difference increased the difficulty of sustaining a national networking between women. What is often retrospectively cited as a key reason for the gradual erosion of feminist ideas is the lack of a party network. Any formal organization of feminism would have been a contradiction of its non-hierarchical, informal networking. But this did mean, however, that there was no concrete and established means through which such ideas could be passed on and take hold. So that, even before the teenage generation of the Thatcher years, young people, particularly young women, were not being exposed to feminist ideas as part of their educational, cultural or familial structures (for example, see McCabe 1981:

57–79). The point is well illustrated in *Teendreams* where, in a scene set in 1975, the women's lib figure Frances, now a teacher, experiences a dislocation between her 'radical' views and the more 'reactionary' viewpoints of the girls she is instructing (Edgar and Todd 1979, Scene 10: 24–8).

As a result of this 'gap' in the transmission of feminist ideas, women find themselves in the position of having to fight the same old battles, and this is as true of theatre as it is of any other sphere. Gillian Hanna and Mary McCusker of Monstrous Regiment commented:

> GILLIAN: I remember talking to the women of the Royal Shakespeare Company at a weekend event which these women had organized because they were feeling really angry about the way they were being treated. Juliet Stevenson . . . and I kept saying to each other, 'Why isn't there some wonderful organiz- ation whereby women who've been through all this could get paired up with a younger woman who could phone them up and say, "This shit has just done X," and the older woman could reply . . .'
> MARY: 'Turn to page five of your manual, and look at diagram six for the pincer movement!'
> (Unpublished interview with Monstrous Regiment, 1990)

That those battles are still being fought, however, is testimony to the way in which women's voices in theatre are refusing to be silenced. It may be that in the aftermath of the Thatcher years women who worked in the theatre during the 1970s and were inspired by the climate of feminism are now 'waiting for the spring to come again' (Hanna 1990). But they, together with younger generations of female practitioners, have not given up. It is only by women refusing to be 'hidden' that women's culture is kept alive.

FURTHER READING

An introductory account of bourgeois, radical and Marxist feminisms is offered in Beechy (1982). The beginnings of the Women's Liberation Movement are considered in O'Sullivan (1982). Essays in *Feminist Review* (Spring 1989) include retrospective analyses of feminism and the 1970s. The contexts of feminism and alternative theatre are surveyed in Wandor (1986) and Itzin (1980). Bassnett (1984) offers a more theoretical approach. Keyssar (1984) and Case (1988) survey developments in Britain and America. Plays from the period can be found in Wandor (1980, 1982)

and female dramatists are interviewed in McFerran (1977). For a detailed account of Monstrous Regiment's work see Hanna (1991).

SELECT BIBLIOGRAPHY

Bassnett, S. (1984) 'Towards a theory of women's theatre', in Herta Schmid and Aloysius Van Kestern (eds) *Semiotics of Drama and Theatre*, Amsterdam and Philadelphia: John Benjamin.

Beauvoir, S. de (1949) *The Second Sex*, reprinted Harmondsworth: Penguin, 1972.

Beechy, V. (ed.) (1982) *The Changing Experience of Women: Unit One*, Milton Keynes: Open University Press.

Caplan, B. (1990) 'Setting a stage for women', *Guardian* 13 January.

Case, S. (1988) *Feminism and Theatre*, London and Basingstoke: Macmillan.

Churchill, C. (1977) Interview in A. McFerran, 'The theatre's (somewhat) angry young women', *Time Out* 21–27 October.

—— (1982) 'Afterword to *Vinegar Tom*', in M. Wandor (ed.) *Plays by Women: Volume One*, London: Methuen, pp. 39–40.

Coward, R. (1984) *Female Desire: Women's Sexuality Today*, London: Paladin.

Craig, S. (1980) 'The bitten hand: patronage and alternative theatre', in S. Craig (ed.) *Dreams and Deconstructions*, London: Amber Lane Press, pp. 176–86.

Curtis, Z. (1989) 'Older women and feminism: don't say sorry', *Feminist Review* 31: 143–7.

Edgar, D. and Todd, S. (1979) *Teendreams*, London: Methuen.

Elsom, J. (1976, revised 1979) *Post-war British Theatre*, London: Routledge.

Fitzsimmons, L. (ed.) (1989) *File on Churchill*, London: Methuen.

Friedan, B. (1963) *The Feminine Mystique*, London: Victor Gollancz.

Gardiner, C. (1987) *What Share of the Cake: The Employment of Women in the English Theatre*, London: Women's Playhouse Trust.

Gems, P. (1982) 'Afterword to *Dusa, Fish, Stas and Vi*', in M. Wandor (ed.) *Plays by Women: Volume One*, London: Methuen, pp. 71–3

Greer, G. (1970) *The Female Eunuch*, London: Granada.

Hanna, G. (1978) *Feminism and Theatre, Theatre Papers*, 2nd series, no. 8, Dartington, Devon: Dartington College.

—— (1989) 'Writing our own history: feminist theatricals', *Trouble and Strife* 16: 47–52.

—— (1990) 'Waiting for spring to come again: feminist theatre, 1978 and 1989', *New Theatre Quarterly* vi (21): 43–56.

—— , selector and compiler, (1991) Introduction to *Monstrous Regiment: Four Plays and a Collective Celebration*, London: Nick Hern.

Harriss, K. (1989) 'New alliances: socialist-feminism in the eighties', *Feminist Review* 31: 34–54.

Haug, F. (1989) 'Lessons from the Women's Movement in Europe', *Feminist Review* 31: 107–16.

Hayman, R. (1979) *British Theatre Since 1955: A Reassessment*, Oxford: Oxford University Press.

Holledge, J. (1981) *Innocent Flowers: Women in the Edwardian Theatre*, London: Virago.

Hurren, K. (1977) *Theatre Inside Out*, London: W. H. Allen.

Innes, C. (1992) *Modern British Drama 1890–1990*, Cambridge: Cambridge University Press.

Itzin, C. (1975) 'Alternative theatre in the mainstream', *Theatre Quarterly* v (19): 3–11.

—— (1980) *Stages in the Revolution: Political Theatre in Britain Since 1968*, London: Methuen.

Keyssar, H. (1984) *Feminist Theatre*, Basingstoke: Macmillan.

McCabe, T. (1981) 'Schools and careers: for girls who *do* want to wear the trousers', in A. McRobbie and T. McCabe (eds) *Feminism for Girls: An Adventure Story*, London: Routledge.

McFerran, A. (1977) 'The theatre's (somewhat) angry young women', *Time Out* 21–27 October: 13–15.

McGrath, J. (1984) 'No politics please, we're British', *Guardian* 5 October.

Millett, K. (1970) *Sexual Politics*, New York: Doubleday.

Mitchell, J. (1974) *Psychoanalysis and Feminism*, Harmondsworth: Penguin.

Moers, E. (1978) *Literary Women*, London: The Women's Press.

Nava, M. (1980) 'Introduction to *My Mother Says I Never Should*', in M. Wandor (ed.) *Strike While the Iron is Hot*, London and West Nyack: Journeyman Press, pp. 115–17.

O'Sullivan, R. (1982) 'Passionate beginnings: ideological politics 1969–1972', *Feminist Review* 11 (Summer): 70–86.

Page, L. (1982) 'Afterword to *Tissue*', in M. Wandor (ed.) *Plays by Women: Volume One*, London: Methuen, pp. 100–3.

Posener, J. (1987) 'Afterword to *Any Woman Can*', in J. Davis (ed.) *Lesbian Plays*, London: Methuen, pp. 24–5.

Rawlence, C. (1980) 'Introduction' to M. Wandor (ed.) *Strike While the Iron is Hot*, London and West Nyack: Journeyman Press, pp. 17–19.

Reinelt, J. (1986) 'Beyond Brecht: Britain's new feminist drama', *Theatre Journal* 38 (2): 154–63.

Remnant, M. (1987) 'Introduction' to M. Remnant (ed.) *Plays by Women: Volume Six*, London: Methuen, pp. 7–12.

Rowbotham, S. (1973a) *Woman's Consciousness, Man's World*, Harmondsworth: Pelican/Penguin.

—— (1973b) *Hidden from History*, London: Pluto Press.

—— (1989) 'To be or not to be: the dilemmas of mothering', *Feminist Review* 31: 82–93.

Spare Tyre (1987) *The Spare Tyre Songbook*, London: Virago.

Trussler, S. (1981) *New Theatre Voices of the Seventies: Sixteen Interviews from Theatre Quarterly (1970–1980)*, London: Methuen.

Wandor, M. (1977) Interview in A. McFerran, 'The theatre's (somewhat) angry young women', *Time Out* 21–27 October.

—— (ed.) (1980) *Strike While the Iron is Hot*, London and West Nyack:

The Journeyman Press.
—— (ed.) (1982) *Plays by Women: Volume One*, London: Methuen.
—— (1986) *Carry on Understudies: Theatre and Sexual Politics*, London: Routledge.
—— (1987) *Look Back in Gender*, London: Methuen.
Woddis, C. (1987) 'Gay sensibility', *Women's Review* 18 (April): 18.

UNPUBLISHED MATERIAL

Interview with Chris Bowler, Gillian Hanna and Mary McCusker of Monstrous Regiment, 1990.
Interview with Jude Winter and Jane Boston of Siren, 1989.
Interview with Clair Chapman, Katina Noble and Harriet Powell of Spare Tyre, 1989.

Chapter 6

Artifice and the everyday world
Poetry in the 1970s

Robert Sheppard

INTRODUCTION

In their introduction to the only book-length survey of the poetry of the 1970s, *British Poetry Since 1970* (1980), Peter Jones and Michael Schmidt can find no more assertive adjective than 'pluralistic' to describe what they identify as the 'positive diversity' of the decade's output (Jones and Schmidt 1980: x). Their book usefully details the work of the establishment poets and outlines certain careers outside of that grouping, and I shall be examining two of its essays in some detail. However, I wish to re-map the decade's poetry in an attempt to foreground the achievements of two of the most impressive alternatives to the mainstream.

I shall be arguing that, while the establishment was receptive to the talent of Seamus Heaney, who appeared to be grappling with one of the most complex political realities of the day, namely Northern Ireland, certain less well received poets were approaching the political in a more oblique way, developing some of the positions of the 1960s counter-culture. However, as Jones and Schmidt point out: 'The 1970s notably lacked defining and unifying social issues with "imaginative content". Inflation and oil-crises did not have the force that, a decade earlier, Vietnam had had' (Jones and Schmidt 1980: xii). The time was unpropitious; the failure of Labour governments to offer genuine answers to economic and cultural decline during the decade did not rekindle a faith in social democracy that could find its outlet in poetry, despite one notable attempt to explore this possibility (see Davie 1973: 71).

There were at least two possible responses for a poetry that was not going to follow the establishment's discourses. On the one

hand, there was a turning away from a utopia of dissent or protest to a study of history and geography, to a poetry of place that attempted alternative valuations of British culture and society outside of the received social democratic consensus. On the other hand, there were a number of attempts to assert the autonomy of the poetic text, to insist upon its division from the world, as though the poem were an endangered species that needed to demand its strange right to exist, beyond ideology and use value.

ARTFUL VOYEURS

Blake Morrison contributed two essays to Jones and Schmidt's survey: 'Young poets in the 1970s' and 'Speech and reticence: Seamus Heaney's "North"' (see also Morrison 1982). The essay on Heaney opens with a fanfare for the commercial success of *North*, which was published by Faber in 1975: it won prizes; it was 'gushed over'; it sold better than Larkin or Hughes, two writers he has joined as school book-cupboard favourites (Jones and Schmidt 1980: 103). More significantly, its 'pulling power can be explained by the fact that it had come out of, and concerned itself with, Northern Ireland' (Jones and Schmidt 1980: 103). Heaney's change from the lyrical ruralist of *Death of a Naturalist* (1966) into the political poet of *North* seemed an answer to the demand that there should be work produced that was adequate to the 'troubles'. However, Heaney's glimpses of actual terrorism are rare: 'Two young men with rifles on the hill,/Profane and bracing as their instruments' (Heaney 1979: 12). Such men are transfigured and debased into functions of their weaponry. This ambivalence and irony, however, is the vehicle of his more characteristically cautious approaches to contemporary Ireland through history and etymology. These approaches may owe something to the superb example of Geoffrey Hill's *Mercian Hymns* (1971) where, for example, incidents from a Second World War childhood are fused with a monologue of Offa, the Anglo-Saxon king, to facilitate meditations upon tyranny, justice and government (Hill 1985: 101–34). Similarly, Heaney's so-called 'bog poems' use descriptions of the preserved bodies catalogued in Glob's *The Bog People* as vehicles for contemporary analysis. In 'Punishment' – a poem Morrison outlines – Heaney as persona deliberately enters the drama of ritual sacrifice: 'I can feel the tug/of the halter' (Heaney 1990: 71). The poem makes an analogy between what Heaney

calls, in another of the 'bog poems', the 'old man-killing parishes' (Heaney 1990: 32) and the modern 'North' of the book's title, subtly connecting the ritual victim with the tar and feathering of Catholic girls who dated British soldiers: 'your/tar-black face was beautiful' (Heaney 1990: 72). The poem is almost a love lyric, suffused with the intimacy of an 'artful voyeur' (Heaney 1990: 72), but Heaney is weighed down with what he calls elsewhere his 'responsible *tristia*' (Heaney 1990: 90) as a Catholic with strong Republican sympathies who knows his complicity in the psychology of retribution, its 'slaughter/for the common good' as 'Kinship' puts it (Heaney 1975: 45). The narrator is morally ambivalent since he

> would connive
> in civilized outrage
> yet understand the exact
> and tribal, intimate revenge.
>
> (Heaney 1990: 73)

Such intimacy is double-edged; 'outrage' and 'revenge' stand poised but suspended, an effect achieved partly through the ponderous short-lined accentual metre that Heaney employs. Morrison praises Heaney's exposure of 'a private world of divided feelings' as a means to both political statement and 'fine poetry' (Jones and Schmidt 1980: 111). Yet I suspect that English liberalism – and its school teachers – prefers this suspension of politics in private feeling in which Heaney's Irish sense of the historical nature of his culture's divisions can be read as a suitably engaged, yet comfortably distant, ironical defence. It is to turn Heaney into what Morrison and Andrew Motion's *The Penguin Book of Contemporary British Poetry* (1982) claims of him: that he represents the latest stage in the development of the Movement orthodoxy which had established itself in British poetry in the 1950s (see Morrison 1980a and Crozier 1983 for detailed readings of this).

In an 'identikit' portrait in 'Young poets of the 1970s', Morrison presents a significantly updated version of the Movement poet, emblematic of the way that Morrison's tradition asserts continuity by minor modulations of focus and style in the name of originality. The poet will most probably be male, middle class, Oxbridge educated in English, a subject he also teaches. Liberal in aspirations, conservative in politics, he will be 'out of sympathy with 60s

Romantic notions of the poet as risk taker, "mad genius" or bard'
(Jones and Schmidt 1980: 142). He will retain a respect for tradi-
tional form, but will be almost boringly familiar with a modernism
he will have long assimilated.

Morrison's article also outlines the early stages of the poetry of
the 'Metaphor Men', 'which began to appear from 1977 onwards'
and declares that 'despite its limited size a new "school" is being
talked of' (Jones and Schmidt 1980: 154). Such hasty praise of a
'school' of two writers, Craig Raine and Christopher Reid, is not,
of course, purely predictive; it belongs to the publicity of group-
ings that, as Morrison himself documented in his study *The
Movement* (1980), the Movement writers had once used to their
enduring advantage.

Craig Raine broadly fits Morrison's identikit, and his assimi-
lation of modernism is manifest in his dilution of modernist ima-
gery and allusion into lyrical perception. In 'An Inquiry into Two
Inches of Ivory' he observes that 'Water painlessly breaks his
bent/Picasso legs' (Morrison and Motion 1982: 170). Like this,
much of Raine's work relies upon a clever, but finally too consist-
ent, use of startling figures of speech. Raine's poem claims to
display 'objects/in the museum of ordinary art' (Morrison and
Motion 1982: 170).

> The vacuum cleaner grazes
> over the carpet, lowing,
> its udder a swollen wobble . . .
>
> (Morrison and Motion 1982: 170)

Failures of method tend towards bathos: 'The milkman delivers/
penguins' (Morrison and Motion 1982: 171). The writing reveals a
'descriptive lust' in the belief that – and Raine quotes Heaney –
'description is revelation' (Haffenden 1982: 179). Raine's prefer-
ence for the domestic event and its metaphoric transformation, its
attempts at defamiliarized description, makes use of this classic
modernist technique for ornamental purposes alone; a bar of soap
is the reader's reward for solving the riddle 'slippery cubist fish/
with perfumed eggs' (Morrison and Motion 1982: 170). Rather
than fulfilling Morrison's claims that Raine's 'essential message' is
'that the secular *is* sacred', the poetry's final result is to limit the
wonder of the presented world, to familiarize rather than *de*-
familiarize, and, arguably, to foreground the cleverness of the
author's invention (Jones and Schmidt 1980: 156). It is a poem

knowinglyassembled for practical criticism exercises. The potential resources of poetry have contracted until a 'way of looking is a way of feeling', in Morrison's and Motion's words (Morrison and Motion 1982: 18). As in Morrison's analysis of Heaney, *feeling* is an unexplained, but traditional, justification of literary work.

VOCIFEROUS SETS OF OPPONENTS

Blake Morrison's essay on young poets does acknowledge two groupings of writers outside his dominant orthodoxy: he lists, as catalysts of activity, Eric Mottram, editor of *Poetry Review*, and J. H. Prynne of Cambridge University. Such acknowledgement makes Morrison's co-authored remark in *The Penguin Book of Contemporary British Poetry* that 'very little – in England at any rate – seemed to be happening' in the late 1960s and 1970s all the stranger; within and between the groupings he mentions, this period was one of organization and consolidation. For example, many small poetry publishers joined the Association of Little Presses, which concerned itself with matters of funding, pro- duction and distribution, and by the end of the 1970s there were ninety members (Griffiths and Cobbing 1988: 23). Poetry readings were as important as they had been in the 1960s for poets outside the mainstream, as events for performing and for selling books. Although many readings were local and limited in scope, there were two large conferences at the Polytechnic of Central London at which dozens of British poets read, and biennial Poetry Festivals in Cambridge that featured major foreign and British poets (see Brookeman 1974; Evans 1977; Booth 1985: 94–7).

The desire of many poets for an organizational base was realized as one radical poet after another was elected onto the General Council of the Poetry Society, until by 1975 they were in the majority. Their reforms of what had become a moribund organiz- ation included regular workshops, readings and experimental per- formances (Bob Cobbing encouraged younger performers such as Lawrence Upton, Cris Cheek and Clive Fencott); a print room and a bookshop at its Earls Court, London, building; and Mottram's 'Poetry Information' interview evenings which began to document the alternative poetries. Mottram became editor of the Society's *Poetry Review* and presented the work of both established and new writers (see Hodgkiss 1979–80: 142–55). For a few years this co- operative venture sustained various kinds of adventurous work

until the Arts Council attempted to exercise 'control' over the organization and to oust Mottram from the magazine. Many poets resigned in 1977 in protest. The Association of Little Presses was quick to document in 1977 and 1978 that the Arts Council was starting to turn down applications for vital funding from presses and individuals who had been associated with the Society (Griffiths and Cobbing 1988: 18).

Morrison's contention that 'there is little sign yet of an important new poet emerging from under' Mottram's 'wing' can be refuted by examining the work of two young writers, Allen Fisher and Bill Griffiths, who shared the Poetry Society's Alice Hunt Bartlett Award for 1974 (Jones and Schmidt 1980: 145). (Both had been active within the Society and the Association of Little Presses.) Morrison, with his sense of the poem as a small-scale crafted artifact, could not be expected to recognize the extensive intermedial and avant-garde practices of these and other Poetry Society poets. In 1975 Fisher listed involvement in thirty-four projects, including collages, found texts, mail art, dream poems, experiments in process music and conceptual art, as well as performances (see Fisher 1975). Such works were often generated by procedures and systems, and the feeling that Fisher was programming himself too strictly at this time is assuaged often by his humour and his desire to influence such systems with personal 'impositions and invitations' (Fisher 1975: 38). Impossible though it is to describe this work fully here, its modernist ambition and Fisher's avowed refusal of 'Perfection, Constancy and Consistency' contrasts with the singularity of Craig Raine's ornamental modernism (Fisher 1975: iii).

Fisher's work is examined in the next section, but Griffiths's exemplary use of disruptive technique, which reshapes his particular concerns with prison and urban deprivation, as well as his interests in Anglo-Saxon and Romany literatures, has an equivalent ambition. *Cycles* (1976), Griffiths's first sustained work, opens with 'Dover Borstal'. Its '*mélange* of ideolects' is unsettling and unstable (Gilonis 1991: 112). As Jeff Nuttall points out: 'Syntax and experience are so manifested as to compel the poem to be read as poetry (as art) – not as news report' (Nuttall 1976: 13). The juxtaposition of the Latin and the demotic with which it begins is a characteristic procedure to avoid the transparency of 'news' language, to break through limitations of discourse which are implicitly as real as the prison which is the poem's focus:

Ictus!
as I ain't like ever to be still but
kaleidoscope,
lock and knock my sleeping

(Griffiths 1976: np)

The poet's measure of time – the beat of 'Ictus!' – complements
the prisoner's rhymed rhythm of incarceration, as he does 'time'.
The commitment to kaleidoscopic experience pitches dream
against reality:

Do you know it's the sea?
the speaking sound
and I wake like a dragon's dream
taut-limb around and my teeth were avid
in wonder

(Griffiths 1976: np)

This almost heroic self prefers alertness and action to meditation
as the dream dissolves the social reality which is pervasively sadis-
tic and repressive:

The ships, turquoise,
cutting open the sea
smiling killing
OK

(Griffiths 1976: np)

Dover, 'kinging the blue', is replete with imperial war-histories:
'the barbwire is German/it is made with razorblades' (Griffiths
1976: np). Its present prisoners are defined repetitively by the
'screws': 'thief you're a thief you/hey you thief come on' (Griffiths
1976: np).

Redemption is figured in a discontinuous statement that
suggests, at least, that financial or verbal exchanges can be altered
by re-stamping, by violence: 'I think on the pattern of an action/till
the gold of the answer I can beat anyway' (Griffiths 1976: np). This
meditation on theft in a violent poetry – a 'beat' – of stolen
discourses is neither 'news' nor revolutionary tract. Its open syntax
re-forms the world as text; it both refers to, and evades, social
reality. As Nuttall remarked in 1976, recognizing that revolution
was now entrusted to the written word and not to be discovered in the

world: 'In a period numb with disappointment at the 1968 failure he burns startlingly' (Nuttall 1976: 17).

Blake Morrison, after dismissing the *Poetry Review* poets as 'wan', conjectures: 'A more feasible alternative may come from the work and teaching of J. H. Prynne, who in Cambridge at any rate has a considerable reputation; but again there is no clear sign of what his following amounts to' (Jones and Schmidt 1980: 146). This outsider's view refers to writers published by Ferry Press and Grosseteste Press. That the two editors of these presses, Andrew Crozier and Tim Longville, edited a Carcanet anthology, *A Various Art* (1987), to document their presses, confirms the exist- ence of a group, though one of its members, Peter Riley, empha- sizes that 'Prynne and Crozier were merely the originators of an "impulse"', and that 'certain people worked together to a greater or lesser extent from about 1966 to 1970' (Riley and Corcoran 1986: 3). I feel that the most typical work belongs to the 1970s, when American projective verse, derived largely from Charles Olson, fused with the resources of the English lyric.

The work of Andrew Crozier is a clear example of this mixture. (Prynne's work will be examined in the following two sections.) *The Veil Poem*, published in 1974, opens with a deliberately unfinished fragment: it is the record of perception *in* language, not a description, and owes to the commitment to process found in Olson's work:

> and the storm I hear wind and rain
> raging is an effect of bathwater
> emptying into the drain.

<div align="right">(Crozier and Longville 1987: 71)</div>

The philosophic ease, which owes equally to Wordsworth, is tren- chantly domestic, even when determining 'What hides in darkness and what truths/it veils' (Crozier and Longville 1987: 72). The world reveals itself, not as a given, but through slow perception; a garden tree is 'flowing smoothly through its changes' and the shadowy narrator realizes, 'I cannot dominate it', an attitude of reverence to the world so different from the metaphoric assimi- lation of Raine's descriptions of his world (Crozier and Longville 1987: 72). One of the sections quotes, without obvious irony, Wordsworth's invocation to the 'Wisdom and Spirit of the Universe' which 'giv'st to forms and images a breath/and everlast- ing motion', and this traditional Romantic theme is elsewhere

restated in terms derived from A. N. Whitehead, the twentieth-
century philosopher who rescued and redefined a holistic cos-
mology that Wordsworth might have applauded (Crozier and
Longville 1987: 74). Whitehead's critique of the bifurcation of
mind and nature – which Olson had drawn on before – is elabor-
ated in perceptual and phenomenological terms:

> This is
> the ordinary world, naturally incomplete and
> is no wise to be verbally separated
> from your picture of it.
>
> (Crozier and Longville 1987: 75)

The punning on 'wise' and 'naturally' introduces the question of
language as a mode of thinking: 'What wisdom there is/in the way
you set it down' (Crozier and Longville 1987: 75). A household fire
provides an image of process; stasis engenders collapse, as coals

> settle slowly
> into themselves and something slips. . . .
> You should never stop.
>
> (Crozier and Longville 1987: 73)

The poem ends with a description of a careful building of this fire
to preserve it; this action is emblematic of the wisdom that nur-
tures process and which returns the narrator to human
relationship:

> The dust beneath my
> fingernails is all the wisdom I have
> to take with me upstairs to my wife.
>
> (Crozier and Longville 1987: 76)

Both Griffiths and Crozier offer inclusive discourses that ambi-
tiously reject the dominant 'new poetry' of the 1970s, and emphasize
the role of language in mediating, and acting upon, the world.

NAMING THE ROCKS IN A LARGER THAN
NATIONAL WAY: PRYNNE, FISHER, SINCLAIR

Charles Olson provided a theory and practice that was influential
upon a wide range of non-establishment British poets in the 1960s
and 1970s. His theories of projective verse emphasized a kinetic
and almost improvisatory way of writing, treating the page as a

compositional field. However, writers as different as J. H. Prynne, Allen Fisher and Iain Sinclair seemed additionally drawn to Olson's *The Maximus Poems* for the way they articulated rich information and documentary sources concerning geography and history. The poem is focused upon Gloucester, Massachusetts, by the late 1940s a run-down fishing port, but which had been important in early American history. Olson's historical span is wide and when he notes, 'Descartes, age 34, date Boston's/settling', he is identifying an originating moment of American civilization with his sense of a dissociation of sensibility within Western thought (Olson 1960: 128). The 1958 essay 'Human universe' goes further and presents all post-Socratic philosophy as a false discourse of logic, classification and idealism, as opposed to a genuine discourse that takes language as an action upon the real (Olson 1973: 161–74). Olson took the pre-Socratic Heraclitus' maxim, 'Man is estranged from that with which he is most familiar', as axiomatic and Whitehead's process philosophy as his guide (Olson 1970: 14).

Such work arguably appealed during the withdrawal from the oppositional politics of the 1960s in that it could be used as a model for a re-articulation of Britain from less immediately social perspectives. (Indeed this matches Olson's own withdrawal from political life after the Second World War (see Meachen 1984: 204).) Olson's fellow Black Mountain poet, Edward Dorn, resident in England, advised young British poets in 'Oxford' in *The North Atlantic Turbine* (1967) to

> start by naming themselves and the rocks
> in a larger than
> national way and then more intimately

(Dorn 1975: 210)

and this was taken up by J. H. Prynne in *The White Stones* (1969), in various attempts to avoid humanistic and accepted socio-historical representations of Britain. In 'The Glacial Question, Unsolved', he uses a variety of (cited) geological and archaeological sources to question whether the Pleistocene Epoch is over. To even ask this question is to switch to a geological time-scale that shrinks even the historical sense of Heaney to insignificance; Prynne's question, working through his persistent verbs of knowing and being, is about the effect of the Epoch's process upon 'us':

We know where the north
is, the ice is an evening whiteness.
We know this, we are what it leaves:
the Pleistocene is our current sense, and
what in sentiment we are, we
are, the coast, a line or sequence, the
cut back down, to the shore.

(Prynne 1982: 65–6)

At times Prynne can sound like Heaney or Geoffrey Hill, where
human history (or Anglo-Saxon literature) is felt as palimpsest:

It is
the battle of Maldon binds
our feet: we tread
only with that weight & the empire
of love, in the mist.

(Prynne 1982: 75)

Reliance upon an imperial love seems dangerous in a restricted
nation whose history can 'bind'. The recurrent second person
plural and the austere diction are typical of the formality with
which Prynne evokes an unlocateable community. Whereas Olson
could more individualistically and intimately address the 'islands/
of men and girls' as 'Isolated person in Gloucester, Massachusetts,
I, Maximus' (Olson 1960: 12), Prynne sounds no less isolated
employing a traditionally English rhetorical posture.

Allen Fisher's *Place*, written between 1971 and 1979, was pub-
lished in four books of approximately a hundred pages each. They
are the notational *Place* (1976), the more polemical and analytical
Stane (1977), the lyrical *Becoming* (1978) and *Unpolished Mirrors*
(1985), a series of monologues. Early on in *Place*, Fisher identifies
with, and dissociates himself from, Olson's persona: 'I, not
Maximus, but a citizen of Lambeth' (Fisher 1976: np). I have
already described Fisher's commitment to procedure and system,
which is enough to distinguish his work from Olson's theory of
kinetic process, although the writing in *Place* often shares Olson's
notational urgency and his use of modernist juxtaposition. The
Place project's central concern is Fisher's own reading about, and
experience of, locality and history, particularly focusing upon
London. Its considerable information resources are not offered as
evidence of a single argument, *a* thesis on place, but are parts of

the work's 'shading', Fisher's term to describe correspondences and contradictions that can be traced between the intricately numbered sections of its open system. The work constitutes not a total meaning but an expansive presentation of various meanings. It is part of the work's argument about the processual complexity of knowledge: 'the beginning and the end of process do not exist/as such but continually summate' (Fisher 1976: np).

The work's overall structure is impossible to outline here, and perhaps this is not necessary; Fisher hopes that a reader could join the text at any point as if – in his persistent metaphor for the work and for London – joining the surface of a moving sphere (see Fisher 1975: 9).

> the centre moves continues to
> move
> us many centres
> ecumenopolis
> and
> or the loci of a point on a moving sphere
>
> I who am where I am
> feel the surges of
> of the pulses that are
> not my heart's

(Fisher 1978: 23)

Fisher presents the many Londons of this ecumenopolis as a kind of multiple archaeology, of 'place of living, locality, house borough city country planet' which is yet intimately involved in the socially constructed, psychosomatic self, 'the place of being, body, breath, brain' (Fisher 1975: 9). As the poet notes sardonically, connecting the two senses of place: 'my father's blood condition/ conditioned' (Fisher 1977: 52).

Fisher acknowledges the influence of Raoul Vaneigem's *The Revolution of Everyday Life* upon his thinking, and the Situationists, who were influential both upon the oppositional movements of 1968 and upon the European avant-garde, suggested a politics or a re-location of politics within everyday experience (Fisher 1975: 9). The Situationists engaged in work 'where the exploration of the city reveals the *psycho-geography* created by the physical and mental conditions of twentieth-century society' (Hewison 1990: 26; but see also Home 1988: 26–49).

In 'Place 48', from *Stane*, Fisher goes further than the Situationists and presents interconnected instances of cosmic, ecological, biological and political forces to acknowledge the complexity of 'everyday life'. It shares an impulse, in its borrowings from Olson and Whitehead, but not a language, with Crozier's *The Veil Poem*. Fisher's language is more akin to Bill Griffiths's in that its linguistic re-orderings of experience, through modernist juxtaposition, amount to a 'revolution' within language. 'The fly on its food route', for example, displays its 'thrust and parry of energy' while the self intervenes in the food chain, by small-scale gestures, suitably notated in an utterance as incomplete as such a snapshot of process must prove.

> I break the web silks
> the fly escapes
> lands on food in kitchen
> its legs coated with

(Fisher 1977: 11)

The 'correct place' for action will be defined by 'context': 'I have no wish to close the opening petals/that lead the bee', yet the narrator can 'see the context in which I ward off pigeons' (Fisher 1977: 11). These microcosmic interventions are presented as more pertinent than those permitted through the rituals of social democracy. This 'citizen of Lambeth' asks 'do I think my vote/counts in the neck pulse of the local councillor' (Fisher 1977: 11). In this expansive 'Dynamegopolis', where the 'place of living' and the 'place of being' interact, political power is registered as much on the human organism as at the ballot box (Fisher 1978: 84).

Iain Sinclair's *Lud Heat* (1975) is another book which charts a palimpsest London, one which Fisher goes so far as to acknowledge in *Stane* in a prose appreciation. (See also Hodgkiss 1976: 3–12 for the original of this and other materials relating to *Lud Heat*.) Fisher registers both *Lud Heat's* similarities to, and differences from, *Place*, but points to an essential shared recognition that 'there are subtle mechanisms at work subjugating our psyches, trying to keep . . . our senses, awareness at a lower level than they need be' (Fisher 1977: 30).

Lud Heat mixes open form poetry and tightly written prose that can combine scholarly and almost new journalistic styles, along with line drawings, prints and Sinclair's own photographs. Its initial premise is that Hawksmoor's London churches emanate

psychic energies which affect the population's actions. Fisher is quick to sense the subjective element of this pattern-making: '*Lud Heat* assumes the kind of symbolic value particular architectural forms possess: what associations they are capable of evoking in individuals. . . . It is from these buildings that the energies of the area are – I was going to say "generated" ' (Fisher 1977: 30). Fisher baulks at the very term that Sinclair uses. As in *Place*, theory is grounded in the everyday, as Sinclair charts his own life as a council grasscutter, working between the talismanic churches, in journals and poems. He also bears witness to the autopic films of Stan Brakage and the sculpture of his friend the poet Brian Catling as artists making similar patternings, and superimposing them upon his own concerns. Whereas Fisher uses theory and his reading to create a divergent, contradictory patterning of self and place, Sinclair is drawn to converging combinations of esoteric wisdom and mysticism:

> *the scientific approach* a bitter farce
> unless it is shot through with high occulting
> fear & need & awe of mysteries.
>
> (Sinclair 1975: 89)

The danger is that the totalizing fiction that develops will amount to a paranoiac sense of interconnectedness:

> it is so connected we share all
> symptoms & meanings,
> bicycle wheel spins
> a wobbly mandala.
>
> (Sinclair 1975: 34)

Although the conspiracy theory seems cosmological, Sinclair does share with Fisher an apprehension of the psychosomatic reso- nances of place. In Sinclair's case this is particular and oracular, as he presents hay-fever and sun-stroke as solar viruses in a prose which is as startling in its comparisons as the poetry is in its spare juxtapositions: 'As the ego breaks I am host to another being, who pushes through and not with the pink tenderness of new skin – but with old flesh, hard as wood' (Sinclair 1975: 86). This abandon- ment of the human perspective might seem open to charges of Fascist mysticism, but this is refuted by noticing how often Sinclair weaves his pattern-making into the fabric of everyday life and, like

Fisher, he can recognize the darkest possible contemporary attachments to place beneath the social democratic surface.

here: Hackney South & Shoreditch where
Mr Robin May polled the National Front's
best result 2,544 votes.

(Sinclair 1975: 102)

As in Fisher, the ballot box is both dangerous and a diversion from real, complex energies.

The presence of Blake as a guiding spirit in both Fisher's and Sinclair's work is not just fashionable or coincidental. Blake, another 'citizen of Lambeth', developed, in his self-published 'Prophetic Books', a mythology to articulate his ambivalence towards an earlier radicalism, and – like Fisher and Sinclair – enacted the potential revival of Albion in a text. The employment of a mythic method, although it retreats somewhat from everyday life, is the later choice of both Sinclair's *Suicide Bridge* (1979), which re-fashions Blake's Sons of Albion as embodiments of contemporary evil, and Fisher's *Unpolished Mirrors* (1985), which speaks prophetically, but generally, of 'a coming English Revolution' (Fisher 1985: 1; see also Middleton 1982).

Prynne, Fisher and Sinclair were not alone in developing what became known as a 'poetry of place'. A whole issue of *Joe Dimaggio* magazine (11, 1975) was dedicated to it. The Polytechnic of Central London British Poetry Conference 1977 featured twenty-one poets constellated around the notions of 'Inheritance Landscape Location', the title of the accompanying essay by Eric Mottram. Mottram clearly marshals theories of 'place' as delineators of a special knowledge and perception, 'both local and international', operating in opposition to 'official British culture' which Mottram represents as having shrunk 'in response to the pressures of British economic and political decline from the raving days of Empire and Influence' (Mottram 1977: 87). Far from simply withdrawing from politics, the 'poetry of place' enabled poets to expand the notion of politics beyond both parliamentary and purely personal articulations of it. It fostered explorations of alternative patterns of connection, process and energy, and of histories that were not officially sanctioned. (See Harwood (1977) for other relevant texts.)

THE USES OF AUTONOMY

J. H. Prynne's work of the 1970s, published in eight books or pamphlets and collected in 1982 in *Poems*, is a by-word for difficulty and enigma. Prynne had abandoned the Olsonian 'human universe' for a writing that encouraged the invasion of the poetic text by non-poetic discourses, and a textual compactness that is made all the more complex by the survival of traditional lyric and argumentative effects. My examples are drawn from *High Pink on Chrome* (1975), in which the language of subjectivity seems to be penned in by the specialist lexis of agricultural biochemistry:

> The distance (2) from a self
> protein is not by nature
> either just or rational but
> the mirror image of both.

(Prynne 1982: 258)

This passage hinges syntactically upon the unlikely collocation 'self/protein', teasingly separated by the line break while grammar pulls it together, and upon its possible relation to justice and rationality. As much as Bill Griffiths's, this work is poetry that stays poetry. The reader is forced to take a greater role than is usually required to attempt to establish some ground-rules before reading it. But the patterns arrived at do not seem to fit; for example, what do we make of the numeral in parentheses? Rather than attempt to answer such questions directly, I wish to examine the critical work of two younger Cambridge poets – Peter Ackroyd and Veronica Forrest-Thomson – to show how this textual autonomy was valued during the 1970s. (For selections of their poems see Ackroyd (1987) and Forrest-Thomson (1990).)

Peter Ackroyd is now best known as a biographer and novelist – his *Hawksmoor* makes considerable use of Sinclair's *Lud Heat* – but he published a provocative cultural history, *Notes for a New Culture*, in 1976. Ackroyd attempts to demonstrate that language has become the only content of literature. The resultant formal autonomy of the text marks its final victory over the attempted annexations of aesthetics, the self and humanism. For Ackroyd, Prynne's work is important both for having admitted non-poetic discourses and for having expunged the poetic voice; there is only a 'written surface' (Ackroyd 1976: 130). Prynne has used a variety of technical discourses, changing their functions by inserting them

into a poem, and, as Ackroyd points out, the utterances seem coldly anonymous. The readers are 'not asked to participate in the lucidity and harmony of the poetry, we can only recognise its exterior signs' (Ackroyd 1976: 130). Yet such signs as the stanzaic shape tease the reader with what, literally at first sight, appears a traditional poem.

> In feare and trembling they descend
> > into threatened shock. Faire and
> softly, too far from the dry arbour.
> > The chisel plough meets tough going,
> we spray off with paraquat 2½ pints
> > per acre. And the ^{51}Cr label shews
> them and us in your same little boat,
> pulling away from the vacant foreshore.
>
> (Prynne 1982: 257)

In parts, meaning can be constructed, but as a whole this stanza only dimly seems to be referring outside of itself and, when it does, it is to language itself: what do the archaic 'feare' and 'faire' have to do with the specialist vocabulary of '^{51}Cr label'? The pastoral impedimenta of 'the dry arbour' however, are juxtaposed with the modern '2½ pints/per acre' of toxic weed-killer, and the reader might suspect an ecological plea is being made. Ackroyd prefers to read such clues as part of the historical dimension of the poem's triumphant autonomy. 'Ambiguity is caused by a language coming into itself against the power of that aesthetic context which had given it meaning and strength for so long' (Ackroyd 1976: 131). Ackroyd senses a tension between the poem as a historically determined entity and its invasion by language in its rich varieties; so that pastoral and chemistry assist the text's linguistic complexity, amounting not to a thematic resolution but to the affirmation of its very autonomy, its ultimate uselessness.

This absolutist argument is supported by a precocious use of what is now called post-structuralist theory – applications of the work of Lacan and Derrida, for example – which is peculiarly out of step with its later uses in Britain as an element of a radical critique. (See Easthope (1983) for one of its few applications to poetry.) Ackroyd is claiming Prynne's poetry in the name of an essentially conservative formulation of autonomy which sees this difficult work as a necessary withdrawal from the 'dispirited nation' to which Ackroyd refers, and from the 'call for personal

"liberation" which became fashionable in the sixties' as well as the 'humanistic kitsch' of its popular poetry (Ackroyd 1976: 136). History and politics are thus denied a role, reduced simply to serving autonomy as pure discourses on a poem's surface.

Veronica Forrest-Thomson's *Poetic Artifice* (1978) is an ambitious theory of twentieth-century poetry which has absorbed post-structuralist concerns and which attempts to account for the poetic devices which create the autonomy that Ackroyd values. Her theory was arguably influenced by, and has had an influence upon, some of the work collected in *A Various Art*. It elevates artifice over poetry's referential function but offers a model of reading that presents 'naturalization' – the reading of a text as a statement about the external world – as a process that is best delayed through concentration upon the poem's conventional, phonological/visual, syntactic and semantic devices. Most readers ignore this exacting route, preferring to move rapidly from text to paraphrase (see Forrest-Thomson 1978: xi, as well as Culler 1975: 131–88). Prynne's work cannot be read by this short cut. Its 'tendentious obscurity' makes this necessarily impossible: for Forrest-Thomson, it recaptures 'the levels of Artifice, of restoring language to its primary beauty as craft by refusing to allow its social comprehension'. (Forrest-Thomson 1978: 142).

At the conventional and visual levels, my example from *High Pink On Chrome* is shaped like a poem with its regular stanzaic form, but at the level of sound organization there is tension between its rhythm – the third line can arguably be scanned as a regular dactylic line with subtle alliterative moments – and the semantic components, such as '^{51}Cr' which resists traditional scansion. The relation of 'faire' and 'feare' is clear in terms of sound and antiquity, but this equivalence cannot be readily converted into meaning. The almost subliminal internal eye rhyme of 'plough' and 'tough' resists its comprehension as statement. The verse is syntactically unclear, with several broken-back sentences, and yet it can be read as a coherent grammatical unit that still means very little.

For Forrest-Thomson, this resistance has a liberal educative role: 'It is only through artifice that poetry can challenge our ordinary linguistic orderings of the world' (Forrest-Thomson 1978: xi). Naturalization can be *delayed* to enable this challenge, but eventually the poem must have sense made of it by an active reader, argues Forrest-Thomson. Good naturalization is a reading

which accounts for poetic devices, which reads through them. It could be said of Prynne's poem (to simplify Forrest-Thomson's theory) that the semantics of science ('^{51}Cr label'), with its own peculiar self-reference, 'shews' that the 'them and us' of popular political debate are in the 'same . . . boat'. The poem's final line is a regular iambic ending, that implies a traditional and authoritative 'voice' for its content. The poem returns to the familiar plural 'we' of community present in Prynne's earlier verse and it gestures towards ethical concerns about complacency in the face of ecological vulnerability and disaster: 'The furrow is still open, we read the papers/with coy amazement and concern' (Prynne 1982: 257). The papers may as well be scientific papers as newspapers; only a comma separates them from the openness of the future.

There are other ways of reading Prynne's work beyond these initial strategies of the 1970s. (See Trotter 1984: 218–30, particularly where he regards the scientific discourses of *High Pink On Chrome* as disabling a free reading of the text with the authority and fixity of its statements.) There are other ways of valuing and evaluating textual autonomy. In *The Aesthetic Dimension* (1978), a book which acknowledges its author's 'despair' at retreating from the world of radical praxis and the optimism of his earlier *An Essay on Liberation* (1969) into the world of aesthetics, Herbert Marcuse theorizes an oppositional, even utopian, role for artistic autonomy (Marcuse 1978: 1). It is possible, for example, to see the discontinuities of Bill Griffiths's style or the perceptual epiphanies of Andrew Crozier's lyricism as creating the space that Marcuse values, in which 'Subjects and objects encounter the appearance of that autonomy which is denied them in their society'. (Marcuse 1978: 72). The work of J. H. Prynne – but not that of Craig Raine which acts to confirm existing social reality – arguably encourages an aesthetic experience which 'happens in the estranging language and images which make perceptible, visible, and audible that which is no longer, or not yet, perceived, said, and heard in everyday life'. (Marcuse 1978: 72). It is the transformation of the 'everyday' that, with only a slight shift of vocabulary, also drives the poetry of Allen Fisher and Iain Sinclair. In Marcuse's view, art's autonomy from social reality enables not the negative perfection of Ackroyd's critique, nor the purely technical re-valuations of Forrest-Thomson's theory, but an imaginative revolution that carried forward, or at least preserved as a memory, the

subversiveness of the late 1960s, to which Marcuse himself had contributed much.

CONCLUSION

Earlier in this essay, I made much of the campaigning criticism of Blake Morrison because of its boldness in asserting a normative view of the 1970s, while it acknowledged, though did not analyse, positions outside that orthodoxy which have been my main focus. His advocacy of the Movement and his largely rhetorical annexation of Seamus Heaney's work to its continuing 'tradition' demonstrates the way mainstream literary culture has operated in this country since the 1950s. The apparently directionless 'pluralism' of the 1970s proved his opportunity to promote Heaney and Raine. The withdrawal of many important writers outside the mainstream from the Poetry Society in 1977 meant that the decade ended for them in organizational chaos and fragmentation. Despite a healthy proliferation of small presses, the demonstrable lack of funding for publishing and the effects of rising inflation on production standards led to a loss of publicity and audience. It was possible, by the end of the decade, for the alternatives to the mainstream to be ignored; the effect of this was to make that mainstream seem more vital. However, in recent years a number of anthologies and collected and selected works have challengingly recovered this work and made it imperative that official accounts of the 1970s be revised. The true 'pluralism' of the decade includes, at least, the poets dealt with here and, at least, the two responses to social and political decline outlined above: re-location within the world of the everyday, particularly in an insistence upon 'place' that rejected the national and ideological centre; or seeking a stylistic purity that rejected the world in favour of autonomy and artifice.

FURTHER READING

For available anthologies and collections with introductions, Morrison and Motion (1982) offer a compendium of the mainstream, while Crozier and Longville (1987) and Allnutt *et al.* (1988) between them present useful cross-sections of the alternatives, the latter also documenting the emergent Black and women's poetries. Fisher *et al.* (1992) offer accessible selections of subsequent work by Fisher and Griffiths. Prynne (1982) is a collection of Prynne's work but a representative selection can be found in Crozier and Longville (1987). Sinclair's poems are selected in Sinclair

(1989), although Sinclair (1988, 1991) shows how his quest to articulate London has been continued in his fiction. Roy Fisher's work of the 1970s would have been included in my discussion if I had not decided to avoid poets dealt with in Sheppard (1992) on the grounds of space limitations, and this is best found in Fisher (1988). Likewise, Harwood's 'The Long Black Veil' in Harwood (1988) and Harwood (1977), Raworth (1982) and Cobbing (1976) should not be overlooked on account of this decision. Jones and Schmidt (1980) give some account of the development of Larkin and Hughes in the 1970s, though Hughes's work is best dealt with in West (1985). Accounts in Jones and Schmidt (1980) of Basil Bunting, W. S. Graham, Charles Tomlinson, Geoffrey Hill, Edwin Morgan, Elaine Feinstein, Christopher Middleton and Ian Hamilton Finlay and Roy Fisher offer valuable, but variable, additions to my account of alternatives. To date, only Trotter (1984) offers general readings of poetry of a comparable range in available form, but much in Easthope and Thompson (1991) is useful.

BIBLIOGRAPHY

Ackroyd, P. (1976) *Notes for a New Culture*, London: Vision Press.
—— (1987) *The Diversions of Purley*, London: Abacus.
Allnutt, G., D'Aguiar, F., Edwards, K. and Mottram, E. (eds) *The New British Poetry 1968–88*, London, Paladin.
Booth, M. (1985) *British Poetry 1964 to 1984*, London: Routledge.
Brookeman, C. (ed.) (1974) *Modern British Poetry Conference*, London: The Polytechnic of Central London.
Cobbing, B. (1976) *Bill Jubobe, Selected Texts 1942–1975*, Toronto: Coach House Press.
Crozier, A. (1983) 'Thrills and frills: poetry as figures of empirical lyricism', in A. Sinfield (ed.) *Society and Literature 1945–1970*, London: Macmillan.
Crozier, A. and Longville, T. (1987) *A Various Art*, Manchester: Carcanet.
Culler, J. (1975) *Structuralist Poetics*, London: Routledge.
Davie, D. (1973) *Thomas Hardy and British Poetry*, London: Routledge.
Dorn, E. (1975) *The Collected Poems 1956–1974*, Bolinas, CA: Four Seasons Foundation.
Easthope, A. (1983) *Poetry as Discourse*, London: Methuen.
Easthope, A. and Thompson, J. O. (1991) *Contemporary Poetry Meets Modern Theory*, Sussex: Harvester Wheatsheaf.
Evans, P. (ed.) (1977) *PCL British Poetry Conference – June 1977*, London: Polytechnic of Central London.
Fisher, A. (1975) *Prosyncel*, New York: Strange Faeces Press.
—— (1976) *Place*, Carrboro: Truck Press.
—— (1977) *Stane*, London: Aloes Books.
—— (1979) *Becoming*, London: Aloes Books.
—— (1985) *Unpolished Mirrors*, London: Reality Studios.
—— (1988) *Poems 1955–1987*, Oxford: Oxford University Press.

Fisher, A., Griffiths, B. and Catling, B. (1992) *Future Exiles: 3 London Poets*, London: Paladin.

Forrest-Thomson, V. (1978) *Poetic Artifice*, Manchester: Manchester University Press.

—— (1990) *Collected Poems and Translations*, Lewes: Allardyce, Barnett.

Gilonis, H. (1991) 'Bill Griffiths, *Coal*; *Coal 2*', *Fragmente* 4: 112–13.

Griffiths, B. (1976) *Cycles*, London: Pirate Press and Writers Forum.

Griffiths, B. and Cobbing, B. (1988) *ALP The First 22¹/₂ Years*, London: The Association of Little Presses.

Haffenden, J. (ed.) (1982) *Viewpoints: Poets in Conversation*, London: Faber.

Harwood, L. (1977) *Boston–Brighton*, London: Oasis.

—— (1988) *Crossing the Frozen River: Selected Poems*, London: Paladin.

Heaney, S. (1966) *Death of a Naturalist*, London: Faber.

—— (1975) *North*, London: Faber

—— (1979) *Field Work*, London: Faber.

—— (1990) *New Selected Poems 1966–1987*, London: Faber.

Hewison, R. (1990) *Future Tense: A New Art for the Nineties*, London: Methuen.

Hill, G. (1985) *Collected Poems*, Harmondsworth: Penguin.

Hilton, J. (ed.) (1975) *Joe Dimaggio* 11.

Hodgkiss, P. (ed.) (1976) *Poetry Information* 15.

—— (ed.) (1979/80) *Poetry Information* 20 and 21.

Home, S. (1988) *The Assault on Culture: Utopian Currents from Letterisme to Class War*, London: Aporia and Unpopular Books.

Jones, P. and Schmidt, M. (eds) (1980) *British Poetry Since 1970: A Critical Survey*, Manchester: Carcanet.

Marcuse, H. (1969) *An Essay on Liberation*, Harmondsworth: Penguin.

—— (1978) *The Aesthetic Dimension*, Basingstoke: Macmillan.

Meachen, C. (1984) 'Robert Duncan: 'To Complete his Mind', in R. W. Butterfield (ed.) *Modern American Poetry*, London and Toronto: Vision & Barnes & Noble.

Middleton, P. (1982) '(Subject) essay on Allen Fisher's *Unpolished Mirrors* & current English poetry. (Title) *The Poetic Project*', *Reality Studios* 4: 31–6.

Morrison, B. (1980a) *The Movement: English Poetry and Fiction of the 1950s*, Oxford: Oxford University Press.

—— (1980b) 'Young poets in the 1970s', in P. Jones and M. Schmidt (eds) *British Poetry Since 1970: A Critical Survey*, Manchester: Carcanet.

—— (1980c) 'Speech and reticence: Seamus Heaney's *North*', in P. Jones and M. Schmidt (eds) *British Poetry Since 1970: A Critical Survey* Manchester: Carcanet

—— (1982) *Seamus Heaney*, London: Macmillan.

Morrison, B. and Motion, A. (eds) (1982) *The Penguin Book of Contemporary British Poetry*, Harmondsworth: Penguin.

Mottram, E. (ed.) (1971–7) *Poetry Review* 62 (3)–67(1/2).

—— (1977) 'Inheritance landscape location', in P. Evans (ed.) *PCL British Poetry Conference – June 1977*, London: Polytechnic of Central London

Nuttall, J. (1976) 'Bill Griffiths', *Poetry Information* 15: 13–17.

Olson, C. (1960) *The Maximus Poems*, New York: Jargon/Corinth Books.

—— (1970) *The Special View of History*, Berkeley: Oyez.

—— (1973) 'Human universe', in D. Allen and W. Tallman (eds) *The Poetics of the New American Poetry*, New York: Grove Press.

Prynne, J. H. (1982) *Poems*, Edinburgh and London: Agneau 2.

Raworth, T. (1982) *Writing*, Berkeley: Figures.

Riley, P. and Corcoran, K. (1986) 'Spitewinter provocations: an interview on the condition of poetry', *Reality Studios* 8: 1–17.

Sheppard, R. (1992) 'British poetry and its discontents', in B. Moore-Gilbert and J. Seed (eds) *Cultural Revolution?*, London: Routledge.

Sinclair, I. (1975) *Lud Heat*, London: Albion Village Press.

—— (1979) *Suicide Bridge*, London: Albion Village Press.

—— (1988) *White Chappell, Scarlet Tracings*, London: Paladin.

—— (1989) *Flesh Eggs & Scalp Metal: Selected Poems 1970–1987*, London: Paladin.

—— (1991) *Downriver*, London: Paladin.

Trotter, D. (1984) *The Making of the Reader*, Basingstoke: Macmillan.

West, T. (1985) *Ted Hughes*, London: Macmillan.

Chapter 7

Apocalypse now?
The novel in the 1970s

Bart Moore-Gilbert

INTRODUCTION: THE STATE OF THE NOVEL/THE NOVEL OF THE STATE

The novel was deeply implicated in the sense of social and cultural crisis characteristic of the 1970s, most obviously because so many novelists expressed the condition of contemporary Britain in apocalyptic terms. This was true not only of established figures like Lessing, Burgess, Powell, Drabble, Kingsley Amis, Ballard and Golding, but also of rising talents such as Paul Theroux, Martin Amis, B. S. Johnson, Alan Burns, Emma Tennant, Angela Carter and Zoe Fairbairns.[1] Industrial confrontation, class warfare, terrorism, regional tensions, conflict between the races and genders – all are staples of the decade's fiction, giving the impression of a society on the verge of disintegration, or even civil war. In many cases the brink has already been crossed, producing social chaos and some kind of totalitarian backlash.

Perceptions of the state of the novel as a cultural form tended, with a few exceptions, to be equally down-beat. A major source of pessimism was the contraction in commercial publishing – as detailed in the introduction to this volume. State support for fiction was uneven and many writers felt discriminated against by the Arts Council. In 1977–8, for instance, it devoted 1.25 per cent of its budget to all forms of literature – £511,461 in total. In comparison drama alone received £6 million. And whereas in 1968–9 the Arts Council supported 109 writers through grants, this had fallen to fifty by 1973 (Hewison 1986: 247). The campaign for Public Lending Right (PLR) intensified in the decade; proponents of PLR hoped it would underwrite fiction by recognizing how public provision for libraries deprived writers of sales. According to Brigid

Brophy and Maureen Duffy, the growth of public libraries be-
tween 1920 and 1946 meant that 'a ratio of ten books purchased to
one borrowing was converted, within 42 years, into a ratio of
eleven borrowings to one purchase' (1972: 3). They concluded that
'the potential loss to authors continues to increase, because bor-
rowing continues to expand – fast' (p. 3). In the 1970s, then, as
Sutherland suggested, 'the author's gaze has been finally removed
from the publisher to the state as the main oppressor of the writing
profession' (1975: 6). (This is corroborated incidentally by
Penelope Fitzgerald's *The Bookshop* (1978), where Florence's
enterprise is undermined when a local library opens and is then
pulled down to make way for an Arts Centre.)

There was also a sense that the prestige of literature within the
cultural canon had been radically undermined. As J. G. Ballard
put it: 'the main underpinning of English culture for the last couple
of centuries has been English Literature. . . . Now this underpin-
ning has completely gone' (Burns and Sugnet 1981: 16). Gedin
concluded that this was 'not merely a question of a temporary
faltering economy but a structural crisis, which was obviously an
outcome of a change in the societies of the West and in their
cultural patterns' (1975: 9). He linked the decline of 'serious'
fiction to a long-term erosion of the status of the bourgeoisie and
the rise of a 'mass' society dominated by visual media – a thesis
echoed by John Gross's *The Rise and Fall of the Man of Letters*
(1969), which argued that 'other media are constantly competing
for attention with books, and as often as not they tend to win the
competition' (p. 286). The 1978 *New Review* symposium on con-
temporary fiction suggests that fear of television was exacerbated
by the arrival of colour transmission in 1969. This is the main
threat to the bookseller Sim Goodchild, in Golding's *Darkness
Visible* (1979), who is engaged in a life or death struggle to 'prise
that crowd of white people away from the telly and bring them to
read old books again' (p. 193).

Many participants in the *New Review* symposium also expressed
doubt about the quality of novelistic practice in 1970s Britain.
Nicolas Freeling was blunt: 'In a decadent society – that it is,
agreement would be fairly general – weeds flourish' (summer 1978:
37). A. S. Byatt compared local work unfavourably with that of
US authors, while Emma Tennant looked to the Commonwealth
for the most exciting developments in the English language novel.
Several writers, moreover, believed fiction to be less vital than

other cultural forms in contemporary Britain. Ian McEwan chose
theatre and David Plante the visual arts to suggest its relative
underachievement. Isobel Colegate is representative of the pre-
dominant tone of the symposium: 'Times have never been harder,
whether as regards the quality of new work, the state of fiction
criticism, the general reputation of the novel as a serious form, or
the economic circumstance in which a novelist has to work' (p.
32).

Some saw the crisis of the novel as symptomatic of a malaise
afflicting most areas of cultural production. There was alarm at
the apparent decline of standards in education and its impli-
cations for the future of a reading public. Once again, television
was held chiefly responsible. The *Literary Review* began life in
1979 protesting against the 'standards of education acceptable'
in 'a culture which is rapidly passing from the verbal to the
visual' (1 (1), 5–18 October: 3). Margaret Drabble's *The Ice Age*
(1977) laments 'the new illiterate visual television age' (p. 252)
and Anthony Burgess's *1985* (1978) bitterly satirizes the way the
medium had become not merely the chief source of entertain-
ment (destroying in the process the cultural vitality of other
visual arts such as painting and cinema) but, by default, of edu-
cation. The pathetic and moronic figure of Bessie represents, for
Burgess, the apotheosis of the contemporary comprehensive sec-
ondary system.

Both writers focus on the declining status of the classics as a
symbol of these wider issues. Thus the protagonist of *The Ice Age*
feels 'the fate of classical studies might . . . reflect something of a
watershed in British history' (p. 75). For much of *The Ice Age*,
Drabble appears to satirize the Oxford don Linton Hancox, whose
embittered defence of his subject is linked to the declining status of
both his profession and class fraction. But Hancox finally takes on
a noble, even tragic cast: he is even seen as defending a 'scholastic
stronghold, standing out against the barbarians' (p. 217). Anthony
Keating, who finds Hancox's views so antipathetic to begin with,
ends by endorsing most of them in a long, disillusioned meditation
on the failures of 'progressive' education (pp. 252–3). Burgess's
pessimism about the future of the traditional liberal values the
subject represents for him is indicated by the fact that the classics
are only kept alive in *1985* by 'deviants' like Tusa's gang from the
ghetto, a young fogey equivalent of the rebellious youth in *A
Clockwork Orange*. (Certainly Tusa's New Right affiliations are

clear: ' "We got lousy education, right? . . . Lousy because it's Labour. Lousy because it levels" ' (p. 134).

Such disquiet reaches a peak in representations of the universities created in the wake of the Robbins Report (1963) to broaden and democratize participation in higher education. Anthony Powell completed his twelve-novel sequence, *A Dance to the Music of Time*, with *Hearing Secret Harmonies* (1975), in which the anti-hero Ken Widmerpool leaves the 1964 Labour government to become Vice-Chancellor of one such 'new' university. His institution is symbolic of the cultural breakdown which the novel represents as beginning in the late 1960s. Powell's narrative discourse embodies its own critique of this process of 'cultural levelling' by virtue of citation of a wide, if not arcane, range of earlier 'high' cultural practice, from literature and philosophy to the visual arts. This assumes, or even constructs, a reader hostile to the values of Widmerpool's students, such as the Quiggin twins, who waste their undergraduate years in demonstration and sexual experimentation. The disruption of the Donners prize for biography symbolizes their contempt for traditional 'high' cultural activity, but the triviality of the counter-culture they offer in its place is indicated by the title of their underground organ, *Toilet Paper*.

Malcolm Bradbury's *The History Man* (1975), while playing over much the same terrain as Powell, is bleaker in tone. For if Widmerpool is essentially misguided, there is a heroic quality to his folly suggested in the parallels with Orlando Furioso. Howard Kirk poses a more sinister threat to the educational system and the humanist values which traditionally underpinned it. Kirk's persecution of his student Carmody for refusing to toe the 'correct' ideological line, and his orchestration of a campaign to deny Mandel a platform to present research findings on genetic aspects of intelligence, typify the author's fear of a ruthless minority imposing a fascistic style of pedagogy in place of pluralism and the spirit of free enquiry. For Bradbury, the threat to educational standards is clear. Kirk is notably philistine in his literary exchanges with Miss Callendar and his research is meretriciously trendy. Like Burgess, Bradbury deplores 'relevance' as an educational criterion, blaming it for the hegemony of social science in the curriculum of the 'new' university and the consequent rise to power of figures like Kirk.

One perceived consequence of the alleged decline in standards

was of particular concern, concerning as it did the very material of the novelist's craft, language. The decline of linguistic purity and competence alike were seen by many as ominous for the future of literature. The breakdown of language (amongst many other things) is a key theme of Martin Amis's *Success* (1978), spectacularly exemplified in some of the passages written in Terry's voice (e.g. p. 52). In *1985* even Tusa is defeated by the struggle to articulate the word 'disinterestedness' (Burgess 1978: 134) – Matthew Arnold's key socio-critical value, significantly – and in Lessing's *The Memoirs of a Survivor* (1974), the narrator is haunted by 'the deprived, thinned speech of the poor. . . . Words in their mouths . . . had a labouring, effortful quality – dreadful, because of the fluencies so easily available, but to others' (p. 100). But while Lessing clearly – and Amis much more ambiguously – places the blame on the inequities of a class-based educational system, Burgess and Bradbury see it as a consequence of attempts to reform established practices. The disfiguring jargon of Kirk and his circle flourishes just as the humanities (English especially) are being decentred within the curriculum in the course of extending the syllabus of, and access to, higher education. *1985*'s 'Note on worker's English' bitterly parodies tolerance of 'non-standard' varieties of English and the 'translations' of *Hamlet* imply that permanent cultural damage will follow the acceptance of 'progressive' ideas about linguistic practice.

The *Black Papers* on education made anxiety about the hegemony of the Left within education a rallying point for the New Right after 1969. But this was only one aspect of an increasingly vociferous argument that Britain was declining into collectivism. Malcolm Bradbury protested in the *New Review* against 'the current drift of thought about society and identity which is progressively turning us into state goods, corporate persons, sociologically and historically derived person-resembling organisms' (1976: 40). Burgess's *1985* warns in Orwellian fashion that 'the total and absolute, planned, philosophically consistent subordination of the individual to the collective' might well be the nemesis of 'the muddle and mess of contemporary Britain' (1978: 19). The power of the unions is Burgess's chief bug-bear. It is not just that they hold the public to ransom through strikes in essential services like fire-fighting. Under their sway, Britain is an ideological closed-shop (Tucland) where dissenters like Bev are subject either to 're-education' or social ostracism. Suspicion of socialism's totalitarian

potential is also evident in Lessing's account of the post-war British Communist Party in *The Four-Gated City* (1969), where it is the Labour Minister Phoebe Coldridge who orders the dispersal of Mark's commune in the name of 'the public good'.

But both novels suggest that if the Left was the most likely source of dictatorship, the threat from the Right was not to be discounted. *1985*'s portrayal of the neo-fascist Free Britons is modelled on the growth of extreme Right organizations in the decade, a phenomenon which Bev finds in the end to be no real alternative to union dominance. Similarly, Lessing predicts a 'swing towards puritanism' (1969: 617) – in reaction to the permissiveness of the 1960s – preparing the way for 'a fascist phase' in British history: 'There it was now in the wings, ready to come on, gentlemanly, bland, vicious' (p. 606). A dictatorship of the Right operates in Fairbairns's *Benefits* (1979), where the government of National Regeneration runs 'rehabilitation' schemes for dissident women similar in aim and method to those in *1985*. Such fears penetrated the most unlikely reaches of the 1970s novel, such as Richard Adams's bestselling *Watership Down* (1972). Originally directed at children, it is structured largely round the conflict between the liberal commune of Hazel's rabbits and the totalitarian regime of General Woundwort.

The spectre of collectivism fed into debate over the novel as cultural form by virtue of the issues it raised in relation to the representation of individual identity. Gedin related the decline of the novel as 'individual biography' to a long-term erosion of the importance of the individual (1975: 177–9) and Bradbury argued that 'this growing anxiety about the representation of character . . . was a political as well as an epistemological quandary' (1976: 40). The threat to 'liberal' models of personality and personal freedom prompts the narrator Nick Jenkins to comment thus in *Hearing Secret Harmonies*: ' "Besides, the very concept of a character in a novel – in real life, too – is under attack" ' (p. 80). To Bradbury, Marxism renders 'character' irrelevant in both senses. Kirk's monograph, *The Defeat of Privacy*, attacks the idea that ' "it is within single, self-achieving individuals that lie the infinite recesses of being and morality that shape and define life" ' (1975: 91). This provides one context for Bradbury's (self-?) parodic description of the retiring English department novelist who achieved two early successes 'filled, as novels then were, with moral scruple and concern. Since then there has been silence, as if,

under the pressure of contemporary change, there was no more moral scruple and concern, no new substance to be spun' (p. 204).

In the 1978 *New Review* symposium, William Trevor alluded to a current perception (which he did not share) that 'the brave new world of sociology has rendered fiction obsolete' (summer 1978: 69). Such misgivings were perhaps reinforced by the advent of the new intellectual discourses associated with post-structuralism (generally seen at the time, if not now, as allied to Marxism). These had, as one specific aim, the decentring of bourgeois-liberal models of subjectivity. Certainly Bradbury and Burgess refer to some of those associated with the new discourses (*1985* includes a couple of characters called Derrida and Chakravorty – the middle name of Derrida's translator G. C. Spivak – and in *The History Man* a close ally of Kirk's is a radical-feminist buffoon called Todoroff.) Paradoxically, however, given the manifest anxieties of these two writers about creeping collectivism, their novels have an oddly monologic discursive feel. Bradbury's caricatures are so loaded, the narrative irony so coercive, that the reader's interpretive freedom is minimal. *1985* is framed by a 'catechism' in which the (unattributed, godlike) directing voice drills its gloomy 'truths' into the hapless unnamed interlocutor (and, by extension, the reader).

Many of the anxieties described above had, of course, exercised writers well before the 1970s. But they are presented with an intensity in this decade which suggests that a watershed had at last been reached. And pessimism about Britain's cultural and social crisis was compounded by a widely shared sense that the domestic predicament was simply one manifestation of a set of problems affecting not just Western culture but global civilization as a whole. In Doris Lessing's *Memoirs*, for instance, the narrator finds no comfort in the prospect of escape abroad, for 'things went on there just the same as they did with us' (1974: 102). The civil disorder in Britain has its foreign analogue in Muriel Spark's Italy in *The Takeover* (1974), Graham Greene's South America in *The Honorary Consul* (1973), Angela Carter's America in *The Passion of New Eve* (1977), V. S. Naipaul's Africa in *In a Bend in the River* (1979) and Margaret Drabble's Eastern Europe in *The Ice Age* (1977) – all of which suggest that the geo-political and cultural contours established at the end of the Second World War were altering irrevocably in the decade. Several other factors give a global perspective to the decade's apocalyptic fictions. Despite a

brief *détente* between the United States and the USSR, formally
instituted by the Helsinki agreement of 1976, the threat of nuclear
catastrophe continued to cause particular anxiety. In Lessing's *The
Four-Gated City*, an accident involving nuclear weapons precipi-
tates the final catastrophe (1969: 652), while the prospect of
planned war between the superpowers haunts Burgess's *1985*
(1978). Such fears are complemented by growing anxiety about
issues such as pollution, over-population and over-exploitation of
natural resources. In *Memoirs*, the narrator and her circle take
'short, reluctant breaths, as if rationing what we took into our
lungs, our systems, could also ration the poisons – what poisons?
But who could know or say!' (1974: 168).

Profound disillusion with contemporary political institutions led
a number of important writers towards a metaphysical or mystical
explanation of the contemporary malaise. Golding's *Darkness
Visible*, for instance, brilliantly, if gnomically, sets its portrayal of
terrorism within a frame of reference derived from *Revelations*, so
that the kidnapping may be one intimation of the disorder which
anticipates the Second Coming. In Drabble's *The Ice Age*, the
representative liberal Englishman Anthony Keating turns to
Boethius's *Consolations of Philosophy*, dedicating his life to 'justi-
fy the ways of God to man' (1977: 282). Prison in an atheistic East
European dictatorship comes almost as a relief from the effort of
trying to make sense of the muddle of both his life and country. In
1985, Burgess's quarrel with Orwell is as much on metaphysical as
political grounds: 'It is perhaps typical of Orwell's wholly secular
culture that he could see the possibility of evil only in the State.
Evil was not for the individual: original sin was to be derided'
(1978: 60). Lessing consistently rejects materialist accounts of the
crisis. In a *New Review* profile of 1974, she told C. J. Driver: 'I
must have been mad . . . thinking that politics comes up with
answers to social problems, which it manifestly doesn't do'
(November: 20). From *The Four-Gated City* (1969) – which cites
chiliastic Sufi texts at a number of key points – to *Shikasta* (1979),
humanity is seen as exacerbating, but not finally determining, the
progressive degeneration which characterizes earth's history.
Shikasta, for instance, sees the decline of the planet Shikasta
(earth) as a consequence of the evil planet Shammat usurping the
influence of the more benevolent Canopus (1979: 355–7).

The extreme determinism of such ideas appears to preclude any
real possibility of social renewal in Lessing's fiction, though it is

just possible that this may be a deliberate provocation to the reader to organize and act before it is too late. Her 1970s novels do posit the existence of a spiritually aware elect which represents a possible model for a reconstituted humanity. Mark Coldridge's commune in *The Four-Gated City*, the narrator of *Memoirs of a Survivor* and Professor Watkins, the protagonist of *Briefing for a Descent into Hell* (1971), form a modern equivalent of the New Testament wise virgins preparing for apocalypse. But however powerful their diagnosis of the malaise about them, such figures are intensely vulnerable to the power of the dominant ideology; Coldridge's commune is scattered and repressed, Charles Watkins is 'rehabilitated' by psychiatric drugs. While the narrator of *Memoirs* escapes into the mystical room 'behind the wall' and a happy band survive the 'Last Days' of Shikasta to re-establish the 'lock' with Canopus from the Andes, ordinary humanity has little chance of escaping the holocaust.

NEW DIRECTIONS: FEMINIST WRITINGS

None the less, it would be a distortion to suggest that the tone of the 1970s novel, or discussion about it, was essentially one of helpless gloom. The emergence of 'feminist' fiction is perhaps the most obvious example of a recognition of the fictional, cultural and social opportunities attendant upon the crisis to which the writers already addressed bear witness. The Women's Movement stimulated new ways of writing which form a clear contrast not just to male writing of the decade but to contemporary women's fiction uncommitted to feminism – against which some of these new writers defined themselves quite as sharply as against its male equivalent. In 'Colette', for instance, Angela Carter attacked 'the revival of the wet and spineless woman-as-hero which graced the seventies', citing the 'zomboid creatures' of Joan Didion's fiction and renewed interest in the 'dippy dames' of Jean Rhys (1982: 177).

It would be a simplification to align Lessing and Drabble with Didion and Rhys in Carter's deliberately polemical set of oppositions, for both certainly identify patriarchy as oppressive to women. In *The Four-Gated City*, the pimp Jake is presented as viciously exploitative and the novel is acute on the coercive nature of fashion and advertising, particularly in the allegedly 'liberationist' 1960s. *The Ice Age* is equally critical, at times, of

traditional gender expectations, seeing them as crucial to the sense of personal crisis which afflicts a number of the female characters: 'For Alison Murray, beauty had for years been identity. She had no other. How could she ever make another, for the second half of her life?' (1977: 95).

None the less there are crucial differences of emphasis between their treatment of such issues and that of writers like Carter. As has been seen, the 1970s fiction of Lessing and Drabble evinces a deep mistrust of political institutions and processes and there is an accompanying suspicion of using art as a political vehicle. Lessing has persistently complained about the appropriation of *The Golden Notebook* for feminist ends and in *The Ice Age* Len watches 'a worthy group of left-wing actors performing a modern morality play about advertising, racism, and the unemployment problem' (p. 183). His verdict upon *agit-prop* as 'inexpressibly naive' (p. 183) is supported by the narrative voice in its hostile depiction of Mike Morgan, whose one-man show seems little more than diatribe.

Moreover, their 1970s novels tend to represent patriarchy not as institutionalized, but as a personal, moral aberration. Thus not only is Jake an exceptional, marginal character in *The Four-Gated City*, but his behaviour is seen as symptomatic of an existential crisis partly excused by the horrors of war he has witnessed. Moreover, it is only at the point that Jake's exploitation of women becomes an *economic* activity that a critical perspective is turned upon him. Hitherto his sexuality is presented as a liberating force. In *The Ice Age*, the one truly rebellious female, Jane, is presented unsympathetically and her point of view is given the least dramatic space of all the female characters. The career of Maureen Kirby, who treats her body as a commodity with a limited shelf-life, is seen conventionally, as an individual moral choice, with her disloyalty in time of crisis to Len contrasting unfavourably with the fidelity of Alison towards Anthony.

Similarly, the mental suffering of female protagonists such as Martha Quest or Alison is presented principally as an existential condition rather than a consequence of gender subordination. *The Four-Gated City*, like much of Lessing's fiction, effectively challenges orthodox definitions of 'madness' and provides an acute critique of the institutions and assumptions of mainstream psychiatry. To some extent, it shares disquiet about the sexual politics of Freudian psychoanalysis typical of contemporary feminist

thinking such as Eva Figes's *Patriarchal Attitudes*, Germaine Greer's *The Female Eunuch* or Kate Millett's *Sexual Politics* (all 1970). But despite the 'break downs' which the female characters endure (Martha, Mrs Quest, Lynda, Phoebe, Dorothy, Elizabeth) – and such 'hysteria' is much less characteristic of the male protagonists – their mental stress is symptomatic of the 'general madness' (p. 614) caused by the dislocation of the times – which in the end has metaphysical determinants. In *The Ice Age*, Alison's unequivocal judgement on 'female hysteria' remains unchallenged by the authorial voice: 'Kitty had chosen the non-self: she, herself, Alison, had chosen a non-self: Anthony and Len had been themselves. Was that something to do with the difference between men and women? Surely not' (p. 157).

Women's political and cultural emancipation is thus never seen by either writer as a precondition for social renewal. In the new society founded at the end of *The Four-Gated City*, for instance, the economy of gender roles is much like that in the perished civilization. *Memoirs* is scornful of the 'women's group' which organizes as catastrophe threatens: 'They were self-consciously and loudly critical of male authority, male organisation. . . . Yet the leader seemed to find it necessary to spend a great deal of energy preventing individuals of her flock from straying off and attaching themselves to the men' (p. 144). *The Ice Age* represents any solution to the predicament of its women characters as 'beyond imagining': 'Britain will recover, but not Alison Murray' (p. 287).

By contrast, many women novelists of the 1970s saw feminism as a force comparable to any of the decade's ostensibly revolutionary groupings. Tennant's *The Bad Sister* (1978), Weldon's *Praxis* (1978) and Fairbairns's *Benefits* (1979), for instance, involve feminists who resort to murder to advance their cause. Whilst sensitive to issues of class and racial injustice, the focus of these writers is on patriarchy as an *institutionalized* discourse over-determining all other forms of oppression. This involves rethinking the treatment of many issues raised by Lessing and Drabble. For instance, *The Bad Sister* and *Praxis* see 'female hysteria' specifically as an issue of sexual politics. In the former novel the editor rejects the validity of the (male) psychiatrist's diagnosis of Jane as a paranoid schizophrenic because he 'showed little interest in the "political" factor involved in her conversion' (p. 137). Despite editorial uncertainty about how, finally, to interpret the events, the evi-

dence suggests that the patient's split personality is 'a condition passed on from divided mother to divided daughter until such day as they regain their vanished power' (p. 137). In *Praxis*, the mental asylum is filled with 'deserted wives' and 'wives committed by their husbands' (p. 169) and all the female members of Praxis's family can be considered, conventionally, as 'mad'. But Praxis gradually comes to see such mental stress as generated by the inferior social and economic status of women: 'I was prepared to believe . . . that I had to cure myself to cure the world. Now I believe I have to cure the world to cure myself' (p. 149).

A distinctive strategy of such novels is the violent disruption of what Carter's *The Sadeian Woman* (1979b) describes as 'the imaginary brothel where ideas of women are sold' (p. 101). This provides a further crucial difference of emphasis between the new feminist writers and the kind of fiction described in the first section of this chapter which characteristically presents 'cultural levelling' as one symptom of impending catastrophe. For writers like Weldon and Carter, 'the high culture' whose decline so exercises figures like Bradbury and Powell is seen as deeply implicated in the practices of 'the imaginary brothel'. Thus in *Praxis*, the protagonist's espousal of feminism involves jettisoning 'belief in the man-made myths of history – great civilisations, great art, great empire. The male version of events' (p. 262).

Reinterpretation of the cultural canon according to feminist criteria involves significant revaluations. In *The Sadeian Woman*, Carter invokes the marginal figure de Sade as an inspiration for revolutionary feminists 'because he is capable of believing, if only intermittently, that . . . only a violent transformation of this world and a fresh start in an absolutely egalitarian society would make this possible' (pp. 23–5). Conversely, Carter's 1970s fictions adapt and interrogate culturally central narratives in order to demonstrate their complicity in 'the imaginary brothel'. Examples include her deconstruction of the gender politics of 'Genesis' in *The Passion of New Eve* (1977) and of fairy tales in *The Bloody Chamber* (1979a). D. H. Lawrence is a favourite target. In her 1975 essay 'Lorenzo as closet-queen', Carter echoes Kate Millett's *Sexual Politics* (1970), arguing that writers 'who preach phallic superiority usually have an enormous dildo tucked away somewhere in their psychic impedimenta' (1982: 162). Lawrence's prestige as a modern writer, she suggests, rests upon mistaken notions of his sensitivity to the material realities of women's experience.

Instead of revealing these, Lawrence in fact literally covers them up in his fetishistic attention to objects of female clothing. 'The con trick . . . is that his version of drag has been widely accepted as the real thing, even by young women who ought to know better. In fact, Lawrence probes as deeply into a woman's heart as the bottom of a hat-box' (p. 168).

Heroes and Villains (1970) displaces many of the structures and thematic concerns of Lawrence's *The Virgin and the Gypsy* (1930) into an apocalyptic future typical of many 1970s novels. (Like *The Four-Gated City*, Carter's novel draws specifically on Wyndham's 1955 novel *The Chrysalids*.) These parallels underpin Carter's critique of her predecessor's presentation of a 'new woman'. The sterile, repressive, world of the Vicarage, for instance, has its analogue in the Professors' society and the class conflict in Yvette's world becomes civil war in Marianne's, where the Barbarians have the qualities of Lawrence's gypsies in exaggerated form. Above all, the two works are linked in their focus upon a young woman's rebellion against the norms of patriarchal society.

Lawrence's criticism of these norms is, in certain respects, searching. The family's dismissal of Cynthia's rebellion as 'madness' (p. 167) is undercut by the ironic narrative voice, and the determination of mother and daughter to express their sexual identities outside a purely reproductive role is clearly approved of. But to read *Heroes and Villains* side by side with Lawrence's text is to see the limitations of his critique. Marianne's final emergence as an independent, empowered woman (' "I'll be the tiger lady and rule them with a rod of iron" ' (p. 150)) suggests the degree to which Yvette's freedom is in fact *contained* by the assumption that she can only achieve full identity through a sexual relationship with a man. (The description of Aunt Cissie as a 'frustrated spinster' and Mater as a 'useless' old single woman mark a path which Yvette must be careful not to follow.) Yvette's 'liberation' can only be accomplished by searching, like Mrs Fawcett, for a new way of relating to men, not on her own. It is further circumscribed by the assumption that Joe is merely a stage on her journey to a traditional bourgeois match: 'And the fling meant, at the moment, the gipsy. The marriage, at the age of twenty-six, meant Leo or Gerry' (p. 237).

Lawrence presents Yvette as essentially passive and incomplete, however much she appears to have the opposite qualities in comparison with her female peer-group: 'The child-like, sleep-walking

eyes of her moment of perfect virginity looked into his, unseeing. She was only aware of the dark strange effluence of him bathing her limbs, washing her at last, purely will-less. She was aware of *him*, as a dark, complete power' (p. 216). While Joe is powerful and 'complete', Yvette is constructed in binary opposition by a series of negatives ('unseeing, will-less') and as acted upon ('him bathing her limbs'). 'Sleep-walking' suggests 'Sleeping Beauty', a connotation reinforced by descriptions of Yvette waiting like the Lady of Shallott (pp. 203, 236). The adjective 'child-like' and the allusion to her 'perfect virginity' (contradictorily suggesting both fullness and lack) paradoxically desexualizes her at the very moment the author is celebrating the power of her desire.

That the gender role against which Yvette rebels is specifically characteristic of a bourgeois milieu is also rejected by *Heroes and Villains*. Lawrence endows the socially marginal gypsies with a freedom from convention which can only be otherwise attained, as in the case of Mrs Fawcett, by complete economic independence. By contrast, Carter suggests that patriarchy cuts across class divisions, so that while in some sense Jewel rescues Marianne from the Professors, rather as Joe liberates Yvette from the Vicarage, it is only to deliver her into a new and more horrifying servitude. Marianne's virgin body, the site upon which Jewel attempts to exercise his power through rape, is given a materiality quite lacking from Lawrence's description of Yvette's first sexual experience: 'Feeling between her legs to ascertain the entrance, he thrust his fingers into the wet hole so roughly she knew what the pain would be like; it was scalding, she felt split to the core. . . . Afterwards, there was a good deal of blood' (p. 55).

Throughout Carter's fiction there is invincible optimism that the liberation of women is attainable. The fiction of Tennant, Weldon and Fairbairns is less sanguine. A key doubt concerns strategy. *Benefits* and *The Bad Sister* are clearly ambivalent about revolutionary feminism. In the latter novel, Meg's 'commune of radical feminists' (p. 18) is sympathetically represented in so far as it mobilizes against the diehard patriarchy of Dalzell and Tony. But at another level Meg is a sinister autocrat whose influence over Jane is finally destructive. So while Meg offers Jane freedom and empowerment on certain levels, Jane's hatred of her half-sister Ishbel (who is innocent of any of the wrongs committed against Jane's family by Dalzell) suggests a disquiet on Tennant's part that this kind of feminism divides her gender by an unwarranted

hostility towards 'straight' women. (A similar anxiety underlies Carter's representation of the Amazon commune in *The Passion of New Eve* – and Fairbairns's of Posy in *Benefits*.) Tennant's sense that revolutionary feminism might ignore the potential for broader alliances is also evident in her piece in the 1978 *New Review* symposium. While welcoming 'the emergence of a heroine in fiction with a more robust identity' (summer: 66), she expressed concern that the new 'feminist-inspired fiction' (p. 65) might construct a readership 'ghetto.'

Fairbairns explores the contrary dangers of attempting to give feminism too broad a base in contemporary society. In this respect, *Benefits* differs sharply from Carter's *Passion of New Eve*, which sees the revolution succeeding through a broad alliance of women, blacks and (in this case literally) reconstructed males. *Benefits* records the plight of a feminist commune within the context of economic retrenchment and the rise of the New Right, represented chiefly by the organization 'Family'. From their decaying inner-city high-rise, the commune sets up a programme which achieves success outside, notably in mobilizing women over questions of abortion, child-care provision and male violence. But its radical thrust is blunted by a combination of internal division and the entrenched patriarchy of institutions as diverse as the state, social services and trades unions. But it is also, crucially, diluted by its success in forming an alliance with disaffected 'Family' members and with a constituency of 'new men'. Thus on the one hand the novel suggests that, by confining itself to the 'ghetto' represented by the tower, the Women's Movement is in danger of failing to consolidate its initial successes: on the other that the consolidation of those successes depends on alliances which threaten to dissipate the specifically gender-based political character of the Movement.

Issues of class and race produced further complications in feminist fiction, as the case of Buchi Emecheta demonstrates. Several of her 1970s novels, such as *In the Ditch* (1972) and *Second-Class Citizen* (1974), chart the experiences of 'New Commonwealth' immigrant women in metropolitan Britain. While Emecheta shares the preoccupation of white feminist writers with issues such as male violence, educational and economic discrimination, and the specific problems facing women as writers and single mothers, her treatment of them has significantly different inflections.

In both novels Adah struggles with a metropolitan racism which

is not gender-specific. Precisely because of the employment disadvantages which confine them to the estate in *In the Ditch*, Adah is exposed to racism principally through white women. Similarly, in *Second-Class Citizen*, she experiences it most brutally from a socially marginal (elderly, single, working-class) white woman. But while Adah eventually forms an alliance with such women, based on resistance to shared deprivation, her affiliation to feminism is complicated by her Nigerian background. For all the oppression which Adah experiences as a girl, a wife and young mother, she sometimes reaffirms the institution of the family in ostensibly patriarchal terms. Moreover, while the failure of Adah's marriage involves, for most of the novel, a sophisticated critique of gender relations, there is finally a dramatic shift of perspective which involves the deep paradoxes of cultural difference: 'If Francis had been an Englishman, or if Francis had not been Francis but somebody else, it would have worked and Adah would willingly have packed up her studies to be a housewife. . . . It was a way of telling him that that was all she asked of life. Just to be a mother and a wife' (p. 179). 1970s 'feminist' writing must, then, be seen differentially. As Carter suggests, the 'notion of a universality of human experience is a confidence trick and the notion of a universality of female experience is a clever confidence trick' (1979b: 12).

CONCLUSION

Since the fall of Thatcher in 1990, it is arguable that the New Right which developed in the 1970s has now itself been marginalized as an effective political force. This makes it more difficult than ever to see the 1970s as a nightmare from which Thatcherism awoke a stricken Britain. Equally, some of the pessimism about the state of the novel as a cultural form in the decade now seems exaggerated. In material terms, the situation was never quite as bad as suggested at the outset of this chapter or in the introduction. Greenfield makes the point that even during Heath's three-day week 'in spite (or perhaps because) of the fuel crisis, the output of new fiction actually *rose*' (1989: 127). According to the Publishers' Association, 1978 was the only blip in an otherwise uninterrupted increase in the number of fiction titles published (1981: Table 3). And spending on books as a percentage of total consumer expenditure grew throughout the decade, while that of newspapers and

magazines declined (1981: Table 8). The climate was buoyant enough to support four major new literary magazines (*New Review* (1974), *Bananas* (1975), *Literary Review* and *Granta* (both from 1979)), in addition to established titles like the *London Magazine*. And while bookshop margins were under pressure, in 1978 *The Bookseller* suggested that 'the overall picture is very much healthier than it was twenty years ago'; those who survived the shakeout of the mid-1970s could anticipate a 'period of profitability' (18 March 1978). Even at the height of the recession, publishing could be highly profitable. Sutherland cites the example of Heinemann which made profits of £3 million on a turnover of £15.5 million in 1976 (1978a: 9).

The apparent indifference of the state also needs re-examination. Retrenchment of the Literature Department of the Arts Council in terms of the number of writers it supported must be set against the provision of larger grants to successful applicants. According to Hewison, allocation of funds to the Literature Department grew nearly three times (far faster than inflation) between 1968 and 1973 (1986: 247). Modest further support for some fiction writers, at least, was indirectly provided by the state when PLR reached the statute book in 1979, with the first payments arriving in the next decade.

Patronage from industry also developed apace, the most notable example perhaps being the foundation of the Booker Prize (1969), worth £10,000 by 1978; whatever distortions it may have created in publishing and consumer behaviour, it undoubtedly stimulated widespread sales of short-listed writers. The *New Review*'s 'Edward Pygge' commented ironically on the growth of such awards, suggesting that 'writers are so carpet-bombed with prizes . . . that they need to be really bad or unlucky to avoid picking up something' (3 (34/5), 1977: 78). And whatever the threat of television, it also encouraged new readers through book programmes like Thames Television's *Writers' Workshop* and the BBC's *Read All About It*, through prestige serializations of established writers, living and dead, and by providing script-writing and other work for a minority of contemporary novelists. (It also suggested to many younger writers – Tennant (1978) and Martin Amis (1978) spring to mind – a range of new possibilities in narrative discourse.)

Moreover, the increased costs of fiction did little to prevent writers such as Burgess and Bradbury from writing critically acclaimed bestsellers lamenting 'the death of the novel' and the

loss of a reading public. This should make one particularly scepti-
cal of the linkage often made between the decline of the novel and
the decline of the English language. As 'Edward Pygge' com-
mented in the *New Review* (February 1978): 'There are more and
more linguistic disciplinarians around, of a conservative political
leaning, bringing out silly books of rules to prove that civilisation
started going downhill the moment literacy hurdled the monastery
wall and started mixing with the plebs' (4 (47): 64). It was not just
that if the barbarians were at the gates, they were paradoxically
clamouring for *The History Man* or *1985*. New writers like
McEwan and Martin Amis showed how effective the speech of the
streets could be as a literary resource and a host of 'Common-
wealth' and immigrant writers demonstrated the rich possibilities
of 'non-standard' English.

In retrospect, Per Gedin seems to strain rather desperately to
support his conviction of the imminent extinction of fiction as a
cultural practice. His pessimism rests on such unwarranted asser-
tions as: 'If one wishes to penetrate to the very essence of an event
in a concentrated way one uses poetry or writes non-fiction directly
from reality' (1975: 182). Sutherland provides a more upbeat
perspective, likening 'the galvanic shock' to the fiction industry in
the 1970s to similar crises in the 1820s and 1890s which then
ushered in long periods of price stability and expanding reader-
ships. Arguing that it had become 'inert, backward-looking and
over-controlled' (1978a: xxiii), Sutherland called for an industry
which 'supports heterogeneity and caters for what are, essentially,
a multitude of minority readerships' (p. xxxv). But with a second
deep recession since Sutherland wrote, many 1970s arguments
over library provision, the Net Book Agreement and the viability
of new hardback fiction have resurfaced in the early 1990s, and
judgement must be reserved on whether the crisis of the 1970s has
really led to a stable publishing industry.

Formally, the 1970s saw the consolidation of a fertile and vigor-
ous synthesis of two narrative modes which had begun to converge
in the 1960s – 'high realism' and 'experimentalism'. The former
was still capable of great achievement as Paul Scott's *Staying On*
(1979) or David Storey's *Saville* (1976) testify, and it retained its
attraction for emerging novelists like Penelope Fitzgerald and
Penelope Lively, who in due course enjoyed considerable critical
success. But, overall, the evidence supports J. G. Ballard's conten-
tion in the *New Review* symposium that realism as traditionally

conceived 'seems finally to have run out of gas' (summer 1978: 19) and the trend was for even its established practitioners to experiment with narrative models traditionally held at arm's length. In Drabble's *The Ice Age*, Anthony Keating defends traditional realism (1977: 144), but the novel plays with the conventions of the mode in an ironic, self-conscious way (pp. 237, 286) and Anthony's journey to Eastern Europe is pastiche thriller drawing quite explicitly on Le Carré. Equally, Lessing's *Four-Gated City* turns from the pure realism of most of her early novels, inaugurating a phase characterized by a mixture of realism, science fiction and autobiography.

High realism's traditional 'other' in the post-war era, experimental fiction – shaped principally by Modernism and the *nouveau roman* – also seemed to lose its way in the 1970s, despite excellent work from figures like Eva Figes, Alan Burns and B. S. Johnson. This may have been due, as Josipovici, Giles Gordon and other practitioners complained in the *New Review* symposium, not just to the economic pressure of a recession, but to the hostility of the reviewing establishment, which they saw as evidence of entrenched parochiality in British cultural life. (John Sutherland, on the other hand, argued in the *New Review* (1978b: 17) that the reviewing establishment was permeated by 'an ethos of dilute avant-gardism'.) Eva Figes, however, was unsure where the blame lay: 'We have failed to change the English literary scene, or it has failed us' (*New Review*, summer 1978: 38). In retrospect there certainly seems to have been a tendency towards the mandarin and self-absorbed in some of the experimental fiction of the period. Christine Brooke-Rose's *Thru* (1975), for instance, contains a warning to readers which is not altogether tongue-in-cheek: 'You are now entering the Metalinguistic Zone. All access forbidden except for Prepared Consumers with special permits from the Authorities' (p. 51).

The apparent exhaustion of much experimental writing led Brian Aldiss to lament 'the collapse of a genuinely exploratory avant-garde' in contemporary fiction (*New Review*, summer 1978: 17). But it is perhaps now possible to argue that its apparent demise was actually a symptom of its success; as Bernice Martin suggests (1981), once realism had been decentred, much of the rationale for an experimental fiction was lost (pp. 96–8). Many of its techniques and the epistemological assumptions which underpinned them became absorbed during the decade into a new kind of mainstream which still drew heavily on realism, as the *New*

Review symposium suggests. A. S. Byatt, for example, sought 'an eclectic way' (summer 1978: 29) to synthesize what was best in both and Aldiss himself noted the emergence of a number of new writers 'who operate like banditti between various well-defined stretches of literary territory' (p. 17). Typical of these was Martin Amis, who described his fiction as an attempt to reconcile Robbe-Grillet with 'the staid satisfactions of pace, plot and humour' of Jane Austen (p. 17). Amis's own work suggests that such accommodations were a good deal more dynamic than a term like 'the aesthetics of compromise' (Lodge 1970) might suggest.

This compromise involves a significant rethinking of the cultural politics associated with choice of narrative form. The traditional preference of writers of the Left for realism (established in the 1930s) was still in evidence in the 1960s in the work of figures like Raymond Williams and was not altogether abandoned in the following decade, as Alan Burns's *The Angry Brigade* (1973) or William McIlvanney's *Docherty* (1975) suggest. Indeed, Burns turned away from experimentalism to realism as a conscious political act (1981: 117). But higher-profile socialist writers like David Caute and John Berger travelled in the opposite direction, in *The Confrontation* trilogy (1970–1) and *G* (1972) respectively. Caute's *The Illusion* (1971) calls for 'a dialectical novel' capable of combining social engagement with the critical self-consciousness of Modernism: 'A literature which invites its audience to question the prevailing social structure and social consciousness must constantly question and expose itself' (p. 22). *G*, equally, is the fruit of Berger's reconsideration, as a result of his study of Picasso (1965), of his 1950s polemics on behalf of realism. For Berger, Cubist painting prior to 1914 demonstrated the possibility of an artistic practice grounded in dialectical materialism and *G* represents an attempt to adapt many of the techniques of Cubism to a socialist aesthetic. At the same time, *G* is a determinedly historical novel (set in 'the moment of cubism') along Lukácsian lines, engaging with a pan-European nationalist crisis with parallels to events contemporary to Berger's own writing.

Apologists for the experimental novel often argued that the mode was socially progressive precisely because realism was a form ideologically compromised by its 'naturalization' of the constructed social world (and its status as the dominant post-war novelistic discourse). Thus Julia Kristeva's category of 'the semiotic', elaborated in *Desire in Language* (1977), suggests that avant-

garde writing established a revolutionary new *écriture* by rejecting the characteristic strategies and modes of the realist mainstream. Kristeva's theory descends ultimately, via Barthes, from the 'negative aesthetics' model provided by Adorno to defend Modernism against Leftist charges of decadence exemplified in Lukács (1957). The 'semiotic' also brings a potentially powerful feminist inflection to the debate, referring as it does to a specifically female psychic and libidinal economy which is repressed by the patriarchal 'symbolic', a term which includes the field of textual representation. In avant-garde practice, Kristeva suggests, 'the semiotic' disrupts and threatens to overturn the 'symbolic', in which patriarchy is conflated with realism. According to Elizabeth Grosz, the implications of this are revolutionary: 'The avant-garde is a catalyst of social upheavals through its capacity to induce crises of representation, expressing and liberating the otherwise unarticulated *jouissance* of the semiotic' (1989: 55).

Grosz acknowledges a number of tactical difficulties in claiming Kristeva for feminism, notably her privileging of a male avant-garde over female practitioners like Woolf. But Kristeva's argument seems fundamentally flawed on a strategic level. Not only is the (often elitist and politically right-wing) avant-garde upon which Kristeva concentrates now institutionalized within the canon, but its contemporary descendant, post-modernism, has flourished in the 1980s, the decade which witnessed the triumph throughout the West of the most reactionary political formations to have emerged since the 1930s. Far from disrupting this process in any revolutionary way, post-modernism has, perhaps, been complicit in it (see Callanicos 1989).

In any case, as Rita Felski (1989) has pointed out, Kristeva's scheme involves the dangers of biological/textual essentialism against which much contemporary feminism has mobilized. Dismissing 'simplistic homologies' (p. 10) between textual and sexual politics, Felski rejects 'an abstract conception of feminine writing practice, which in recent years has been most frequently derived from an anti-realist aesthetic of textuality' (p. 2). Proposing instead a context- and reception-based definition of feminist fiction, she is able to recuperate the traditionally realist forms of confession and the novel of self-discovery as appropriate genres for feminist writers. Felski's argument seems to be corroborated by much of the fiction discussed in the second half of this chapter. For instance, it would certainly be difficult to argue that

any of Lessing's experimental 1970s fiction is more obviously feminist than the semi-autobiographical search for self undertaken in Emecheta's apparently naively realist novels.

Comparison of a feminist like Carter with an obvious cultural conservative like Burgess – to take two representative figures from this chapter – indicates that by the 1970s the use of 'radical' formal strategies can no longer safely be equated with a radical politics. It is not just that both writers converge in their thematic interest, the struggle of the individual to escape the ideological coercions of a totalitarian society. *1985* and *Heroes and Villains* are each apocalyptic texts which interrogate modern classics – Orwell and Lawrence respectively – using the 'popular' mode of science fiction to produce a polemical art of ideas which, by virtue of both writers' deconstruction of literary forebears, is as self-consciously an act of literary criticism as of creation. In a decade often characterized as one in which Britain's consensual culture irrevocably broke down, it is indeed ironic that 'the aesthetics of compromise' should become so dominant in its novelistic practice.

NOTE

1 These themes were also a staple of 'popular' fiction in the decade. See Sutherland's *Bestsellers* (1981: 240–4). The 'disaster' movie genre (*Towering Inferno*, *Earthquake*, *Airport*, etc.) is a further variant.

FURTHER READING

Kermode (1966) provides an essential cultural history of the eschatological imagination prior to the decade. Little has been published on the novel in the 1970s specifically, though Bergonzi (1970) and Bradbury and Palmer (1979) provide useful, if conflicting, estimations of its state of health at either end of the decade. Gedin (1975), Greenfield (1989), Hewison (1986) and Sutherland (1978a) are recommended on the fiction industry and its cultural politics. Waugh (1984) and McHale (1987) are good on 'experimental writing', while Felski (1989), Alexander (1989) and Anderson (1990) are recommended on contemporary women's writing. Palmer (1989) provides a radical feminist assessment of the field and includes a useful glossary of the varieties of feminist writing.

SELECT BIBLIOGRAPHY

Adams, Richard (1972) *Watership Down*, reprinted Harmondsworth: Penguin, 1974.

Alexander, Flora (1989) *Contemporary Women's Novelists*, London: Arnold.

Amis, Martin (1978) *Success*, reprinted Harmondsworth: Penguin, 1985.

Anderson, Linda (ed.) (1990) *Plotting Change: Contemporary Women's Fiction*, London: Arnold.

Berger, John (1972) *G*, reprinted Harmondsworth: Penguin, 1976.

Bergonzi, Bernard (1970) *The Situation of the Novel*, London: Macmillan.

Bookseller, The no. 3760, 14 January 1978; no. 3769, 18 March 1978; no. 3763, 4 February 1978; no. 3766, 25 February 1978.

Bradbury, Malcolm (1975) *The History Man*, reprinted London: Arena, 1984.

—— (1976) 'I want it here', *The New Review* 3(33) (December): 39–41.

Bradbury, Malcolm and David Palmer (1979) *The Contemporary English Novel*, London: Arnold.

Brooke-Rose, Christine (1975) *Thru*, London: Hamish Hamilton.

Brophy, Brigid and Maureen Duffy (1972) *Ex Libris: The Working Writers' Report on PLR*, London: Writers' Action Group.

Burgess, Anthony (1978) *1985*, reprinted London: Arrow, 1980.

Burns, Alan (1973) *The Angry Brigade: A Documentary Novel*, London: Allison & Busby.

Burns, Alan and Charles Sugnet (1981) *The Imagination on Trial: British and American Writers Discuss Their Working Practice*, London: Allison & Busby.

Callanicos, Alex (1989) *Against Postmodernism: A Marxist Critique*, London: Polity.

Carter, Angela (1970) *Heroes and Villains*, reprinted Harmondsworth: Penguin, 1981.

—— (1977) *The Passion of New Eve*, reprinted London: Virago, 1982.

—— (1979a) *The Bloody Chamber*, reprinted Harmondsworth: Penguin, 1981.

—— (1979b) *The Sadeian Woman: An Exercise in Cultural History*, London: Virago.

—— (1982) *Nothing Sacred: Selected Writings*, London: Virago.

Caute, David (1971) *The Illusion: An Essay on Politics, the Theatre and the Novel*, London: Deutsch.

Drabble, Margaret (1977) *The Ice Age*, Harmondsworth: Penguin.

Emecheta, Buchi (1972) *In the Ditch*, London: Allison & Busby.

—— (1974) *Second-class Citizen*, reprinted London: Fontana, 1989.

Fairbairns, Zoe (1979) *Benefits*, London: Virago.

Felski, Rita (1989) *Beyond Feminist Aesthetics: Feminist Literature and Social Change*, London: Hutchinson.

Figes, Eva (1970) *Patriarchal Attitudes: Women in Society*, reprinted London: Virago, 1978.

Fitzgerald, Penelope (1978) *The Bookshop*, London: Duckworth.

Gedin, Per (1975) *Literature in the Marketplace*, trans. G. Bisset, reprinted London: Faber, 1982.

Golding, William (1979) *Darkness Visible*, reprinted London: Faber, 1990.

Greene, Graham (1973) *The Honorary Consul*, reprinted Harmonds-

worth: Penguin, 1975.

Greenfield, George (1989) *Scribblers for Bread: Aspects of the English Novel Since 1945*, London: Hodder & Stoughton.

Greer, Germaine (1970) *The Female Eunuch*, London: MacGibbon & Kee.

Gross, John (1969) *The Rise and Fall of the Man of Letters: Aspects of English Literary life since 1800*, London: Weidenfeld & Nicolson.

Grosz, Elizabeth (1989) *Sexual Subversions: Three French Feminists*, London: Allen and Unwin.

Hewison, Robert (1986) *Too Much: Art and Society in the Sixties 1960–75*, reprinted London: Methuen, 1988.

Kermode, Frank (1966) *The Sense of an Ending: Studies in the Theory of Fiction*, London: Oxford University Press.

Kristeva, Julia (1977) *Desire In Language: A Semiotic Approach to Literature and Art*, ed. L. Rodiez, reprinted Oxford: Blackwell, 1980.

Lawrence, D. H. (1930) *The Virgin and the Gipsy*, reprinted Harmondsworth: Penguin, 1971.

Lessing, Doris (1969) *The Four-Gated City*, reprinted London: Granada, 1972.

—— (1971) *Briefing for a Descent into Hell*, reprinted London: Panther, 1975.

—— (1974) *The Memoirs of a Survivor*, reprinted London: Picador, 1976.

—— (1979) *Shikasta*, reprinted London: Granada, 1979.

Lodge, David (1970) 'The novelist at the crossroads', reprinted in Malcolm Bradbury (ed.) *The Novel Today*, London: Fontana, 1977.

Lukács, G. (1957) *The Meaning of Contemporary Realism*, trans. J. and N. Mander, reprinted London: Merlin, 1963.

McHale, Brian (1987) *Postmodernist Fiction*, London: Methuen.

McIlvanney, William (1975) *Docherty*, Edinburgh: Canongate.

Martin, Bernice (1981) *A Sociology of Contemporary Cultural Change*, Oxford: Blackwell.

Millett, Kate (1970) *Sexual Politics*, reprinted London: Virago, 1977.

Naipaul, V. S. (1979) *A Bend in the River*, London: Deutsch.

Palmer, Pauline (1989) *Contemporary Women's Fiction: Narrative Practice and Feminist Theory*, London: Harvester.

Powell, Anthony (1975) *Hearing Secret Harmonies*, reprinted London: Fontana, 1977.

Publishers' Association (1981) *Quarterly Statistical Bulletin*, March.

Scott, Paul (1977) *Staying On*, London: Heinemann.

Spark, Muriel (1974) *The Takeover*, London: Macmillan.

Storey, David (1976) *Saville*, London: Cape.

Sutherland, John (1975) 'Hard times for the novel', *The New Review*, 2 (18) (September): 3–10.

—— (1978a) *Fiction and the Fiction Industry*, London: Athlone.

—— (1978b) 'The reviewing establishment', *The New Review*, 4 (47) (February): 11–18.

—— (1981) *Bestsellers: Popular Fiction of the 1970s*, London: RKP.

Tennant, Emma (1978) *The Bad Sister*, reprinted London: Picador, 1979.

Waugh, Patricia (1984) *Metafiction: The Theory and Practice of Self-Conscious Fiction*, London: Methuen.

Weldon, Fay (1978) *Praxis*, reprinted London: Coronet, 1980.

Chapter 8

Boxed in
Television in the 1970s

Garry Whannel

INTRODUCTION

While the 1970s was a decade of economic crisis, political conflict and cultural change, television by contrast experienced an unusual degree of stability. Indeed the 1970s is the only decade in television not to have been marked by structural innovation. ITV was launched in the 1950s and its franchises were first re-allocated in the 1960s. Channel Four and satellite television were established in the 1980s, and it is already clear that the 1990s will see unprecedented upheavals in television, with the ITV franchise auction to be followed by the launch of Channel Five, and the probable revision of the BBC Charter.

At the start of the 1970s the ITV system was just settling down after the 1968 franchise re-allocation and the subsequent LWT débâcle. LWT had gained a franchise with a bid laden with adventurous intentions to provide quality television, but poor ratings led to boardroom panic, policy changes and the departure of most of the key figures whose presence had led the Independent Broadcasting Authority (IBA) to award the franchise in the first place (see Smith 1974: 130–4). The episode was to be one of the catalysts triggering off a campaign to ensure that the proposed fourth channel would not merely be an ITV mark two. But, despite the belated appearance of the Annan Report (1977), the fourth channel debate only developed into a detailed struggle over policy towards the end of the decade (see Lambert 1982; and Blanchard and Morley 1982). The 1970s, or more exactly the period from 1968 to 1982, constitutes the longest period of structural stability in British television history.

During the 1970s, ITV strengthened its position at the expense

of the BBC, largely owing to the particular economic structure of British television. By the mid-1960s television had reached saturation point, with the vast majority of homes already having a licence. From this time, the BBC could only increase its income by politically unpopular increases in the licence fee. The introduction of colour and the more expensive colour licence in 1968 did provide additional funds, but this was offset by the substantial capital investment colour required. Consequently, high inflation rates in the 1970s hit the BBC particularly hard. By contrast, as advertising revenue remained relatively buoyant, ITV's position strengthened, and they were increasingly able to attract trained BBC personnel, at all levels, to switch to the commercial sector.

To a certain extent the decade saw a convergence of styles and content. The BBC increasingly tried to compete with ITV on its own terms, whilst ITV attempted to challenge some of the BBC's traditional strengths. The provision of serious programmes on ITV between 1969 and 1976 increased at the expense of light entertainment, whilst serious programming on BBC1 was cut by almost 20 per cent (Potter 1990: 227).

BITS AND PIECES: CONSENSUS FRAGMENTATION

The 1970s began with the dis-articulation of the elements of the post-war consensus, and by mid-decade the elements of Thatcherism were establishing themselves within public discourse (Hall 1983). To become hegemonic, Thatcherism needed to re-organize commonsense within its own terms. I am using the term commonsense, as in the writing of Gramsci, to refer to the confused, inchoate and contradictory mass of sayings, aphorisms and philosophical fragments out of which everyday speech is partly composed. Public political discourses try to organize this commonsense, connecting it up to more systematic ideological positions. Popular television occupies a middle position, constituting one of the sites on which the ground of commonsense is constantly trod and re-trod. This does not presume that the practices of television are necessarily linked to the needs of any particular political discourse, despite a general, if highly uneven, tendency to restructure commonsense in the broad interests of the dominant bloc. Because popular culture must address, win and hold the mass popular audience, it must address and incorporate elements of

their own political, cultural and moral projects. This is precisely what makes television a significant site in the continuing struggle of dominant class elements to secure hegemony.

The Conservative electoral victory in 1979, which depended in part on the winning of a stratum of working-class support, suggested some partial success in the construction of a new hegemony, but Thatcherism divided the nation and was unable to secure a new hegemonic stability. Passing through its heroic phase, Thatcherism dominated but only briefly exercised full moral and political leadership (see Hall and Jacques 1983). Popular television in the 1970s constituted one terrain in which, in complex and contradictory ways, the process of dis-articulation and re-articulation of ideological elements could be seen at work. In trying to connect with its audience, television both draws upon and re-organizes commonsense. During the 1970s the ground was shifting, as one political formation fragmented and another fought to establish itself. This process of change produced an uneasy and less self-confident era for television, which tried various strategies to win and hold its audiences.

Yet at certain times during the decade, despite the need to address mass heterogenous audiences, television seemed to become detached from some of the social dynamics of the period. During the 1960s, by way of contrast, television, because of its own relatively liberal orientation, became overly caught up in the reformist *Zeitgeist*. Middle-class progressivist elements within television were synchronized to the processes of social change. During the 1970s, that same liberalism was disengaged from trade union militancy and socialist radicalism on the Left, yet could not be successfully coupled to emergent Thatcherism and authoritarianism on the Right.

From the end of the 1960s the gradual decline in power of the Butskellite consensus began to put increasing pressure on television's posture of impartiality. As political tensions opened up and the parties diverged during the 1970s, media bias became an issue of growing significance. The treatment of trade union issues, strikes and student and political militancy became the subject of close scrutiny, and the work of the Glasgow University Media Group in this area drew some detailed and defensive responses from broadcasting institutions.

The rise of the women's movement helped to make image and representation an issue around which new forms of cultural politics

developed. Traditional stereotypical portrayals of gender roles, the almost total absence of women presenters of news, current affairs and sport and the use of women as visual spectacle all began to attract cogent and forceful criticism. Enoch Powell's interventions in the late 1960s on the subject of immigration placed the issue of race on the public agenda (Seymour-Ure 1974) and the growth of the National Front in the early 1970s contributed to a heightened racial tension. The rise, in response, of anti-racist movements led to an attempt to prevent racist parties from using television to spread propaganda, with a campaign calling for 'no plugs for Nazi thugs' (Cohen 1982). The reaction of broadcasting was defensive, and marked a distinct retreat from the assertive and self-confident liberalism of the 1960s, when one Director-General proclaimed, with reference to racialism, that the BBC was expected to be impartial between Right and Left, but not between right and wrong.

POINTS OF VIEW, WAYS OF SEEING

During the 1970s the Glasgow University Media Group devoted extensive resources to exploring the hypothesis that television systematically favoured the agenda, perspectives and ways of seeing of socially dominant groups. Their findings suggested that television's economics coverage emphasized the high-wage explanation for inflation at the expense of alternative explanations; industrial coverage emphasized disputes at the expense of other stories, and strikes tended to be seen as the fault of workers rather than managers. Most dramatically their study of a Glasgow dustcart strike in 1975 revealed that not one interview with a striker was broadcast (Glasgow University Media Group 1976, 1980, 1982). The Group argued that television's bias constituted a violation of its formal obligations to give a balanced account and suggested that broadcasting institutions had close links with official sources and tended systematically to relay their ways of seeing (Goodwin 1990: 46–8).

The work of the Glasgow University Media Group produced a defensive and at times almost hysterical response from some media professionals. Alistair Hetherington (ex-*Guardian* editor and ex-controller of BBC Scotland) referred to it as 'academic codswallop' and Louis Heren wrote in *The Times* that the team knew 'very little about television or journalism' (Skirrow 1980:

95–9). In retrospect it is clear that the reaction showed that a vulnerable nerve had been struck. Accusations of bias had been made before but never backed up by painstaking work carried out with patient methodological integrity. The debate continued into the 1980s, fuelled by the coal industry strike, and media bias continues to produce heated exchanges (Cumberbatch *et al.* 1986; Sparks 1987; Brown *et al.* 1987; Barker 1988; Cumberbatch *et al.* 1988; Philo 1988).

If television came under pressure from the Left on the grounds of political bias, the new Right that emerged, from the late 1960s, around The Festival of Light and Mary Whitehouse's National Viewers and Listeners Association, mounted an assault on television's supposed moral laxity, a product of so-called 1960s permissiveness. Pressure from this source and the departure of BBC Director-General Hugh Greene in 1968 contributed to a growing caution and a declining willingness to experiment. The Right also were increasingly prepared to attack the BBC for bias towards the Left, seeing Broadcasting House as a haven of over-permissive Left-liberals.

Accused of bias from both sides, broadcasters claimed that this only showed they had the balance right. But the decline of consensus politics and the emergence of the new phase of turmoil in the north of Ireland placed the relation between broadcasters and the state under new strain, with broadcaster's day-to-day independence increasingly encroached upon. A major row between Harold Wilson and the BBC over the 1971 programme *Yesterday's Men*, which explored the personal impact of the 1970 election defeat on ex-Cabinet Ministers, soured relations between the Labour Party and the BBC for much of the decade, and confirmed Wilson's own deep suspicions of the Corporation (Tracey 1977). *The Question of Ulster*, a 1972 debate on the Irish issue, was eventually only screened by the BBC, in altered format, after intense government pressure (Schlesinger 1978). The episode ushered in an era which saw an ever lengthening list of programmes, both factual and fictional, that encountered problems, were altered or were simply never screened as a result of growing institutional caution, inspired by governmental pressure, both open and covert (May and Rowan 1982).

The heightened caution, the weakening confidence in the impartiality of broadcasting, the crises in relations with the state and the reaction to *Bad News*, both from those on the Left who took it as

proof of their case and from those in the media who felt them-
selves under attack and responded in retaliatory fashion, all pro-
vides compelling evidence of a fracturing of consent and a growing
crisis in authority. The ability of the dominant bloc to continue to
exert effective moral and political leadership in the form of welfare
statism and Butskellite consensual politics had been significantly
eroded. The elements of a new authoritarian populism were start-
ing to emerge. The crisis for television was that, whilst being
required to be impartial, it was no longer clear where the point of
balance lay.

THE POLITICS OF DRAMA

Just as news, with the growth of the bias debate, became a
contested and politicized site, so discussion of drama was also
inflected by the changing climate. Particular plays, most notably
the work of Loach and Garnett, became indentified as political
drama. Their work underwent increasing scrutiny and monitoring
from within the broadcasting industry, and was attacked from the
Right for being propagandist and for supposed distortions of
reality. Of course all drama is political, but inasmuch as they had a
clear political intent and focus to their work, Ken Loach, John
McGrath, Trevor Griffiths and Jim Allen could all fairly be
regarded as producing political drama. In the 1970s, however, the
status of their work triggered growing debate and controversy. As
Ken Loach has shrewdly pointed out, their critics typically tried to
translate political issues into aesthetic ones. At the BBC, rather
than try and directly censor scenes, executives would suggest that a
scene did not work well.

 Cathy Come Home (BBC 1966)[1] established the particular
'grainy realism' that was to be the hallmark of Loach and Garnett's
style of drama, but the subject matter, homelessness, and the
liberal social climate meant that it could be interpreted in liberal
consensual terms as a plea for reforms. *Cathy* was read as a human
tragedy, and everyone could easily be in favour of dealing with
homelessness. A massive public response led to the emergence of
the organization Shelter. On the one hand, *Cathy* had been highly
successful as a drama aimed to produce action as well as emotion;
but it failed to confront people fully with the underlying factors
producing homelessness, allowing them to feel it was largely
merely because bureaucrats were heartless.

The subsequent work of Loach and Garnett, in the 1970s, harder edged and more explicitly socialist, challenged this cosy consensuality and in the new, more confrontational social context became the focus of debate and controversy. *Days of Hope* (BBC 1975) offered an interpretation of events in working-class history between 1914 and 1926, in particular portraying the General Strike as a betrayal of the working class by trade union bureaucrats and Labour politicians. The subsequent public discussion revolved around the correctness of this interpretation of history. Many confusions underlay the debate, most notably in the belief that there is one historical truth, rather than a range of interpretations from different viewpoints, and that the role of drama is that of accurate reflection. The work of Loach and Garnett and others, which became labelled, rather misleadingly, drama-documentary, was threatening the solidity of factual/fictional distinctions (Kerr 1990). But in the end, it was the political content rather than the aesthetic form that produced the Right-wing critical response. The early 1970s ITV drama series *Upstairs Downstairs* had also featured the General Strike, with characters adopting various positions but with a stress on notions that the strikers were 'holding the country to ransom', 'nobody wants this wretched strike', 'it must not be allowed to succeed' etc. These viewpoints, of course, were not publicly attacked for being political, biased or a distortion of the truth (McArthur 1982).

While the public debate focused on historical truth, a more rarified academic debate examined the nature of realism and its relation to effective political drama (Bennett *et al.* 1981: 285–352). Colin MacCabe argued that the realist drama of Loach and Garnett could not produce contradictions to be resolved by the viewer. Rather, they offered a dominant narrative discourse with the viewer placed in a privileged position from which all contradictions could be seen to be resolved and from which a correct understanding could be gained. This was counterposed to Brechtian anti-realist drama which aimed to reveal the mechanisms of meaning production, leaving contradictions open, to be worked on by an active and reflective spectator (MacCabe 1974, 1976).

MacCabe's argument was criticized for being formalist, for implicitly advocating the superiority of a particular formal strategy, independently of considerations of content. Brecht himself believed that the appropriate aesthetic means for educating the

spectator and revealing the real nature of social relations vary according to the medium and the nature of the period. We do not know what his own strategy for British television drama in the 1970s would have been, so it is not really valid to recruit him for one side or the other in this debate.

The debate did highlight the dominance of realism on British television. It is notable that there has been far less anti-realist drama on television and very little politically explicit anti-realism. The most striking example from the period was John McGrath's *The Cheviot, The Stag and the Black Black Oil* (BBC 1974), which presented and juxtaposed episodes of Scottish history told in terms of colonial exploitation by the English, allied with Scottish landowners, and the American oil industry, allied with the British government (McArthur 1978). Despite the highly entertaining style of *The Cheviot*, there appeared to be a strong strand of conservatism within the BBC drama department that felt uneasy about the ability of anti-realist forms of production to win audiences. A combination of aesthetic and political caution marginalized Brechtian anti-realism and maintained realism in the mainstream.

So despite the debates over *Days of Hope*, realism remained a more viable option for writers wishing to produce political drama. Just as there had been debates in both the public and the academic spheres, so there was also discussion amongst playwrights as to the most effective political form. Trevor Griffiths, determined to work in the heartland of popular culture even if formal compromise was necessary, wrote the drama series *Bill Brand*, (ITV 1976), the story of a Labour politician running for parliament. The thirteen episodes and the serial narrative structure gave Griffiths the space to incorporate extensive political discussion and long monologues, mostly from Brand. Through Brand's relations with his wife and his lover, the series also concerned gender politics and the relation of personal and political. Unlike some other political dramas both before and since, the series tried not to compartmentalize. It traced the ways in which Brand's personal life had implications for his political trajectory and vice versa. It picked up on some of the implications of the feminist slogan 'the personal is political' by portraying the potential contradictions between the two, and the problems men often have in reconciling them. The series had some success in reaching the popular audience, but it may well be that the focus of audience interest was in the personal drama of Brand

rather than the underlying debate between reformism and revolution within socialist political debate (Poole and Wyver 1984). In this sense the drama may have been too successful at borrowing elements of soap opera, in effect giving the audience a way of avoiding the implications of the political–theoretical discourse the drama contained. However, until the recent *GBH* (Channel Four 1991), it stood out as the longest and most sustained television attempt to deal with contemporary politics in dramatic form.

LAW AND ORDER: REGAN AND BEYOND

One of the significant developments in the 1970s was the emergence in the political foreground of the law and order theme, which was to become a cornerstone of Thatcherism. Three processes of change, from the late 1950s to the 1970s, were intertwined here. Crime figures suggested a real and objective rise in the incidence of many crimes, although public understanding was severely skewed by the ways in which these statistics were refracted through the popular press. Policing methods changed, with beat patrols on foot being replaced by patrol cars, the introduction of special squads and task forces and the growing use of technology. Television's representations of the police shifted ground so that the cosy paternal parochialism of *Dixon of Dock Green* (BBC 1955) gave way to the concerned but mobile policeman as social worker in *Z-Cars* (BBC 1962), and *Z-Cars* in turn spawned the more specialized and professional squad of *Softly Softly* (BBC 1962). This in turn was superceded by the tougher, even ruthless, *The Sweeney* (ITV 1975), in which Inspector Regan was 'an animal' but 'it's a jungle out there' (Screen Education 1976). Dixon did in fact survive until 1976, but seen through 1970s eyes, Dock Green must increasingly have seemed merely nostalgic – an attempt at magical recovery of an organic community that always was part myth. Regan, by contrast, represented the notion that just as criminals are tough and ruthless and did not keep to the rules, so the police needed to be similarly prepared to rule-break (see Clarke 1982; and Donald 1985). *The Sweeney* marked the high point in the development of the police series genre, both because of its massive popularity and longevity (four series, which have been repeated periodically ever since) and because, whereas until then the genre developed in a relatively linear fashion, after *The Sweeney* it began to fragment into a number of distinct routes. From *Dixon* through *Z-Cars* and

Softly Softly to *The Sweeney*, the genre paralleled the rise of concern over crime, the emergence of 'law and order' as a political theme and the consequent modernization of policing methods. After *The Sweeney* a range of crime fighters emerged – anti-terrorist squads, women police officers, non-white officers, private detectives and comic cops.

The concept of ruthless policing and specialized squads spawned *The Sandbaggers*, *Target* and *The Professionals*. *The Professionals* (ITV 1977), tilted as it was against political 'deviants' or terrorists, marked the appearance in mainstream popular discourse of a New Right authoritarianism, later matched in the factual domain by the elevation to heroic status of the SAS following the (almost) live broadcast of their raid which ended the Embassy siege in 1980. Just as Regan broke the rules in order to nick villains, so the new terrorist villain required in response a specialized squad, shadowy and unaccountable, that made its own rules (Schlesinger *et al.* 1983). *The Professionals* marked the end of one particular road. Bodie and Doyle, the action-men protagonists, seemed to be popular figures, but no further escalation was possible. The forces of law and order could not easily be made more ruthless and more exclusive and still remain figures for popular identification.

The fragmenting social climate, the rise of the women's movement and the increasing visibility of images of multi-culturalism all had their impact on the fragmentation of the police series genre. One consequence of the break up of consensus was a divergence of attitudes to law and order. The New Right were calling for tougher policing, heavier sentences and a return of capital punishment, whilst the Left called for greater controls on the police. It is noteworthy that the fragmentation of the police series genre occurs in a period in which the image of policing was just beginning to suffer. The 1970s began with allegations of police corruption that culminated in three major inquiries and five major trials of London detectives (Cox *et al.* 1977). Student and union militancy in the early 1970s had highlighted the political role of policing, while inner city tensions exposed the police as representatives of white society. The decline of community policing, corruption trials and the perceived failure to win the war against crime all contributed to an erosion of public confidence.

New directions emerged within the genre. *The Gentle Touch* (ITV 1978) introduced a woman police officer as the main character, as did *Juliet Bravo* (BBC 1980), which also harked back to the

community-centred policing of Dixon. Both series played, in rather different ways, with the tensions surrounding the introduction of a female character into a world whose norms and conventions were male centred and male defined. The images of women in these series were neither simply progressive nor traditional, but were precisely situated at the uneasy site of tension between traditional gender roles and changes taking place socially. They had cogency as images because of their relation to social tensions produced by the challenge to patriarchy that the women's movement constituted (see Skirrow 1987).

A black policeman appeared in *Wolcott* (ITV 1981), and *The Chinese Detective* (BBC 1980) also turned on the difference between a non-white policeman and a largely white force. The appearance on the public agenda of 'race', 'racism', 'immigration' and 'multi-culturalism' provided a context by which difference was understood. Detective Ho, in *The Chinese Detective*, was a form of marking difference. It was not just that he was Chinese, but that he was 'not-white'. As such he posed a threat to an entrenched white force, who regarded him with suspicion and treated him, as the outsider, in a racist manner. Yet the fact that he was Chinese also suggested that British television was still not really able to tackle issues of race head on in popular drama. Similarly, it has been argued that *Coronation Street* has never introduced regular black characters because it would force it to confront racism, with consequent disruption to the slightly nostalgic image of organic (white) community that the programme rests upon.

After Regan, a new interest in private detectives emerged in figures like *Hazell* (ITV 1978) and *Shoestring* (BBC 1979), and in formal narrative terms, loners like *The Chinese Detective* and *Bergerac* (BBC 1981) were closer to the traditional 1940s private eye than to the teamwork of police series (Alvarado and Buscombe 1978). The genre also turned to self-parody with the emergence of police-centred sit-coms like *Rosie*.

The massive popularity of police and crime series helped to stimulate drama productions in limited episode form. The memorable *Out* (ITV 1978), in which Frank Ross emerged from prison determined to track down those who had grassed and the police who had fixed the evidence, was a rare example of a popular drama from the criminal's perspective rather than the cops. *Law and Order* (BBC 1978) showed police corruption as absolutely routine, and in its cine-verite-inspired graininess, shaky visuals

and consciously poor sound, made *The Sweeney* look very gla-
mourized by comparison. The extraordinary non-realist drama
series *Gangsters* (BBC 1976), a post-modernist text before its time
if there ever was one, combined intertextual references to *film
noir*, Oriental villains, kung fu, westerns, gangster movies and
silent film comedy etc. as a bewildering mix of ethnic groups
interacted in a complex criminal subculture. While perspectives
were thoroughly dislodged, the viewer was certainly not simply
invited to identify, as in *The Sweeney*, with the forces of law and
order (Bennett *et al*. 1981: 71–84).

Obviously popular culture is in no sense providing a simple
reflection of social change or of public opinion. However, the
extent to which the police genre after Regan explored a range of
divergent images of policing may have been in part a reaction to
the problem of finding an image of policing that could adequately
strike popular chords. The most enduring cop, *Bergerac*, clearly
neither a Dixon nor a Regan, was also distanced from the main-
land and its cluster of inner city issues by his remote island location
of Jersey, cosier than Camberwell but not as serene as Dock
Green. *Bergerac*, in his combination of romantic individualism and
tough professionalism, was distinctly a cop for the 1980s.

MAKE 'EM LAUGH: POPULAR TELEVISION

Popular drama, be it crime series, soap opera or situation comedy,
has to address its audience in meaningful ways, striking chords in
popular commonsense. It is not a matter of reflecting the world in
any simple way. The themes and issues of popular drama, the
characters and their ways of speaking, have to echo the themes
and issues present in the way people are choosing to understand
their world. Popular drama is tapping into commonsense and in
order to work needs to be alert to the constantly shifting forms
through which commonsense is ordered. The situation comedy
Citizen Smith in parodying a left-wing political activist from the
'Tooting Liberation Front', was echoing an emergent anti-leftism
which later surfaced in more organized form in the tabloid attack
on the 'loony left' in the early 1980s. It is more complex, however,
in that popular media products like *Citizen Smith* not only echo
but also help to restructure commonsense, and precisely organize
the ground for the articulation of more coherent ideological ele-
ments, like the construction of left-wing councillors as folk devils.

Coronation Street (ITV 1960) was born at the end of the 1950s as a picture of life in a traditional working-class inner city community (Dyer *et al.* 1977). By the 1970s that picture, always somewhat idealized and over-organic, had begun to look to some distinctly nostalgic. Few of the dynamics of urban change – slum clearance, immigration, gentrification, unemployment and redeployment – touched the programme's world more than fleetingly. Political issues – the miners' strike, the three day week, the troubles in Northern Ireland – were at best referred to only briefly.

For a short but significant period, under producer Susi Hush, the programme tried to introduce some of these elements. In one story line a black soldier turned up in the Rovers with news for barmaid Bet Lynch – her illegitimate son, never before mentioned, had been killed in action in Ireland. Later a distraught Bet attempted suicide (BFI 1983). But audience figures seemed to decline, Hush departed, and her replacement Bill Podmore steered the programme back towards its cosier orientation in which humour was more prominent than social topicality. One implication could be that the audience preferred the nostalgic magical recovery of organic community that the programme offered to images of conflict, division and fragmentation that appeared elsewhere as emblematic of contemporary inner city life.

The rise of the women's movement was, perversely, most marked in that relatively conservative genre, situation comedy. In the 1960s the best situation comedies were rooted in concepts of class and class mobility – *The Likely Lads* (BBC 1964), *Steptoe and Son* (BBC 1963) and *Hancock* (BBC 1961) all revolved around characters who felt trapped by their social circumstances and tried to better themselves, only to be undermined by those around them or by their own limitations. Situation comedies, like other forms of humour, are frequently addressing areas of anxiety in displaced ways.

Just as in the 1960s the limits of social mobility, even in the more liberal social climate of the times, underlay the themes of class and entrapment in many sit-coms, so the politicization of gender and the consequent social unease about traditional gender roles that took shape during the 1970s underlay the greater prominence that gender as a theme acquired. *George and Mildred*, *Butterflies*, *Man About the House* and *Shelley* were all about relations between men and women and in various ways turned on the laughter that grows out of subconscious anxieties. George and Shelley, in their lazi-

ness, fail to fulfil the proper work ethic, just as Rea in *Butterflies* felt unable to perform adequately the housewife role. It was notable that, where George and Shelley typically triumphed over the aspirations of their partners, Rea was perpetually trapped in her circumstances, never quite succeeding in consummating the viewer-teasing relationship with her putative lover. However, the audience could read the family, through Rea's eyes, as being constituted of a series of endless demands, the meeting of which rarely resulted in appreciation. Later sit-coms, like *Solo* and *Agony* in the early 1980s, featured leading characters who positively chose not to be part of a traditional couple relationship.

Class, however, remained an important theme, albeit in changed form. In probably the most successful situation comedy of the period, Bob and Terry returned in *Whatever Happened to The Likely Lads?* (BBC 1972). The title sequences established graphically the two north-easts of the 1970s. Bob was seen against a background of new office buildings and modern housing estates, with his own car and his new white collar job. Terry, returning from the army, was seen missing a bus (actually and symbolically) amidst decaying slum housing and derelict heavy industry. Terry's return threatened Bob's new embourgeoised status, which through Terry's eyes stood exposed as full of false values, stuffy conventions and phoney pretensions. Clearly there was a reference to underlying anxieties about the very real erosion of a whole complex working-class cultural life that was handled in and through the comedy.

Race constituted a more problematic area. A range of attempts to root comedy in racial difference (*Love Thy Neighbour, Mixed Blessings, Curry and Chips*) remained doggedly fixed within a white perspective, and merely exposed the degree to which the stock stereotypes of comedy are imbued with racism. The issue was memorably explored in Trevor Griffiths's extraordinary play *The Comedians* (BBC 1979), about a local authority evening class in comedy. Six would-be comedians turn up to be tutored by an ex-professional comic, Eddie Waters. Waters tries to persuade them that while you can joke about almost anything, good jokes have to do more than simply recycle stereotypes. But the class, confronted in their first live performance with a talent spotter rooted in that comic tradition of derogatory jokes about women and minority groups, become confused, unsure whether they are being asked to unmask stereotypes or recycle them. In the process the

mechanisms of the jokes and the assumptions behind them stand revealed. Only one comic, bovver boy Gethin Price, attacks the whole situation and the audience with an angry assault on bourgeois norms (Poole and Wyver 1984). The play was thus an attack on a dominant regime of comedy, effectively challenged since by the rise of alternative comedy. The problem of handling race both in situation comedy and in soap opera suggested the very real problems that the English audience and English cultural producers experienced, and continue to experience, in attempting to confront the extent to which our cultural perspectives are so etched through with racist assumptions.

The most striking comic success of the decade, however, was *Monty Python's Flying Circus* (BBC 1969). The Python team, following on the rich absurdist strain in British humour, led an assault on the conventions and formal clichés of television and upon rationalist logic itself, often by pursuing it to absurd lengths. In retrospect the success of the series marks the beginning of postmodern self-reflexiveness in television. Much of the humour of the programme depended on a familiarity with televisual conventions and its success was a sign of the central place that television had come to occupy in our lives by 1970 (see Wilmut 1980; and Thompson 1982).

QUIZZES AND GAMES

One of the features of a developing hegemonic crisis is the loss of faith in an established regime of knowledge and the emergence of competing modes of organizing knowledge and information. The failure of a ruling bloc to be a leading moral and intellectual force undermines the power of authority and, in the process of recomposition, popular commonsense temporarily comes to the fore as political forces struggle to establish new organizing ideological structures.

There is of course no sense in which television's forms merely reflect this process, but as a part of the social production of ideas they are inevitably implicated in it. This is not of course limited to the 'serious' areas of news, current affairs and high drama. It is precisely in the areas of the popular genres that such processes are likely to be at their most significant. Consequently it is at the least an interesting coincidence that during this period in which the post-war consensus started breaking up, a whole new breed of

game shows began to appear. Unlike earlier quiz shows that were rooted in the ability to produce rapid answers to knowledge – or information-based questions (Tulloch 1977), the new breed of game show that began to emerge at the end of the 1970s (*Blankety Blank* (BBC 1978), *Play your Cards Right* (ITV 1979), *Family Fortunes* (ITV 1979)) called on contestants to produce answers that matched the answers most frequently produced by a poll of one hundred audience members or one hundred people on the street. Winning depended, then, not on recall of discrete items of information, but on how closely a contestant's responses matched those of the people. In a way the more embedded your own instinctive thought processes were in popular commonsense, the better chance you had. While the relationship is only indirect it is worth noting that this took place in context of the rise of Thatcherism which itself, in its early populist phase, depended so much on an appeal to commonsense and to 'what every housewife knows . . .' (Whannel 1992b).

INFO-TAINMENT AND NOSTALGIA

Whilst in all these ways television was an integral part of the cultural processes through which hegemonic struggle took place, there were also ways in which, during the 1970s, television seemed to be peculiarly distanced from some elements of change. Two main responses developed around info-tainment and nostalgia.

At a time when culture was becoming more politicized, a contrary process was underway within television whereby information content was increasingly clothed in the form of entertainment; indeed the seeds of what became known as info-tainment lay in this era. The technology of television now allowed an ever more sophisticated handling of material, and the audience imperative demanded that public service broadcasting, with BBC locked into competition with ITV, should not produce information, education and entertainment in separate packages but rather ensure that everything was entertaining. Both channels revamped their styles of news and topical current affairs coverage in order to produce more entertaining modes of address. Even the weather began to be as much a show as a source of information. *Tonight* (BBC 1958) had blazed a trail since the late 1950s, to be followed in the 1970s by *Nationwide* (BBC 1966). New programme forms emerged, most notably *That's Life* (BBC 1973), which blended serious and

funny, weighty and trivial, factual and fictional in a uniquely televisual package that carried the audience along effortlessly, hailing the viewer in a self-confidently populist tone (O'Shaughnessy 1990). Info-tainment took the real world as its subject, but in smoothing and planing it to fit neatly into the conventions of televisual entertainment, was able to keep it at bay.

In a period of turmoil and conflict, television increasingly resorted to nostalgic explorations of the past. Television's facility at historical reconstruction, the soap opera appeal of serial narrative and the appeal of the mythic organic communities of the past combined in such productions as *Upstairs Downstairs*, *The Forsyte Saga*, *Edward and Mrs Simpson* and *The Duchess of Duke Street*. This process was also highly visible in situation comedies, especially those of Perry and Crofts. Productions such as *Dads Army*, *Are You being Served*, *It Ain't Half Hot Mum* and *The Last of the Summer Wine* tapped a rich vein of popular nostalgia for the past. The popular game show *It's a Knockout*, a slapstick contest between teams from small towns, seemed to call up images of a more organically connected world of small town community life (Whannel 1982).

Such productions were far more than simple nostalgia, of course. But the fact that they were especially popular during this era suggests a growing loss of cultural self-confidence. The notion of a golden age recently eroded has been a significant part of the English cultural sensibility for at least one hundred years, but it wells to the surface with particular prominence at times of cultural fragmentation and recomposition.

BEFORE YOUR VERY EYES: SPORT AND THE PERFECTION OF SPECTACLE

During the 1970s television began to perfect its technological command of reality. The sense of veracity and immediacy was heightened by colour, high-resolution images, the spread of satellites and the introduction of new lightweight cameras. The ability to manipulate was greatly enhanced by developments in video technology. During the period in which punk pushed art and graphics towards more rough-edged and improvised styles, television became more slick and glossy (Birrell and Loy 1979; Barnett 1990; Whannel 1992a).

Television's presentation of sport became much more self-

consciously mediated. Television was quite clearly doing far more than merely acting as a channel down which images of sport events could be relayed. Programmes like *The Big Match* (ITV 1968) and *Match of the Day* (1964), at the peak of their popularity in the mid-1970s, featured packages of recorded highlights, action replays, slow motion, experts-cum-celebrities and goal-of-the-month competitions. ITV had introduced the panel of experts for the 1970 World Cup and the decade saw the tele-expert move centre-stage as BBC and ITV competed to offer the liveliest and most charismatic contributors. In the process ex-footballers like Derek Dougan and Pat Crerand and managers like Malcolm Allison and Brian Clough became TV stars, increasingly exposed to the tendency to become self-parodies – indeed the roots of Saint and Greavsie are to be found here (Tudor 1975). The media present sport as very much a world of its own, with its own programmes and sections of newspapers. Rarely are the social and political concerns of the real world allowed to intrude on the spectacle. The thousand students gunned down before the Mexico Olympics in 1968, the seizing of Israeli hostages by a Palestinian group and the subsequent death of hostages and hostage takers in a gun battle at the airport during the 1972 Munich Olympics, the attempt to isolate South Africa in sport and the thousands of Argentinians who 'disappeared' prior to the 1978 World Cup in Argentina, were all mentioned in sport programmes. But all were regarded as unwelcome intrusions, invasions from outside, to be dispensed with and forgotten. Television sport continued to exclude the outside world as much as possible, rarely admitting into the spectacle any events that took place, in Daney's phrase, 'hors-champs' (Daney 1978).

While on the streets the punk subculture mounted a critique of slick mass production by encouraging a rip and paste, do-it-yourself style that revolutionized fashion, music, graphic design and publishing, television itself, thanks to technical innovation, proceeded to grow ever more slick and spectacular. Little of the aesthetic excitement or political challenge of punk found its way into the studios. Television seemed increasingly cast in the mould of Bob Dylan's Mr Jones, vaguely aware that 'something's happening here but you don't know what it is'.

BEYOND THE FRAGMENTS . . .

In summary, the 1970s saw the gradual break up and disintegration of the post-war consensus and the emergence of the new political and ideological elements that became articulated together in the form of Thatcherism. Television did not simply reflect this process, but rather, in particular forms, was caught up in it. In addition, as one of the principal links between the complex and contradictory strata of popular commonsense on the one hand and organized practical ideologies on the other, it was one site on which elements were worked and reworked during the process of ideological contestation.

The fragmentation of consensus could be seen in the growing debate over media bias, the politicization of drama and the emergence of diverse images of policing. This fragmentation saw gender and race emerge more prominently as contested areas, in which new emergent forms (feminism, multi-culturalism) clashed with traditional elements (patriarchy and racism). The tensions produced by these struggles between traditional and emergent cultural elements can be seen at work in the shifting ground on which popular drama series constructed their own narratives. Cultural uncertainties and a loss of confidence also helped to push nostalgia and spectacle into prominence.

As Thatcherism began to take political shape, its main themes were also at work within popular culture. The authoritarian law and order policy, the appeal to popular commonsense and 'what everyone knows . . .' and the new self-reliant individualism could draw on a growing range of media images. *Bergerac*, unlike many other television cops, worked solo. J. R. Ewing, like *Wall Street*'s Gordon Gecko, cared only about himself. Highly publicized entrepreneurs like Richard Branson and Clive Sinclair entered popular mythology through news coverage of their exploits. Aspiring entrepreneurs like Arthur Daley in *Minder*, Del Boy in *Only Fools and Horses* and most of the Boswell family in *Bread* occupied centre-stage in popular drama. As the Thatcherite project took over the political landscape, its victims too became mythologized, most notably in the form of Yosser Hughes in *The Boys from the Blackstuff* (BBC 1982), whose 'gissa job' catchphrase echoed through the 1980s. The fascination with enterprise, share ownership and the financial markets was matched by increased coverage of finance in *The City Programme*, *The Money Programme* and

news and current affairs programmes generally. Enterprise w̱ͅ coming in, and J. R. Ewing and Yosser Hughes were waiting round the corner.

NOTE

1 In all cases dates of programmes refer to the first year of transmission.

FURTHER READING

For studies of production practices and the television industry, see Alvarado and Buscombe (1978), Alvarado and Stewart (1985) and Schlesinger (1978). Bennett *et al.* (1981) contains extracts from some influential text analyses, and see also Brunsdon and Morley (1978). News coverage and politics are examined in the work of the Glasgow University Media Group (1976, 1980, 1982) and also in Schlesinger *et al.* (1983). The debates surrounding the politics of drama can be traced in McArthur (1978) and Poole and Wyver (1984).

SELECT BIBLIOGRAPHY

Alvarado, M. and Buscombe, E. (1978) *Hazell: The Making of a TV Series*, London: British Film Institute.
Alvarado, M. and Stewart, J. (1985) *Made For Television: Euston Films*, London: British Film Institute.
Annan (1977) *Report of the Committee on the Future of the BBC*, London: HMSO.
Barker, Martin (1988) 'News bias and the miners' strike: the debate continues . . .', *Media Culture and Society* 10 (1): 107–12 (London: Sage).
Barnett, Steven (1990) *Games and Sets: The Changing Face of Sport on Television*, London: British Film Institute.
BBC (1974) *The Coverage of Sport on BBC TV*, London: BBC.
Bennett, T., Boyd-Bowman, S., Mercer, C. and Woollacott, J. (1981) *Popular Television and Film*, London: British Film Institute/Open University Press.
BFI (1983) *Teaching Coronation Street*, London: British Film Insititute.
Birrell, S. and Loy, J. (1979) 'Media sport: hot and cool', *International Review of Sport Sociology* 14 (1): 128–40.
Blanchard, S. and Morley, D. (1982) *What's This Channel For?*, London: Comedia.
Brown, J., McGregor, R. and Cumberbatch, G. (1987) 'Tilting at windmills: an attempted murder by misrepresentation', *Media Culture and Society* 9 (3): 381–3 (London: Sage).
Brunsdon, Charlotte and Morley, David (1978) *Everyday Television: Nationwide*, London: British Film Institute.

Buscombe, E. (ed.) (1975) *Football on Television*, London: British Film Institute.

Clarke, Alan (1982) 'Television police series and law and order', unit 22 of Open University course U203 *Popular Culture*, Milton Keynes: Open University Press, pp. 35–58.

Cohen, Phil (ed.) (1982) *It Ain't Half Racist Mum*, London: Comedia.

Cox, B., Shirley, J. and Short, M. (1977) *The Fall of Scotland Yard*, London: Penguin.

Cumberbatch, G., McGregor, R. and Brown, J. (1986) *TV and the Miners' Strike* London: Broadcasting Research Unit.

Cumberbatch, G., Brown, J., McGregor, R. and Morrison, D. (1988) 'Arresting knowledge: a response to the debate about TV and the miners' strike', *Media Culture and Society* 10 (1): 112–16 (London: Sage).

Daney, Serge (1978) *Le Sport dans la television*, Cahiers du Cinema no. 292.

Donald, James (1985) 'Anxious moments: *The Sweeney* in 1975,' in M. Alvarado and J. Stewart (eds) *Made for Television: Euston Films* London: British Film Institute

Dyer, R., Lovell, T. and McCrindle, J. (1977) 'Soap opera and women', *Edinburgh International Television Festival* Programme, Edinburgh.

Glasgow University Media Group (1976) *Bad News*, London: RKP.

—— (1980) *More Bad News*, London: RKP.

—— (1982) *Really Bad News*, London: Writers and Readers.

Goodwin, Andrew (1990) 'TV news: striking the right balance?', in A. Goodwin and G. Whannel (eds) *Understanding Television* London: Routledge.

Hall, Stuart (1983) 'The great moving right show', *the Politics of Thatcherism*, London: Lawrence & Wishart.

Hall, Stuart and Jacques, Martin (eds) (1983) *The Politics of Thatcherism*, London: Lawrence & Wishart.

Kerr, Paul (1990) 'F for fake? Friction over faction', in A. Goodwin and G. Whannel (eds) *Understanding Television*, London: Routledge.

Lambert, Stephen (1982) *Channel Four: Television with a Difference,* London: British Film Institute.

MacCabe, Colin (1974) 'Realism and the cinema: notes on some Brechtian theses', *Screen* 15 (2): 7–27 (London: SEFT).

—— (1976) 'Days of hope – a response to Colin McArthur', *Screen* 17 (1): 98–101 (London: SEFT).

May, Annabelle and Rowan, Kathryn (eds) (1982) *Inside Information: British Government and the Media*, London: Constable.

McArthur, Colin (1978) *Television and History*, London: British Film Institute.

O'Shaughnessy, Michael (1990) 'Box pop: popular television and hegemony', in A. Goodwin and G. Whannel (eds) *Understanding Television*, London: Routledge.

Philo, Greg (1988) 'Television and the miners' strike: a note on method', *Media Culture and Society* 10 (4): 517–22 (London: Sage).

Poole, Mike and Wyver, John (1984) *Powerplays: Trevor Griffiths in Television*, London: British Film Institute.

Potter, Jeremy (1990) *Independent Television in Britain vol. 4: Companies*

and Programmes 1968–80, London, Macmillan.

Schlesinger, Philip (1978) *Putting Reality Together*, London: Constable.

Schlesinger, Philip, Murdock, Graham and Elliott, Philip (1983) *Televising Terrorism*, London: Comedia.

Screen Education (1976) 'Special issue on *The Sweeney*', *Screen Education* no. 20, London: SEFT.

Seymour-Ure, Colin (1974) *The Political Impact of Mass Media*, London: Constable.

Skirrow, Gillian (1980) 'More bad news – a review of the reviews', *Screen* 21 (2): 95–9 (London: SEFT).

—— (1987) 'Women/acting/power', in Helen Baehr and Gillian Dyer (eds) *Boxed In: Women and Television*, London: Pandora.

Smith, Anthony (1974) *British Broadcasting*, Newton Abbott: David & Charles.

Sparks, Colin (1987) 'Striking results', *Media Culture and Society* 9 (3): 369–77 (London: Sage).

Thompson, John O. (1982) *Monty Python: A Complete and Utter Theory of the Grotesque*, London: British Film Institute.

Tracey, M. (1977) *The Production of Political Television*, London: RKP.

Tudor, Andrew (1975) 'The panels', in E. Buscombe (ed.) *Football on Television*, London: British Film Institute.

Tulloch, John (1977) 'Gradgrind's heirs: the quiz and the presentation of "knowledge" by British television', in T. G. Whitty and M. Young (eds) *Explorations in the Politics of School Knowledge*, London: Driffield.

Whannel, Garry (1982) 'It's a knock-out: constructing communities', *Block* 6: 37–45 (London).

—— (1992a) *Fields in Vision: Television Sport and Cultural Transformation*, London: Routledge.

—— (1992b) 'The price is right but the moments are sticky', in D. Strinati and S. Wagg (eds) *Come On Down? Popular Media Culture in Post-War Britain*, London: Routledge,

Whitty, T. G. and Young, M. (eds) (1977) *Explorations in the Politics of School Knowledge*, London: Driffield.

Wilmut, Roger (1980) *From Fringe to Flying Circus*, London: Methuen.

Chapter 9

Stepping out of line
British 'new dance' in the 1970s

Judith Mackrell

INTRODUCTION

For most of its history, British dance has been patronized as a kind of second division art form. Even during the 1960s when immense glamour was attached to the Royal Ballet, when Nureyev and Fonteyn enjoyed headline status and when the work of Britain's leading choreographer Frederick Ashton became internationally acclaimed, most of the arbiters and privileged consumers of our culture continued to assume that dance lacked intellectual muscle and excitement. Being wholly physical, it was regarded as pretty, sexy, emotional, intuitive – and thus inescapably dumb.

For a brief and heady moment in the late 1970s, however, it seemed as if dance was throwing off its inferior status. Around 1978 a wholly un-British phenomenon occurred – the much hyped 'dance explosion'. Arts and fashion editors as well as cultural pundits seized on dance as a new and modish topic. Audiences, particularly for modern dance, peaked to a new high and radical, energizing changes began to take place within the structure of the whole dance scene.

Back in 1968 Britain's first ever modern dance companies, the re-formed Ballet Rambert (1966) and London Contemporary Dance Theatre (LCDT) (1966), were still tentatively building up both their repertoires and their dancers. Audiences needed coaxing into performances and both companies had to devote much of their energy to lecture demonstrations and classes. Britain's first modern dance students were just emerging from the recently formed London School of Contemporary Dance (LSCD), and our first modern choreographer Richard Alston was about to make his own work *Something to Do* (1970). British classical ballet,

arguably still at the peak of its most golden period, effortlessly dominated the scene, with the two Royal companies flanked by London Festival Ballet and a host of smaller companies in and outside the capital.

By 1978, however, the Royal Ballet was embarking on a period of declining standards and morale which was to last well into the 1980s. The 'English' style which had always permeated the company from principals to *corps de ballet* was beginning to look neglected and shoddy; new additions into the repertoire such as Balanchine's *Ballet Imperial* were simply incompetently danced. The company had found no star dancers to replace Fonteyn, Antoinette Sibley and Lynn Seymour. Modern dance on the other hand was radiating confidence and vitality. Rambert and LCDT could easily fill large-scale theatres around the country and a wide range of other companies flourished in their wake. Middle-scale groups like the London-based Extemporary Dance Theatre (founded 1975) were beginning to play in smaller mainstream theatres while fringe venues and festivals were presenting a now burgeoning number of small-scale companies. Also, while modern dance in the 1960s was understood primarily in terms of the relatively mainstream Martha Graham technique, and while that technique still dominated the repertoires of LCDT and Rambert, young independent choreographers in the 1970s were working in a more aggressively experimental climate, many of them using a far wider range of styles and questioning most of the inherited definitions and practices of their art.

Britain seemed to be becoming a dancing nation again for perhaps the first time since a visitor to the court of Queen Elizabeth, impressed by the enthusiasm with which she led her retinue in dances like the volta, spoke admiringly of the 'dancing English'. Trained dancers were graduating in increasing numbers from the London School of Contemporary Dance, from the Laban Centre and from Dartington College, and, even more significantly, dance classes for non-professionals were becoming extraordinarily popular.

In the late 1960s any adult wanting to take a class in ballet, jazz, tap or modern dance would have had a discouragingly hard time trying to find one that was neither for professionals nor children. By the late 1970s, however, there were several dance centres in London including the highly successful Pineapple Centre, opened by Debbie Moore in 1979, as well as numerous available classes in

church halls, arts centres, universities and colleges in the capital and around the country.

For many enthusiasts the search for co-ordination, grace, self-expression and a good time was motive enough for attending dance classes. But it was the quest for the body beautiful that gave crucial impetus to this new national enthusiasm. As alternative lifestyles gave way to fitness cults, dance and aerobics became *the* fashionable activities of the 1970s. And though dance as an art form did undoubtedly develop dramatically during this decade, the factor which made that development so visible was the consumer explosion in dance-exercise that ran parallel to it.

This explosion arose not just because there was money to be made out of drilling bodies into shape but also because of the possibilities inherent in retailing the whole 'dance' image. Leotards, tights, leg warmers, headbands, jazz shoes, sweat pants etc. appeared on the market in a constant turnover of styles. And the high street reflected this new body consciousness in clothes that were fashion versions of the same accessories.

Dance companies benefited from the boom in terms of publicity buzz and media attention, yet only a relatively small proportion of class-goers nationwide actually attended stage performances. The kind of money, too, that was turning over in the dance-exercise industry bore no relation to the money supporting the art form. Dance was in fact engaged in an unequal battle for funding. And it is the struggle for money, facilities, theatre space and even survival that is the true story of new dance in the 1970s – rather than the glitzy, commercial 'dance explosion'. The 1970s was genuinely a decade for dance, a decade of growth, innovation and change, but hard political and financial battles had to be fought to make them so.

Dance in this country has never received the level of state support that drama, for example, has. A typical instance of the distribution of cash can be seen in the figures for 1979 when dance received £1,451,892 while drama received £7,360,857. (These figures exclude the money given to the Royal Ballet companies, the National Theatre and the Royal Shakespeare Theatre which were all separately funded.) Until 1980 dance did not even have its own Panel at the Arts Council to argue its case. But the area which was particularly hard hit in the 1970s was the new dance avant-garde which started to flourish in the middle of the decade and which has subsequently given British modern dance its distinctively volatile

and dynamic character. Too late for the heyday of public arts funding in the 1960s and early 1970s, this emerging group of dancers and choreographers had to scrabble for tiny amounts of money from the already over-burdened Arts Council dance budget. In 1976 the total money for dance was about £3 million. Of that £1,364,000 went to the two Royal Ballet companies at the Opera House while most of the rest went to the relatively established large-scale companies like London Festival Ballet, LCDT and Rambert. Three per cent was left for new small-scale work. (See *New Dance*, Spring 1977: 21.)

This lack of funding obviously had an effect on the kind of dance work that was made, which means that any discussion of a 1970s style has to be aware of the material circumstances in which the choreography was made. There *was* during this period a genuine drift towards a shoestring aesthetic – towards minimal design and simplified staging. Many choreographers like Richard Alston were working out of choice with spare musical accompaniment or with none at all. Many, like Rosemary Butcher, were interested in performing in public spaces – parks, galleries, streets – rather than in theatres (expensive to hire). Many, like Laurie Booth, did prefer to work solo or in small groups, to present work in process rather than highly polished products (that would require more rehearsal hours). Yet a grinding lack of money intensified these working practices even where they were not necessarily sought – limiting choreographers who wanted to develop on a more ambitious scale, who wanted to collaborate with musicians and designers, who wanted to use more dancers and who needed more rehearsal time.

Another consequence of this low level of funding was the fact that many British dancers and choreographers became far more politicized than their New York counterparts like Trisha Brown and Lucinda Childs. (Money was tight in New York, too, but loft space for rehearsal and performance was far more readily available and the general culture much more receptive to new dance.) The British not only had to learn to organize themselves to lobby for more money, but formed collectives like X6 to run independent dance spaces, founded festivals, and started the magazine *New Dance* in 1977 to ensure informed criticism of their work. Dance, as I shall argue, was also opened up as an arena for political discussion with feminism a particularly potent force. Women examined, as never before, the kinds of role model and

the punitively restricted physical stereotypes imposed on them in their profession. The competitiveness and the style of company hierarchy that had also been taken for granted in the dance world were consciously subverted in every area of activity – from open classes to collective organizations. An article by Emilyn Claid in *New Dance* (summer 1977: 2), for instance, urged the importance of dancers becoming conscious of their political situation. Thus although the economic conditions which prompted this political activity could be seen as hampering the development of the work – they did serve to stir up what had hitherto been a relatively passive profession.

TOWARDS 'NEW DANCE'

The dance avant-garde basically emerged out of two training institutions, The LSCD and Dartington College for the Arts. In its early days, LSCD was open to almost anyone interested in learning modern dance techniques, from disaffected ballet dancers, to filmmakers and art students. There was thus a volatile mix of pupils, some of whom happened to be versed in experimental movements outside the province of dance – minimalism, structuralism, performance art and so on. Also, though the main base of the schooling was the rather mainstream Graham technique, there were teachers offering classes in ballet, t'ai chi, the Cunningham and Nikolais techniques – again promoting a plurality of approaches. Above all, students were encouraged from the outset to make their own work. The whole place was a kind of creative dance laboratory where time, space and bodies were freely available for the exploration of new ideas and influences. Richard Alston, Siobhan Davies, Jacky Lansley and Julyen Hamilton were among the many leading fringe choreographers of the 1970s and 1980s who emerged from the school.

Dartington ran a dance course during the late 1960s and early 1970s which was basically for training teachers and was also grounded in the Graham technique. But in 1975 the department was taken over by the American dancer and choreographer Mary Fulkerson. She changed the orientation of the course radically by encouraging a multidisciplinary approach that embraced film, theatre, music and the visual arts and by introducing alternative movement techniques such as release and contact improvisation. (Contact improvisation is a duet form, evolved in New York in the

early 1970s, where the movement is invented moment by moment by the dancers. The only rule is that the participants have to keep in close contact. Any part of the body may be used to lean against, balance on, lift or support as the dancers fly, balance and roll on the high of their joint momentum. Release is popularly described as dancing from the inside out. Dancers begin from a state of stillness and awareness – focusing on the inner state of their bodies. As they dance they find the most natural and economical ways of moving, often working with mental images to facilitate the ease and success of a given movement.)

Fulkerson also instituted a new approach to teaching. Rather than using traditional methods of imitation and repetition she encouraged pupils to explore the feel, dynamics and placing of movement within their own bodies. Rather than working towards an objective standard of 'perfection' she had students develop their own individual style and skills through improvisation. In America Fulkerson had frequently choreographed her work on non-dancers, intrigued by the particular qualities and quirks of the untrained body. Aspects of her theory are argued in two essays included in the *Theatre Papers* series published by the Department of Theatre, Dartington College, and entitled 'Language of axis' (series 1, no. 12, 1977) and 'The move to stillness' (series 4, no. 10, 1981–2). Among the graduates from her course in the 1970s and 1980s were Laurie Booth and Yolande Snaith, both of whom went on to become leading soloists in 'New Dance' and directors of their own companies – Laurie Booth and Company and Dance Quorum.

A third important support to the emergent fringe was the X6 dance collective which was formed in London in 1976 to circumvent the problems facing experimental dance. While dancers and choreographers were relatively free to experiment within the security of a training institution, conditions in the outside world were bleak. Rehearsal and performance space was hard to find and it also cost money, as did musicians and designers. There were almost no classes in which graduate dancers could continue training and working, nor was there an organized point of contact with other members of the profession. Unless they were among the privileged few employed by established companies, these dancers were entirely thrown back on their own resources.

Addressing themselves to these problems, a small group of dancers – including Jacky Lansley, Fergus Early and Emilyn Claid

– searched out a large and cheap warehouse space in Butler's Wharf, part of London's then undeveloped Docklands, which could provide a meeting place for dancers as well as an affordable space for class and rehearsals. The group, calling themselves X6, celebrated the opening of the space with an ambitious performance event, *By River and Wharf*, which signalled the radical nature of their enterprise. Made by several choreographers, it was a defiantly anti-proscenium piece that took place around Bermondsey Docklands. As the audience strolled through the area they encountered a series of performances each specially devised for its location, 'across Tower Bridge, down alleys, on old bomb sites, suspended from iron girders, knee deep in Thames mud, on the grass of an urban square, beneath high rise flats' (Fergus Early, 1986 *Papers from the Chisenhale/NODM Weekend to Celebrate New Dance*: 4).

That year X6 also initiated its own summer school, a conference on experimental dance (Britain's first) as well as a series of regular workshops and classes. A range of techniques was available, including Cunningham, t'ai chi, release, contact improvisation and a basic form of ballet stripped of its more glossy and decorative mannerisms. Classes were conducted on strictly non-competitive lines; some were for women only.

In 1977 X6 began to publish the magazine *New Dance* which was to serve as a forum for comment, ideas and information. Most importantly, it was to be a means of by-passing the hostility, ignorance and indifference which were frequently displayed by the national critics to experimental work, and to evolve a language that was adequate to the task of articulating and evaluating experimental work.

It was not uncommon, for instance, to find critics dismissing a performance on the grounds that the dancers did not point their feet or lift their legs high enough – a point relevant to classical ballet but hardly appropriate to choreography that was exploring the relaxed fluid style of release. There was also similarly inappropriate complaint about the lack of finished structure in performances that were deliberately improvised; about slowness in works exploring 'real' rather than theatrical time or about the absence of logic in pieces of performance art.

An article in *New Dance* could still point bitterly to this kind of willed incomprehension even in the early 1980s. Chris Crickmay's 'The apparently invisible dances of Miranda Tufnell and Dennis

Greenwood' (*New Dance* March 1982: 7–8) contrasted two re-
views of the same performance – one appearing in the *Sunday
Times* and the other written by Steve Paxton, one of the origina-
tors of contact improvisation. The work under discussion was
choreographed and performed by Miranda Tufnell and Dennis
Greenwood. It employed everyday rituals and actions, the per-
formers manipulating a series of props to create surreal and dis-
junct images. Paxton praised the work with terms like
'humorous', 'elegant', 'mysterious' and 'intelligent'. The *Sunday
Times*, however, fumed about an 'evening of British rubbish'
created by 'people who have never grown up', and all its 'de-
scriptions' of the work were couched in heavy-handed ridicule:
'In *Night Pieces*, a man in an overcoat intoned an interminable
monologue of gobbledegook while sitting on and falling off a
chair, and two dancers pawed the ground, pausing to switch
hanging lights on and off. In *Other Rooms*, Miss Tufnell was
crawling on all fours with a table on her back and a lamp dang-
ling from her teeth. . . .'.

Articles in *Dance Theatre Journal* (a quarterly, critical dance
magazine which began publishing from the Laban Centre in 1983)
continued to hammer the same points. Alastair Macaulay's
editorial for the first issue (spring 1983: 2–3) noted that the
previous autumn's Dance Umbrella festival (a major event in the
independent dance calendar and discussed below), with five weeks
of performances, elicited 'barely a murmur from most London
newspaper critics. (An honourable and solitary exception in this
respect was *The Times*.) Several Sundays went by with no mention
of the Umbrella in any of the Sunday papers; among the dailies,
the *Financial Times* covered no more than three performances'. A
survey of the reviews attracted by the 1983 Umbrella in Lesley-
Anne Davis's 'Revealing the reviews' (*Dance Theatre Journal* 2
(1):6) pointed again to scanty coverage by the critics; twice as
much space was given to reviews of ballet performances as to
reviews of Umbrella performances even though many of the for-
mer dealt only with changes of cast. Davis's article also cites a
comment from the critic of the *Sunday Telegraph* as an extreme
version of the press's hostility to new work (and its non-balletic
performers): 'Too many barefoot dancers are a bit like those pre-
historic plesiosaurs "who make up for their tiny minds by having
extra large behinds", and I sometimes watch unbelievingly as a
building quakes before the daunting onslaught of large bosomed,

wide haunched, well padded amazons, seemingly only too ready to act out their aggressions in public.'

Back in the 1970s, the writers contributing to *New Dance* were not only committed to assessing new work on its own terms but also to experimenting with reviewing conventions. Some felt that the most useful and appropriate response was to give as straight a descriptive record as possible, some chose to give a frankly personal account of their own reactions, some slanted their reviews towards political analysis. The tone of the magazine was generally very serious, very committed, at times naive. But it gave choreographers and dancers the chance to articulate the concepts that underpinned their work, it provided a platform for new writers and it became one of the key sources for our understanding of this particular period of dance history. (Fringe dance companies naturally could not afford the luxury of film or a dance notator to record their work.)

This move towards self-help among dancers was also evident in the formation of the nation-wide Association of Dance and Mime Artists (ADMA). In 1977 this group organized the first of its two annual dance festivals at London's Drill Hall to give independent dancers and choreographers a platform to show their work. Organization, publicity, lighting and sound management were shared between all the participants, and the events – by virtue of its scale – gave the works a much higher profile than any single performance could achieve. In accordance with the egalitarian spirit of alternative dance the festival operated an open-door policy so that anyone who applied could perform – and during its first year at least it stood as a testament to the burgeoning vitality and diversity of the fringe scene. It featured many choreographers who would later go on to dominate the independent dance scene such as Laurie Booth, Emilyn Claid and Julyen Hamilton.

It also featured many others who were not subsequently to succeed and at the second festival in 1978, where there were three times as many performances, the unevenness of the quality was seen as a potential embarrassment. The Arts Council said that the general standard was unacceptable and told ADMA that it would have to drop its open-door policy if it was to be given further funding.

ADMA resisted and the Arts Council decided to put its money behind the Dance Umbrella, founded by the publicist and administrator Val Bourne. Originally this was designed as a showcase of

the best new British work – but its timing coincided with an already planned London season of American dance at the Institute of Contemporary Arts (ICA) and Riverside. A broad cross-section of British work, including Richard Alston and Dancers, Rosemary Butcher Dance Company, Extemporary Dance Company and Janet Smith, was seen alongside more established artists from the United States like Douglas Dunn (who used to dance with Cunningham) and Sara Rudner (ex-Twyla Tharp) – initiating London audiences into a more international perspective on the new dance scene.

The Umbrella went on to become a regular annual event – presenting increasingly ambitious programmes of work from around the world. By this time, too, the rest of the dance fringe had begun to develop something like its own infrastructure, at least in London. There was a small network of performance spaces regularly available to small companies including The Place, Riverside Studios, the ICA and the Drill Hall. Church halls and schools supplemented the rehearsal space at X6. A small but growing number of companies managed to sustain a hand to mouth existence via project grants, box office and teaching. And the work produced by the fringe as a whole was generally recognized and categorized as 'new dance.'

Before describing the major trends within 'new dance', a word or two should be said about the label itself. It was first coined around the time of the magazine's publication and was used in connection with the choreographers and dancers associated with the X6 collective. By extension it then came to refer to any style of dance that challenged the politics and aesthetics of mainstream dance and was subsequently used even more loosely to describe any work produced by small independent companies. There are thus possible areas of confusion in applying the term but for brevity I shall use it to refer to the most radically innovative work of the period.

During the 1970s that work developed in two basic directions. The first evolved in reaction to the purely expressionist aesthetic of the Graham technique that dominated the work performed by LCDT and Rambert and that worked on the assumption that every movement should have a motive and meaning. The roots and influences of this contrary style were also American and derived initially from Merce Cunningham (who began creating work in the late 1940s) and from the radical minimalists/improvisors/

deconstructionists of the 1960s and early 1970s. Unlike the dramatic base of Graham's choreography, the underlying concepts of this work displayed close links with music and the visual arts. Merce Cunningham's choreography, for instance, was partly indebted to the compositional theories of John Cage. He held that any movement (like any sound) could be used as material for dance and that chance could play an active and creative role in the making of work. His dances had no programme or theme; they were simply about bodies moving in time and space.

Although Cunningham collaborated with musicians and designers he did so in a spirit of mutual independence. If his designers (who included Jasper Johns, Robert Rauschenberg and Andy Warhol) chose to scatter the stage with objects, then Cunningham's own separately devised movement would skirt or somehow deal with them. Equally, though his music would probably occupy the same length of time as the dance, Cunningham's movements would not actually be composed to it, and whatever coincidences, contrasts or chimings occurred between sound and dance they would always be accidental.

Believing that the unlooked-for event enriched the possibilities of his own creation, Cunningham frequently employed chance procedures (tossing of coins etc.) to determine the ordering of a phrase of movement, the spacing of the dancers on stage, the number of performers and so on. The impression of spontaneity was also emphasized by the way he disposed his dancers in space. As in a painting by Jasper Johns, there would rarely be a single focus to the stage, a sense of subject and background or of image and frame. Rather, several dance events would be occurring on stage at the same time, just as within a single dancer's body several apparently independent movements might be going on at once. A leg may be tracing a figure of eight in space as the head turns from side to side and the arms move in a calm arc. Cunningham's choice of vocabulary was also subversively eclectic, He juxtaposed the bending, curving torso of modern dance with the long extended legs of ballet and added odd movements from everyday life such as a casual walk or a handshake and the manipulation of mundane objects like chairs, a television – even a potted plant.

In the 1960s, many American choreographers took Cunningham's incorporation of 'found' movements and objects much further. Paralleling the work of minimalists in the visual arts (Carl André's 'brick' series for instance) they began a sustained and

systematic exploration of ordinary movement as material for dance. They rolled, walked, squatted and crawled, and if they danced at all it was in a defiantly low key fashion. A uniform of tea shirts and sneakers emphasized the image of dancer as 'ordinary person' and some choreographers went so far as to use non-dancers in their work. In this atmosphere of radical simplicity, dances were constructed on basic principles. Tasks and games were the basis of some works; in others movements were repeated many times with minute variations in direction, speed or gesture – following the principles of minimalist composers like Steve Reich.

'NEW DANCE' PRACTICES

Richard Alston, the first British choreographer to emerge out of LSCD, initially looked to Cunningham when he began reacting against the Graham aesthetic of his training. (His impatience with its dramatic burden reached a crisis during class when he was told to imagine that some basic exercise in fall and recovery was about the experience of being in hell.) In Cunningham's ideas and technique he found the kind of objectivity of movement he was looking for as well as a complexity of rhythm and interest of line (Alston was an art student before embarking on a career in dance). His movement was also influenced by the smoothness and serenity of t'ai chi and the lyricism of English classical ballet. Inevitably, the vocabulary of Alston's early compositions showed evidence of his Graham training. Yet his own individual direction was equally manifest – with his first professional piece *Something to Do* (1970, made for LCDT) functioning as a very personal credo in anti-expressionism.

The choreography was accompanied by fragments of a text by Gertrude Stein which mused on the nature of doing things (doing things for the first time, not getting bored when you have to repeat them), which seemed particularly applicable to the practice of dance. Certainly it underscored Alston's idea that dance was an activity justified by its own doing, rather than needing the extra weight of message or plot.

The movement in the piece (a duet for two men) was calm, smooth and objective. Recognizeable Graham moves like a fall or a deep contraction in the torso were stripped of their usual dramatic implications and the structure of the piece had a clear design – with

phrases of dance material being recycled in constantly changing variations.

That interest in variations on a theme was at work too in *Headlong* (1973) which Alston made for his own small company Strider. (He had left LCDT by this time in order to make the kind of work he wanted with the dancers he wanted and for the kind of audiences he wanted.) *Headlong* was about falling and flying, with movement based on runs, balances and falls. The dancers wore khaki flying suits and the piece was accompanied by a sound collage mixing the soundtrack from a Tom and Jerry cartoon, a string of comic stories and the tape of US astronauts counting down to lift-off. In the manner of Cunningham's use of 'music', this jumble of sounds simply provided an 'environment' in which the dance took place.

Although Alston's choreography was radical in its choice of music (or non-music), in its rejection of 'meaning' and in its choice of venue (his company performed in gyms, galleries, outdoor spaces – even, memorably, Wormwood Scrubs) the movement itself retained many traditional dance virtues. With its strong open lines below the waist, its soft curving torso and arms, Alston's movements demanded grace, control, clarity, balance and stretch. Some critics referred to his choreography as classical in temper if not in style.

In the mid-1970s, however, Alston started working closely with Mary Fulkerson in order to explore the potential of a non-dance vocabulary, and to return to the choreographic basics of weight, dynamics, space, time. His choreography at this point was much more contemplative and low key, involving more pedestrian than dance movement, though Alston retained the emphasis on design and structure (one work toured with an exhibition of drawings by Jasper Johns – indicating Alston's shared concerns with composition). During this phase Alston moved much closer to the kind of new work being made by his peers in America – minimal, improvisatory, relaxed and defiantly set against conventional forms of virtuosity. It was this school of 'anti-technique' which also shaped the work of Rosemary Butcher.

Butcher trained at Dartington during the 1960s in conventional Graham technique but on visits to New York was profoundly influenced by choreographers like Trisha Brown, Yvonne Rainer and Steve Paxton. When she started making her own work she drew heavily on the principles of release; her movement was plain

and functional, executed with minimal tension or display. It was also created via a long and rigorous process of improvisation – where the dancers worked as democratic equals with the choreographer. Ideas and instructions would be fed to the dancers as a basis from which to develop their own movement. And though the final structure of the work would be set, even in performance the specifics of movement and gesture remained fluid.

Ordinary actions like running, walking and rolling, simple floor patterns and unadorned gestures became the hallmarks of Butcher's style (as in the duet *Landings*, 1976), as did her use of real rather than theatrical time. Instead of striving for an artificial climax in a phrase of dance, each movement was given the time it needed for its natural realization so that it seemed to be meditating on its own processes. The power of the work lay not in its kinetic dazzle but in its design. Butcher regarded her dancers as material for visual composition (her most frequently cited influences have been the artists Richard Long and Ben Nicolson) and she saw the stage as a three-dimensional canvas in which bodies could be disposed and textures of movement contrasted. She was also fascinated by the possibilities of placing dance within different frames – creating works for non-theatrical spaces like fields, galleries and public squares and seeing how longer perspectives and different backdrops altered the impact of the moving body. (In 1977 Butcher made a series of works sponsored by the GLC Parks Department which were performed outside the *Economist* Building in St James', on the National Theatre Terrace, outside the new London Museum in the Barbican and in Paternoster Square.)

Butcher's work, understated, extemporary and scrupulously composed, set the tone for a whole strand of British dance in the 1970s (and 1980s) – influencing Dennis Greenwood and Miranda Tufnell, Sue MacLennan, Siobhan Davies and even some early work by ballet-trained choreographers such as Ashley Page and Jonathan Burrows. But there was another equally significant body of work produced at this time which adopted a far more theatrically provocative approach. Its range of movement was eclectic (ballet, martial arts, music hall and modern as well as more pedestrian/improvisatory styles) while its non-dance influences ranged as widely as performance art, European film and experimental theatre. Far from being contemplative, it usually had a political message to deliver.

The forerunner of this school was the company Moving Being, a multi-media group in which dance played a powerful role. It was founded by Geoff Moore in 1968 and a programme note for the work *Sun* (1973) indicates the broad (and very late-1960s) scope of his ambitions. The works were 'to do with painting and the power of the visual image, theatre and the "presence" of live perform-ance, film, music, newspaper reports, dancing and "natural" movement, science, popular culture, poetry, psychology, infor-mation of all sorts about people and events'. In *Sun* itself the spiritual collapse of the Western world was anatomized through texts from Freud, Norman O. Brown, R. D. Laing, Joyce and Germaine Greer and through the taped music of Mahler, The Beach Boys, Frank Zappa and Irving Berlin. A vision of Eastern calm (oriental dance movements) and balance was contrasted with a death-oriented West (film of crashing cars and bombing raids).

Within 'new dance', feminism proved the most powerful motive force of politically oriented and theatrical work. In 1974 Jacky Lansley formed the two woman group Limited Dance Company (with Sally Potter) and adopted the specific agenda of challenging female stereotypes in art and life. Many of their shock tactics have since become relatively common currency in the world of art installations and pop video. But at that time their use of surreal imagery and their exploitation of bizarre performance contexts appeared genuinely provocative. In a piece performed during the Edinburgh Arts 1974 Programme, Lansley recalls how 'two women emerged from the sea in black evening dresses, with flippers on their feet, into a moving tableau which had been previously set up around the swings, paddling pool and public benches on the sea front; and they were met in the pool by two corresponding white figures who had moved down the main street gathering litter' ('The centre line'; collected in *Papers from the Chisenhale NODM Weekend to Celebrate New Dance*, May 1986: 2). Another performance from that period was given at Oxford's Museum of Modern Art in the same gallery as an exhibition of Frank Stella's paintings. According to Lansley, the idea was to set up a dialogue with the art works – drawing attention to the fact that two women were performing the traditionally female art of dance within a space normally reserved for the male-dominated world of painting.

After disbanding Limited Dance Company in 1975, Lansley went on to make other work for women, such as *Bleeding Fairies*

(1978). Her collaborators here were Emilyn Claid and Mary Prestidge and Lansley's own account of the work in *New Dance* suggests that it was an exploration of the most basic female imagery in Western culture: 'the witch, the whore, the fairy, Mother Earth. It was', she recalls, 'a chaotic, aggressive kind of performance. At one point we formed a series of classical tableaux made up of balletic poses . . . gradually our pace quickened and our poses became more and more macho and "attacking" until eventually we had destroyed the classical tableau structure, breaking out in a display of aggressive virtuosity' (1978: 11).

In much of her work Lansley used words and song alongside movement both to subvert the conventions of the traditionally 'pure' dance performance and also to extend the language available to herself. This free mixing of material turned out to be one of the most liberating forces in 'new dance'. Fergus Early, Julyen Hamilton and later Laurie Booth and Yolande Snaith were among many who found ways of enriching and focusing their movement through extra visual and aural resources. In a very early work by Hamilton in 1977, for instance, male stereotypes were offered for examination as two men improvised fighting movements; a chorus of anonymous footballers did a workout and passages were read from Jung on the subject of male violence.

As the 'new dance' movement challenged and eroded many of the inherited definitions of dance practice, so black and Asian dance also began to establish their own platforms in this country. Although star performers like Ram Gopal had made guest appearances in this country from the 1940s onwards, Britain's own Asian dancers only started to appear in their own right in the late 1970s with Alpana Sengupta giving a Kathak recital at the first ADMA festival. Black dancers too began to set up their own companies rather than wait for elusive openings in Britain's mostly white dance world. The jazz and modern based black dance company MAAS Movers was founded in 1977, although it was not until the 1980s that companies working in black African dance forms such as Kokuma and later Adzido really became established. As old patterns of performance and viewing were changed, so audiences grew more receptive to non-Western as well as alternative dance forms. Individual choreographers furthered this eclectic spirit by their own borrowings from non-Western movement – Alston for

instance in his use of the principles of t'ai chi and Booth in his intensive explorations of the Brazilian martial art Capoiera.

CONCLUSION

By the end of the 1970s a long roll call of independent dance companies had emerged, constituting a healthy and varied fringe. The standard of work was obviously wildly erratic – some of it half-baked, eccentric, arcane, puritanical, even downright boring. (One of the more naive premises was that there was a choreographer inherent in every dancer.) Yet the prevailing *Zeitgeist* of the 'new dance' scene was one of hope, energy and commitment – it seemed as if change and growth could only continue.

In the 1980s, of course, an increasingly chill financial wind dealt harshly with such optimism, ushering in a new marketplace attitude towards the arts. Public funding became more and more subsidiary to the handouts of private sponsors and independent dance artists were put under increasing pressure to make work that was successful, i.e. popular, well-packaged and properly presented. The right to fail, to take risk, to irritate or provoke thus became increasingly precious as the dance world found itself chasing decreasing resources.

Yet it was precisely because the choreographers of the 1970s had exercised their right to fail that so much new ground had been broken. The number of available languages for dance multiplied dramatically during the decade, as did the possibilities of subject matter and of staging. In many respects the choreographers of the 1980s and 1990s are still working through the ideas thrown up during the 1970s. Yet where they are most reliant on the legacy of the 1970s is simply in the existence of a workable independent dance scene. Without X6, without the early festivals, without the slog that went into building up a network of venues, rehearsal spaces and audiences, today's choreographers simply would not have anywhere to operate.

FURTHER READING

Useful contextual and supplementary material can be found in *New Dance Magazine* 1977–86 (London: X6); *Dance Theatre Journal* 1983– (London: Laban Centre); *Dartington Theatre Papers Series 1–4* 1977– (Dartingon: Dartington College); *Papers from the Chisenhale NODM Weekend*

to Celebrate New Dance, May 1986 (London: Chisenhale Dance); Sally
Banes and Robert Alexander (1980) *Terpsichore in Sneakers* (Boston:
Houghton Mifflin); Stephanie Jordon (1992) *Striding Out* (London:
Dance Books); Merce Cunningham (1985) *The Dancer and the Dance*
(London: Marion Boyars); Jan Murray (1979) *Dance Now* (Harmonds-
worth: Penguin).

Chapter 10

A diversity of film practices
Renewing British cinema in the 1970s

Andrew Higson

INTRODUCTION

In this chapter, I shall explore how films were produced and circulated within British cinema as a whole in the 1970s. This will involve looking at the organization of both the film industry and film culture. It will also mean looking at the whole range of film practices in Britain in the 1970s: the popular, commercial end of cinema but also art cinema and other more marginal forms of cinema. We should remember, too, that most of the films seen by audiences were American, and that Hollywood dominated the film culture. Further, there are problems in deciding what should be counted as a British film. The government employed a conventional legal definition of a British film to determine which films should receive the limited amounts of state subsidy available. However, this was open to all sorts of anomalies and abuses, a good example of which were the James Bond films of the 1970s. They were registered as British, which seems appropriate for a series of films about the adventures of a British secret agent, and usually made at British studios by British directors. However, the producers were an American and a Canadian, their holding company was Swiss and the films were financed and distributed by United Artists, an American company. The films were also of course made with the international market in mind – which meant first and foremost the American market.

THE DECLINE OF CINEMA?

Several British directors went into the 1970s with high reputations, including Lindsay Anderson, Karel Reisz, John Schlesinger,

Joseph Losey (an American in fact), Tony Richardson and Bryan Forbes. The turn of the decade brought to critical attention several men new to feature film direction: Richard Attenborough, Nic Roeg, Ken Russell, Stephen Frears and Ken Loach, among others. All of these directors had made films that were intelligent, sophisticated, intellectually demanding and strongly cinematic. But the expected pay-off for the new decade was not really forthcoming, or at least not for British cinema. Some of those named worked in television for most of the 1970s (Frears, Loach); several others moved to Hollywood for some or all of their films (Reisz, Schlesinger, Richardson – while Losey moved to France); yet others directed only a very few films in the decade (Anderson, Forbes, Attenborough). It was really only Russell and Roeg who produced work fairly consistently and consolidated their reputations.

Conventional wisdom sees British cinema of the 1970s as shying away from innovation, lacking in confidence and generally of little interest apart from a few isolated films. Alexander Walker (1985), for instance, suggests that the British cinema of the 1970s was suffering from a hangover after the hedonism of the 1960s, facing up to mundane reality after the fantasies of swinging London. But it is not enough to suggest that film art was in decline in the 1970s. The central problem was the nature of the film industry and in particular the lack of finance for British film production in the 1970s. Hence the lack of continuity of production on the part of the big names of the 1960s, or the moves to Hollywood or into television. That loss of finance was intimately related to the decline in cinema admissions across the decade and the social and cultural changes which meant that the film industry could no longer rely on what they conceived of as the 'mass' audience in marketing their films.

In many ways, the 1970s can be regarded as a transitional period for cinema, caught between two more significant moments. The period opens with the withdrawal of the extensive American financial support for British production which had been such a key feature of the industry's optimism in the 1960s. At the other end of the decade, as we move into the 1980s, we find the international success of *Chariots of Fire* (1981) ushering in another revival of British film production. It is by contrast that the period in-between comes to be seen as indeterminate, even stagnant. In fact, British cinema was going through a complex series of transformations in

the 1970s in response to cultural, social and economic changes taking place elsewhere. From this point of view, it might make more sense to see the decade as a continuation of the cinema of the 1950s, with the buoyancy of the mid-1960s as a temporary aberration.

Cinema admissions had been falling steadily since just after the end of the war, and dramatically from the mid-1950s. They continued to fall throughout the 1970s, the 1980 figure being less than half of what it had been at the start of the decade (and a mere 6 per cent of the 1945 figure). In the 1930s and 1940s many people went to the cinema two or even three times a week. By 1970, only 2 per cent of the population went to the cinema even once a week (Wood 1983: 148; Docherty *et al*. 1987: 29). The 1970s was, then, another poignant moment in the longer post-war decline of cinema. Except that to talk of the decline of cinema is misleading. It is not cinema itself which declines, but a particular cinematic formation, the classical cinema of the middle years of the century, organized around the on-going, studio-based production of highly standardized genre films and star vehicles for a huge and regular cinema-going public for whom the cinema was the dominant leisure activity (see Ellis 1977b).

TRANSFORMING THE INSTITUTION OF CINEMA

The changes in British cinema in the 1970s were part of a much longer term transformation of the institution of cinema. In the post-war period, film shifts from being something consumed at the cinema, in a public environment, to something consumed at home, in the private domestic environment – on television and, by the late 1970s, increasingly on video too. The 1970s themselves were marked by a series of attempts to renew the spectacular fantasy experience of cinema and the profitability of the film industry in this changing space of audio-visual media usage. It was less a matter of losing artistic confidence than of finding that certain cinematic forms were no longer commercially viable and having to seek out new forms.

One of the more successful results of this searching was the production by the major Hollywood studios of hugely expensive blockbuster films like *Jaws* (1975), *Star Wars* (1977), *Grease* (1978) and *Superman* (1978; registered as a British film), which temporarily slowed down the fall in admissions in Britain in the late 1970s.

However, the blockbuster is a one-off attraction, a special event: it renews the spectacle of cinema, but it also confirms the irregularity and specialness of cinema-going, rather than the regularity of the 'mass' audience of thirty years earlier.

The major British companies of the 1960s and 1970s had sought to consolidate their market position through the processes of conglomeration and rationalization. As such, they were very different from their predecessors of two or three decades earlier. Rank had been around since the late 1930s, ABPC even longer, but it had been taken over by the music industry giant EMI in 1969. Ten years later, EMI was itself taken over by Thorn, one of the country's leading electronic equipment manufacturers. Rank and EMI were joined at the top of the ladder in the mid-1970s by ACC, Lord Grade's company, with its base in commercial television (ATV). By this time, none of the three was a conventional film industry operation. They were all by now not only vertically integrated, bringing together in one company the three separate arms of the film industry, production, distribution and exhibition, but also highly diversified multi-media leisure and entertainments conglomerates with international interests. As the cultural economy had changed, so these companies had bought into other areas of the leisure and entertainments markets to maintain profit margins and reduce risks. Their film interests were only a small proportion of their overall operations; and film production, being essentially a high-risk business, was low on the corporate agenda, while film as an art was probably not on it at all.

In conjunction with changes in the patterns of leisure activity, these economic changes, which further concentrated the ownership and control of the media, leisure and entertainments industries in Britain, had significant effects on the development of British cinema in the 1970s (Murdock and Golding 1974, 1977a, b). Rank and ABPC/EMI had been rationalizing their film activities since the late 1950s, gradually pulling out of high-risk areas like production and concentrating on the more profitable areas of distribution and exhibition, where they could exploit the American films which they handled. All of this of course meant limited opportunities for British filmmakers – the majors were no longer involved in on-going production programmes and distribution and exhibition were dominated by American films.

In the exhibition sector, the majors had responded to falling admissions in the 1960s by closing their least profitable cinemas

(often re-opening them as bingo clubs etc.). In the late 1960s and into the 1970s, they increasingly began to acknowledge that the 'mass' audience upon which their business policies were founded no longer existed (if it ever had), and looked for ways to offer a greater diversity at the point of exhibition. The mass audience was in effect a consensual notion, cast in the mould of the family: as the post-war consensus began to fragment, so the cinema-going public came slowly to be recognized as a series of small publics, rather than a mass entity, the family audience. For years, the major circuits had been resisting the X certificate, which could not cater for the family audience; increasingly, they recognized that the expectations of X-certificated films generated sufficient admissions, and they began wholeheartedly to embrace sexploitation films, violent thrillers and horror films.

This policy was enabled by another, that of converting their old cinema palaces into two or three screen complexes instead of closing them altogether. This spread the costs of an individual cinema across several screens and enabled a more flexible booking policy, allowing the commercial potential of a film to be thoroughly milked by moving it from larger to smaller screens in the same cinema as audiences fell. Previously, the film would have been passed on to independent competitors. Twinning and tripling also encouraged a contained diversity catering for a series of specialized audiences – in effect, those established by the censorship certificate system. Thus in school vacations cinemas would show an X-certificated soft-porn film alongside a U-certificated Disney film for the family – and perhaps also an AA-certificated film suitable for the increasingly important adolescent market.

PRODUCTION AS PACKAGING

The studio system, a version of which had operated in Britain, was the dominant mode of production in the classical period. By the 1970s, with the majors pulling out of production and with so little finance available, the dominant mode of production became the package system. Each film became a separate entity, an individual package for which finance would have to be raised, rather than being part of an on-going production schedule employing the semi-permanent capital, resources and personnel of a studio (Pirie 1981: 40ff.). The blockbuster was the pinnacle of the package system, but, increasingly, each film, however modest, was in itself a pack-

age of attractions, each preferably with some sort of proven track record – producer, director, screenwriter, stars, but also the attractions of the story and vital ingredients like sex, violence and the spectacle of the body.

The onus of production shifted from the majors and their subsidiaries to small independent companies. As in Hollywood, the majors became banker-distributors, providing the facilities of their studios to independent producers on a film by film basis – at the same time retaining control over the sorts of films made, since they still held the purse strings and owned two of the three most important studios, as well as the most important distribution companies and exhibition circuits.

In order to gain finance or a distribution guarantee, a package needed not so much artistic credentials as marketing potential. It is perhaps not surprising, therefore, that one of the most successful producers of the 1970s was David Puttnam, who had himself come out of the advertising business. Puttnam was also one of the people who pioneered the concept of the film package with tie-ins to other media. One of the main reasons that he was able to gain capital for the production of *That'll Be The Day* (1973), for instance, was that he could interest the record company Ronco in acquiring the soundtrack rights for the film, which was to be packed with rock and roll classics from the 1950s (Yule 1989: 85–6). The package also included pop stars David Essex and Ringo Starr in the leading roles. It was in effect a multi-media package, the filmic equivalent of EMI, the multi-media conglomerate which provided the rest of the money for the film (Kramer 1990). It was also an astute recognition that the cinema-going audience was now primarily a young audience, for whom cinema was only one leisure activity among others. Young people were most likely to leave the domestic space of the family for their entertainments, however, and they were also one of the social groups least well catered for by television.

The decade saw the links between cinema and the world of pop music and various youth sub-cultures explored in many other films too. There were films organized around a band or bands, like *Glastonbury Fayre* (1973), a record of a rock festival, *Quadrophenia* (1979), a rock musical featuring The Who, *The Great Rock 'n' Roll Swindle* (1980), a sort of 'imaginative documentary' about the punk band The Sex Pistols, and *Exodus – Bob Marley Live* (1978), whose title speaks for itself. There were films

featuring pop stars in dramatic roles: Mick Jagger in *Performance* (1970), David Essex in *That'll Be The Day* and its sequel *Stardust* (1974), Roger Daltrey in *Lisztomania* (1975) and *Tommy* (1975), David Bowie in *The Man Who Fell To Earth* (1976), various punk 'heroes' in *Jubilee* (1978), Hazel O'Connor in *Breaking Glass* (1980) and so on.

CINEMA AND TELEVISION

Cinema was thus able to renew itself partly by strategically aligning itself within the multi-media entertainment market. This was true too of the relations between television and cinema in the 1970s. The British film majors now had extensive interests in commercial television, and feature films were a vital component of the television schedule. In fact, the cinema industry was involved in a double-edged strategy. On the one hand vast resources were thrown into the production of blockbusters enhanced by spectacular special effects, wide screen and 70 mm projection and Dolby stereo sound, in an effort to produce an aura and an experience which could not be reproduced by home viewing facilities. On the other hand, the cinema industry came to rely more and more on sales to television in order to generate revenue for film production. Television companies moved into feature film production too, with Thames, ATV and Southern, the three companies in which the film majors had interests, all setting up film production subsidiaries (Euston Films, Black Lion Films and Southern Films respectively).

The television spin-off was a yet more obvious way in which British cinema of the 1970s tapped the television market. Numerous feature films re-worked the characters, settings and themes of popular television series during the 1970s, and many of those films were box-office hits. Apart from cinema versions of *Callan* (1974) and *The Sweeney* (1976; made by Euston Films), most of the films were drawn from sit-coms, including *Dad's Army*, *Up Pompeii* and *On The Buses* (all 1971), *Steptoe and Son* and *Please Sir* (both 1972), *Love Thy Neighbour* (1973), *The Likely Lads* (1976) and *Porridge* (1979). Box-office success also encouraged the producers to make sequels to several of these films. Monty Python also moved from television to film, tying books in to the multi-media package, with *And Now For Something Completely Different* (1971), *Monty Python and The Holy Grail*

(1975), *Jabberwocky* (1977) and *The Life of Brian* (1979).

The television spin-off was one of the staples of British film production in the first half of the 1970s, along with numerous horror films, sex comedies and farces. Indeed the spin-off needs to be situated in the tradition of British cinematic farce and other forms of 'low' comedy, which historically played an important if under-valued role in constructing a national cinema in a country dominated by Hollywood films. Made on a low budget specifically for the domestic market rather than for export, and recruiting their performers and their audiences from pre-existing entertainment forms such as music hall, revue, variety and theatrical farce, 'low' comedy was a means of maintaining a stake for British film-makers in production and for British films in exhibition (Medhurst 1986; Higson 1990: 162ff.). The film versions of television sit-coms made in the 1970s were a renewal of this tradition, bringing together television, variety and cinema. They could still, at least in the first half of the 1970s, be made on a relatively low budget and guarantee an audience from the millions of fans of the same characters and situations on television. It was a rather desperate strategy, however, for television was not just another popular entertainment form but was symptomatic of the whole cultural shift from communal leisure activities requiring a public space to a privatized, home-based leisure culture. Despite the box-office successes of many of the television spin-offs, they were bound in the long run to fail. They were able to survive initially because they were made on a low enough budget to allow them to make a profit in the domestic market alone. As production costs spiralled in the latter part of the decade, the strategy was no longer so feasible.

MAINSTREAM FILM CULTURE

One of the major symptoms of the fragmentation of the 'mass audience' and the culture of consensus was the growth in minority cinema and minority film culture in the 1970s. Mainstream or majority film culture continued to be organized around popular commercial cinema, however. This dominant film culture actually engaged with two types of film in the first half of the decade. First, there were the Hollywood films which made up the bulk of films in distribution, and which captured the largest share of the box-office. To this category we need to add those British-

registered films which aimed to mimic the Hollywood formulae – i.e. films made on a high budget with generous production values and aimed at the international and especially the American market. Many of the British films made in this category continued to be funded by the American majors, while both EMI and ACC made a concerted and in the end financially disastrous assault on the American market in the late 1970s, with films like *Death On The Nile* (1978) and *The Boys From Brazil* (1978). Both films were replete with stars, though many of them were by now in fact past their prime (Peter Ustinov, David Niven and Bette Davis in EMI's *Death On The Nile*; Laurence Olivier, Gregory Peck and James Mason in ACC's *The Boys From Brazil*); both also had insistently international settings – touristic Egypt as well as heritage England in the former, and Austria, Germany, Paraguay, Brazil and the United States in the latter!

The second category of popular films includes all the horror films, farces and television spin-offs discussed earlier, many of which were made by small independent companies. The production of such films dwindled in the late 1970s: this was the end of the low budget British genre film, one of those cinematic forms that proved to be no longer commercially viable. In effect, this whole category of film-making has moved into television: the 'Carry On' films, for instance, which had been such a vital feature of British cinema for two decades, were re-edited for television series from the late 1970s.

Modestly budgeted, independently produced films continued to be made, but those that survived were of a rather different order, and were the product of a new generation of film makers, both enterprising creative producers such as Puttnam and Don Boyd and directors such as Alan Parker, Ridley Scott and Bill Forsyth. Rather than operating in the arena of popular genre production, these film makers tended to work in the realms of 'quality' cinema, aiming at a more 'sophisticated' and 'educated' middle-class audience, refusing to exploit the obvious commercial formulae and rejecting the vulgar innuendo of the sex comedy, the slapstick of the farce and the gothic sensibility of the horror film. This in no way meant ignoring the demands of the box-office, rather it meant going for a different sector of the market, in what was anyway a changing cultural economy.

The emergence of this new breed of independent production depended on re-invigorating the finance of British films: looking

for multi-media tie-ins; attracting venture capital from outside the industry; and putting together packages that could interest American distributors while remaining modestly budgeted. Even so, the task of raising production finance was monumental and reinforced the sense of each film being a one-off package – although this was also a creative decision, an effort to move away from popular genre films and serialization into the realm of the distinctive individual text. Since the domestic market was no longer seen as a significant generator of revenue, even for more modestly budgeted films, distributors and other sources of finance were concerned that the packages they supported were not too parochial. Where the 'Carry On' films and television spin-offs of the early 1970s had been self-consciously English in their sensibility, independent productions of the later 1970s had increasingly to take into account the wider international market-place. This inevitably had its consequences for the development of a *national* cinema. Thus two of Puttnam's more successful productions of the 1970s, *Bugsy Malone* (1976) and *Midnight Express* (1978), were, respectively, a musical pastiche of the American gangster film played by (American) children, and a tale of a young American imprisoned in a Turkish jail (both were directed by Alan Parker, another migrant from television advertising). Later, when Puttnam was trying to raise finance for *Chariots of Fire*, he was repeatedly told that the package was 'too British for the international market' (Yule 1989: 164).

A new organization, the Association of Independent Producers (AIP), was set up to lobby on behalf of this emergent cinema, particularly to put pressure on the government to provide greater protection for it, to enable it to remain a *national* cinema. This was the beginning of the renaissance of British cinema in the 1980s, which owed so much to the rise of the creative producer, the 'English' film made for the international market and the appearance of Channel Four television on the funding scene.

CINEMA AND THE STATE

The government had for some decades provided limited protection for a national cinema dominated by the American film industry. Such intervention had always been caught between demands for a cultural programme and the primarily economic policies which were adopted. Indeed, government responsibility for the industry

throughout the 1970s was split between the Department of Trade, concerned with film as commerce, and the Department of Education and Science (DES), concerned with film as culture. The former administered the National Film Finance Corporation (NFFC), a sort of government bank for film-producers, and administered the Eady levy, a surcharge on all tickets sold at the box-office which was re-distributed to the producers of the year's most successful British films. The NFFC and the Eady levy were of most importance to the independent producers working in the main-stream film industry, but most of the Eady money went regularly to a small number of high-grossing films, such as the Bond films and *Superman*, which least needed subsidies. The DES had a very different brief, providing funds to the British Film Institute (BFI), the Arts Council of Great Britain and the Regional Arts Associations, important sources of finance for minority film culture in the 1970s.

With the crisis in production funding caused by the withdrawal of American capital and the continuing fall in admissions in the early 1970s, there were calls for the government to increase its subsidies to the industry. Such calls fell on deaf ears with the Tory government of 1970, who were in no mind to support what they saw as a failing industry, unable to pay its way in the competitive environment of the market-place; as a result, they required the NFFC to match a depleted government subsidy with privately raised capital (the NFFC was finally privatized under the Thatcher government). When Labour were returned to power, they developed plans for a reasonably well-funded British Film Authority to bring together all the various state responsibilities towards cinema, with a commitment to producing a greater diversity of film practice in Britain. The election of a new Tory government in 1979 put an end to these proposals, and government support for the film industry was gradually curtailed over the next few years (Ellis 1976; Dickinson and Street 1985: 227ff.).

State support for the commercial film industry in the 1970s was thus minimal and ineffective. Indeed, the protectionist policies had the opposite effect to that which was intended, encouraging American companies to fulfil the requirements for British registration for some of their productions in order to reap the benefits of the system. In these circumstances, British cinema relinquished its role as producer of popular culture to Hollywood and to television. The British film economy could no longer support the

production of popular films for the domestic market alone, which meant in effect that indigenous popular cultural forms no longer had a space in the public forum of cinema, except insofar as American popular culture had become a vital part of the British scene.

MINORITY FILM CULTURE

On the other side of the fence from cinema as popular culture were the various minority film cultures of the 1970s. If the decade saw the decline of a classical cinema with its foundations in the studio system and the genre film, it also saw the emergence and consolidation of alternatives to it, various more or less small-scale, marginal cinemas, each with a very different relationship to the culture and economy of Hollywood. This is yet another instance of the diversification and renewal of the cinema institution. As we have seen, ownership and control of the media was concentrated in fewer and fewer corporations during the 1970s, but since these corporations tend to work only in the most profitable areas of the media, they do at the same time create a space on the margins of the industry for innovative or unconventional work. Of course, it is one thing for a space to exist, another to find it well capitalized, and even though there has been a minority film culture in Britain since the mid-1920s, it has never commanded significant financial resources. To some extent, then, the various marginal cinemas and minority film cultures of the 1970s functioned as a sort of research and development sector of the industry, working in the least profitable and highest risk areas of the market, however much they would have liked to resist such a role.

There were three distinctive marginal cinemas and minority film cultures in the 1970s: first, art cinema and the culture of auteurism, which to some extent overlapped with the new mainstream indigenous 'quality' film promoted by the AIP; second, what was rather confusingly called independent or avant-garde cinema, but which needs to be understood as in many ways quite distinct from the independent production sector of the dominant film culture; and third, pornographic cinema (see Ellis 1977a: 61).

Each of these marginal cinemas was involved in constructing a new type of film and in recruiting and reconvening an audience for it. Each therefore involved not just a body of films but an infrastructure of funding, production, distribution and exhibition, as

well as a critical culture to promote its interests. Each therefore also pushed cinema beyond its conventional boundaries, in terms of both its traditional modes of production and consumption and its traditional subject matter and modes of representation.

Art cinema and independent cinema also benefited from state support in the form of arts subsidies which other more commercial sectors of the film industry had failed to get (Blanchard and Harvey 1983). Indeed, one distinction between majority and minority cinema – and particularly between the independent production sector of the former and the independent cinema of the latter is that the former was most dependent on the vagaries of the market-place and on private capital and the latter on funding from the public sector.

ART CINEMA

There had been an art cinema of sorts in Britain since the 1920s, insofar as a parallel exhibition circuit was set up in the form of the Film Society movement to show films of minority interest which did not find their way into the mainstream cinemas. In the post-war period, art cinema was organized primarily around European 'auteurist' productions. By the 1970s, art-house cinemas were established in most major cities for screening such films, serviced by specialist distributors; further art-houses were opened during the decade, many of them designated Regional Film Theatres and receiving BFI and local authority funding. Few British films were produced specifically with this emergent circuit in mind, not least because box-office takings could hardly support such a practice. At the same time, 'quality' films were being made which addressed the middle-class, 'educated' audiences that frequented art-houses, and which found it difficult to gain adequate distribution with the majors, who did not really know how to handle such fare.

There were, for instance, an increasing number of films made during the 1970s which eschewed the narrative linearity of the classical film, and which shifted towards the narrational complexity, the fragmentation of time, space and action and the psychological realism of modernist fiction and European art cinema. Other films broke down the economy of motivation of the tightly causal action film, to replace it with the much looser, more episodic form of the picaresque. The films of Nic Roeg, Joseph Losey, John Schlesinger and Ken Russell all fall into these

areas. For instance, *Performance* (co-directed by Roeg and Donald Cammell) was a gangster film of sorts, but hardly typical mainstream fare and although it was made in 1968 with money from the American major, Warner Bros, it was held up by its distributors until 1970 (Yule 1989: 53, 57; Armes 1978: 317). The film was sexually explicit and included scenes of lesbian sex; it was often very violent; it celebrated drug culture quite openly. Formally it was very innovative, at times using a radically disjunctive, almost stroboscopic montage style; images and scenes were frequently cut together in a quite unexpected way; and a whole range of other non-classical devices were used – hand-held camera, slow-motion, out of focus and wide angle shots, unconventional camera angles, un-motivated or simply unfamiliar music and other sound effects and an obsessive use of mirrors. The film is constantly dream-like in its play with time, perception and identity.

This break with the expectations of mainstream films, testing the limits of representation, really had no place in the cinema of the late 1960s or early 1970s: it was too expensive to distribute solely as an art film and too unconventional to be successful as a mainstream film. Yet, somehow, Roeg continued to attract the funds of both British and American majors, suggesting either a certain open-mindedness and innovatory bent on their part, seeking out new audiences, or a failure to assess successfully the packages in which they had invested – or, indeed, a conflict of interests between different sections of a corporation. Rank, for instance, put up the bulk of the money for *Bad Timing* (1980), but then their chief booker refused initially to show it on their Odeon circuit (Perry 1985: 287; A. Walker 1985: 208).

Roeg, Losey, Schlesinger and Russell all worked in the independent production sector, their films straddling the divide between majority and minority film culture. Several of their films would seem to have minority appeal, yet became box-office hits; others, as one would expect, did not fare well on the mainstream circuits. As the emphasis in the low to medium budget category shifted in the decade from genre films and series to one-off 'quality' productions, so the divide between minority and majority film culture became more blurred, at least in the middle-ground. On the other hand, a small but growing number of low budget British features were made which were addressed primarily to the circuit of art-houses and international festivals. These included the films made

under the auspices of the BFI Production Board, whose function was precisely to encourage innovative and experimental work that could be made with minimal funds. Making a virtue out of necessity, several of these films were off-beat, low-key dramas shot on location and in one way or another exploring a culture of poverty and eschewing the glamorous production values of mainstream film: the oppression of young black Britons in Horace Ove's *Pressure* (1974); the mundane alienated lives of some very ordinary lower-middle-class people in Mike Leigh's *Bleak Moments* (1971); an austere working-class upbringing in Scotland in Bill Douglas's trilogy of shorts, *My Childhood*, *My Ain Folk* and *My Way Home* (1972–7); and a soul-less picaresque search though a drab English landscape in Chris Petit's *Radio On* (1979).

Another filmmaker whose feature films could only really work on the art-house model was Derek Jarman, equally adept at creating evocative, often camp, or grotesque *mise-en-scène* on a minimal budget. His three feature-length films of the 1970s were all demandingly reflective post-modern allegories, each in their own way refusing conventional dramatic values: *Sebastiane* (1976), a gay historical drama, *Jubilee* (1978), an angry, bleak punk vision of contemporary England, and a version of Shakespeare's *The Tempest* (1980).

AVANT-GARDE AND INDEPENDENT CINEMA

Where Roeg seemed to straddle majority and minority film culture, Jarman, with his roots in fine art, his avant-garde sensibility, his gay politics and his hostile dismissal of most contemporary mainstream cinema, shared more with the independent cinema of the 1970s. Since the late 1960s, various models for avant-garde, alternative or oppositional film-making had emerged: there were those who were using film for political purposes, making feminist or socialist documentaries and later dramas, community action films, campaign films or self-reflexive issue films drawing on the techniques of Bertolt Brecht and Jean-Luc Godard (e.g. Cinema Action, The Berwick Street Collective and The London Women's Film Group). There were others who came out of art schools and the 'underground' culture of the late 1960s and early 1970s, who saw film-making as more closely aligned with avant-garde and modernist developments in the other arts and who concentrated on exploring the formal possibilities of filmic representation (e.g.

Malcolm Le Grice and Peter Gidal, both associated with the London Film-makers' Co-op.). Another influence was the development through the decade of the radical critical theory – Russian formalism, structuralism, semiotics, psychoanalysis – associated with the journals *New Left Review* and *Screen* and the calls made for a type of cinema that could integrate theory and practice. This led to the production of several 'theory films', such as Laura Mulvey and Peter Wollen's *Riddles of the Sphinx* (1977). In some cases attempts were made to draw together these various strands of radical artistic and political practice, arguing, for instance, for the *political* importance of formal experimentation (e.g. Wollen 1982). In 1974, the Independent Film-makers' Association (IFA) was set up to represent the interests of its members, becoming an important lobby and a forum for debates about independent cinema in the late 1970s.

Asserting their independence from illusionist narrative aesthetics, capitalist modes of production, consumerist modes of consumption and the at best liberal politics of mainstream cinema, the IFA and others in the independent sector explicitly saw themselves as forging a new cinema with a transformed social function (Stoneman and Thompson 1981). Most self-conscious of all the alternatives to the mainstream Hollywood-oriented film, they also saw themselves as a movement with a coherent and distinctive programme of aims and objectives. One of the most clearly articulated aspects of this programme was the belief that those involved were building not only a new cinema and a new audience but a new, more interactive relationship between producer and consumer. Although this argument was founded upon the problematic assumption that audiences for more mainstream fare were passive dupes of the text, some of the practices developed were innovatory: developing intellectually demanding, self-reflexive film styles; involving the subjects of a documentary in decisions about their representation; setting up discussions with filmmakers after a screening; producing extensive documentation around a film or programme of films; and so on. As such, independent cinema was one of the most exciting, regenerative and transformative aspects of 1970s British cinema. In its very self-consciousness and its oppositional stance to the mainstream, as well as in the form and subject matter of the various films produced, we can see the cultural and political fragmentations of the period being addressed in a way that was alien to the mainstream, however hard it tried to

break with the idea of the 'mass' audience and its presumed tastes and concerns.

The emergence and consolidation of independent cinema in the late 1960s and 1970s suggests that, while some of the other art-forms of the period may have witnessed the death of the avant-garde, cinema actually gave birth to a new avant-garde. The movement saw itself very much at the forefront of innovation and experimentation, and it mobilized some of the more dynamic social movements of the period, notably the Women's Movement (Black film-making was minimal in this period, being more a feature of the next decade). Indeed, this was one of the very few areas of British cinema in the 1970s in which women were not only active but also in positions of creative responsibility, and several films were made dealing with questions of sexual politics in an avowedly feminist way. Susan Clayton and Jonathan Curling's *The Song of the Shirt* (1979), for instance, explored representations of women in the clothes trade in the 1830s and 1840s, and their implications for the social positioning of women today. *Riddles of the Sphinx* and Sally Potter's short *Thriller* (1979), were also both concerned with the representation of women in western patriarchal culture, the former focusing on the politics of mothering and childcare, the latter deconstructing the narrative of the opera *La Bohème*. They are all typically complex and demanding avant-garde films, collages of material from a variety of sources and in a variety of styles, which foreground their own processes of production.

Inevitably, given its radical difference from mainstream cinema, the independent movement was open to accusations of elitism. Later in the decade, efforts were made to re-engage with popular culture – or at least to work with more conventional narrative forms on bigger budgets, as with *Brothers and Sisters* (1980), a thriller about sexual violence which explores male attitudes towards women and their relation to class politics. In order to find a more accessible merging of popular and elitist icons and cultural forms, however, we would need to turn to Derek Jarman's postmodernist films.

In a period characterized by an increasing concentration in the ownership and control of the media, the independent cinema embraced a whole range of local, small-scale initiatives, including production workshops, flexible screening venues and specialist distribution organizations – sometimes all under one roof, as in the

case of the London Film-makers' Co-op. Promoting the interests of this realm of film practice were numerous often short-lived magazines and journals such as *Afterimage* and *Framework*. Ironically, the strength of this self-proclaimed independent cinema was its increasing dependence on (limited) state subsidies for various of the practices of the movement: the funds of the BFI Production Board, the Arts Council and the Regional Arts Associations (RAAs) for production, and the funds of the BFI, the RAAs and local government for exhibition – Regional Film Theatres (RFTs), for instance, were among the few cinemas that might be persuaded to screen independent material.

PORNOGRAPHY, SEXUAL DISPLAY AND INNUENDO

The third marginal cinema of the 1970s was the pornographic film industry – both the scores of cheaply made films exploiting the patriarchal culture of sexual liberation and the numerous private cinema clubs that sprang up in London's Soho district and else-where to show such films. The club status was important in that it enabled the cinemas to get round the prevailing censorship laws, and the shift from a public to a private space indicates yet again the fragmentation of the 'mass' audience and the culture of consensus through the 1970s. At the same time, however, the concerns and the modes of representation of the pornographic film were really only more extreme versions of a fascination with sexuality and with the body as object of display that pervaded most aspects of 1970s cinema. The pornographic film undoubtedly worked at the very limits of representation in respect of sexuality, but other film cultures were testing those limits in other ways. The combination of the culture of 'permissiveness', the rise of the Women's Movement, the debates about morality and censorship and the widespread dissatisfaction with traditional portrayals of sexuality provoked a breakdown in consensual views of sexuality, a crisis in representation which could be variously explored and exploited across the several film cultures and cinemas of the 1970s.

There remains a split in representation during the 1970s be-tween, on the one hand, the ostentatious and often crude display of the body engaged in sexual activity, or the verbal description of or direct reference to such activity, and on the other hand, innuendo – that is, suggesting what is actually hidden, rather than

overtly displaying it. This strategy was preferred by the more mainstream films addressed to the traditional 'family audience' – the Bond films, or the 'Carry On' films, which delighted in their vulgarity, in their acknowledgement of sexuality and the physical body and in their camp representation of patriarchy. But the 'Carry On' style of innuendo could not last in the 1970s: in order to remain abreast of the times, the films had to show more, which made the innuendo redundant – it made no sense to intimate what was actually on display. The pleasure of innuendo depends upon an underlying current of sexual repression, but the prevailing cinematic current in the 1970s was sexual liberation. The final film in the series was *Carry On Emanuelle* (1978), a parody of the soft-core pornographic film. This was a fitting place to end, where the traditional culture of innuendo met the new culture of display head-on.

One of the on-going themes of the 'Carry On' films was male anxiety about the castrating figure of the matronly woman (usually played by Hattie Jacques). In the wake of the Women's Movement, numerous films of the 1970s expanded this anxiety into a fear of women usurping the power of men. The women in *O Lucky Man* (1973) are all-engulfing, sexually voracious figures, as are the female vampires of Hammer's trilogy of horror films *The Vampire Lovers*, *Lust For A Vampire* (both 1970) and *Twins of Evil* (1971); *The Likely Lads* are worried about their containment by women in marriage; a murderous gang of women in *Jubilee* literally castrate a gun-toting policeman; and James Bond is repeatedly taxed by women who threaten his position and his body – he must curb their excesses, put them back in their place (see Bennett and Woollacott 1987: 39).

Once again, Roeg's films, from *Performance* to *Bad Timing*, are a good indication of how British art cinema was pushing at the boundaries of what was acceptable in terms of erotic fantasy and images of sexuality. Art-house distributors were also importing European films with equally controversial representations of the body, such as *Last Tango In Paris* (1972) and *WR – Mysteries of the Organism* (1971). Jarman was one of the few filmmakers to explore homoerotic imagery, but a wide range of films acknowledged homosexuality in various ways, from art films such as *Sunday, Bloody Sunday* (1971) and *Nighthawks* (1979), to popular comedy such as *Porridge* and the camp representations, cross-dressing and mistaken identities of the 'Carry On' films, and

numerous other farces and sex comedies. The Hammer trilogy noted above was one of the few places in which lesbianism was confronted, however. Indeed, it was rare to find films made from a committed feminist perspective outside the independent movement.

NOSTALGIA, CAMP AND PARODY

Much of the British cinema of the 1970s was engaged in a desperate, often exploitative and invariably ambivalent bid to 'modernize' its representation of sexuality in search of new audiences. But there is a cross-current flowing through some of the more Hollywood-oriented mainstream films, a nostalgic attempt to reconstruct the cinema of the 1930s, 1940s and 1950s, to return to the traditions of family entertainment and classical style. Numerous costume dramas and period films display beautifully a timeless pastoral England, as in the opening sequences of *Death On The Nile*. (Even in the midst of *Jubilee*'s apocalyptic vision of the last of England there is a nostalgic vision of a stately rural England and a reassuring Shakespearean culture.) In *The Thirty Nine Steps* (1978) it is the old country itself which is under threat from foreign powers, and which is saved by the daring of Richard Hannay. Even the Bond films, for all their fascination with modern technology and a modern attitude to sexual relations, are bound to tradition. The villains represent a modernity taken to extremes, which must therefore be held in check. And Bond himself represents the perfect indestructibility of a traditional national identity, a class style and a gender role. But all is not what it seems, as is clear from *The Go-Between* (1971), which reveals some of the tensions at the heart of this Englishness, which it locates in an Edwardian country house setting (inevitably, it is sexuality which disturbs the class heritage).

A certain strand of mainstream cinema thus looks back nostalgically – but it can rarely do so in all seriousness. The return to classical conventions and traditional ideological standpoints is repeatedly done tongue-in-cheek; nostalgia becomes camp pastiche. The Bond films become self-mocking parodies of an archaic Englishness carried to excess. *Death on the Nile* plays facetiously with stereotypes of class, gender, race and national identity; upper-class types are parodied in *The Go-Between*. Indeed, a camp or parodic sensibility pervades much of the cinema of the

1970s, from Ken Russell to 'Carry On', from *Are You Being Served?* to *The Great Rock 'n' Roll Swindle*, from *The Rocky Horror Picture Show* (1975) to *O Lucky Man*. *Jabberwocky*, for instance, goes to great lengths to construct a credible medieval landscape, but it cannot help at the same time parodying the conventions of that verisimilitude, just as Hammer parody their own Frankenstein tradition in *The Horror of Frankenstein* (1970).

THE CULTURE OF DISSENT

The nostalgic sensibility can therefore only uneasily embrace the traditional culture of consensus, perhaps inevitably in a period which sees the increasing fragmentation of and disenchantment with that culture. However, it is left to the more innovative, more marginal strands of British cinema to confront head-on the issues of marginality itself, of dissent, of cultural change – except insofar as the transformations in the institution of cinema as a whole in this period are a response to this unravelling of hegemony. For many commentators, the moral decadence of *Performance* at the beginning of the decade marked the end of one era and the beginning of another; the theme is picked up again in *Jubilee*, when one of the characters remarks that 'love snuffed it with the hippies'. Certainly, the harsh, unpolished punk aesthetics of Jarman's allegory of the collapse of Elizabethan England in Jubilee year are a direct affront to the purveyors of good taste and consensual imagery in the period. Young people and youth culture are indeed the bearers of anarchy in this film and in the equally aggressive *The Great Rock 'n' Roll Swindle*, another document of punk dissent, while *Pressure* was one of the few British films of the 1970s to engage with race relations, exploring the oppressive circumstances of London's black youth.

There are other less marginal dramas which might be read as allegories of the breakdown of national unity. Violent conflict erupts in the pastoral English community of *Straw Dogs* (1971). In *Frenzy* (1972), there is a murderer loose in Covent Garden, the urban pastoral heart of Little England, Ealing Studios' old stamping-ground. In *The Wicker Man* (1974), another Ealing strategy – imagining the nation as an organic, self-sufficient community in remotest Scotland – has a terminally violent confrontation between the perverse community and the representative of external authorities that could never have been entertained in an Ealing

film. In *Taste The Blood of Dracula* (1969), the family, the moral centre of the post-war consensus, is destroyed from within when the children slaughter their parents.

THE END

What can the various film practices of the 1970s tell us about the condition of Britain? Above all, perhaps, that the post-war culture of consensus was in disarray and new social forces were emerging, a fact signalled in some individual films but just as eloquently in the institutional changes within cinema as a whole and especially in the emergence of the various alternative film cultures. Cinema also responded to and reinforced this cultural fragmentation in its diversity of representations of sexuality and the occasionally intense debates about censorship. In that sense, *Carry On Emanuelle*, with its articulation of some dominant desires and anxieties concerning sexuality, may tell us as much about the condition of Britain as *Jubilee*, with its overt dramatization of a society in turmoil, but in which the most positive social groupings are those which acknowledge the contemporary vitality of the Women's Movement, gay liberation and punk youth culture.

American cinema, and the culture which celebrated it, remained dominant in Britain, but alternatives were available. Cinema itself was not in decline, but was going through a complex process of diversification and renewal. While the commercial cinema had to transform to remain in business, the several minority film cultures, perhaps the real forces for innovation and diversity in the period, emerged less as commercial imperatives than as responses to felt cultural needs on the part of those involved in building these new cinemas.

FURTHER READING

Both J. Walker (1985) and A. Walker (1985) are book-length journalistic studies of British cinema in the 1970s and 1980s; two much more modest publications are very suggestive about the period (Ellis 1977a: 60ff.; 1978). The standard histories of British cinema also have chapters on the 1970s (Armes 1978; Perry 1985; Park 1990), and some of the essays in Barr (1986) and Curran and Porter (1983) are useful. On the political economy of the film industry, see Dickinson and Street (1985), Murdock and Golding (1974, 1977a, b) and Ellis (1976). Wood (1983) is a good source of statistics, especially on production; Edson (1980) is helpful on

distribution and exhibition. Yule (1989) provides a fascinating narrative account of the period focused on the exploits of one key individual, David Puttnam. Bennett and Woollacott (1987) on Bond films, Jordan (1983) and Medhurst (1992) on 'Carry On' films and Pirie (1974) on horror films all provide good discussions of popular cinema, though the latter only goes as far as 1973. On independent and avant-garde cinema, see Blanchard and Harvey (1983), Ellis (1982), Harvey (1986), Stoneman and Thompson (1981) and Le Grice (1977).

BIBLIOGRAPHY

Armes, R. (1978) *A Critical History of British Cinema*, London: Secker & Warburg.

Barr, C. (ed.) (1986) *All Our Yesterdays: 90 Years of British Cinema*, London: British Film Institute.

Beharrell, P. and Philo, G. (eds) (1977) *Trade Unions and the Media*, London: Macmillan.

Bennett, T. and Woollacott, J. (1987) *Bond and Beyond: The Political Career of a Popular Hero*, Basingstoke: Macmillan.

Blanchard, S. and Harvey, S. (1983) 'The post-war independent cinema – structure and organisation', in J. Curran and V. Porter (eds) *British Cinema History*, London: Weidenfeld & Nicolson.

Curran, J. and Porter, V. (eds) (1983) *British Cinema History*, London: Weidenfeld & Nicolson.

Curran, J., Gurevitch, M. and Woollacott, J. (eds) (1977) *Mass Communication and Society*, London: Edward Arnold/Open University Press.

Dickinson, M. and Street, S. (1985) *Cinema and State: The Film Industry and the British Government, 1927–1984*, London: British Film Institute.

Docherty, D., Morrison, D. and Tracey, M. (1987) *The Last Picture Show: Britain's Changing Film Audiences*, London: British Film Institute.

Edson, B. (1980) 'Film distribution and exhibition in the UK', *Screen* 21 (3): 36–44.

Ellis, J. (1976) 'The future of the British film industry', *Screen* 17 (1): 84–92.

—— (ed.) (1977a) *1951–1976. Catalogue: British Film Institute Productions*, London: British Film Institute.

—— (1977b) 'The institution of cinema', *Edinburgh '77 Magazine*: 56–66.

—— (1978) 'Art, culture and quality – terms for a cinema in the forties and seventies', *Screen* 19 (3): 9–49.

—— (1982) 'Beyond the Hollywood film: the British independent cinema', in J. Ellis (ed.) *Visible Fictions*, London: RKP.

Harvey, S. (1986) 'The "other cinema" in Britain: unfinished business in oppositional and independent film, 1929–1984', in C. Barr (ed.) *All Our Yesterdays: 90 Years of British Cinema*, London: British Film Institute.

Higson, A. (1990) 'Constructing a national cinema in Britain', PhD thesis, University of Kent at Canterbury.

Jordan, M. (1983) 'Carry on . . . follow that stereotype', in J. Curran and V. Porter (eds) *British Cinema History*, London: Weidenfeld & Nicolson.

Kramer, P. (1990) 'Contemporary American cinema', unpublished paper, Film Studies, School of English and American Studies, University of East Anglia.

Le Grice, M. (1977) *Abstract Film and Beyond*, London: Studio Vista.

Medhurst, A. (1986) 'Music hall and British cinema', in C. Barr (ed.) *All Our Yesterdays: 90 Years of British Cinema*, London: British Film Institute.

—— (1992) 'Carry on camp', *Sight and Sound* 2(4) (New series): 16–19.

Miliband, R. and Saville, J. (eds) (1974) *Socialist Register 1973*, London: Merlin Press.

Murdock, G. and Golding, P. (1974) 'The political economy of mass communications', in R. Miliband and J. Saville (eds) *Socialist Register 1973*, London: Merlin Press

—— and —— (1977a) 'Beyond monopoly: mass communications in an age of conglomerates', in P. Beharrell and G. Philo (eds) *Trade Unions and the Media*, London: Macmillan.

—— and —— (1977b) 'Capitalism, communication and class relations', in J. Curran, M. Gurevitch and J. Woollacott (eds) *Mass Communication and Society*, London: Edward Arnold/Open University Press.

Park, J. (1990) *British Cinema: The Lights That Failed*, London: Batsford.

Perry, G. (1985) *The Great British Picture Show*, Boston, IL: Little, Brown.

Pirie, D. (1974) *A Heritage of Horror: The English Gothic Cinema, 1946–1972*, New York: Equinox/Avon.

—— (ed.) (1981) *Anatomy of the Movies*, New York: Macmillan.

Stoneman, R. and Thompson, H. (1981) *The New Social Function of Cinema. Catalogue: British Film Institute Productions '79–80*, London: British Film Institute.

Walker, A. (1985) *National Heroes: British Cinema in the Seventies and Eighties*, London: Harrap.

Walker, J. (1985) *The Once and Future Film: British Cinema in the Seventies and Eighties*, London: Methuen.

Wollen, P. (1982) 'The two avant-gardes', in P. Wollen, *Readings and Writings*, London: Verso (first published 1975).

Wood, L. (ed.) (1983) *British Films, 1971–1981*, London: British Film Institute Library Services.

Yule, A. (1989) *David Puttnam: The Story So Far*, London: Sphere Books.

Chapter 11

Blood on the tracks
Popular music in the 1970s

Dave Harker

INTRODUCTION: NEVER MIND THE BOLLOCKS – IS THIS ROCK AND ROLL?

What *was* popular music in the 1970s? If you were around then, you could list your own and your friends' tastes; if you weren't, you could ask your parents. But you can't find out in the books, because they tend to rely on an implicit consensus about how, for example, 'the sixties' became 'the seventies' and then 'the eighties', and how, as Frith puts it, 'the sound of the early seventies' *was* 'rock' (Frith 1983: 11). As though any particular 'sound' could be so universal, monolithic and unproblematical! This rhetorical strategy relies, however, on two main tactics. First, the 'rock' critics tend to take over the same terminology as musicians, music business people and journalists – the terms we use conversationally, without ever examining what they might deliver conceptually. Then they construct a chronology and a geography for popular musical development which relies on an unargued but agreed hierarchy of value, with 'rock' at the apex and its *locus classicus* in America (Frith 1983: 11). Whenever it becomes unmistakably clear that certain musics are different, prefixes and suffixes get added to 'rock' to suggest both continuity and development. So, in that fascinating flow-chart on the back cover of Chapple and Garofalo's *Rock 'n' Roll Is Here To Pay* (1977), we are offered an almost Darwinian progression from 'rockabilly', 'rock 'n' roll' and 'rock and roll', through 'folk rock', 'hard rock', 'acid rock' or 'pop rock' and so on to 'country rock' and 'soft rock'. Thereafter, presumably, came 'punk rock', and so on into infinity.

This is a comforting perspective: something, seed-like, seems to have landed in the southern United States in the early 1950s,

flowered, wilted and gone back to seed, to be blown elsewhere, to take root and bloom once again, at irregular intervals. There is no sense from such narratives, however, of how Frith's 'sound of the early seventies' came to be silenced, or where 'it' went between, say, 1973 and 1975, let alone how 'it' reappeared in a strikingly different form somewhere in London, England, around 1976, only to wilt and fade once again. Nor is there any explanation of how these supposedly different flora kept separate from each other, or developed their own distinctive colourings. Was there, for example, not only 'progressive' but also *reactionary* 'rock'? Did 'glam rock' have a drab cousin? Did 'country rock' stop at the city limits? I have tried to show that such terms always tend to be conceptually slithery (Harker 1985: *passim*; Harker 1992: *passim*); but for the 1970s the problem is, if anything, more acute, since influential critics such as Frith insist that 'the sound of the early seventies' was in some ways archetypally 'rock', and 'rock' had by then become *the* popular music industry.

The truth is we just do not know what music most people liked in the 1970s. Instead, all we have are the industry's chart rankings for a tiny number of countries, the industry's awards of 'gold' and 'platinum' status, and the industry's claimed sales figures for particular singles and albums, virtually all of which are anglophone and originate in either the United States or the United Kingdom. Much of this data was gathered together by Joseph Murrells for his *Book of Golden Discs*, last updated in 1978 but dealing chiefly with the period up to 1975, so the rest of the 1970s are served only patchily.

However, even from this grossly inadequate data we can discern some interesting patterns in over-the-counter transactions. Take singles: Murrells's (1978: 395) list of 1970s best-sellers looks like this:

George McRae	*Rock Your Baby* (1974)	11 million
Middle of the Road	*Chirpy Chirpy Cheep Cheep* (1971)	10 million
Danyel Gerard	*Butterfly* (1971)	7 million
Royal Scots Dragoon Guards	*Amazing Grace* (1972)	7 million
Dawn	*Knock Three Times* (1970)	6½ + million
Simon & Garfunkel	*Bridge Over Troubled Waters* (1970)	6 + million
Dawn	*Tie a Yellow Ribbon* (1973)	6 million

Neil Diamond	*Cracklin' Rosie* (1970)	6 million
New Seekers	*I'd Like to Teach the World to Sing* (1971)	6 million
Terry Jacks	*Seasons in the Sun* (1974)	6 million
The Jackson 5	*I'll Be There* (1970)	5 + million
Donny Osmond	*Puppy Love* (1972)	5 + million
Abba	*Waterloo* (1974)	5 + million

It would be hard to argue that 'rock' music is dominant here, though there is a concentration of US-based artists, with occasional representation from the United Kingdom and, once, somewhere else in Western Europe (though Abba recorded in English). But what is interesting, even allowing for Murrells's partial data, is the concentration of successful singles releases in 1970 and 1971. Singles, after all, usually have a relatively short shelf-life, so it is remarkable that nine of the twelve best-sellers were released in 1970–2 and none after 1974. George McRae's *Rock Your Baby* is usually termed a 'disco' record. As for Middle of the Road, they chose their name to fit their own conception of their repertoire; they were orginally from Glasgow, worked cruise boats and then Italian clubs and recorded their 10-million-seller for an Italian RCA producer. *Chirpy Chirpy Cheep Cheep* was written by an expatriate Liverpool man, first became a hit in Belgium in 1970, and then in Britain and Germany and a further seventeen European countries, plus Australia, Mexico and Argentina. According to Murrells (1978: 298–9), it 'did not register big in the USA'; though a version by Mac & Katie Kissoon (a brother and sister act from Trinidad) got as high as No. 20 in the US charts in April 1971. And contrary to Dannen's assertion (1991: 87) that 'Pop in the record industry is a euphemism for white', McRae's record sold forty times as many as the biggest 'punk' hit, The Sex Pistols' *God Save the Queen* (1977), even though the latter had the advantage of being banned in the UK. In fact, the best-selling single of 1977 may well have been Wings' *Mull of Kintyre*, which had sales of over 2 million copies, and 1978 saw the release of four of the highest-ever singles sellers, including discs by Boney M and John Travolta and Olivia Newton-John (Laing 1985: 34, 38). So, in spite of the 'rock' critics' enthusiasms, 'punk' hardly mattered commercially, especially in the United States where 'punk' singles made no serious impression at all.

Perhaps, then, 'punk' was an album phenomenon, as much as 'rock' had been since at least the later 1960s? Well, it is true that

both The Sex Pistols' *Never Mind the Bollocks* and The Clash's
Combat Rock shifted half a million copies in the United States
alone, with the latter going on to sell a million; but *Never Mind the
Bollocks* took ten years to 'go gold' and *Combat Rock*, not released
until after the alleged 'punk' peak had passed, in 1982, took nine
years to 'go platinum'. In any case, compared with the really big
sellers of the 1970s, both albums sold modestly. Simon &
Garfunkel's *Bridge Over Troubled Waters* (1970) sold 10 million
copies and Carole King's *Tapestry* (1971) reached 13 million, and
these are only those non-'rock' albums which are accounted for in
Murrells's 1978 book. From other sources we gather that both
Grease (1978) and *Saturday Night Fever* (1977) eventually sold
over 30 million copies apiece, and the films from which they were
taken both grossed over $100 million at the box office (Dannen
1991: 174). Fleetwood Mac's *Rumours* (1977) went on to sell 13
million copies, to add to the 8½ million copies of their other 1970s
album releases; while Chicago's 1970s albums sold an aggregate of
16 million copies (Murrells 1978: 387). In fact, 1970 and 1971 were
the years in which over half of Murrells's 1970s best-sellers were
released: so the 'rock' 'sound of the early seventies' was not,
apparently, what most people in the early 1970s bought and,
presumably, listened to, in anglophone countries at any rate. And
if there was a 'sound' of 'the seventies' as a whole it looks, on the
surface at least, that so-called 'disco' seems to have been the major
contender, with 'soft rock' its only serious rival. Perhaps, then,
'rock' lurked in those mid-decade years of 1973–5, or maybe some
crucial artist with non-spectacular but regularly high sales has been
overlooked in this singling-out of major commercial successes.

As it turns out there is a figure who has some claim to being the
single most representative 'sound of the seventies', but you will
not find him or his work studied (or, sometimes, even mentioned)
in the work of the better-known anglophone 'rock' critics. His
name is Elton John. Between May 1970 and October 1979 John
had no fewer than sixteen Top 50 albums in the United Kingdom;
only two failed to make the Top 20 and four went to No. 1 – an
Elton John album was likely to be in the charts for two weeks in
three throughout the decade. John was mainly an album-oriented
artist: his singles got into the UK charts – twenty-four of them in
fact – but only his joint recording with Kiki Dee, *Don't Go
Breaking My Heart* (1976), reached No. 1. In the United States,
also, John was a major chart success: five of his singles reached

No. 1 and a further three got to No. 2; while no fewer than seven of his eighteen charting albums reached No. 1. In the United States, twelve of his singles sold over a million copies apiece, as did three of his albums. *Captain Fantastic and the Brown Dirt Cowboy* (1975) sold 1,400,000 copies in its first four days of release in the United States, with a further 1,200,000 sales in the next three months. *Rock of the Westies* (also 1975) was certified 'gold' in the United States on its day of release. By 1978, Elton John is accredited with having twenty-two million-selling records, ten of them albums, including sales of 7 million apiece for *Captain Fantastic* (1975), *Greatest Hits* (1974) and *Goodbye Yellow Brick Road* (1973), 4 million each of *Rock of the Westies* (1975), *Caribou* (1974) and *Don't Shoot Me, I'm Only the Piano Player* (1973), a part of the 5 million sales of the 'rock opera', *Tommy* (1975), and 2 million for his own *Madman Across the Water* (1972), *Honky Chateau* (1972) and *Elton John* (1974) (Murrells 1978: *passim*).

John's economic success was equally impressive. By 1978, with total unit sales estimated at 60 million, including 42 million albums, he had almost outpaced the Rolling Stones, who had six years start on him at this level. Moreover, John owned a share of the material co-written with Bernie Taupin, and he soon became very rich indeed. In 1973, he set up his own recording company, Rocket Records. By 1974, his monthly royalties cheque exceeded even that of the Beatles at their peak, and his contract with MCA, worth $8,000,000, made him one of the highest-paid recording artists in history, though his work in the United States is said to have brought him as much again and more (Hardy and Laing 1976: 142; Murrells 1978: *passim*). By 1985, John is said to have sold over 80 million records, which alone brought him 20 million pounds; but he hankered after a greater share of the 200 million pounds that his early songs had reputedly grossed and, in 1985, he took his publisher to court (Garfield 1986: 89, 95).

Now, these are indeed 'intimidating statistics' as Hardy and Laing already accepted in 1976 (p. 142); yet while John does find his way into their 'Rock' *Encyclopedia*, where is the critical analysis of his work from the majority of 'rock' critics? Don't the millions of people who bought this 'rock' matter? And is it good enough to patronize the artist and his vast audience by suggesting that his appeal lay in an ability 'to synthesize the prevailing styles and postures in an amiable – and sometimes moving – manner' (Hardy and Laing 1976: 142)? It is as though Hardy, Laing and

those other critics who ignore John believe that, since they find his work 'lacking a defined musical character', then *his* 'rock' isn't *really* 'rock' at all! At this point, the size of the canonical 'rock' repertoire and audience seems to shrink almost to a minority taste.

DESPERATELY SEEKING 'THE SEVENTIES'

Elton John was, and is, British, insofar as that matters. But if, as the 'rock' critics claim, 'rock' is American – a position, interestingly, shared by both US 'rock' journalists and key figures in the US music industry – how did 'the sixties' become 'the seventies'? What continuities and discontinuities can we discern? Once again, of course, we are thrown back on the 'commonsense' of 'rock' journalists, musicians and critics, since the people who bought and used the music remain largely unquestioned. And what we learn, most often, is that 'Whatever the sixties were, they ended at Woodstock' (Eliot 1990: 149). As for 'the seventies', well, they began at Altamont, late in 1969; so the key places of transition were, obviously, up-state New York and a deserted speedway east of San Fransisco. In between a lot of people rolling around in a muddy field and the murder of a black man, Meredith Hunter, *something* happened (Harker 1980: 103, 108; Chapple and Garofalo 1977: 143–6); and after that, the rot set in:

> By 1971, the Fillmore, the Greenwich Village club scene, rock festivals and the independent record movement were mostly memories. Rock's social statements turned into financial ones, as big-name performers eagerly traded their self-worth for net worth.
>
> (Eliot 1990: 152)

It was, then, fundamentally a *moral* question to do with US artists, and the transition was historically new. All those major stars – a surprising number of them being British, including the Rolling Stones who played at Altamont – suddenly and spontaneously *got greedy*. No critic has satisfactorily explained this alleged instant conversion to the agenda of Mammon: but what virtually every 'rock' critic assumes is that, to some extent, the music business in the 1960s had been organized around different principles. Not only would this theory have come as a surprise to Sinatra or Presley, it might also have caused Bob Dylan or The Beatles to pause for thought. In fact, the case articulated by Eliot (1990) revolves

around his claim that The Beatles broke up in 1969 over *money*.

Eliot's thesis is difficult to support from published data. First, The Beatles earned more in the period from May 1969 to December 1970 than in all of their career previously: the *rate* of earnings was rising dramatically. True, they had thrown a lot of money at their ailing Apple venture, but their last new release as a band, *Let It Be*, was an instant 'gold' record in the United States, broke all records by shifting 3,700,000 units in just two weeks (then worth $25,000,000 or £10,000,000) and, by 1975, had sales of 'well over four million' copies. Even four years after the break-up, the two greatest hits albums, *The Beatles 1962–1966* and *The Beatles 1967–1970*, went on to achieve sales of 1½ million and 2 million respectively; so that, by 1975, collective Beatles sales amounted to 575,000,000 units. Later, mopping-up albums such as the double-LP *Rock 'n' Roll Music* (1976) and *The Beatles Live at Hollywood Bowl* (1977) soon notched up sales of a million apiece. As for lucrative publishing, both Lennon and McCartney received $5 million apiece for their share of Northern Songs in 1973; while sales of Beatles records remained strategically crucial to Capitol Records until at least 1980, when they represented 30 per cent of that company's annual sales. Capitol also had to admit, in 1979, that it owed The Beatles some $19 million in unpaid royalties from after the break-up (Eliot 1990: 159, 211). If anything, then, The Beatles broke up when their earnings potential was at its highest as a band, and they had already begun to show that they could have solo album successes as well. This, to say the least, is a strange kind of 'greed'.

Was it the case, then, that concentration on solo albums was going to be more profitable than staying together, let alone staying together and making some solo albums? This thesis works better: in 1970, there were 2,500,000 advance orders for *John Lennon/Plastic Ono Band*; McCartney's *Paul McCartney* sold 2 million copies and Harrison's *All Things Must Pass* shifted 3 million copies. Even Ringo (with Harrison's help) managed to rack up a million sales for his 1971 single, the aptly-named *It Don't Come Easy*. And yet, Lennon's first album had not done as well as his second, while his third, *Imagine* (1971) – in spite of all the critical attention it received – took until 1975 to sell its first million and seems not to have reached a second million even in the 1990s. *Mind Games* (1973) did less well; and while *Walls and Bridges* (1974) sold a million copies in the United States, his next million-

seller there came only in 1989, almost a decade after his death. Of the other ex-Beatles, McCartney hung on longer, chiefly as part of Wings; but, after 1980, even the widening of his audiences to France and Japan did not prevent first a dip and then a free-fall in his new album sales. George Harrison's solo albums fared quite well during the 1970s, clocking up regular 'gold' status in the United States; but, after 1979, his fortunes also took a dive until what may have been a one-off million-seller in 1987. Ringo's solo record career also spluttered out before 1975 (Murrells 1978: *passim*; White 1990: *passim*). Eliot's thesis does not fit: it seems likely that The Beatles – even Lennon and McCartney – would have done much better, were they simply greedy, to stick together and hang on to their own publishing. Much more likely, added to the various rumours that they could not stand each other and did not really need the money anyway, is that the *comparative* sales of their last few albums pointed steadily downwards. *Let It Be* and *Hey Jude*, together, barely sold as many copies as *Sergeant Pepper* by itself (Murrells 1978: 385); and it was Capitol, not Apple, which cranked out compilation and earlier albums during the later 1970s, culminating in all the nastiness revealed in the 1980s lawsuit, including those 95,000 'promotion' copies of *Abbey Road* (1969) – ten times the usual number – which mysteriously found their way on to the market, royalty-free (Eliot 1990: 214). As in the 1940s, 1950s and 1960s, the music industry was doing its level best to pump the maximum surplus value out of its road-tested product and producers. Neither particular spectacular events, like Woodstock or Altamont, nor what happened to individuals – the break-up of a mega-group like the Beatles, or that of Simon from Garfunkel, let alone the drug problems of Sly Stone, the death of Janis Joplin or the pulling of television shows by Andy Williams or Johnny Cash – changed that. As the 1960s turned into the early 1970s, the major record companies, artists' managers and lawyers had been able to set up people of the stature of Holland-Dozier-Holland (who had to sue Motown for $22,000,000 in unpaid royalties) and the Grateful Dead (who had to spend five years on the road simply to be able to break even). Older stars like Bob Dylan, and newer ones like Bruce Springsteen, spent years fighting for control over their own material and royalties.

It is difficult to under-estimate the music industry's conservatism in relation to back catalogues, royalties and road-tested artists and

material. From 1938 until 1988, for example, the copyright holders of *Happy Birthday* raked in a steady million dollars a year, and then sold the remaining twenty-two years' rights for $28 million. Bing Crosby's records, with little or no fuss, aside from the prominence of *White Christmas* every twelve months, went on accumulating aggregate sales of half a billion units. Presley's new releases and back catalogue did twice as well as that, boosted by the way RCA rushed out chunks of their list after his early death in 1978. Presley, judging by his estate – which took thirteen years to settle and then contained only $7 million – saw only a tiny fraction of the money his work brought in during the 1960s and the 1970s (Eliot 1990: 12n, 20n, 251), when he could still sell a million copies of *The Wonder of You* (1970) and *Burning Love* (1972), his sixty-fourth and sixty-sixth million-selling singles, and attract a television audience estimated at 1 billion for his 'Aloha from Hawaii'. The fact is that, below the megastars and the critically acclaimed figures, there was by the early 1970s a solid body of less spectacular but steady sellers, the industry's reliable bread-and-butter people, who included not only individuals such as Perry Como (who had his twentieth million-selling single with *It's Impossible* in 1970), but also a sizeable body of mainly 1960s artists whose album releases of the 1970s could notch up aggregate sales of 10 million copies – people like Aerosmith, the Doobie Brothers, Earth, Wind and Fire, Billy Joel, Lynyrd Skynyrd, Barry Manilow and Barbra Streisand.

Through their consistent silence about such artists, the skewing of the 'rock' critics' narratives shows up very clearly indeed. But there is also the question of a consistent over-emphasis in 'rock' criticism on certain important, but not greatly successful, artists. Some people simply appear in 'rock' criticism as though their status was obvious. Jimi Hendrix, for example, might have received $75,000 for playing New York's Randall Island concert; but Bob Dylan got $84,000 for playing in England, at the Isle of Wight (Eliot 1990: 147, 149). Dylan, of course, has been the major exception to the rule of critical indifference to second-ranking earners or cult figures, yet his record as a chart-making artist often gets forgotten. Between 1970 and 1979, Dylan had three 'platinum' albums in the United States, seven 'gold' albums and four other Top 40 entries, plus five Top 40 singles successes. In the United Kingdom, too, he got eleven out of thirteen albums into the Top 10. All this, remember, in spite of the holding-back of

material during the early 1970s until his battle with Grossman was resolved and some of it appeared on *Blood on the Tracks* (Eliot 1990: 120). The breadth of Dylan's appeal, even – perhaps, particularly – outside the United States, is registered mainly as a consequence of his 'intellectual' or 'literary' status, since, even on film, he is said to have been upstaged by his manager (Frith 1978: 81, 186; Frith 1983: 21). As for the market significance of a Joni Mitchell or a Leonard Cohen (who had little enough success inside the US markets during the 1970s, but was in demand for marathon concert tours from Europe to the Near East, and could get 'gold' records in Germany), the 'rock' critics tell us little or nothing. But then, Simon & Garfunkel's 90 million unit sales draw almost as little attention and, more surprisingly, even Springsteen's 1970s successes rarely rate a footnote or an aside. British-based 'punk' still grabs the critical headlines even though, as we have seen, to the industry and their major customers 'punk' hardly mattered. In reality, popular music – including 'rock' – was ceasing to be located or locateable only in the United States; so, while the 'rock' critics' ideology remained stuck in the 1960s, the material realities of the early 1970s were already working away to undermine the critics' familiar oscillation between naive optimism and naive pessimism.

THE 'WORLD' INDUSTRY

A key part of the dominant critical discourse around 'rock' is the idea that, after the later 1960s, the music industry (especially in the United States) went on to rise and rise again. Of course, using the industry's published data it is possible to construct a plausible narrative which supports that thesis. So-called 'world' sales during the 1970s rose impressively, from $2.3 billion to $11.4 billion, an almost five fold increase. Within these totals, the US market alone accounted for 70 per cent of 'world' sales in 1970, and was, by 1980, worth a massive $4 billion on its own. That market consumed, by 1980, 500 million albums a year and 190 million singles, out of 'world' totals of 1.3 billion and 500 million; while even the comparatively smaller UK market consumed around one-third of the number of albums as the United States, and over half the US volume of singles. The UK market, too, had grown impressively, to over £250 million in wholesale values (four times the 1970 figure) and to retail sales of £439 million.

And yet, the heroic narrative offered by these numbers is subverted by slightly more critical examination. Even with the IFPI's aborted conception of the 'world', the balance of power was shifting away from the US industry right through the 1970s. From a share of 70 per cent of reported trade in 1970, the US market represented just 33.8 per cent in 1980; and while that market was still the largest single one, its pre-eminence was already being challenged, not as yet by other single-nation states but certainly by its closest industrial rivals. By 1980, for example, the combined markets of Japan, West Germany (as it was then) and the United Kingdom all but equalled that of the United States; while the combined markets of the top six Western European nations already accounted for a larger share of world trade in recorded music than the United States. Moreover, those ever-rising dollar figures mask the fact that, at constant 1980 values, the *real* value of the US market was barely higher in 1980 than it had been in 1970: the US market was stagnating, and so was the UK's, which lost 'world' second place to Japan in 1975 and then third place to West Germany the next year.

Within these national markets, other structural changes were taking place. For CBS, the major US company, the 1970s began promisingly. They controlled 22 per cent of the US market, had their own distribution system and profits of $6.7 million in 1968 had grown to $10 million in 1969 and then to over $15 million in 1970. In order to compete, lesser majors had to buy market share, as Warner Bros did with Elektra (bought for $9.8 million in 1970) and Asylum (bought for $7 million in 1971), before going on to invest in a rival distribution system to CBS in the early 1970s, as WEA. These two companies ended 1973 with very satisfactory profits on sales: CBS made profits of $25 million on $362 million sales, and WEA made $22 million on $236 million, which was proportionally better. According to Dannen (1991: *passim*), the six US majors helped their dominance to continue by buying air-play time through so-called independent promoters and, of course, by continuing to corral major established artists; but this latter policy, paradoxically, tended to discourage the signing and fostering of 'baby acts', who were now not cheap to sign up and were more expensive to promote than already-established major artists on the same labels. In strategic terms, this made the majors more dependent on the success of a very small number of established stars.

By 1974, even internally, there were worries about the state of the US industry. *Variety* noted that only the biggest names – Dylan, the Stones, the Who, Crosby, Stills and Nash, Elvis Presley and Jethro Tull – were still managing sell-out US tours; and the journal went on to argue that concentration on such known money-spinners only seemed sensible in a period of projected 'financial downturn in the dollar gross of the music industry' (Eliot 1990: 172, 183). What *Variety* effectively championed was a concentration on the older, richer sector of the record market, if need be at the expense of any serious attention to the rising young teenage generation and to the singles market in general. Emptying the granary and paying insufficient attention to the seed-corn is not, perhaps, the best strategy to adopt in difficult economic times; when the downturn came, after the so-called 1973–4 'Oil Crisis' and, especially, the eventual defeat of the United States in Vietnam, the medium-term effects on the US record industry were going to be savage indeed.

At a more modest level, the situation in the UK market was strikingly similar. In 1974, it was estimated that there were a hundred UK-based artists earning £100,000 a year apiece. Here, too, the singles market was declining in importance relative to the album market, falling from 31 per cent of the latter's value in 1970 to 20 per cent ten years later; and there was a similar degree of concentration, with some of the same names cropping up. In 1972, for example, five major companies dominated all but two-thirds of the UK singles record market: EMI with 17 per cent; Decca with 16.3 per cent; Polydor with 14.6 per cent; RCA with 9.5 per cent; and CBS with 7.6 per cent. By 1980, if anything, that degree of concentration had grown greater, but the balance of forces had shifted: EMI were still top with 19.5 per cent, but then came Polygram (which now included Polydor, Phonogram and Decca) with 14.8 per cent, WEA with 13.6 per cent, CBS with 13.1 per cent and RCA with 6.4 per cent. UK-based companies had become less important at the expense of conglomerates based on the Continent and in the United States. It was a similar story with the UK album market: in 1972, five companies accounted for over three-fifths of that market – EMI with 18.1 per cent, CBS with 11.9 per cent, Decca with 10.6 per cent, Polydor with 10.5 per cent and WEA with 9.8 per cent – and by 1980 those same companies accounted for over 64 per cent of that market. Again, the share of the market owned by EMI, the only remaining indigenous

company, had risen slightly, but the general dominance of the same Continental and USA-based forms had increased markedly: EMI with 19 per cent; Polygram with 15.5 per cent; CBS with 13.9 per cent; WEA with 12.7 per cent; and RCA with 5.2 per cent.

So much for production. As for the vital distribution business, far from the 'punk' period blasting apart actual or incipient monopolies and cartels, if anything this trade, too, was becoming more concentrated in fewer hands. In 1977, for example, three UK companies accounted for 34 per cent of all singles sales and 30 per cent of all album sales. By 1981, these same companies – Boots, Woolworth and WHSmith – sold 38 per cent of all records in both formats; and Woolworth alone regularly sold between 20 per cent and 25 per cent of all Top 10 singles in the country, while WHSmith dominated the growing market for mail-order records and tapes and up-and-coming HMV and Virgin shops had already secured 3 per cent apiece of the full-price album market. Interestingly, the introduction of cassettes and cassette-players did not have a shattering effect on either production or distribution in the United Kingdom during the 1970s. In 1978, for example, the UK industry cranked out 160 million albums, of which 130 million were discs and only 30 million were cassettes. In fact, vinyl album output had doubled since 1970, and up until 1978 the UK industry managed to export three times as many albums as were being imported. Singles production too, appeared to be healthy, rising to over 102 million in 1979, though here imports exceeded exports by 10 million, largely because the UK plants were working to capacity in every pre-Christmas period. So, aside from a grumble about the problems of home-taping, the tone of the 1978 *BPI Yearbook* (from which all these UK figures derive) was largely up-beat and optimistic. 'Pop', in Britain, was buoyant:

> Whether through inventive ingenuity by superstar musicians, or through technical developments in the studios, or even by spasms of outrageous gimmickry [by which I think he meant 'punk'] with little to do with the music as such, the pop scene thrived and progressed.
>
> (BPI 1978: 19)

Talent, entrepreneurial skill and advanced technology – plus the likely bonus of a Labour government going down to defeat – promised a Tory golden age in the 1980s, with the UK-based music business, to all intents and purposes, escaping the worst effects of

the post-1974 recession which had hit other trades. When, however, the 1982 *BPI Yearbook* appeared, it was one-third the normal length, carried no glossy advertisements and the previous Director-General, Geoffrey Bridge, figured only as another 'consultant' on page 76. Something had gone wrong.

The crisis showed itself in terms of 'over-production'; so, with its usual lack of foresight, the industry lurched the other way:

> In the past two years the Decca Record factory at New Malden, the PRT (formerly Pye) factory in Mitcham and the RCA factory in Washington, Tyne and Wear have all ceased production. This has left the UK record industry under capacity with a capability to produce approximately 190 million 7″ and 12″ discs per annum compared with a current demand of just over 200 million units. In 1978 the industry was able to manufacture approximately 250 million discs per annum.
>
> (BPI 1982: 8)

Already, 1978 and even 1979 were being looked on as golden days; but the anonymous BPI editorialist now blamed, in addition to home-taping, Tory government policy over the valuation of the pound sterling and the effects of European Community agreements allowing comparatively free trade in previously protected markets such as records – 'parallel imports' of records also manufactured in the United Kingdom, especially from France and Germany. The industry held itself to be blameless, as profits took a dive from over £20 million in 1978 to a loss of almost £4 million in 1980 – or so they said. Of course, it wasn't really the share-holders who paid the price for this crisis, but the workers. Five thousand record industry employees got their cards and, probably, even more in those industries which supplied (or relied on) the core industry jobs. Meanwhile, the UK record business still retained 6 per cent of total 'world' value, worth £1.8 billion, not simply because of exports of records but also because of performance royalties, broadcasting royalties and publishing royalties. Why bother making serious investments in cassette-producing factories, even though UK cassette-player penetration had reached 73 per cent? Instead, throw £200,000 at trying to find technical solutions to the alleged menace of bootlegging, taking pirates and counterfeiters to court – oh, and stretch the singles Top 50 to the Top 75, and the album Top 75 (which had been a Top 50 in 1971) to a Top 100.

In the United States, however, even corporate heads rolled, and

the expectations of the 1970s were sharply reviewed. Fleetwood Mac's *Tusk*, with sales of over 2 million, could be branded a *disappointment*. Tom Petty, who 'owed' his recording company $600,000 that his tours had not recouped, was forced into bankruptcy. CBS's profits, which had stood at $51 million on $1 billion sales in 1978, fell by 46 per cent in 1979, and so Head Office staff were let go: fifty-three in June, and another hundred in August. In 1979, the US record market's value slumped by 11 per cent, or $600 million, from a peak of $4.2 billion; but the customer was lined up to pay, since an extra dollar was put on all albums at a stroke (Eliot 1990: 186–9; Dannen 1991: 5, 24).

What had now become clear was that the majors' policy (as advocated by *Variety* in 1974) of concentrating on best-selling established acts had back-fired on them. In 1978, Olivia Newton-John and Elton John by themselves supplied a major section of MCA's profits (Frith 1983: 134). Springsteen's *Darkness on the Edge of Town* 'provided the basis of CBS's billion-dollar year' (Eliot 1990: 178). Even Presley's death spurred RCA into cranking out large lumps of their back-catalogue to help out; and while *Saturday Night Fever* (which brought in $1.6 billion) and *Grease* shoved Polygram's market share up from 5 per cent to 20 per cent at a stroke, this too contributed to the eventual crisis. Simply by trying to compete with US-based record company giants like CBS and WEA, the Dutch/German conglomerates were forced to invest in smaller companies and secure market share through cash. Polygram bought half of RSO in 1976 and half of Casablanca in 1977 (for $10 million), to add to MGM Records and Verve. To compete with the market leaders' distribution, Polygram bought the whole United Artists system; and they paid the going rate for established artists, at around $100,000 or so apiece. When the crash of 1979 came, for reasons outside any record company's control, these market-grabbing decisions exposed Polygram to what turned out to be losses of around $200 million on their US operations alone. The key problem was that *Grease* and *Saturday Night Fever*, and, indeed, the whole 'disco' boomlet, was not *reproducible* (Dannen 1991: 168, 171, 175–6), any more than was the 'punk' mini-boom in the UK singles market.

This is not to claim, of course, that the crisis in the record industry in the United Kingdom and the United States was somehow avertable, though its worst effects could have been avoided. The hard fact was that while the United States was throwing

billions of borrowed dollars into a war it was about to lose humiliatingly, the internal effects on the US home economy in general were enough to cut US citizens' real disposable income by 3.8 per cent between 1973 and 1975 (Harris 1983: 78). Records – let alone expensive new hardware for music-making – were not top of most people's budget priorities; and this, in part, accounts for the slippage in the value of US sales as early as 1970 and 1971, which went down quite steeply after 1974. In fact, since 1971, popular music on radio had been a more profitable business than selling records, hence the later importance of 'The Network' of record-pluggers organized around 1978, and visible to *Billboard* by November 1980 (Eliot 1990: 168–9; Dannen 1991: 11). (Radio had also become important to the record business since its developing practice of playing whole albums, uninterrupted, on FM Stereo enabled owners of cassette-recorders to bypass the record shop completely. It also enabled people, with minimum technology, to re-record all their vinyl albums and singles, if they were in good enough condition, or to borrow from friends if they were not – even to pool resources in terms of new software purchases.)

CONCLUSION: IT WAS TEMPORARY

Popular music in the 1970s, as in every previous decade back to the 1890s, was produced and commodified between sets of pressures, the decisive pair being that of the industry's need to maximize short-term profits *and* to guarantee future profits at the same time. In practical terms, this involved squeezing the maximum amount of surplus value out of established acts and technology, while recruiting and developing new acts and technology – and all within the cyclical (if recently irregular) booms and slumps of capitalist production in general. This is why, for all the large-heartedness of much of *Beating Time*, even Dave Widgery has to admit that 'Nothing fundamental has changed, except for the worse'. Rock Against Racism's admirable ambition, to 'establish an anti-racist, multi-cultural and polysexual feeling in pop music which would be self-generating, and to make politics as legitimate a subject matter as love' (1986: 115), was, for instance, largely idealistic. The effects of Rock Against Racism were 'temporary', as Widgery admits, but its efforts were also *necessary*, in spite of the ideological danger of subscribing to that tired 'sixties' idea that the music can somehow set you free, which wreaked havoc amongst the

reformist Left across the planet and still lingers on amongst much 'rock' criticism.

In his review of Widgery's book, Ian Birchall tried to identify the theoretical problem such music has engendered:

> There have been two conceptions of rock music current on the left. The protagonists of the former claim that rock is in some sense inherently revolutionary; they base their case on the roots of the music in black oppression, on the selective quotation of allegedly subversive lyrics, and on the equally selective quotation of expressions of outrage by ageing clergymen and right-wing politicians.
>
> The proponents of the opposing case deny any specifically progressive qualities to the music. They point to the conservative and often sexist nature of many of the songs; to the competitive and individualist nature of the star system; and above all to the way the music becomes a commodity and a source of huge profits, something totally integrated within the capitalist system.

'Both accounts are true', says Birchall, but 'both, taken in isolation, are patent nonsense. What is needed is some way of understanding the contradictions that riddle the history and practice of rock music' (Birchall 1986: 128–9). I agree, in general, with this (somewhat over-stated) argument, and would extend it so as to include 'rock' critics themselves. Analysts of popular music of the 1970s (or any other decade) need to beware of generalizing from their often bizarrely atypical experiences and tastes, to stop acting as the cheer-leaders of 'the kids' who are 'all right' one minute and then, very often, all wrong another; and, perhaps above all, to stop believing all the music industry's propaganda about such important conceptual issues such as genre-labels, about which, so to speak, we know *rock all*.

NOTE

I would like to thank Matt Kelly and Annie Makepeace for their help and support in the writing of this chapter.

FURTHER READING

The fact that this chapter challenges even the better critical works dealing with aspects of the anglophone popular music of the 1970s should underline that none of them are wholly satisfactory. Probably the best place to start for the United Kingdom is with Street (1986), supplemented by Widgery (1986). For the United States, Chapple and Garofalo (1977) stops short of 1980, though Garofalo is producing a book which will develop some of his earlier insights. Both Dannen (1991) and Eliot (1990), though not offering to be academic works, are extremely useful for empirical data on the US industry. For the music industry in the United Kingdom unfortunately, little has been produced since Harker (1980), though he, too, is in the process of producing a new work, provisionally entitled *Two for the Show*. Middleton (1990) looks set to be the best attempt by an academic musicologist to try to analyse the relationship between musical sound and meaning for some years to come.

BIBLIOGRAPHY

Birchall, Ian (1986) 'Only rock and roll? A review of Dave Widgery's *Beating Time*', *International Socialism*, 2nd series, 33 (autumn): 123–33.
BPI (1978) *BPI Yearbook 1978*, London: British Phonographic Industry.
—— (1982) *BPI Yearbook 1982*, London: British Phonographic Industry.
Chapple, Steve and Garofalo, Reebee (1977) *Rock 'n' Roll is here to Pay: The History and Politics of the Music Industry*, Chicago: Nelson-Hall.
Dannen, Frederic (1991) *Hit Men: Power Brokers and Fast Money Inside the Music Business*, London: Vintage.
Eliot, Marc (1990) *Rockonomics: The Money Behind the Music*, London: Omnibus.
Frith, Simon (1978) *The Sociology of Rock*, London: Constable.
—— (1983) *Sound Effects: Youth, Leisure and the Politics of Rock 'n' Roll*, London: Constable.
Garfield, Simon (1986) *Expensive Habits. The Dark Side of The Music Business*, London: Faber & Faber.
Hardy, Phil and Laing, Dave (eds) (1976) *The Encyclopedia of Rock*, vol. 3: *The Sounds of the Seventies*, St Albans: Panther.
Harker, Dave (1980) *One for the Money: Politics and Popular Song*, London: Hutchinson.
—— (1985) *Fakesong: The Manufacture of British 'Folksong', 1700 to the Present Day*, Milton Keynes: Open University Press.
—— (1992) 'Still crazy after all these years? What *was* popular music in the 1960s?', in John Seed and Bart Moore-Gilbert (eds) *Cultural Revolution: The Challenge of the Arts in the 1960s*, London: Routledge.
Harris, Nigel (1983) *Of Bread and Guns: The World Economy in Crisis*, Harmondsworth: Penguin.
Laing, Dave (1985) *One Chord Wonders: Power and Meaning in Punk*

Rock, Milton Keynes: Open University Press.

Middleton, Richard (1990) *Studying Popular Music*, Milton Keynes: Open University Press.

Murrells, Joseph (1978) *The Book of Golden Discs: The Records That Sold a Million*, London: Barrie & Jenkins.

Street, John (1986) *Rebel Rock: The Politics of Popular Music*, Oxford: Blackwell.

White, Alan (1990) *The Billboard Book of Gold & Platinum Records*, London: Omnibus.

Widgery, Dave (1986) *Beating Time: Riot 'n' Race 'n' Rock 'n' Roll*, London: Chatto & Windus.

Chapter 12

'Is it possible for me to do nothing as my contribution?'
Visual art in the 1970s

Stuart Sillars

INTRODUCTION: CHANGE AND TRADITION IN THE 1970s

If the 1960s was the decade in which art burst out of the galleries and into the streets, boutiques and hoardings, the 1970s might be seen as the years when visual art almost deconstructed itself into theories, ideologies and concepts. The 1960s had seen an attempt to remodel an art world dominated by Bond Street galleries, national collections and educated élites deciding the nation's taste and bring art into the consciousness of the ordinary person; but at the end of that decade, it was clear that the earlier relationships between artist, gallery and public remained intact. As a result, many artists turned inwards, to an art based on aesthetic theory and political ideology which – wrongly, as it turned out – they felt that the gallery establishment could not possess. In consequence, the public was left bewildered and, in many cases, angry at what was now considered 'art'.

But to suggest a simple, wholesale change of direction would be to overlook the many artists whose work continued along more conventional lines. Alongside the new forms, there were many that were more traditional: although easel-painting did not perhaps have the vigour and variety that it was to have in the 1980s, there were many figures working in the medium with verve and immediacy. Patrick Caulfield painted work which oddly combined super-realism and surrealism, as in *After Lunch* (1975). Victor Pasmore's work of the decade moves towards textures of great freedom, watercolour-like washes and stains presented very sparsely against wood-grained surfaces on which canvases are mounted, to suggest loosened versions of Japanese prints. Lucian

Freud's portraits and nudes reveal skeletal human forms while showing subtle concern for painterly values, simultaneously exploring structure and exploiting texture. Bridget Riley developed her 1960s exploration of geometric forms by moving from monochrome to colour. Francis Bacon continued the brutal caresses that had been his mature style since the 1950s, combining it with a greater spatial freedom which both broadened and concentrated its impact, in images such as *Three Figures and a Portrait* (1975).

Other artists combined tradition with more conceptual concerns. Throughout the decade, Howard Hodgkin produced work of great tonal depth and richness, working and re-working broad swathes of deep colour to suggest at first sight that colour and shape – aesthetic surface – is all. Yet this is deceptive: his paintings are also much concerned with formal qualities of recession and depth, and with statements of emotional experience, very often concerned with relationships between people, for example in *In a French Restaurant* (1977–9). The work is both an allusion to reality and an illusion of it, suggesting what Hodgkin himself calls 'the elusiveness of reality' (McEwen and Sylvester 1984: 97). Tom Phillips combined lush textures with literary references, as in *The Dark Wood* (1978) where the opening words of Dante's *Purgatorio* are painted repeatedly to embody a deep-green forest and thus make a philosophical point on the identity of word and object.

Several of David Hockney's large portraits of the decade developed his earlier representational strand, growing towards simplicity of surface and the rhythmic arrangement of objects that often have referential significance. In *My Parents* (1977), some paperbacks of Proust signal the painting's importance as personal memory, and a volume on Chardin places it within an art-historical context; the artist's father reads Aaron Scharf's *Art and Photography*, suggesting both the painting's foundation in repeated photographs of the sitters and the growing importance of photography as a medium of equal importance to painting for Hockney, as in *Le Nid du Duc, April 1972* (1972). Hockney's rediscovery of two earlier artists, Hogarth and Picasso, led him in new directions, seen respectively in the designs for *The Rake's Progress* (1974–5) and in paintings such as those inspired by Wallace Stevens's poem 'The Blue Guitar', which in turn is based on Picasso's painting of that name. The paintings executed in California at the end of the decade, such as *Canyon Painting* (1978), show another stylistic movement, reaching back to Dufy

and Matisse, while the stage designs, notably for *The Magic Flute* (1977–8), show a concern for planes which seems an abstracted refinement of his more representational style. Overall, Hockney seemed to be moving more towards the freedom he admired in Picasso, Matisse and Van Gogh; yet the stress on photography, and his greater willingness to discuss his own work, places him within the self-conscious theorizing of the decade.

If Hodgkin's work makes its effect by combining sensuality of colour and texture with emotional and formal intensity, R. B. Kitaj's functions by using a sensuality just as strong, yet different in style, with a complex and personal iconographic language. Already important in his work of the 1960s, this element became dominant in the succeeding decade, shown to the full in paintings such as *If Not, Not* (1975–6). The composition combines references to Giorgione's *Tempesta*, Eliot's *The Waste Land* and Conrad's *Heart of Darkness*, and work by Bassano and Matisse: the gatehouse at Auschwitz dominates the upper left-hand quadrant of the canvas. Yet the iconography is not fixed: the artist himself stresses that his work acquires new 'meanings' with time. Here, the incongruity of stasis and movement, beauty and evil, is amplified by the artist's later discovery that 'Buchenwald was constructed on the very hill where Goethe often walked with Eckermann' (Livingstone 1985: 151). Iconic complexity is not the whole story, though; many of Kitaj's paintings have a remarkable erotic tenderness, and suggest the shift to figuration important in the 1980s.

VARIETIES OF CONCEPTUALISM

The most significant development of 1970s art was the rapid expansion and diversification of conceptual art. This is perhaps best encapsulated in the subtitle of an influential exhibition of 1969: *When Attitudes Become Form: Live in Your Head*. In his introduction to the catalogue, Charles Harrison described this new preoccupation while discussing the ways in which art changed human consciousness: 'The less an art work can be seen to be dependent, in its reference, on specific and identifiable facts and appearances in the world at one time, the more potent it becomes as a force for effecting . . . change' (Szeemann 1969: 6). Conceptual art can perhaps be separated into two strands: that which is primarily self-referential and that which is propelled by a

specific social, political or moral impetus. This is, of course, a simplistic distinction: even the most self-referential art makes a political statement, since the apparent absence of social stance has ideological implications. But the division is perhaps a useful initial approach.

The first major showing of representative British conceptual work of the former kind was *Beyond Painting and Sculpture* (1974), which included photo-pieces by Victor Burgin, a video piece by Gilbert and George and a work by David Lamelas exploring, through photographs, the structural meanings of pouring milk into a glass. All of these shared the definition of 'art work' as an entity in which the concept, not the material reality, was dominant. The concepts themselves ranged widely, from explorations of time and movement to statements of the relation between 'art' and 'life'. Language was very frequently chosen as a way of embodying those concepts – hence 'works' such as *Keith Arnatt is an Artist* (1972) which consisted of those words painted on a gallery wall. The same artist's *Is it Possible for me to do Nothing as my Contribution to this Exhibition?* (1970), similarly constituted, embodied another key concern: the denial of an art market which turned all art into objects of possession or 'commodity fetishes'. This reveals the ideological premise of much conceptual art: disillusioned with the way the galleries had appropriated pop art in the preceding years, artists turned to something that openly rejected the possibility of ownership – or, at least, so they hoped. But the inherent paradox of this aim is revealed in the catalogue to *Beyond Painting and Sculpture*, where Richard Cork stressed 'a wish to question the supremacy of a value-system' (the market forces of the galleries), which had hitherto conditioned the nature of the art work (1974: 3). Yet the subtitle of the exhibition, *Works Bought for the Arts Council by Richard Cork*, reveals a problem which conceptual art never really solved. If it sought to escape the materialism of the art market, what was conceptual art doing selling itself – literally and perhaps also (depending on your standpoint) morally – to one of the very forces which decided on 'values' of art at auctions and in galleries?

Despite being labelled as 'performance art', 'land art' and 'earth art', the work of Richard Long is probably best seen as the most successful example of self-referential conceptual art – although, while its identity has always been clear, it is rarely simple. The earliest work consisted of walks made in straight lines, circles and

other geometric configurations, to reveal the nature of the land-
scape and the coming together of the artist and the land he passes
through. This led early critics to see it as a reinvention of
Romantic tourism: not so, since it was concerned rather with the
way in which the artist's presence reveals and modifies the land,
articulating a quality that was inherent within it but hitherto
unmarked.

This articulation expanded into different forms as the work
developed. Early work stressed phenomena such as the changed
form of grass which Long had walked over (*A Line made by
Walking*, 1967); the patterning of stones or even of soil as it was
changed and eroded by the tide (*A Sculpture Left by the Tide*,
1970); the arrangement of stones or sticks in a particular fashion
by the artist in a given location (*A Line in Ireland*, 1974; *A Line in
Australia*, 1979). Along with the physical elements – the walks, the
land changed by movements and arrangements of wood and stones
– went maps, photographs and 'word-pieces', statements which in
some way added to the art work as well as recording it, but which
did not constitute the work itself.

During the 1970s Long's work expanded to cover new conti-
nents: the walks and arrangements of natural materials took place
in India, Canada, Bolivia, Iceland, Japan and elsewhere, revealing
both their local immediacy and their global significance. Another
development was a move to collecting rocks, stones and short
pieces of wood from particular locations and arranging them,
according to strict principles, on gallery floors. *Wood Circle, Bern*
(1977) and *Slate Circle, London* (1979), for example, show a
concentration on texture, form and the discrepancy between inter-
ior and exterior spaces which give them profound conceptual
force. At the same time, the works return us directly to the most
basic of natural materials, in strong contrast to the built sculptures
of Caro and the New Generation, or the experiential landscapes of
the Romantic tradition. Long is now being read as a prophet of
social and political greening; but he is primarily concerned with
the articulation of landscape and the reciprocal effects between it
and the artist. In this he is a powerfully important conceptual
artist, but one who never loses immediate touch with his
surroundings.

The more direct socio-political commitment of the second kind
of conceptual art – what we might term 'engaged conceptualism' –
was shown most insistently in two exhibitions mounted in London

in 1978. *Art for Whom*, a show of work chosen by Richard Cork at the Serpentine Gallery, included works which were produced for and in some cases partly by members of specific communities in and around London. The exhibition contained a joint manifesto by the artists, who declared themselves opposed to the minority, mercantile function of art as the possession of the few and in favour of an art which was engaged and egalitarian. It concluded: 'We declare that art needs people as much as people need art: the two should be inextricably linked with each other, and never divorced so damagingly again' (Cork 1978: 3). This link showed itself in a variety of forms. David Binnington and Desmond Rochfort painted murals under a flyover near the Edgware Road in styles respectively expressionist and Socialist Realist; the onlooker was left to decide whether the flyover was a massive image of urban desolation or a tribute to workers' solidarity. The Laycock School Experiment took designs from the school's 330 children and transferred them into fluorescent, high-keyed murals on the school's walls.

These projects tackled social issues in traditional ways: other work was more experimental. Peter Dunn and Lorraine Leeson mounted an installation at South Ruislip library in which local residents were encouraged to bring photographs, recollections and other memorabilia of the area's history during the last seventy years. This material was then placed alongside a similar treatment of Peterlee, a north-country working-class new town. Some critics felt that this differed little from traditional local history exhibitions, but the key was the context: by placing the experiences of 'ordinary people' at the centre, and by comparing two very different communities, the work changed 'life' into 'art' and led the viewer into comparing two social structures.

Art for Society, at the Whitechapel Art Gallery, showed the work of ninety-nine artists who directly addressed social issues. Conrad Atkinson – who also exhibited at the Serpentine – showed *Asbestos (The Lungs of Capitalism)*, an arrangement of documents about industrial illness. Tony Rickaby's *Fascade* was a series of drawings of London buildings, each the headquarters of an organization with right-wing leanings, their traditional and rather bland appearance becoming quite secondary to the political impulse of the images. Leeson and Dunn showed posters protesting against cuts to London hospitals; works by collectives addressing a range of social issues were prominent. In work of this sort, the engage-

ment and passion of conceptualism was never in doubt.

Probably the most successful politically engaged conceptual artist of the decade was Victor Burgin. His earliest work in the 1970s, such as *Performative/Narrative* (1971), took the form of repeated identical photographic prints with a series of different captions which both created and destroyed a narrative and conceptual context. This was work of intellectual complexity and coolness, but which often appeared inaccessible. By contrast, Burgin's 'appropriated image' work in the mid-1970s borrowed images from advertising to use them in a way that was both immediate and conceptually challenging; he explained his aim as being 'to deconstruct the ideological division between the inside and the outside of the gallery' (Burgin 1986: 12). *Possession* (1976) achieves this well. Commissioned by the Scottish Arts Council, it was later produced in an edition of 500 and displayed as a poster on commercial hoardings in Newcastle-upon-Tyne. A photograph of a couple embracing appears between two statements: 'What does possession mean to you?' and '7 per cent of our population own 84 per cent of our wealth'. Yet whether the work reached its desired consumers is another question. In a *Studio International* article, passers-by were asked what they thought; out of seven people, only one understood the economic nature of the statement. But the work is not invalidated by this response, which is after all not statistically reliable. Burgin had succeeded in making a comment about contemporary values in which the form was as important as the content – instead of putting posters in galleries, like many other artists, he took an art work on to the hoardings.

Burgin's later work moves towards greater complexity, in which the relation between photographic image and verbal text exists on many levels, demanding careful reading by the onlooker. *UK 76* (1976) is a series of eleven panels, each showing a contemporary scene accompanied by a text chosen for its ironic relation to the image. One shows an Asian woman on a factory production line with an accompanying text from a fashion magazine, headed *St Laurent Demands a Whole New Lifestyle*. The irony is self-evident; but, as Burgin himself felt, there was also a hint of exploitation in the intrusiveness of his presence as a photographer. The final image of the series shows a woman with a baby-buggy walking through a suburban housing estate, with an ecstatic holiday-brochure text extolling dawn in the Pacific islands: a concluding legend reads *Today is the Tomorrow you were Promised*

Yesterday. This is powerful social criticism, attacking the sterility of suburban life, the irrelevance of the advertiser's dream and the lie of the politician. Here, as always with Burgin, the formal perfection of the photograph adds elegant counterpoise to the passion of the message: overall the 'concept' is clear and powerful. Yet there were doubts about the political validity of Burgin's method. Richard Cork regretted, in the *Evening Standard*, that the works were shown in a traditional Bond Street gallery, for sale in an edition of three at the price of £1,300 each. Should there not, he wondered, be a cheaper, larger edition, so that people outside the charmed circle of the art collector could share in the image?

This was one way in which Burgin's work seemed to be self-defeating, regardless of its intellectual and visual elegance. Another was its growing espousal of literary and social theory. *Zoo 78* (1978) is a series of photographic diptychs which parallel a zoo in Berlin with a pornographic peepshow nearby, to locate the scopophilic view of women within an urban and historical context and confront the question: 'To what extent is the male-coded voice of sexual oppression the archetype of all oppressive discourses – the very pattern through which oppression in general operates' (Burgin 1986: 97). The post-structuralist thinking continues in *In Lyon* (1980), three triptychs exploring 'the imbrication of the psychic and the social, of sexuality and politics' (Burgin 1986: 97). One of the panels consists of three texts: a narrative, a psycho-analytic commentary and a history of Lyon. Conceptually this is an extremely vigorous and lucid exploration of kinds of discourse-in-parallel: yet this very complexity moves it further into the art establishment of which Burgin is now inevitably a part, since its theoretical allusions are known only to a well-informed readership. This may, of course, not matter: in an interview given in 1979 (*Block* 7, 1982: 2–27), Burgin stressed the need to fight the system from within, quoting Althusser's idea that institutions are not only the stake but also the site of the class struggle.

THE ART OF 'MINORITIES'

The stress on idea, not image, of conceptual art was fundamentally appropriate to the feminist and black movements which were growing in strength in the 1970s – although both produced work which was as powerful in its medium as in its message.

Feminist art was well represented in the *Art for Society* show.

Margaret Harrison's *Rape* presented reproductions of 'fine art' images of woman as sex-object – Manet's *Déjeuner sur l'herbe* (1863) among them – a series of photographs of a dark street, and a dialogue recording how the artist talked herself out of rape. In linking autobiography with photography and images borrowed from earlier art, it was representative of techniques frequently used by politically committed conceptualists. *A Portrait of the Artist as a Young Housewife*, an installation at the Institute of Contemporary Arts (ICA) (1977) showing a domestic living room, began as a postal event – another aspect of early conceptualism which allowed artists to exchange and share images and ideas and to propagate them beyond the gallery network. In this 'event', and the installation which grew from it, women artists displayed as art objects items that were 'cooked and eaten, washed and worn'. Perhaps there was an ambiguity here: was this a celebration of the value of such work and such settings, or was it a cry from the sexual prison-cell?

New approaches to the position of women were prominent in other exhibitions. Margaret Harrison's work – at the *Women's Work* show, Battersea Arts Centre (1974) – included a treatment of rape in paint and collage and a collection of official documents on scandalously low-paid women 'outworkers'. A feminist statement of a different sort was Mary Kelly's *Post-partum Document*, a range of representations of and comments on birth and early childhood, including writings by the artist as mother, diagrams and charts related to Lacanian psychology and – to the delighted outrage of some critics – soiled nappies. This was a serious exploration of the mother–child relationship in terms that were both physically immediate and intellectually challenging.

Black art was similarly politically engaged. The magazine *Black Phoenix* was founded in 1978 and in its first issue directly linked the struggle for the acceptance of black art to the larger fight for acceptance of black people: *Britain is our Home and we will not Accept our Secondary and Inferior Roles in this Society*. Its claim about the way art was organized was accurate and direct: 'the English chauvinistic art promotion pattern ignores the art activity of black people in the country, or relegates it to ethnic pigeon-holes' (*Black Phoenix* 1 (winter) 1978: 10). At the third regional Minority Arts Advisory Service Conference on Ethnic Arts held in London in June 1976, Ruth Marks, the speaker from the Arts Council, said that the Council's function was to support traditional

British artists (like Gilbert and George, perhaps? Hard to see what is traditional or British there . . .). The statement is all the more alarming since it appeared in the same year as Naseem Khan's report on *The Arts Britain Ignores* for the Arts Council, which stated clearly the need for institutional involvement in art of every part of society, whatever its origin.

Rasheed Araeen, the editor of *Black Phoenix*, was arguably the most important artist in the black visual art movement. His *Oluwale* (1973), the third of four collage panels, reproduced newspaper and magazine articles on police brutality to black people. The later *How Could One Paint a Self-Portrait* (1978–9) was a head and shoulders portrait with racist graffiti sprayed over it. Elsewhere, Araeen made statements about the treatment of black people by attacking American imperialism. *Fire* (1975) is a series of photomontages showing a version of the stars and stripes. The stars have been replaced by warplanes, and 'Down with American Imperialism' is sprayed graffito-like across the surface. In one image, the flag is shown being burned away, revealing beneath it a single star and the legend 'long live the VICTORY of the INDOCHINESE PEOPLE'. The Vietnam protest paintings place black culture alongside that of other exploited minorities, and thus, like much feminist and other engaged conceptual art of the decade, revealed an attempt to build broader political and cultural allegiances.

Other artists preferred to change attitudes through education: the Poster-Film Collective, for example, designed a series of posters to be displayed in primary schools to spread racial awareness. One, shown at the Whitechapel's *Art and Society*, framed images of Third World cultures with the assertion: 'We are often told that before the Europeans "discovered" us we were uncivilized savages. This is not true'. This was certainly a powerful statement when seen on the wall of a crumbling school or college in Hackney.

That breaking out of the ghetto of 'ethnic art' was still difficult, however, is shown in the relative obscurity of Afro-Asian artists who were working in a wide range of idioms in the 1970s. The Sri Lankan painter Ivan Peries showed, in work such as *Dehiwala* (1978), a fresco-like quality in the use of thin washes of paint; Ahmed Parraz developed very energetic, gestural paintings such as *Composition* (1975); Baraj Khanna conjoined the imagery of Indian temple sculpture with a mainstream style influenced by

Klee and Miró in work such as *Festival* (1970); Autarjeet Dharjal's metal sculptures, for example *Low Spiral* (1976), continued the work of the New Generation sculptors of the 1960s. Yet it was known only to a handful of contemporary onlookers: not until 1989 was a major show of Afro-Asian art held in Britain, with the Hayward's *The Other Story*.

PERFORMANCE ART

Although performance art in the 1970s had affinities with conceptualism, its concern with the presence of the performers and the involvement of the audience in a single shared act marks it off as a separate development. A socially engaged version of performance art was produced by groups based in the north of England. In Liverpool, the Great Georges Project involved itself in community activities from bingo sessions to play-groups, as well as organizing a programme of *Gifts to the City* (1970) which involved giving breakfast to local commuters in a special bus, or processing in Victorian costume through derelict parts of the city to lay wreaths on the sites of buildings that were once important but were now in ruins. John Fox's Welfare State, the largest performance art group, used elements of popular theatre – 'mummers, circus, fairground, puppets, music-hall' (Fox, quoted in Henri 1974: 119) – in long, loosely structured productions which used closed circuit television and pop music to convey, directly and explicitly, commitment in their form as much as in their content. A more indirect approach to social issues, by contrast, was taken by Bruce MacLean's group 'Nice Style, the World's First Pose Band', formed in 1972. Its starting point was the contemporary obsession with pose and gesture – fuelled by Desmond Morris's book *The Naked Ape* – which was treated with masterly irony as a serious intellectual discourse in work such as *The Pose that Took Us to the Top, Deep Freeze* (1972). The film *Seen From the Side* (1973) was described by MacLean himself as discussing 'the problem of bad style, superficiality and acquisitiveness in a society that holds pose to be very important' (Goldberg 1979: 117).

The most significant figures in performance art, however, were Gilbert and George. Gilbert Proesch and George Passmore, sculpture students at St Martin's in the late 1960s, rejected the school's concerns with abstract forms and industrial materials and instead declared *themselves* works of living sculpture. Their earliest works

were 'singing sculptures', the most well known of which was *Underneath the Arches* (1971), a six-minute sequence in which, dressed in the 'respectable suits' which became their habitual working costume, they stood on a table and made mechanical movements to a recording of the music-hall act Flanagan and Allan. The nature of their actions turned the performance from popular entertainment into ritual; the covering of their faces and hands with bronze paint made a comic reference to formal, representational 'sculpture'; and the repetition of the act for anything up to eight hours rid it of any referential 'meaning'. What emerged was a reinvention of an act of popular entertainment in a new idiom of sculpture, existing in time as well as space, yet inevitably related to 'real life' through its ostensible 'subject'. Sculpture and life had indeed merged, but it was not as simple as that: Gilbert and George's work was full of levels of irony about art, ownership and performance in both a 'popular' and a 'fine art' context. The same was true in other early works, such as *Impressions of the Art World* (1971), a mock lecture on sculpture given with Bruce McLean, who acted out sculptures by members of the St Martin's staff, and *The Meal* (1969), where thirty guests, including David Hockney, were served a meal by a descendant of Mrs Beeton.

Other works explore the idea of ritualistic movement in different ways. The 'drinking sculptures', which involved moving through East End pubs, not only show the self-conscious wit of the performers but also force us to reconsider the relation between art and everyday life. At their most direct, they reveal the absurdity of daily suburban rituals such as commuting, in a kind of abstracted version of the ritualistic performance of thousands of men in 'respectable suits' satirized by the Reginald Perrin television series. More subtly, they almost deconstruct the very idea of sculpture: instead of our walking around a sculpture, the sculpture now walks around us, in a redefinition of space which is almost a completion of Caro's work in the late 1960s.

It is probably not for their performance pieces that Gilbert and George will come to be valued, however, but for their photopieces, which they began to produce at the same time. Covering a range of subjects from art and landscape to clinical depression, the city, religion and homosexuality, these present a world view that is at once detached and passionately committed. In the early years of the decade Gilbert and George had produced 'Charcoal on Paper Sculptures', large drawings which placed their two figures in vari-

ous settings as part of the 'life as art' idea. From these evolved work with photographs, a medium which they saw as being concerned with 'content' and thus removing elements of romantic 'expressiveness' from the image. After experimenting with narrative sequences of separate images, the artists moved towards presentation of apparently documentary photographs linked in rectangular grids with no narrative but rather a simultaneous presentation of images which comment on and redefine each other.

The Dirty Words (1977) exemplifies these qualities. Each of the twenty-six images uses a sprayed graffito of a 'dirty word' as its title and its text, itself an absorption of the contemporary visual scene into an art form both original and obvious. This raises questions of the 'ownership' of the walls on which graffiti are drawn as well as the 'rightness' of the political or social messages they contain and the 'offensiveness' of the words themselves. That one of the dirty words is 'rich' is both significant and, given the nature of the other images, inevitable. The initial image, *Are You Angry or Are You Boring?*, seems to postulate the only possible alternative views of urban life, with the words of the title as graffiti on a brick wall across the top, images of young blacks, city buildings and city crowds in the centre, and flanking images of the artists themselves. Others are even more explicit. *Cunt Scum* shows policemen and office blocks alongside homeless people; *Fucked Up* has six images of the Stock Exchange dealing floor and two silhouettes of soldiers with rifles; the overall conclusion seems to be encapsulated in *Bollocks We're All Angry*.

The size of the images, as well as their messages, make them compelling: so, too, does the use of blood-red tinting for some of the photographs in each one, meticulously applied to be quite uniform and flat in surface, thus avoiding any self-consciously 'expressive' elements and focusing the interest on the object, not the presentation. This results in social comment that is powerful, disturbing and, because of its use of immediately recognizeable late twentieth-century images, accessible – even if, to many, it is also deeply offensive. Not all of their photographic work is so provocative; indeed, it can be very gentle, as in the sequence *Mental* (1976), which shows the two men juxtaposed with images of the city and of trees and blossom, conveying an idea of the individual astray in the built environment which is at once calm, angry and

moving and which, like all of the sequences, builds to a very powerful cumulative effect.

Critical appreciation of Gilbert and George is made hazardous by their own refusal to accept the usual terms and questions of the art critic. They assert that they are conservatives, yet their political message is radically opposed to Thatcherite greed: they stress the need to wear 'respectable suits' yet have appeared with them covered in cut-out letters reading 'George the Cunt' and 'Gilbert the Shit'. They have offered their own critical commentaries to their work, satirizing the pretensions of art critics before they have had a chance to comment. Their own manifestos stress the accessibility of their art – 'We say that puzzling, obscure and form-obsessed art is decadent and a cruel denial of the Life of the People' (Gilbert and George 1986: vii) – yet their logo is a mock royal crest; and some of their pronouncements – 'The Lord chisels still, so don't leave your bench for long' (Goldberg 1979: 108) – show a witty awareness of the Victorian tradition of religious pomposity in art criticism that is known only to an educated élite.

Despite all this, Gilbert and George seem clearly to be in the mainstream of British social realist art. Their use of 'dirty words' is angry; but it also has a tenderness of the sort found in the soldiers' songs of the First World War, where obscene litanies convey the otherwise inexpressible frustration and compassion of individuals caught up in global political movements. Their photo-pieces have a directness and an inevitability which both achieve their aim of unmediated speech and, ironically, show a purity of form which is almost classical in its chasteness.

THE MATERIAL BASE

In many ways, the art world of the 1970s was concerned more with consolidation than with experimentation. At auction, it seemed that many of the artists whose work was at the start of the decade quite outside the market had been safely absorbed as commodities. In the final year of the decade, a Christo relief sold for £19,000; a comic-strip painting by Roy Lichtenstein sold for £89,000. The older galleries were still more concerned with the past than the present. As in the preceding decade, the Royal Academy played safe, with Rossetti, Lowry, Victorian and Edwardian Decorative Art, Victorian paintings from the *Forbes* magazine collection, and historical shows from Poland, China,

Spain and the USSR. There were signs of hope – *British Sculptors* (1972) showed contemporary work, but by then the New Generation was becoming old hat. The Vienna Secessionists show gestured towards modernism, but was eclipsed by the blockbusting show of *The Impressionists*.

The large loan exhibition became a dominant form in the decade, often involving re-valuations of earlier figures or periods. The Tate's *Landscape in Britain c.1750–1850* (1974) was an important re-assessment of Romantic landscape and its origins, aided by the shows of Constable (1976) and the blockbusting Turner of 1975. Other facets of Romantic art were explored too – Fuseli in 1975, and the links between Stubbs and Wedgwood in 1974. But these were excitingly new in their approach: social awareness and intellectual precision had taken over from the genteel country-housism for so long associated with the commissioning and display of English landscape.

It was left to the smaller galleries to show what was currently going on, and amongst them the Whitechapel was important, beginning with *3 → a: New Multiple Art in 1970* and moving on, through Hockney and *Three Israeli Artists* to the *Art and Society* show already discussed. Even the historical shows at the Whitechapel explored social and ideological issues: a fine and long-needed exhibition presented Hawksmoor in the context of local architecture, and *G. F. Watts: a Nineteenth-Century Phenomenon* presented the artist in the context of the Victorian art market. The Serpentine, newly acquired by the Arts Council, produced vigorous exhibitions: *Art for Whom* (1978) followed on from *Art as Thought Process* (1976).

The most important individual collectors were Robert and Lisa Sainsbury, who in 1978 opened their collection to the public in the Sainsbury Centre at the University of East Anglia. The collection had always been more concerned with sculpture, and largely consists of African, Pacific and Pre-Colombian American art, but Sainsbury also has strong interests in more recent artists, in particular Henry Moore and the sculptor John Davies. As a broadening of the traditional British concept of visual art, and in its desire to present art within a context both educational and available to the public, the Sainsbury collection is typical of the best thinking about art and society of the decade.

Corporate sponsorship of the arts was much discussed, although in practice its effects were limited. Guinness sponsored a show by

the sculptor Bernard Shottlander at their London offices; IBM gave a grant to the Serpentine Gallery and, with Marks & Spencer, helped to support the Arnolfini Gallery in Bristol. Other bodies funded specific exhibitions: the *Sunday Times* made a profit of £100,000 from the *Tutankhamen* show, and went on to fund *China* and *1776*. Players funded the *British Genius* show of 1977; the *Daily Telegraph* and Imperial Tobacco jointly funded AD *79 Pompeii*. The question remains whether this was a genuine response to public need or business playing safe in supporting the cosily historic. A similar uncertainty surrounds the Association of Business Sponsorship of the Arts, founded in 1976 by seventeen companies including Imperial Tobacco and ICI. Some found the trend a vibrant partnership between business and art; but others saw in it the genesis of, at best, bland foyer art and riskless conventional exhibitions and, at worst, the interference of multinational corporations in yet another facet of public life.

Corporate support waned as the economy declined in mid-decade. The competitions of the 1960s, such as the Stuyvesant and John Moores, continued only for the first few years of the 1970s; private buyers were hard to find. Many small commercial galleries were badly hit by their policy of including 'buy-back' clauses into earlier contracts, which obliged them to re-purchase works for their original price should the buyer so wish. In a climate of inflation and recession, this forced many closures: included in the casualty list was the Kasmin, which had done much to bring 1960s artists into the Bond Street circuit.

Thus it was the large state-funded institutions, principally the public galleries, to which the artists turned for sales and support. During the decade the Tate bought work by Hockney, Caulfield, Tom Phillips and Richard Long, and also broadened its collection of contemporary American and European artists' work. The donation of the Institute of Contemporary Prints' collection to the gallery in 1975 further extended its holdings, as did the gift of Alistair McAlpine's fine collection of recent British sculpture. Galleries outside London, aided and expanded in some cases by the development of Arts Centres, also played their part: the Museum of Modern Art in Oxford, the Glynn Vivian in Swansea and city art galleries in Leeds, Sheffield and other northern centres were significant in their selection of recent art, if not in the volume of their purchases.

Overall, though, it was the Arts Council which emerged as the

most significant single institutional support. The Council's collec-
tion – 3,000 items in 1976 – was widely displayed in touring
exhibitions or as individual items on loan to public buildings.
Two-thirds of its purchase budget was allocated each year to one
or two individuals briefed to buy the work of contemporary artists
whom they considered important. Richard Cork's *Beyond
Painting and Sculpture* exhibition was the result in 1974; in 1975
the selectors were Ron Kitaj and Paul Huxley, whose purchases
were displayed at the Hayward the following summer. *British Art
1940–80* (Hayward Gallery 1980) showed the range of the
Council's collection at the end of the decade.

But the influence of the Arts Council reached much further
than its purchases. As the main state instrument of funding the
arts, it inevitably had the effect of nudging artistic change in
directions which suited its own thinking. At first glance, it
certainly seemed to support new directions. The New Activities
Committee, founded in 1968, sounded impressive: but with a
budget of £15,000 split between eight regions in 1969–70 and no
separate allowance for the next year, it was hard to see what it
could achieve. The Community Arts Committee, established
in 1975, and Khan's *The Arts Britain Ignores* report of the
following year demonstrate the discrepancy between apparent
radicalism and practical inactivity. Even the more apparently se-
cure Works of Arts for Public Buildings scheme, started in 1967,
had dwindled to the extent that by the end of the 1970s only 1.5
per cent of the total visual art budget was available for
purchases.

The question of support for the artist was similarly vexed. A
1974 report on *Patronage of the Creative Artist* (what other sort is
there?) flirted inconclusively with *droit de suite*, the artist's right to
a part of the subsequent sale price of his or her work. Some Arts
Council awards and bursaries were offered: for 1975, there were
five of £2,500; sixteen of between £500 and £750; and 52 of up to
£500; Noel Forster was chosen as the first artist-in-residence at
Balliol. Support was given to artists' collectives, such as SPACE,
in providing studios, and the Artists' Placement Group, in moving
artists into new locations. The underlying policy seemed to be that
the artist should get on and produce something, and then the Arts
Council might think about buying it. Many artists saw the Council
as a group of Londoners whose idea of dynamic action was to write
a pretty nifty memo. Around them, according to this view, was a

charmed circle of court favourites whose work was promoted at the expense of other, worthier figures.

Final judgements on the Arts Council's policies varied. Marina Vaizey thought there had been 'an honest even arduous attempt to involve as many tastes as possible' (Hewison 1986: 87) in its selection of works for display or purchase. Others were less generous: Robert Hutchison complained that 'the culture of the Arts Council' was 'too cosy and incestuous' (Hutchison 1982: 157); Janet Daley saw the annual policy of awards and exhibitions as a 'ritual dance in which the partners periodically change position, but no one ever leaves the floor' (*New Universities Quarterly* 35 (1) (winter 1980–1): 64).

Criticism and study of art underwent a considerable rejuvenation in the decade, at every level from popular journalism to university studies. Partly this was the usual process of historical accident; partly it had deeper causes. Richard Cork became art critic of the London *Evening News*, and wrote criticism that was direct, questioning and above all both intelligent and accessible to a non-specialist public. The growth of colour supplements in the Sunday papers allowed the spread of popular art criticism accompanied by reasonably sound colour reproduction, and this pushed the awareness of art a little beyond its traditional constituency of owners, dealers and gallery-visiting *cognoscenti*. More specialized publications also thrived and developed. One example of this was the foundation of *Black Phoenix*, as discussed earlier. The longstanding artist's journal *The Studio* changed its name to *Studio International* and – under the editorship first of Charles Harrison and later of Richard Cork – expanded to cover new forms such as performance art, film and video.

In a more academic sphere, *Block* (founded 1979) deliberately changed the focus of art-historical writing from issues of attribution and connoisseurship to those of the social context and ideology implicit within art works of a far wider range than that hitherto studied, taking its theoretical lead from French critics such as Barthes. This was complemented by the introduction of more academic elements in practical art courses as art colleges were subsumed into polytechnics, and also by the study of art history in new universities such as Sussex, Essex and East Anglia and – perhaps more important – in polytechnics, especially Middlesex, home of *Block*. This 'new art history', as it came to be known, was evidenced in books such as T. J. Clark's *The Absolute*

Bourgeois: Artists and Politics in France 1848–51 (1973) and Nikos Hadjinicolaou's *Art History and the Class Struggle* (1970), and in courses such as Clark's MA in the social history of art founded at Leeds in 1975, or the Open University's cross-disciplinary units.

LARGER SIGNIFICANCES

Given the strong commitment to engaging with contemporary issues and reaching a wider public of so many artists during the 1970s, it may seem ironic that the gulf between the artist and the public – even the gallery-going public accustomed to Cubism and Abstract Expressionism – grew so large in the decade. The problem was that what artists saw as the needs and concerns of the people were not, apparently, the same as what the people wanted, as comments in the visitors' book at the Whitechapel's *Art for Society* show suggest:

> People want to get away from industrial work and things associated with daily living. Why not fantasize?
>
> Paint a beach
>
> (Lippard 1984: 82)

This is not to say that a great deal of the art, and art policy, of the decade did not have considerable public impact. When Carl Andre's *Equivalent VIII* was bought for the Tate in 1975, the tabloids leapt in to decry the waste of public money, epitomized in the *Daily Mirror* headline 'What a load of Rubbish'. And the confrontation of social issues such as rape has had valuable if limited results in changing attitudes since the 1970s.

One major reason why the new art of the decade seemed aloof from daily concerns was that it remained immured in complex theory. Self-referential conceptual art in particular seemed to be exploring a blind alley, most clearly so in *Art & Language*. This – the group, its journal, its exhibitions – was begun by Michael Baldwin and colleagues at Coventry College of Art in 1968. The journal was concerned to explore the ideological foundations of art using the British tradition of analytic linguistic philosophy, but to do this in a manner in which the analysis itself became the artwork. Charles Harrison, who took over as editor in 1971, stressed that the quest was to 'establish some kind of common-sense-ontology' (1974 vol. 4: 12) for art – to establish the basic principles of its

nature and existence – rather than to propangandize the cause of conceptualism. While this might well have been the aim, the result seems now to be another piece of aesthetic navel-contemplation instead of real redefinition of the nature of art and art criticism. The group inevitably became implicated in the suspension of the course in art theory at Coventry when the Art College was subsumed into Lanchester Polytechnic.

Perhaps the greatest irony about the art of the decade is the commercial success of conceptual art. Despite all of the plans to make art something both less and more than a 'commodity fetish', by the end of the decade it had become just that, with Burgin selling in Bond Street and galleries incurring public wrath for their policies of buying conceptual art for what onlookers saw as absurd prices. The most successful conceptual artists, despite their own irritation, ended up as part of the art establishment. And that process contains an even greater irony: the artists who began by agreeing with the public that art was fetishized and inaccessible ended up more distant than ever from the wider public. It was left to Tom Keating to provide the most telling comment on the art market in his forgeries of Samuel Palmer: despite being signed in ball-point pen and being inscribed with legends like 'Fuck the capitalists' in their margins, they fooled many experts in the London salerooms. But twenty years later, even they are being collected: the capacity of the market to absorb its enemies should never be underestimated.

FURTHER READING

No single work covers the ground fully. Hewison (1986) outlines the first half of the period, and Lucie-Smith (1980) has a fair range of illustrations, though is thin on the ideas of the decade. Catalogues to individual exhibitions, such as Cork (1974, 1978), Paoletti (1984) and Szeemann (1969) are valuable contemporary statements; Lippard (1973, 1984) and Cork (1979) are useful collections of reviews. Goldberg (1979) and Smith (1981) are useful introductions to performance and conceptualism respectively; Araeen (1989) is indispensable on the work of Afro-Asian artists. Further information on the historical context of art in the 1970s can be found in Spalding (1986); Sillars (1992) discusses art in the preceding decade. Writing on individual artists is listed in the references: in most cases these include illustrations of the works mentioned in this chapter.

BIBLIOGRAPHY

Araeen, Rashid (1989) *The Other Story: Afro-Asian Artists in Post-war Britain*, London: Hayward Gallery.
Burgin, Victor (1973) *Work and Commentary*, London: Latimer New Dimensions.
—— (1986) *Between*, Oxford: Blackwell.
Colpitt, Frances (1990) *Minimal Art: The Critical Perspective*, London: UMI Research Press.
Cork, Richard (1974) *Beyond Painting and Sculpture: Works bought for the Arts Council by Richard Cork*, London: Arts Council.
—— (1978) *Art for Whom?*, London: Serpentine Gallery.
—— (1979) *The Social Role of Art: Essays in Criticism for a Newspaper Public*, London: Gordon Fraser.
Fuchs, R. H. (1986) *Richard Long*, London: Thames & Hudson.
Gilbert and George (1986) *Gilbert and George: The Complete Pictures 1971–1985*, London: Thames & Hudson.
Goldberg, RoseLee (1979) *Performance: Live Art 1909 to the present*, London: Thames & Hudson.
Gowing, Lawrence (1982) *Lucian Freud*, London: Thames & Hudson.
Hadjinicolaou, Nikos (1970) *Art History and the Class Struggle*, London: Pluto.
Henri, Adrian (1974) *Environments and Happenings*, London: Thames & Hudson.
Hewison, Robert (1986) *Too Much: Art and Society in the Sixties 1960–75*, London: Methuen.
Hutchison, Robert (1982) *The Politics of the Arts Council*, London: Sinclair Browne.
Lippard, Lucy R. (1973) *Six Years: The Dematerialization of the Art Object*, New York: Praeger; London: Studio Vista.
—— (1984) *Get the Message? A Decade of Art for Social Change*, New York: Dutton.
Livingstone, Marco (1981) *David Hockney*, London: Thames & Hudson.
—— (1985) *R. B. Kitaj*, Oxford: Phaidon.
Lucie-Smith, Edward (1980) *Art in the Seventies*, London: Thames & Hudson.
Maenz, Paul and de Vries, Gerd (1972) *Art & Language*, Cologne: DuMont.
McEwen, John and Sylvester, David (1984) *Howard Hodgkin: Forty Paintings 1973–84*, London: Trefoil Books and Whitechapel Art Gallery.
Meyer, Ursula (1972) *Conceptual Art*, New York: Dutton.
Paoletti, John T. (1984) *The Critical Eye 1*, Yale: Yale Center for British Art.
Sillars, Stuart (1992) 'Caro verbum factus est: British art in the 1960s', in B. Moore-Gilbert and J. Seed (eds) *Cultural Revolution? The Challenge of the Arts in the 1960s*, London: Routledge.
Smith, Roberta (1981) 'Conceptual art', in Nikos Stangos (ed.) *Concepts*

of Modern Art, London: Thames & Hudson.

Spalding, Frances (1986) *British Art since 1900*, London: Thames & Hudson.

Szeemann, Harald (ed.) (1969) *When Attitudes become Form: Live in Your Head*, London: Institute of Contemporary Arts.

Chapter 13

Up against the wall
Drama in the 1970s

Martin Priestman

INTRODUCTION: PARTINGS OF THE WAYS 1970–3

The main battle-lines of 1970s British drama are easier to draw than those of the preceding decade. Although the 1960s saw great innovations in drama, most of them can be traced back to the extraordinary years 1955–6, when the agenda of a hitherto comfortably bourgeois theatre was re-set by a three-pronged attack from (a) left-wing 'political theatre' in the shape of the first British appearance of Bertolt Brecht's Berliner Ensemble; (b) philosophical 'theatre of the absurd', as represented by the British première of Samuel Beckett's *Waiting for Godot*; and (c) the less clearly defined voice-finding rebellion of the indigenous 'angry young man', as typified by John Osborne's *Look Back in Anger*. The new drama of the 1960s repeatedly referred (or was referred) back to all three of these models on the unspoken understanding that they were all, roughly, allied in their rejection of established mainstream practice.

The equivalent watershed year for 1970s drama was 1968, when radical and student unrest in the United States, France, Germany and (more timidly) Britain was matched by new notions of theatre as an activist force able to address an expanding 'alternative' subculture. The years from 1968 to 1970 were marked by a flowering of British Fringe groups, in which the three main post-1955 developments still seemed at first equally influential: political 'agit-prop' (e.g. David Edgar's company The General Will); absurdist reality-questioning (from the dadaist People Show to the Tom Stoppard pieces performed by the communally minded Inter-Action); and 'angry' discovery of new constituencies and voices (e.g. David Hare's and Howard Brenton's Portable Theatre).

If the main new constituency busy discovering itself at the start of the 1970s was the young-radical Left, more specific identities soon emerged from under this umbrella. A fair idea of the sequence can be gleaned from the three special 'Seasons' presented at Inter-Action's Ambience and Almost Free Theatres in the first half of the decade: the Black, Women's and Gay Seasons of 1970, 1973 and 1975. While Black and Asian theatre had to wait another decade to have much impact on the mainstream (white audiences still most frequently encountered black experience through the eyes of such white writers as Athol Fugard and Michael Hastings), the 1970s saw the emergence of several new groups like Temba and Tara Arts as well as playwrights like Mustapha Matura and Michael Abbensetts. The decade's most powerful new voice was undoubtedly women's theatre, which is discussed elsewhere in this volume. The third new constituency, the gay community, may appear to have been always well represented in the theatre, but not until the founding of Gay Sweatshop, a group which emerged from the Almost Free season, were gay experiences and feelings presented without disguise or apology (see Osment 1989: xiv–xix). While still sidelined from the mainstream in rather the same way as Black theatre, Gay Sweatshop's work directly inspired Martin Sherman's *Bent* (RSC 1979), the huge success of which helped to transform mainstream presentation of gay experience and history.

There is much more to be said about these three developments, but the main general point to make is that, in articulating shared personal and social experiences, each constituency encountered itself as 'political' in a new way, and thus saw itself as engaged, at least dialectically, with the broader movement of the Left. On the other hand, 'absurdism's' success in playing its wry view of epistemological collapse back to the theatre-going classes had already started to differentiate it from the other post-1956 developments. Very broadly, then, the reasonably amiable three-way split of innovative 1960s drama gave way to a much clearer two-way split in the 1970s, between a society-comedy of the absurd and a drama (indeed most often a tragedy) of contemporary society and/or politics.

At least in the academic world, much more has by now been written about 'political theatre' than its absurd-tinged 'non-political' counterpart. For this reason, an attempt to explore 1970s drama afresh has some obligation to give at least a sketch of the latter (while trying to avoid some of the absurdities the 'non-

political' label seems to imply). At the start of the decade, the radical Left still chiefly inhabited the wilderness of the non-establishment Fringe, to which it also began to attract such established left-wing dramatists as John Arden, John McGrath and Edward Bond. By contrast, the takeover of the main stages by the *comic* 'class of 1968' took place with astounding smoothness.

In 1970, London saw plays by Alan Ayckbourn (*How the Other Half Loves*, first performed in Scarborough two years earlier), Tom Stoppard (*After Magritte*) and Michael Frayn (*The Two of Us*); and in 1971 by Simon Gray (*Butley*), Alan Bennett (*Getting On*) and Peter Nicholls (*Forget-Me-Not Lane*). Most of these writers had emerged as formal if not thematic radicals in the later 1960s, and now established a collective impetus which maintained itself comfortably for the rest of the decade and much of the 1980s. Equally welcome in West End or subsidized theatres, often built round some enjoyable and easily identified disruption of theatrical conventions of space or time or both (such as Ayckbourn's meticulously plotted merging of two living rooms into a single set), these plays could be greeted with relief as heralds of a renaissance in which the innovations of the 1960s were married to attention to craftsmanship and an ability to attract audiences.

The work of these six writers is typically complex, sophisticated and by no means impervious to the interpersonal and social malaises registered by more 'serious' dramatists. Stoppard, in particular, was often bracketed with Pinter, who in turn now established himself as the leading director of his friend Gray's work, with *Butley*. Such plays often represent their decade very well by celebrating an accelerating descent into a confusion and disorder which sometimes appears more terminal and final even than the worst imaginings of the radicals, who tend to take the worst for granted in order to re-imagine the best. The main difference is that these plays largely accept the comic conventions whereby the audience identifies automatically with recognizeable, usually middle-class characters whose normal routine is disrupted for a while and then restored. Among the twists within this basic pattern which may add seriousness and resonance are revelations of real unpleasantness in a main character, or a failure completely to reverse the descent into chaos at the end in the expected way. Such devices were often handled powerfully and innovatively by these writers, and it became a commonplace of reviewing that Ayckbourn's comedies, in particular, were really pieces of tragic

social observation (see Billington 1983: 1). The difference between such comedies and the drama/tragedy of the Left lies chiefly in the nature of the audience's emotional identification: for these plays this is with the *survival* of the main characters and as much of their normal routine as possible; on the Left, with the accomplishing of change, whether consciously desired by the central characters or not.

The two camps did have some things in common, however: in a formula often repeated but largely accurate, much 1970s drama was about the choice of appropriate microcosms of the current 'condition of Britain' – usually seen by both sides as one of increasing decline and uncertainty. The Fringe-based Left explored this theme more explicitly, repeatedly epitomizing Britain as a site of crumbling 1960s optimism, often with a lurking potential for fascism. Such microcosms include an ambivalently named 'party' unable to produce either enjoyment or political coherence (Trevor Griffiths, *The Party*, 1973); a Shakespeare more corruptly 'our contemporary' than we had bargained for (Edward Bond, *Lear*, 1971; *Bingo*, 1973); a hidden concentration camp (Howard Brenton, *The Churchill Play*, 1974); a racist popular comic discourse (Griffiths, *Comedians*, 1975); a failed rock concert (David Hare, *Teeth 'n' Smiles*, 1975); a foundering crisp factory (Brenton, *Weapons of Happiness*, 1976), a post-imperial greenhouse of Nazism (David Edgar, *Destiny*, 1976); a prison burned down by its progressive governor (Howard Barker, *The Hang of the Gaol*, 1978); a sexually crippled imperial family (Caryl Churchill, *Cloud Nine*, 1979).

The absurd-tinged comic writers, on the other hand, tended to examine the British malaise through such stagnating institutions as a chaos-ridden newspaper office or a work-shy college common room (Michael Frayn, *Alphabetical Order*, 1975; Simon Gray, *Butley*, 1971); through communication-entropy within families and marriages (Alan Ayckbourn, *Just Between Ourselves*, 1976); or through such specific images as the slowly collapsing pyramid of acrobats in Tom Stoppard's *Jumpers* (1972).

The apparent contradiction of comedic conservatives revelling in the slow passing of the old order and radicals with barely any confidence in their own recent panaceas also involves an initial sense of paradox in their relative uses of 'absurd' and 'realist' techniques. Initially, in many cases, radical drama relies strongly on the *données* and assumptions of absurdism – the apocalyptic

post-everything wasteland, feeding strongly into a typically 1970s
sense of (self-)betrayal – while 'non-political' comedy relies on the
initially realist assumption that it is simply and wryly taking notes
on modern life. Yet it is fair to say that, given their crossed
starting-points, the former aims at a tightening sense of social
specificity, often involving a distinctly non-absurd debate over the
immediate future, while the latter allows its vision of breakdown
and meaning-loss to widen slowly until it fills the frame. Some of
the difference and tension between the two camps can be
explained by the comic writers' pride in the virtuoso formal crafts-
manship so well learned from Beckett, Pinter and that third great
Absurdist influence, French farce; and, on the other side, the
radicals' more casual assumption of such techniques as useful but
not essential devices for initially disrupting socially determined
assumptions of the normal.

On the main stages at the start of the decade, however, neither
of these tendencies was quite the central influence hindsight may
project it as. The leading heavyweights of the post-1956 dramatic
renaissance all produced substantial, eagerly awaited new plays in
the early 1970s. Arnold Wesker's *The Friends* (1970), John
Osborne's *West of Suez* (1971), Harold Pinter's *Old Times* (1971)
and (with qualifications to be explored later) John Arden's *The
Island of the Mighty*, co-written with Margaretta D'Arcy (1972)
were all greeted with considerable relief as their respective
authors' most identifiably characteristic work for some time. The
previous London-produced works of these writers – Wesker's
Their Very Own and Golden City (1966), Osborne's *Time Present*
and *A Hotel in Amsterdam* (1968), Pinter's *Landscape* and *Silence*
(1969) and Arden and D'Arcy's *The Hero Rises Up* (1968) – had
all been written dangerously long ago, and/or somehow under full
length or strength: now they all suddenly produced what most
critics agreed to be genuinely central and major work. It is inter-
esting, though, that each of these works is in itself a retrospect,
and virtually declares as much in its title. Wesker's 'Friends' are
mourners at the death of that 1960s arts-and-crafts comradeship-
in-arms whose end would soon be announced more forcefully by
the RSC actors' mutiny against the form and suspected right-wing
content of his next play, *The Journalists* (see Leeming 1983: 96);
Osborne's 'West of Suez' is the end-of-empire mental region
better explored in *Look Back in Anger* and *The Entertainer* than
any of his intervening work; Pinter's 'Old Times' betoken not only

the uncertainly agreed past of all his plays, but also a crucially nostalgic nod to his own mastery of this particular terrain; Arden and D'Arcy's 'Island of the Mighty' is the British mainland they were about to abandon for good both as a theatrical home and a dramatic subject – ironically, after disagreements over the RSC's staging of this very play (see Arden 1977: 159–72). If the virtual exile of the Ardens and Wesker was a symptom of profound new rifts in the old theatrical Left, it is also necessary to note that the theatrical disappearance of other writers – Robert Bolt, John Mortimer and to some extent Pinter – was the result of new and increasingly lucrative openings in film and television.

A last introductory point: the 1970s saw a gradual shift away from the previous decade's celebration of 'sexual liberation' to what some critics identified as a new puritanism (see Lloyd Evans and Lloyd Evans 1985: 219). Though not avoided as a topic, sex was treated with a new complexity and irony, as can even be seen in the transition between two hugely popular shows on the subject: Kenneth Tynan's somewhat solemn erotic compilation *Oh! Calcutta!* (1970), and Richard O'Brien's polymorphous-perverse spoof-musical *The Rocky Horror Picture Show* (1973). The retreat from 1960s luxuriance was also signalled in the replacement of such titles as *K. D. Dufford Hears K. D. Dufford Ask K. D. Dufford How K. D. Dufford'll Make K. D. Dufford* (David Halliwell 1969) by *Flint* (David Mercer), *Home* (David Storey), *Fruit* (Howard Brenton) and *Slag* (David Hare) (all in 1970). Throughout the decade, the deliberately hard-sounding one-word title was to remain a particular trademark of the Left, emphasizing the suppressed violence of 'normal' discourse as well as the kind of interventionist impact the play hopes to have.

By 1973 the fissures described so far had come into such clear focus that if one had to choose a paradigmatic 'moment of the 1970s' this might well be it. The year of *The Rocky Horror Picture Show* and Ayckbourn's most ambitious hit, the three-play *The Norman Conquests*, this was also the year in which radical Fringe writers pre-eminently began to 'take over' the main stages of the subsidized sector, with Brenton's *Magnificence* (the main Royal Court Theatre, as opposed to its Theatre Upstairs, already a frequent Brenton venue), Brenton and Hare's *Brassneck* (Nottingham Playhouse, revelling in the scenic possibilities and large cast of a major regional theatre) and Griffiths's *The Party* (The National, with Olivier leading a crack classical cast). In this year

too Edward Bond, the slightly older dramatist whose uncom-
promising use of political shock, poetry and surreal parody had
done most to fire and inspire the Fringe aesthetic, settled firmly
into the role of sage with the new maturity, or at least obliqueness,
of *The Sea* (Royal Court) and *Bingo* (Exeter).

Though the departure from the scene of such late 1950s writers
as Arden and Wesker was now virtually complete, two exceptions
illustrate the now-yawning gulf between wholly different notions
of dramatic experimentation. One of the biggest hits of 1973 was
Peter Shaffer's *Equus*, whose use of 'progressive' techniques for
reactionary ends I shall discuss more fully later. The same year
also saw a completely different kind of achievement by another
older writer, John McGrath. Following fifteen productive years in
television and regional theatre, McGrath founded the touring
group 7:84 (England) in 1972, and in 1973 the far more influential
7:84 (Scotland), acclaimed by many as the actual 'National
Theatre of Scotland' long denied by successive Anglo-oriented
bureaucracies (see McGrath 1990: 87). The company's first pro-
duction was McGrath's *The Cheviot, the Stag, and the Black, Black
Oil*, which linked the eighteenth-century Highland Clearances
with the current Anglo-American exploitation of the Scottish
North Sea oil-boom and, though it visited Glasgow and
Edinburgh, was chiefly performed in the small communities being
exploited – a constituency naturally defined by the content of the
play itself.

DIVERTED ENERGIES 1973–6

Eventually televised to wide acclaim, *The Cheviot*'s status as an
exemplary social play of the 1970s was coincidentally reinforced by
the OPEC oil-price hike which made its theme of the diversion of
oil profits specially poignant. The OPEC decision also changed the
thrust of Britain's economic, social and cultural life permanently
and virtually overnight.

In drama, such 1960s preoccupations as the malaises of material
affluence, the generation gap brought on by the rising expectations
of youth, and the abuse of British power overseas, now began to
be replaced by perceptions of irreversible urban squalor, youthful
nihilism and Britain's international impotence. To some extent,
the frequent aspiration to see the organized working class (hith-
erto often portrayed as too apathetic and obsequious to achieve

anything for itself) dictating its own terms to government seemed to have been partly realized in the miners' victorious 1974 strike, which handed an apparently clear mandate to Harold Wilson's Labour government to effect a really radical redistribution of power. At the same time, however, the millennial hopes of 1968 had faded, and Wilson and Heath had long been perceived as two sides of the same coin, so that rapid disillusion with the new dispensation was – if only half-consciously – almost guaranteed.

Though never exactly dewy-eyed optimists, such radical writers as Brenton and Hare now began to delve back into the reasons for the failure of the earlier revolutionary spirit. While their 1973 collaboration *Brassneck* had been paradoxically optimistic in presenting only monsters – bent jerry-builders, drug pushers and venal Labourites – destined, it could be hoped, for the scrap-heap of history, Hare and Brenton now turned their attention to the twisted and half-corrupted idealists with whom their audience might be expected to identify more closely. In *Knuckle* (1974) and *Teeth 'n' Smiles* (1975) Hare sets up potentially positive figures – a private-eye-like avenger and a once-inspirational rock singer – only to show their personal failures as virtually inevitable consequences of the culture in which they are enmeshed. The one positive on offer is a varyingly honest acceptance of collapse and decay. (Though 1975 also saw Hare's *Fanshen*, in which a revolutionary society is shown taking on positive shape and direction, it is situated on the other side of the world, in China.) In *The Churchill Play* (1974), Brenton takes the imminent collapse of the new union militancy for granted; Wilson or no Wilson, the old Establishment will only tolerate a certain amount of disruption, after which it will resort to force: the play is set in a future concentration camp for dissidents, who attempt to trace the failure of their cause back to the lie of national unity symbolized by Churchill. With *Weapons of Happiness* (1976) Brenton focuses more fully on the theme of revolutionary failure, juxtaposing the callow nihilism of current youth/industrial unrest with the perversion of Eastern European communism, as recalled through the eyes of a ghost-like revenant from Stalin's purges. While hope of a kind is held out at the end, it is in terms for which the anxiously excavated revolutionary past offers a message, but no precedent.

Much of this was territory already explored by a dramatist apparently more interested in argument than outrageous metaphor, Trevor Griffiths. In *Occupations* (1971) and *The Party*

(1973), Griffiths had analysed a number of Leftist dead-ends, leaving only small room for hope. (In this, and perhaps explicitly in the character of the wise but alcoholic dramatist Sloman in *The Party*, Griffiths is an important link between the radical Fringe and the work of David Mercer, the previous master of this terrain.) Curiously, the play with which Griffiths made his greatest impact was *Comedians* (1975), where the Leftist soul-searching is outweighed by the kind of dadaist shock effect which had earlier been the stock-in-trade of Brenton in particular. The immaculately 'performed' savaging of two middle-class dummies by a trainee comedian got up as a cross between a clown and a skinhead gives the play some claim to be one of the inspirations for the stylized aggression of punk the following year, while the arguments it generated have often been acknowledged as the beginning of an 'alternative' comedy which attempts to reject racist and sexist stereotypes without losing a sense of bite and shock. At least part of the play's impact may have lain in the way it *explained* the shock-aesthetic of the old Brentonesque Fringe while boiling it down into a brief, savage 'turn'. It is arguable that in such works of the mid-1970s the old political Fringe began reflecting on itself, and in doing so turned into something else.

The aggression of punk was also adumbrated in such plays as Stephen Poliakoff's *Hitting Town* and *City Sugar* (1975), with their stress on the hopelessness of the concrete urban jungles created with such idealism only a few years previously; Steven Berkoff's *East* (1975), with its stylized relish in the squalor and violence of East End street life; Howard Barker's *Claw* (1976) about the doomed power-bid of a stud-jacketed working-class weakling with the Dickensian name Biledew; and Barrie Keeffe's *Gotcha* (1976), in which a pre-punk vision of 'no future' leads a schoolboy to terrorize the teachers who have failed to educate him. It would not be hard to demonstrate what each of these might have contributed to punk's distinctive mixture of stylized attacks on and celebration of dead-end urban culture-as-nature. If punk partly denoted the re-embrace of a working-class/unemployed destiny by a generation its parents and teachers intended to have been declassed (see Hebdige 1979: 62–3), it is not too surprising that playwrights should try to hang on to this generational constituency by following, and perhaps helping to define, its plummeting self-esteem.

One direction in which no Fringe dramatist wished either to lead or to follow the new disfranchized generation was the far Right.

From well before the swastika jewellery of the punk era neo-Nazi groups like the National Front and National Movement had been attracting young working-class whites in significant numbers. The first play to tackle this topic in depth, David Edgar's *Destiny*, made a great impact when it was staged (1976) and then televised (1978). Though disturbing in its demonstration of the logical links between fascism and the collapse of empire, Edgar's play replaces fashionable 'no future' angst with a quest for specific solutions to a specific problem, in line with the *agit-prop* tradition from which Edgar had emerged (with the Bradford-based General Will in 1971). Outside London, especially where local issues could be highlighted, *agit-prop* and community theatre remained active throughout the decade, confronting in particular (as in Peter Cheeseman's 1974 production *The Fight for Shelton Bar* at Stoke) the impact of national government policies on specific, often dwindling, local industries. In drawing attention to these issues, such performances increasingly problematized the assumed consensus between 'national' and 'regional' theatre.

A NATIONAL THEATRE? 1976–9

The long-delayed transfer of the National Theatre from the modest-sized Old Vic to its costly new three-auditorium South Bank building finally took place between March and October, 1976. Conceived in the heady 1960s amid a consensus that it should divide with the equally prestigious Royal Shakespeare Company the lion's share of an increasingly generous Arts Council theatre subsidy, the building opened to a storm of controversy which indicated how fast that consensus was now evaporating. Among other things, the 1972 transfer of the RSC's founding genius Peter Hall to the National had sharply raised the question of why the two companies could not cut costs by combining – a possibility secretly discussed by Hall and his RSC successor Trevor Nunn throughout the decade, and perhaps baulked as much by the RSC's prior commitment to an eventual new Barbican Theatre as by personalities. But the 'score or so of the Fringe chanting "Whose National Theatre? Whose National Theatre?"' (Hall 1983: 265) at the Royal opening night were also expressing a more widely held view that the centre of gravity of innovative and relevant drama had shifted away from such huge corporate state enterprises and towards the more flexible regional and/or touring

companies initially encouraged by subsidy and now in danger of being starved of it by the National's colossal costs.

Among the theatre's greatest problems was a massive initial oversight: the day-to-day cost of running the building itself, irrespective of productions, had simply not been included in the original calculations. In the year before opening this had already totalled £788,000, rising to £1 million in 1976–7 and £2.5 million in 1987 (see Lewis 1990: 125–6). But of course the National's story is more widely typical of the gap between 1960s hopes and 1970s realities than that. It was the 1973 oil crisis which lay behind the progressive braking of government 'social' spending from which the theatre as a whole was now suffering; and the union militancy which was largely another response to the same phenomenon now ran full-tilt into the efficiency-driven 'managerial' role into which the theatre's director, Peter Hall, had been thrust (or had leapt). In his *Diaries*, Hall vividly conveys his frustration at the three-year building delays, causing numerous costly revisions of production strategy, and at the August 1976 stagehands' strike over job demarcations between the three auditoria which yet further delayed the opening of the main Olivier stage (Hall 1983: 248–69).

A comparison with the 1972 disputes at Hall's previous company, the RSC, is instructive. These were led by playwrights and actors respectively, with Arden and D'Arcy picketing their own *Island of the Mighty* on the grounds of right-wing production values, and actors boycotting Wesker's *The Journalists* on grounds of undramatic and/or right-wing content. Silly and destructive as these quarrels can easily sound, they were also attempts to take seriously the ideal of ensemble involvement on which the 1960s RSC had claimed to be based (the Ardens attempted to add not only writers but also stage and front-of-house staff to the decision-making group; the actors had a 'right-to-refuse' clause in their contracts). The largely good-humoured response of the departing Hall to such events (and to his successor Trevor Nunn's public claim that the RSC was 'basically a left-wing organization') contrasts strongly with his fury at the National's stagehands four years later. Their readiness to treat the massively but finitely subsidized enterprise as a paternalistic nationalized body like the Coal Board, and his determination to run it like an inspirational family firm, spectacularly exemplified the ever-widening rift between Labourist assumptions and the returning entrepreneurialism that would sweep Margaret Thatcher to power in 1979 (when Hall felt

'positively good' about voting Tory for the first time; see Hall 1983: 434). In the conflicts it so dramatically embodied, at least, Hall's could truly be called a national theatre.

What of the plays? The first new work at the Lyttleton (the first of the National's stages to open) was Osborne's last full stage play for sixteen years, *Watch It Come Down*. A poorly received piece about disintegrating relationships within an off-beat group of intellectuals, the play did at least hit the mood of the times with its title, which could have been applied equally well to any recent play by Brenton (whose *Weapons of Happiness* followed it into the Lyttleton later in the year), Hare (who directed *Weapons*), Barker or Griffiths – and supporters and critics of the strike-torn National may well have thought the same about the infant theatre itself. But where Osborne's final acceptance of irreversible decline expresses a kind of 'I told you so' terminalism, the younger writers' obsession with decay is more a matter of impatience, a sense that the order mentally removed long ago has still physically refused completely to collapse.

From the start, Brenton's and Hare's virtual takeover of the National's limited but clearly defined 'radical new drama' slot was thoroughly prepared for and theorized. One of the most publicized statements of intent by any 1970s playwright was Brenton's 1976 farewell to the Fringe 'because we want consciously to use the National facilities to show off our work to its best advantage' (see Bull 1984: 29). The wording is significant: the work already somehow exists; the relation between meaning and form, writing and staging is already established; the National is the place to show it off. This concept of the National as a 'showcase' recurs over and over again through the decade, contrasting strongly with such 1950s–1960s metaphors as 'seedbed' (the Royal Court) and 'ensemble' (Hall's RSC and, to some extent, the early National under Olivier and a strong ex-Royal Court team). The new National, by contrast, was almost forced to counterbalance endless charges of white-elephantcy and megalomania with the claim, not to be merely one theatre among many, but an epitome: the place where the 'best' of everything was eventually bound to end up.

In executing the leap from white elephant to showcase, the Lyttleton was in particular danger of looking like an elephant's graveyard. (This is where some committed Fringers saw Brenton and Hare as now headed following their occupation of the National's most conservative – prosceniumed – space.) But the

graveyard danger loomed equally for the Cottesloe. The National's 'studio' was as big as some other main stages, but none the less attempted to operate like the circuit of studio spaces which had sprung up since the late 1960s. (Whether purpose-built into new regional theatres like the Sheffield Crucible or converted from other uses, such studio spaces were the lifeblood of innovative 1970s theatre, both in offering affordable subsidized venues for touring Fringe companies and in allowing local experimental work to develop under the same terms – often in a loose but creative association with a larger main stage company. In London, an early model was the Royal Court's Theatre Upstairs, opened in 1968, where many key early Fringe pieces were staged and which often challenged its main house as a writers' 'seedbed' throughout the 1970s.) Upon finally opening in March 1977, the Cottesloe happily fulfilled its brief to 'showcase' the best of the itinerant Fringe by giving houseroom to the Ken Campbell Roadshow's eight-hour science-fiction fantasy *Illuminatus*. But despite much initial enthusiasm for such activities, the Cottesloe rapidly reverted to a more manageable role as the National's third house, only innovative within a clearly circumscribed policy structure. Under Bill Bryden's direction, the Cottesloe rapidly developed a distinctive popular-folklorist house-style in such 'promenade' productions as Tony Harrison's translation of *The Mysteries* (1977–85) and Keith Dewhurst's adaptations *Lark Rise* and *The World Turned Upside Down* (1978). True to the democratic-yet-classic nature of the space, these adaptations spoke powerfully if somewhat mistily of the spirit of the English common people through the ages, and remain perhaps the National's one really distinctive addition to the national dramatic vocabulary. But if these productions, and their many Cottesloe successors, 'showcased' some of what the Fringe was supposed to be about, the traffic was largely one-way: while its pay and resources attracted talent and know-how from across the country, there was in fact to be little reciprocal interchange between the Cottesloe and the rest of the Fringe circuit.

The National's main stage, the Olivier, was chiefly used for classics. Conceived as an inflexible apron in an arena-sized auditorium, in the days when historical, Brecht-tinged 'public' theatre seemed to be the coming thing, it was only capable of presenting a small segment of what new writers actually wanted to write; and then only when they had committed themselves to write specifically for the Olivier, which in turn depended on full confidence

amongst the management. The first such writer, Edward Bond, understandably threatened to withdraw his play altogether when Hall belatedly suggested a switch to the cheaper Cottesloe (Hall 1983: 318); in fact there is wide agreement that *The Woman* (1978) was one of the most successful uses ever made of the Olivier for new work – but this depended on a cradle-to-grave integration of writing and staging (Bond directed the play too) that was only rarely practicable.

The other great purpose-built Olivier play of the 1970s was *Amadeus* by Peter Shaffer, a brief account of whose symbiotic relationship with the National since *The Royal Hunt of the Sun* in 1964 may be instructive at this point. One of the inventors of comic space–time subversion (with *Black Comedy* (1965) where light means its opposite throughout), Shaffer managed in the 1970s to hang on superbly to the task of purveying private conservative angst through public 'epic' techniques for which he and the National Theatre seemed to have been mutually created. If this sounds sceptical, it is only an attempt to register the thoroughness with which the excitement of brilliantly conceived 'Brechtian' production devices (mimed mountaineering, red ribbons for blood, horselike stilts, amplified music and, everywhere, masks) were repeatedly subsumed to a single reverse-oedipal obsession. In Shaffer's three main successes, the youthful threats of the pre-capitalist Inca king Atahuallpa (*The Royal Hunt of the Sun*, 1964), the violent but visionary Alan Strang (*Equus*, 1973) and the foul-mouthed genius Mozart (*Amadeus*) to a series of ageing, spiritually second-rate protagonists seem quite deliberately to mirror the successive threats of the Brechtian history play, the gestural sex and violence of the Fringe, and the abusive energy of punk rock to the central culture – as represented by the National Theatre in general and its guilty conscience Shaffer in particular.

In their revisionary use of public staging methods to present private – and increasingly elitist – messages, the National and Shaffer had long seemed made for each other, and the Olivier was now able to amplify these effects even further (with Hall himself replacing Shaffer's usual director John Dexter, who refused to work in the daunting space). Some such sense of primal bonding seems expressed in Hall's 1979 assertion, a month after casting his first Tory vote, that 'for years I have been praying for a sincere radical right-wing play, and this is it, because *Amadeus* is about

the uniqueness of talent, its refusal to be part of the system, its refusal to be other than selfish' (Hall 1983: 448).

In devoting so much space to the National Theatre in and around 1976, I do not at all mean to deny the importance of other major theatres in London or elsewhere. But if the main fault-lines of theatrical change can by common agreement best be found in Theatre Workshop and at the Royal Court in the 1950s, and at the RSC in the 1960s, the same is true of the National in the 1970s. There is less agreement, though, as to the positive nature of the change. The National truly was, as already suggested, a major 'showcase' of much of the richness and diversity of new British drama; at the same time the fact that the ultimate showcase of the Olivier was only 'conquered' in the first instance by dramatists as diametrically opposed in everything else as Bond and Shaffer raises the question of whether diversity should be seen as an absolute in itself. Though hindsight may overstress this, it is undeniable that in their respective heydays Theatre Workshop, the Royal Court and the RSC all forged highly distinctive approaches which crucially depended on *excluding* parts of the currently available dramatic spectrum. By contrast, a pluralism extending from Bond and Brenton to Shaffer and Ayckbourn (from 1977 a bedrock of the company's viability) was virtually forced on the National by its sheer size as much as by its official agenda. But it is arguable that, in a decade where 'new' writing was divided against itself more violently than at any time before or since, any 'National' quest for a sense of dramatic direction or identity was almost bound to find itself drowned in a Babel-like confusion of tongues.

CONCLUSION

The 1970s were brought to a dramatic close by the 1979 election victory of the Conservatives under Margaret Thatcher. It could easily be argued that the great failure of a decade of unprecedentedly left-wing drama was its inability either to predict this event or to understand quickly enough the depth of the change which it represented. This may seem unfair given that plays like Brenton's *The Churchill Play*, Edgar's *Destiny* and Barker's *That Good Between Us* did little else *but* fantasize extreme versions of such a backlash; but was the lipsmacking relishing of Labourite decay, interspersed with sporadic cries for often violent action,

actually the best way to rally the theatre-going part of a dwindling liberal-Left consensus against the coming right-wing revival? In delineating so bitterly its disgust with welfarist promises not always kept, in pacemaking so accurately the ideological nihilism of punk, didn't the 'political theatre' generation wilfully deliver itself up to the Thatcherite 'short sharp shock'?

The sharp change in the cultural atmosphere was perhaps most dramatically registered by Mary Whitehouse's 1980 prosecution under the Sexual Offences Act of Michael Bogdanov, whose National Theatre production of Brenton's *The Romans in Britain* contained a simulated buggery in an early scene. Though the prosecution was unsuccessful, liberal support for the play was far more muted than in previous similar cases. And Whitehouse's agenda was implicitly accepted in the way in which the play's complex meditation on imperialism from Roman times to the current British inclusion of parts of Roman Catholic Ireland was widely overlooked in favour of the minutiae of the 'obscenity' issue.

If Brenton's play offered the New Right's cultural police the perfect 'permissive' object to try its teeth out on, late 1970s drama was in fact much more often characterized by a new respectability, a turning away from shock effects in favour of 'issue' plays calculated to unite liberal opinion across a broad spectrum. David Edgar's *Mary Barnes* and *The Jail Diary of Albie Sachs* dealt respectively with schizophrenia and the known wrongs of South African apartheid; Hare's *Plenty* inaugurated the kind of understated middle-class *angst* drama for which he is now acclaimed; Brian Clarke, a collaborator with Hare, Edgar and Brenton on such early 1970s shock-pieces as *Lay-By* and *England's Ireland*, now had his biggest hit with *Whose Life is it Anyway?*, a fair-minded study of euthanasia; Michael Hastings's *Gloo Joo* offered the West End a newly positive view of black British culture; Nigel Williams's *Class Enemy* used a school classroom to pun on national tensions, but sided with the would-be liberal teacher in ways that might have seemed 'soft' a year or two earlier. In 1978, too, feminism finally worked its way on to the main stages in plays excavating history for heroic role models such as Pam Gems's *Piaf*, Steve Gooch's *The Woman-Pirates Anne Bonney and Mary Read*, and Edward Bond's *The Woman* (marking a rather belated conversion, given the preponderance of monstrous harpies in Bond's previous work). In 1979 Martin Sherman's *Bent* similarly placed

gay issues in a historical context, as did Caryl Churchill's more surreal *Cloud Nine*. Simon Gray, normally known for his ironic pictures of middle-class academics, became uncharacteristically social in *The Rear Column*, depicting the savagery and incompetence of Empire; and even Pinter indicated a major change of direction with *Betrayal*, where for almost the first time recognizeable moral issues outweigh the usual hermetic ironies.

The end of the 1970s, then, saw a striking coming together of writers and audiences across a broad spectrum on a consensual liberal middle-ground, which was more interested in problem-solving than in root-and-branch denunciations of, or forbiddingly alienated indifference to, current society. But this was accompanied by plays such as *Amadeus* (1979), Ayckbourn's *Ten Times Table* (Scarborough 1977, London 1978), with its violent caricature of 'loony left' local councillors, and Stoppard's *Night and Day* (1978), with its scatter-gun attacks on African dictators, press freedom and the union closed shop.

The simultaneous identification of the decade's three most financially successful dramatists with the resurgent Right was an important cultural shift. At the same time, the old notion of subsidy as a way of enabling the creation of radical work with which the public might or might not eventually 'catch up' received a significant set-back. The West End/Broadway profitability of the three dramatists most lavishly nurtured by the taxpayer, along with the hit-musical success of such RSC-seeded enterprises as *Les Miserables*, began to set up a new agenda whereby state subsidy fed consciously into the culture of the big smash hit which came increasingly to dominate theatrical aspirations. Following some initial controversy over the personal profits made by the two great national company directors Peter Hall and Trevor Nunn from this process, the theatrical economy of the 1980s came increasingly to parallel the Thatcherite diversion of publicly nurtured profits to private hands in such industries as energy and telecommunications. And rather as these privatization profits owed much to the judicious dropping of less profitable lines and services, the 1980s saw a dwindling use of the studio spaces so definitive of 1970s drama in favour of large traditional stages capable of housing the London hits which now began to resume the pre-1960s custom of exhaustive touring. If not abolished, subsidy was decisively rechannelled, particularly in directions where it could combine forces with sponsorship. And a generation of writers whose

articulacy and energy derived from a shared sense of being in tune with real social change found itself increasingly with its own back to the wall.

FURTHER READING

Writing on the period is still to some extent bedevilled by the ideological divisions described above. On radical drama Itzin (1980) covers the broad field very effectively, while Bull's (1984) is perhaps the best account over a narrower range. Wandor (1987 and elsewhere) is the acknowledged scribe of feminist drama and Osment (1989) is informative on the gay movement. Non-radical drama, often simply ignored by academic/radical critics, tends to be left in more traditional hands such as Cave's (1987), for whom Pinter still occupies centre-stage and Ayckbourn and Brenton both offer equally interesting aesthetic innovations. Cornish and Ketels (1986) enshrine a similar approach in their influential anthology, while Lloyd Evans and Lloyd Evans (1985) is almost as instructive for its editorial commentary (whereby political theatre only seems to start around 1976) as for its useful sampling of contemporary reviews over a range of plays from Left, Right and Centre. The one book which, it seems to me, does produce a valid and reasonably comprehensive account of the decade's drama as a whole without ignoring longer perspectives (though here too non-radical 1970s writers get rather short shrift) is Chambers and Prior (1987), to which I am indebted for many connections and starting-points. Otherwise, the most stimulating entry into the whole field is via such practitioners as Arden (1977), Arden and D'Arcy (1988), McGrath (1981, 1990), Hall (1983), Edgar (1988), Gaskill (1988) and Hare (1991).

BIBLIOGRAPHY

Arden, John (1977) *To Present the Pretence: Essays on the Theatre and its Public*, London: Eyre Methuen.

Arden, John and D'Arcy, Margaretta (1988) *Awkward Corners*, London: Methuen.

Billington, Michael (1983) *Alan Ayckbourn*, London: Macmillan.

Bull, John (1984) *New British Political Dramatists*, London: Macmillan.

Cave, Richard Allen (1987) *New British Drama in Performance on the London Stage: 1970–1985*, Gerrards Cross: Colin Smythe.

Chambers, Colin and Prior, Mike (1987) *Playwright's Progress: Patterns of Postwar British Drama*, Oxford: Amber Lane Press.

Cornish, Roger, and Ketels, Violet (1986) *Landmarks of Modern British Drama*, vol. 2: *The Plays of the Seventies*, London: Methuen.

Edgar, David (1978) *Plays: One*, London: Methuen.

—— (1988) *The Second Time as Farce: Reflections on the Drama of Mean Times*, London: Lawrence & Wishart.

Elsom, John (1976) *Post-war British Theatre*, London: Routledge.

Gaskill, William (1988) *A Sense of Direction: Life at the Royal Court*,

London: Faber & Faber.

Hall, Peter (1983) *Peter Hall's Diaries*, ed. John Goodwin, London: Hamish Hamilton.

Hare, David (1991) *Writing Left-Handed*, London: Faber & Faber.

Hebdige, Dick (1979) *Subculture: The Meaning of Style*, London: Methuen.

Itzin, Catherine (1980) *Stages in the Revolution: British Political Theatre Since 1968*, London: Eyre Methuen.

Leeming, Glenda (1983) *Wesker the Playwright*, London: Methuen.

Lewis, Peter (1990) *The National: A Dream Made Concrete*, London: Methuen.

Lloyd Evans, Gareth and Lloyd Evans, Barbara (eds) (1985) *Plays in Review 1956–1980: British Drama and the Critics*, London: Batsford.

McGrath, John (1981) *A Good Night Out: Popular Theatre: Audience, Class, and Form*, London: Methuen.

—— (1990) *The Bone Won't Break: On the Theatre of Hope in Hard Times*, London: Methuen.

Osment, Philip (1989) *Gay Sweatshop: Four Plays and a Company*, London: Methuen.

Wandor, Michelene (1987) *Look Back in Gender: Sexuality and the Family in Post-war British Drama*, London: Methuen.

Index